French
Tapestries
& Textiles

IN THE J. PAUL GETTY MUSEUM

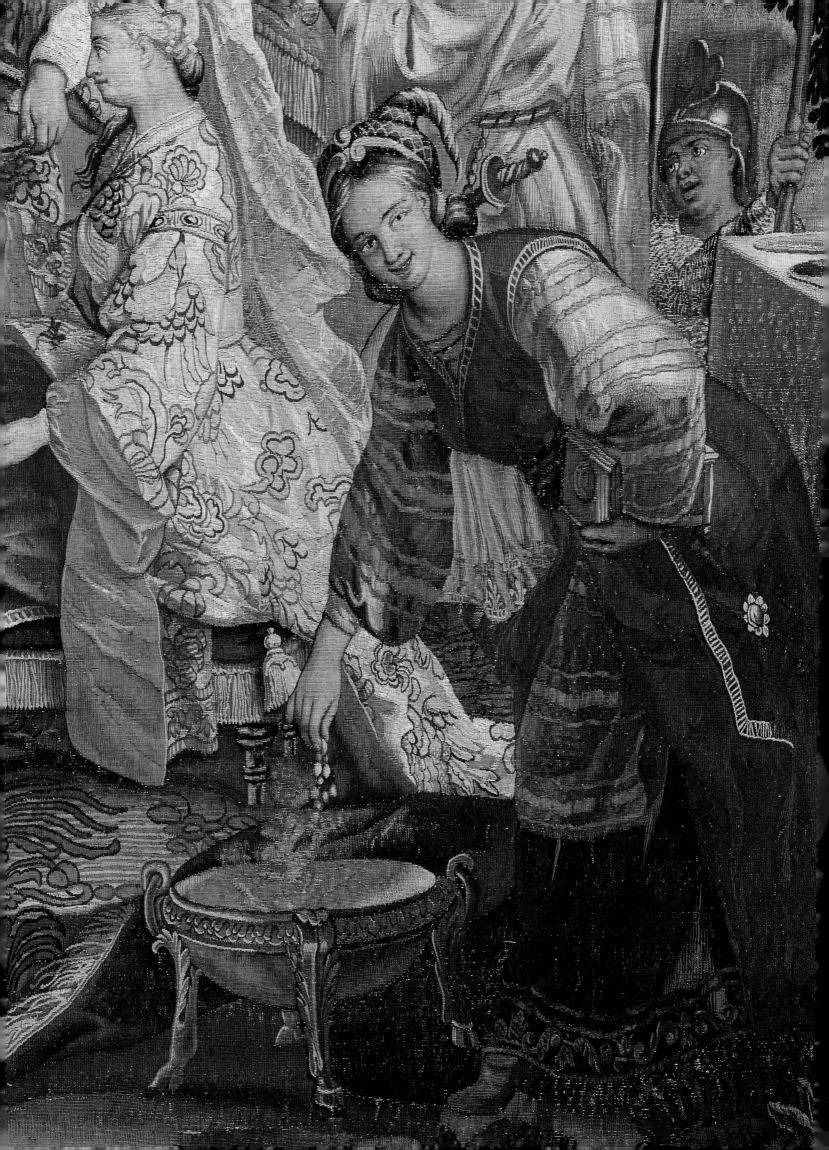

French Tapestries & Textiles

IN THE J. PAUL GETTY MUSEUM

Charissa Bremer-David

THE J. PAUL GETTY MUSEUM ∼ LOS ANGELES

Dedicated to
Edith A. Standen
and
Gillian Wilson

© 1997 The J. Paul Getty Museum
1200 Getty Center Drive, Suite 1000
Los Angeles, California 90049-1687

Christopher Hudson, Publisher
Mark Greenberg, Managing Editor

William Peterson, Editor
Vickie Sawyer Karten, Designer
Amy Armstrong, Production Coordinator
Jack Ross, Photographer

Library of Congress Cataloging-in-Publication Data

J. Paul Getty Museum.
 French tapestries and textiles in the J. Paul Getty Museum /
Charissa Bremer-David.
 p. cm.
 Includes bibliographical references and index.
 ISBN 0-89236-379-7
 1. Tapestry—France—History—17th century—Catalogs.
2. Tapestry—France—History—18th century—Catalogs.
3. Tapestry—California—Los Angeles—Catalogs. 4. Textile fabrics—
France—History—17th century—Catalogs. 5. Textile fabrics—France—
History—18th century—Catalogs. 6. Textile fabrics—California—
Los Angeles—Catalogs. 7. Manufacture nationale de tapisserie des
Gobelins (France)—Catalogs. 8. Manufacture nationale de tapisserie de
Beauvais (France)—Catalogs. 9. Manufacture nationale de la Savonnerie
(France)—Catalogs. 10. J. Paul Getty Museum—Catalogs.
I. Bremer-David, Charissa, 1958– II. Title.
NK3049.A1J18 1997
746.3'0944'07479493—dc20 96-28310
 CIP

FRONT AND BACK COVER: Detail of *Le Mois de décembre, Le Château
du Monceaux* from *Les Maisons royales.* 85.DD.309 (see Cat. no. 3).

FRONTISPIECE: Detail of *La Collation* from *L'Histoire de l'empereur
de la Chine.* 83.DD.336 (see Cat. no. 9).

FIRST DIVIDER (Gobelins): Detail of *Portière du Char de triomphe.*
83.DD.20 (see Cat. no. 1).

SECOND DIVIDER (Beauvais): Detail of *Psyché et le vannier* from
L'Histoire de Psyché. 63.DD.4 (see Cat. no. 11).

THIRD DIVIDER (Savonnerie): Detail of *Four-Panel Screen (Paravent).*
75.DD.1 (see Cat. no. 16).

FOURTH DIVIDER (Needlework Hangings): Detail of headboard
(*champtourné*) from *Hangings for a Bed (Lit à la duchesse).*
79.DH.3.3 (see Cat. no. 18).

Contents

Foreword

THIS CATALOGUE of the Getty Museum's French tapestries, carpets, and textiles is the fourth in a series produced by the Department of Decorative Arts. Preceded by *Mounted Oriental Porcelain* (1982), *Vincennes and Sèvres Porcelain* (1991), and *European Clocks* (1996), this latest catalogue offers readers the first opportunity to study the Museum's entire collection of French textiles. Because these hangings can never be displayed all at once, owing to their large size and to the sensitivity of their dyes to light, this book offers the only complete overview possible. Regular visitors to the Museum will recognize many familiar hangings as they turn the pages, and they will discover others that were never before displayed at the Villa in Malibu. With the opening of the new museum at the Getty Center we have at last the gallery space to show tapestries in rotation.

The keen eye of Gillian Wilson, Curator of Decorative Arts, can be discerned in the choice of virtually every one of the Getty's exceptional collection of textiles. Her acquisitions over the last twenty-five years form not only a series of splendidly made and well-preserved examples, but also a range of fascinating subjects.

The author, Charissa Bremer-David, Assistant Curator of Decorative Arts, has our admiration and thanks for the years of original research that have borne fruit in this book. I am grateful, too, for the conscientious editing of Bill Peterson and the handsome design by Vickie Sawyer Karten. The Photo Services staff of the Getty Museum, especially Jack Ross, made heroic efforts to photograph these very large objects and produced images of a high degree of fidelity. The departments of Decorative Arts Conservation and Preparations also contributed in important ways to this survey of the Museum's textiles. To all of these staff members I am most grateful.

John Walsh
Director

Acknowledgments

THIS CATALOGUE would not have been possible without the contributions of the staff of the J. Paul Getty Museum. In particular, the author is deeply grateful to Gillian Wilson, Curator of Decorative Arts, for her support, encouragement, and unfailing interest throughout the project. Jack Ross, Photographer, worked tirelessly and met every challenge of photographing the oversize textiles. Editor Bill Peterson reviewed the text with intelligence, sensitivity, and unflagging diligence. Mark Greenberg, Managing Editor, offered experienced advice and support throughout. Designer Vickie Sawyer Karten and Production Coordinator Amy Armstrong have produced a handsome book. Other staff members of the Museum contributed to this effort: Jeffrey Weaver, Department of Decorative Arts; Brian Considine, Jane Bassett, and Adrienne Pamp, Department of Decorative Arts Conservation; Peter Shapiro, Michael Mitchell, Gary Lopez, and the crew of art handlers in the Preparations Department; Ann Friedman, Education Department; José Sanchez, Photographic Services Department.

Textile conservator Sharon Shore, of Caring for Textiles, Los Angeles, conducted thorough condition evaluations on almost all the textiles and was essential in assembling the hangings for the bed (*lit à la duchesse*). Her expertise and knowledge is reflected herein.

The author thanks Edith A. Standen, Curator Emeritus, The Metropolitan Museum of Art, New York, who has generously and unreservedly shared her scholarship for more than a decade.

Sincere thanks are offered to those who provided access to archival documents: Jean-Pierre Samoyault and Chantal Gastinel-Coural, Mobilier National, Paris; Daniel Alcouffe, Musée du Louvre, Paris; Tamara Préaud, Archives, Manufacture Nationale de Sèvres.

Many others have assisted the author over the years by contributing information, facilitating research, or by providing photographic images: Monsieur Achkar, Galerie Achkar-Charrière, Paris; Candace Adelson, Memorial Art Gallery, University of Rochester, New York; Tracey Albainy, Detroit Institute of Arts; Irina Artemieva, The State Hermitage, Saint Petersburg; Jacqueline Boccara, Paris; Joseph Baillio, Wildenstein and Company, New York; Nina Banna, The J. Paul Getty Museum; Christian Baulez, Musée National du Château de Versailles; Shelley Bennett, Henry E. Huntington Library and Art Gallery, San Marino, California; Nadja Berri, Sotheby's, Zurich; Marie-Hélène Bersani, Mobilier National, Paris; Dominique Bondu, Paris; Onica Busuioceanu, The Getty Research Institute for the History of Art and the Humanities; Tom Campbell, The Metropolitan Museum of Art, New York; Charles Cator, Christie's, London; Jean-Pierre Cuzin, Musée du Louvre, Paris; Theodore Dell, New York; Isabelle Denis, Monuments Historiques, Paris; Emmanuel Ducamp, Alain de Gourcuff Editeur, Paris; Kathy Francis, Boston; Gay N. Gassmann, Paris; Ekaterina Vassilievna Grichina, Forchungsmuseum der Akademie der Künst, Saint Petersburg; Ebeltje Hartkamp, The Rijksmuseum, Amsterdam; Wendy Hefford, The Victoria and Albert Museum, London; William Iselin, Christie's, New York; Deborah Kraak, The Henry Francis du Pont Winterthur Museum; Ulrich Leben, Paris; Alexia Lebeurre, Paris; Amaury Lefébure, Musée National du Château de Fontainebleau; Amélie Lefébure, Musée Condé, Chantilly; Christophe Leribault, Musée Carnvalet, Paris; Jérôme Letellier, Saint-Leu-la-Forêt; Roman Malek, Monumenta Serica, Sankt Augustin; Christa Mayer Thurman, The Art Institute of Chicago; Sarah Medlam, The Victoria and Albert Museum, London; Paul Mironneau, Musée National du Château de Pau; Philippe Poindront, Musée National du Château de Compiègne; Alexandre Pradère, Sotheby's, Paris; Tamara Rappé, The State Hermitage, Saint Petersburg; Anne Ratzki-Kraatz, Paris; Jean-Marie Rossi, Aveline, Paris; Adrian Sassoon, London; V. K. Schouisky, Forchungsmuseum der Akademie der Künste, Saint Petersburg; Arlette Serullaz, Musée du Louvre, Paris; Margaret Swain, Edinburgh; George Vilinbakhov, The State Hermitage, Saint Petersburg; comte Patrice de Vogüé, Vaux-le-Vicomte; Deirdre Windsor, The Textile Conservation Center, Lowell, Massachusetts; Alice Zrebiec, Sausalito, California; and Henry S. David, Los Angeles, whose patience and endurance made this all possible.

Charissa Bremer-David
October 1996

Introduction

THE COLLECTION of tapestries and textiles in the J. Paul Getty Museum is exceptional among American institutions, for it was formed at the initiative of two individuals, J. Paul Getty and the Museum's curator of decorative arts since 1971, Gillian Wilson. Their efforts, spanning a combined collecting period of approximately sixty years, have produced a representative survey of the French royal manufactories that operated from about 1660 until the period of the Revolution at the end of the eighteenth century. Though they both acted under self-imposed criteria demanding the highest standards of quality, condition, rarity, and provenance, they acquired with enthusiasm and passion. Mr. Getty had firm convictions as a collector of the decorative arts, stating that "a rug or carpet or a piece of furniture can be as beautiful, possess as much artistic merit, and reflect as much creative genius as a painting or a statue."

J. Paul Getty (1892–1976) began acquiring textiles during the second half of the 1930s, subsequent to gaining his mother's shares in the family's oil business. His interests included French eighteenth-century tapestries and Savonnerie carpets, as well as sixteenth-century Persian carpets. By 1937 he had established a steadfast relationship with the New York gallery of French and Company and its associate Mitchell Samuels, the dealer who was to exert an influence for many years to come. From this source Mr. Getty purchased the first of many hangings after the designs of François Boucher, two from *L'Histoire de Psyché* and the large *Arianne et Bacchus*. Mr Getty was particularly proud of the latter, referring to it in 1951 as "my finest" and "one of the greatest tapestries ever created." The year 1938 was one of intense activity for him in the arena of decorative arts. In addition to private purchases of tapestries from Paris dealers, he bought, through intermediaries, at no fewer than three auctions: at Parke-Bernet in New York in April; at the Galerie Charpentier in Paris in May, and at Christie's in London in June (where he obtained the early Savonnerie carpet and the *Chancellerie* portière). He culminated this flurry in the fall of that year by securing the famous Persian carpet known as the *Ardabil*, dated to 1540, from the personal collection of Lord Duveen.

It was not long before Mr. Getty felt the need to share the pleasures of his collection more broadly. He loaned textiles to public exhibitions in New York beginning in 1940, and by 1951 his generous spirit engendered donations to American museums including the Metropolitan Museum of Art in New York and the Los Angeles County Museum of Art. To the latter he gave not only the *Ardabil* but also an equally famous sixteenth-century Persian piece called the *Coronation Carpet*. Eventually, in 1954, he founded his own museum in Malibu and among the highlights of the first galleries were his French tapestries.

Mr. Getty's taste for French tapestries was shared and complemented by that of his curator of decorative arts, Gillian Wilson. During the 1970s the two worked together to strengthen the collection, adding in 1971 the Neo-Classical set of the *Tenture Boucher* from the Gobelins manufactory. However, concerns for creating a significant and balanced presentation in the new galleries of the Villa museum, which opened in 1974, meant that the curatorial focus had to encompass all of the decorative arts and further additions of tapestries were few. It was not until the 1980s that the textile collection enjoyed a period of intense growth equal to that of Mr. Getty's pre-war years. Now acting under a board of trustees, Gillian Wilson presented for purchase hangings uniquely significant for their historical importance as well as their beauty. Her special preference for the Baroque style of the seventeenth century led to an expansion in this field and the purchase of subjects designed during the early years of Louis XIV's reign, such as the *Char de triomphe* and the elaborate series of *L'Empereur de la Chine*. The collection of eighteenth-century weavings, until then dominated by Boucher scenes, was further broadened with the *Portière aux armes de France* and *L'Histoire de don Quichotte*. Finally needlework was added, an area completely lacking until the two acquisitions of embroidered bed hangings.

The similarity of taste between patron and curator can best be exemplified in the case of the Savonnerie carpet woven for the Galerie du Bord de l'Eau of the Palais du Louvre. When Ms. Wilson finally negotiated its purchase in 1985 after months of effort, she had no idea that Mr. Getty himself had attempted, unsuccessfully, to purchase it from a Paris dealer nearly fifty years earlier.

Mr. Getty appreciated the complicated technique and time-consuming method of tapestry weaving and carpet knotting. During a visit in 1951 to the Gobelins manu-

factory he observed the slow progress of the skilled crafts-men working there in the old tradition. As in the eigh-teenth century, a single weaver could produce only one to six square meters per year, depending on the intricacy of the pattern. The looms required that weavers work the composition from its reverse and, frequently, from a per-pendicular orientation.

Ultimately, for all their splendor, the products of the looms are also vulnerable. Their dyes are light-sensitive and subject to fading, and silk fibers in particular degrade with long exposure to air. Because of preservation con-cerns, visitors to the Museum's galleries in the new Getty Center will see only a selection of the textile collection on display at any given time. This catalogue, therefore, will enable those who are interested to study and enjoy the complete collection, as Mr. Getty would have wished.

This catalogue has arranged the Museum's collection of French textiles by technique: tapestry, knotted pile, and needlework. Tapestries are grouped by their place of man-ufacture, Gobelins or Beauvais, in chronological order followed by the knotted pile textiles from the Savonnerie manufactory, also in chronological order. The last two entries in the catalogue are needlework hangings.

Each entry is prefaced by general information that includes dates of manufacture, artists and weavers, woven marks, materials, the gauge of warps or knots per inch, and dimensions. This is followed by a description of the tex-tile's imagery or design. A condition statement accompa-nies each entry; it includes a note on the preservation of the textile's color that is based on a comparison of the obverse of the hanging to its reverse.

Commentary follows providing information on the literary, historical, and visual sources of the subjects portrayed, as well as the context of the textile's commission and its early provenance. Related textiles are noted by their location, publication, or appearance on the art market. Each entry concludes with a full provenance, exhibition history, and bibliography related to the specific tapestry or set of textiles catalogued. The bibliographies are not intended to include all works discussing the general sub-

ject, set, or series under consideration although the end-notes generally include a range of such related publications.

Seventeenth- and eighteenth-century documents are quoted verbatim, retaining the original spellings and idiosyncrasies of the texts. Reference is also made to his-torical units of measure and currency. The following table provides the modern conversions applied.

UNITS OF MEASURE
Eighteenth-century weavers were paid by the basic unit of mea-sure called the ell or *aune*. The *aune de France* was in use at the Gobelins and Savonnerie manufactories while the *aune de Flan-dre* was used at Beauvais. Both were divided into 16 *seizièmes*.

1 *aune de France* = 118.8 cm = 3 ft. 10¾ in.
1 *aune de Flandre* = 69.5 cm = 2 ft. 3⅜ in.

The *pied* was a linear measure used here in reference to paintings, models, and cartoons. It was divided into 12 *pouces*.

1 *pied* = 32.4 cm = 1 ft. ¼ in.

UNITS OF CURRENCY
Prices are noted in the value of *livres*, *sous*, and *derniers*. Their relative values were:

1 *livre* = 20 *sous*
1 *sou* = 12 *derniers*

Note: For further reference consult H. Delesalle, "Aunes de France et aunes de Flandre. Note sur le mesurage des anciennes tapisseries de Beauvais," *Revue de métrologie pratique et légal* 3 (March 1964), pp. 95–98.

Abbreviations

Adelson 1994
C. J. Adelson. *European Tapestry in the Minneapolis Institute of Arts.* Minneapolis, 1994.

A.N.
Archives Nationale, Paris.

Badin 1909
J. Badin. *La Manufacture de tapisseries de Beauvais depuis ses origines jusqu'à nos jours.* Paris, 1909.

Bremer-David et. al., 1993
C. Bremer-David et al. *Decorative Arts: An Illustrated Summary Catalogue of the Collections of the J. Paul Getty Museum.* Malibu, 1993.

Compin and Roquebert + vol.
I. Compin and A. Roquebert. *Catalogue sommaire illustré des peintures du Musée du Louvre et du Musée d'Orsay.* Vol. 3, *Ecole française A–K.* Vol. 4, *Ecole française L–Z.* Paris, 1986.

Coural 1992
J. Coural and C. Gastinel-Coural. *Beauvais: Manufacture nationale de tapisserie.* Paris, 1992.

Engerand 1901
F. Engerand. *Inventaire des tableaux commandés et achetés par la Direction des bâtiments du roi (1709–1792).* Paris, 1901.

Fenaille + vol.
M. Fenaille. *Etat général des tapisseries de la manufacture des Gobelins depuis son origine jusqu'à nos jours 1600–1900.* 5 vols. Paris, 1903–1923 [includes M. Fenaille and M. F. Calmette. *Etat général des tapisseries. . . .* Vol. 5, *Période du dix-neuvième siècle 1794–1900.* Paris, 1912].

Forti Grazzini 1994
N. Forti Grazzini. *Il patrimonio artistico del Quirinale: Gli arazzi.* 2 vols. Rome, 1994.

GettyMusHbk + date
The J. Paul Getty Museum Handbook of the Collections. Malibu, 1986, 1991.

GettyMusJ
The J. Paul Getty Museum Journal.

Getty/LeVane 1955
J. Paul Getty and E. Le Vane. *Collector's Choice: The Chronicle of an Artistic Odyssey through Europe.* London, 1955.

Göbel 1923
H. Göbel. *Wandteppiche.* Part 1, *Die Niederlände.* 2 vols. Leipzig, 1923.

Göbel 1928
H. Göbel. *Wandteppiche.* Part 2, *Die romanischen Länder: Die Wandteppiche und ihre manufakturen in Frankreich, Italien, Spanien und Portugal.* 2 vols. Leipzig, 1928.

GRI
Getty Research Institute for the History of Art and the Humanities.

Guiffrey, *Comptes des Bâtiments* + vol.
J. Guiffrey. *Comptes des Bâtiments du Roi sous le règne de Louis XIV.* 2 vols. Paris, 1881.

Guiffrey, *Inventaire* + vol.
J. Guiffrey. *Inventaire général du Mobilier de la Couronne sous Louis XIV (1663–1715).* 2 vols. Paris, 1885–1886.

Guiffrey 1886
J. Guiffrey. *Histoire de la tapisserie depuis le Moyen Age jusqu'à nos jours.* Tours, 1886.

Hunter 1925
G. L. Hunter. *The Practical Book of Tapestries.* Philadelphia, 1925.

JPGM
J. Paul Getty Museum.

M.N. + serial number
Mobilier National. *Manufacture Nationale de Beauvais, Prix des ouvrages et compte des ouvriers.*

MNS archives
Archives of the Manufacture Nationale de Sèvres.

Meyer 1989
D. Meyer. "Les Tapisseries des appartements royaux à Versailles et la Révolution." In *De Versailles à Paris: Le destin des collections royales.* Exh. cat. Centre Culturel du Panthéon, Paris, 1989.

Sassoon and Wilson 1986
A. Sassoon and G. Wilson. *Decorative Arts: A Handbook of the Collections of the J. Paul Getty Museum.* Malibu, 1986.

Standen 1985
E. Standen. *European Post-Medieval Tapestries and Related Hangings in the Metropolitan Museum of Art.* 2 vols. New York, 1985.

Verlet 1982
P. Verlet. *The James A. de Rothschild Collection at Waddesdon Manor: The Savonnerie.* Fribourg, 1982.

Wilson 1983
G. Wilson. *Selections from the Decorative Arts in the J. Paul Getty Museum.* Malibu, 1983.

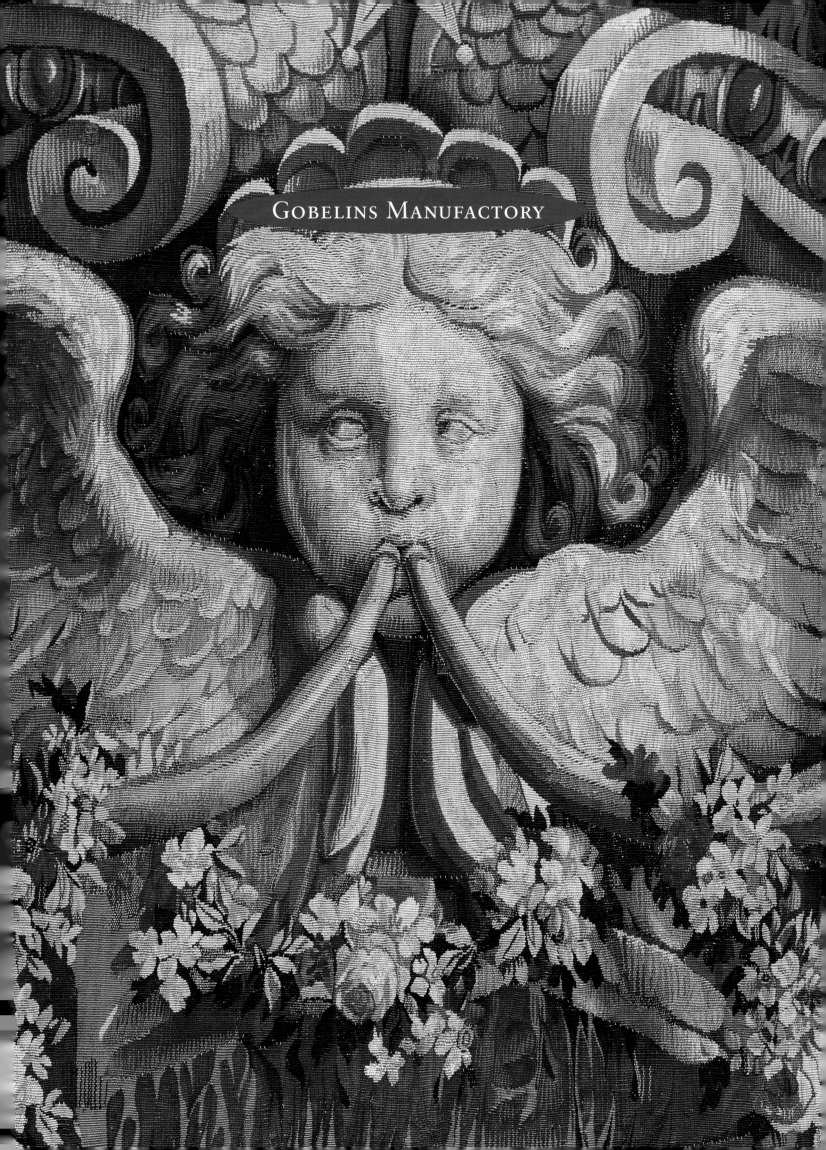

Gobelins Manufactory

I

Portière du Char de triomphe

Gobelins manufactory, Paris; circa 1699–1717

Cartoon designed circa 1662 by Charles Le Brun (1619–1690) and painted by Beaudrin Yvart *le père* (1611–1680). Woven on the low-warp loom between 1699 and 1717 under the direction of Jean de la Croix *père* (*entrepreneur* of the first low-warp workshop, 1662–1712) and/or Jean de la Fraye (circa 1655–1730) or Jean Souet (circa 1653–1724).

WOVEN HERALDRY
Woven with the arms of France and Navarre.

ADDITIONAL MARKS
A portion of the original lining survives, inscribed in ink:

> *N° 194. Port^s Du Char,*
> *6: Sur 3: aus. [aunes] de haut –*
> *2: au [aunes] de Cours*

and (inverted):

> *10-6 six pieces*
> *8 520*

MATERIALS
Wool and silk; linen; modern linen lining

GAUGE
20 to 22 warps per inch / 84 to 112 wefts per inch

DIMENSIONS
height 11 ft. 8¾ in. (357.5 cm)
width 9 ft. 1⅛ in. (277.8 cm)

83.DD.20

DESCRIPTION
This armorial *portière* was designed to hang over a door in a formal interior. The central area of the tapestry is conceived as an architectural niche with an arched cornice upon which are seated two winged putti, each holding a terrestrial globe. Suspended from a ribbon that is pinned at the top of the arch is the heraldic crown of the French kings together with a set of balance scales. Another ribbon, woven with the motto *Nec Pluribus Impar* (literally "not unequal to many," originally translated as "not unequal to the most numerous tasks"), entwines the balancing arm of the scales (fig. 1.1). Shining from the back of the niche is a head of Apollo, representing the Sun God. A blue drapery embellished with golden fleur-de-lys is tied below the cornice and forms a backdrop for a large gilt escutcheon from which rise two fruit-filled cornucopias. The woven cartouche bears the arms of France (*d'azure à tois fleur-de-lys or*) and Navarre (*de gueules à une chaine d'or en triple orle, en croix et en sautoir*), encircled by palm fronds that are laced into the collars of the order of Saint-Michel and the order of the Saint-Esprit.[1] The armorial is secured to a gilded parade chariot that is filled with military trophies of armor, weapons, shields, and flags. Fame, in the form of a winged head blowing two flower-garlanded trumpets, adorns the front of the chariot, and the chariot's wheels crush and sever the enemy, a serpent. The border of the *portière* simulates a gilt frame decorated with guilloche encircling rosettes and fleur-de-lys. A larger fleur-de-lys against a small field of mail fills each corner.

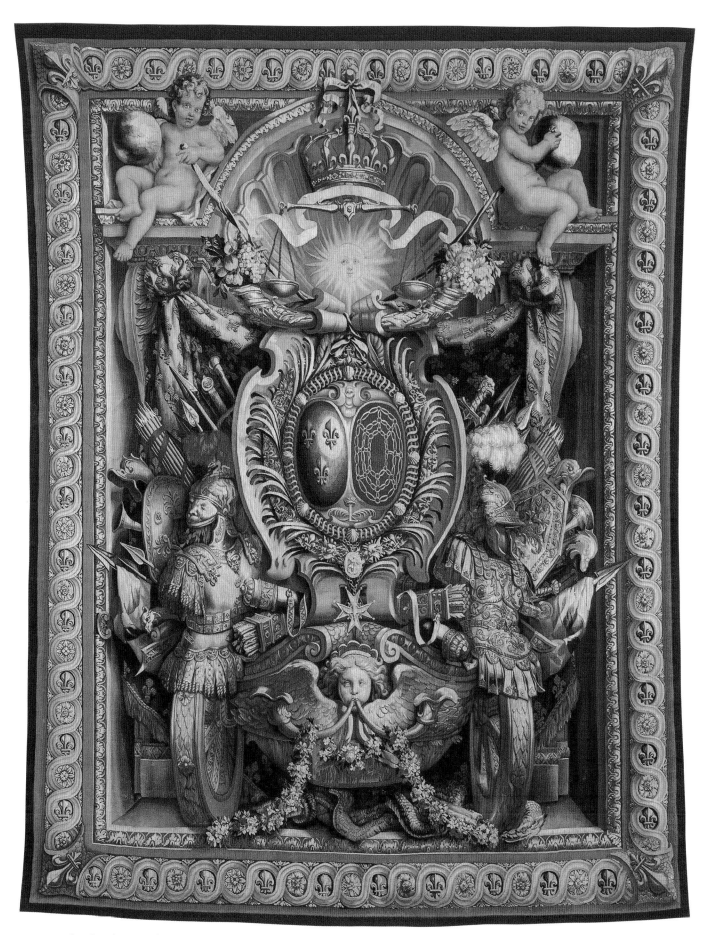

Portière du Char de triomphe 83.DD.20

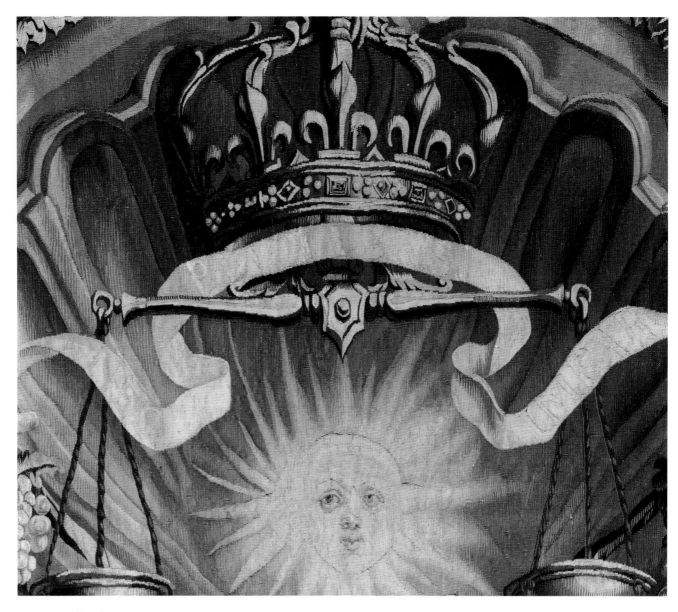

FIGURE 1.1 Detail.

CONDITION

The warps of this tapestry are wool, Z spun S ply (8). The ply of the warps is very hard and tightly twisted, resulting in a smooth, strong fiber. Both the wool and silk wefts are Z spun S ply (2). There is frequent use of two yarns, one of wool and one of silk, plied as one weft. A comparison of the reverse to the obverse shows that the tapestry has faded over time, most notably in the yellows. The woven motto in the ribbon above Apollo's head was probably once yellow, but is now discernible by the texture of the weave rather than by color contrast. Black and blue colors have suffered the least amount of fading. The silk weft yarns are relatively fragile, and in tightly woven figurative areas they have been abraded. Throughout the hanging, small woven mends occur that have faded at a rate differing from the original yarns. The tapestry is supported by two straps of plain-weave jute near each vertical edge, and it is backed entirely by a modern lining of plain-weave linen. A section from the original plain-weave linen lining survives; stitched to the lower corner of the replacement lining, it has a warp count of 24 and a weft count of 24 threads per inch and bears an inscription in ink.

COMMENTARY

The *Char de triomphe* (Chariot of Triumph) belongs to a group of *portières* thought to have been designed by Charles Le Brun while he directed the Maincy tapestry workshop of Nicolas Fouquet (1615–1680), the ill-fated finance minister to Louis XIV. The designs of these *portières* were referred to as *Renommées* (renown), *Lion*, *Licorne* (unicorn), *Mars*, and *Char de triomphe*, but unfortunately their early history is unclear. Their production began at Maincy and later continued at the royal Gobelins manufactory in Paris. The short-lived Maincy factory began activity in 1658, weaving tapestries for Fouquet's nearby Château de Vaux-le-Vicomte. In 1662, following Fouquet's fall from power in September 1661, the factory was moved to the Hôtel des Gobelins at the edge of Paris. The king's minis-

ter, Jean-Baptiste Colbert (1619–1683), organized the complete transfer of the workshop, including the weavers and looms, the painters and cartoons, as well as the tapestries in progress.[2] Louis XIV approved production of at least three of these *portière* designs and royal emblems were substituted for those of Fouquet. Simultaneously, Colbert also commissioned tapestries after these designs for himself, varying them with his own emblem of a sinuous snake.

Three drawings and one painted cartoon related to this period of Le Brun's work survive, showing various alterations that reflect the change in patronage. The first is a sketch for an armorial *portière* that depicts two female figures leaning against the central cartouche and has a unicorn in the lower left (fig. 1.2). The sketch is transitional, but the figures are shown to be standing freely with their feet visible below the two cornucopias to either side of the shield. On the shield it can be seen that the outline of Fouquet's device, a rampant squirrel, has been drawn over with the Colbert snake.[3] No tapestries were woven directly after this drawing, but it seems to have been a preliminary sketch for the *Portière des Renommées*.

A second sketch (fig. 1.3), now in the State Hermitage, Saint Petersburg, reveals a further development of the design.[4] The escutcheon still bears a rampant squirrel, but the two female figures have shed their legs and are now shown as emerging from the cornucopias. They have lost their feet to make room for a dog to the left and a lion to the right. A lionskin was added to adorn the head of the figure on the right, and it is therefore possible that the design represents the *Portière du Lion*, hitherto unidentified. Given the heraldic emblem of Fouquet, these animals probably represented Fidelity and Fortitude, attributes fitting for a minister in the king's service.

Colbert appropriated a combination of the two designs to his own use, and several *portières* survive bearing his arms. In the Colbert hangings the two females stand freely behind horns of plenty, their feet flanked by an animal to the left and right. At least two (and possibly three) *portières* were made with a cockerel substituted for the dog at the lower left (fig. 1.4).[5] In this case, the cockerel must have been symbolic of Vigilence, a suitable quality for the minister who replaced Fouquet on the Conseil d'en Haut. Another three (possibly four) *portières* bear the cockerel at the lower left and the dog to the lower right (fig. 1.5).[6]

Also derived from a variation of the second design was the king's commission for the *Portière des Renommées* (fig. 1.6). The bundles of military trophies and weapons, which can be seen delicately sketched behind the dog and lion in the Hermitage drawing, were made major features of the royal tapestries. The metal ewer with the single looped handle in the lower right of the tapestries and the fasces in the lower left can both be traced to the drawing (fig. 1.3).

Although no woven examples of the *Portière de la Licorne* have survived, a cartoon was painted by Beaudrin

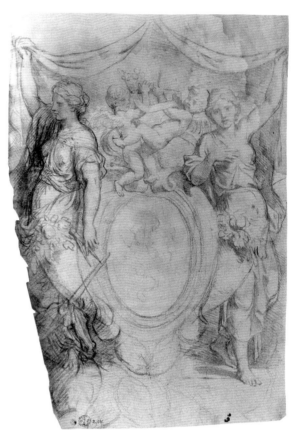

FIGURE 1.2 Charles Le Brun (French, 1619–1690). Drawing for *Portière des Renommées* with the arms of Fouquet superimposed by the snake of Colbert. Musée de Besançon, inv. D 1786.

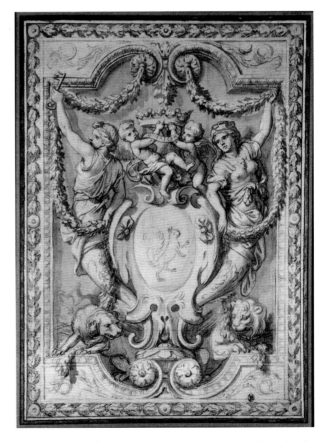

FIGURE 1.3 Charles Le Brun (French, 1619–1690). Drawing for *Portière des Renommées* with the arms of Fouquet. (Formerly in the Bibliothèque Stieglitz, Saint Petersburg.) Saint Petersburg, The State Hermitage, inv. 18959.

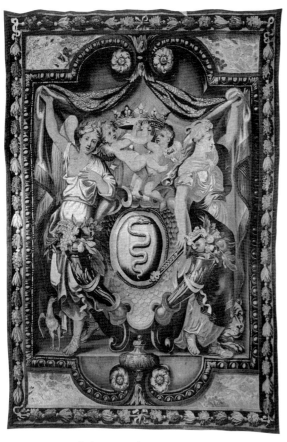

FIGURE 1.4 Gobelins manufactory (French, circa 1662–1683). *Portière des Renommées*. Les Affaires Culturelles: Ile-de-France, on loan to the Château de Vaux-le-Vicomte, near Melun.

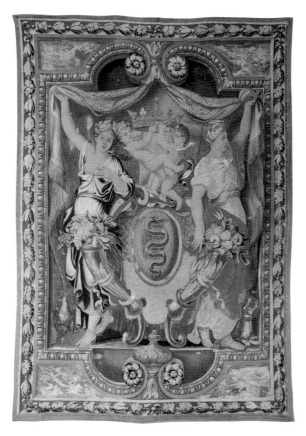

FIGURE 1.5 Gobelins manufactory (French, circa 1662–1683). *Portière des Renommées*. Sold Sotheby's, Zurich, November 25, 1992, lot 74.

Yvart *le père* after Le Brun's design for Fouquet (fig. 1.7). It was adapted with the arms of Colbert for use at the Gobelins and survives in a ruined state in the Musée du Louvre.[7] Two putti, one with a key and the other with a flaming lamp, hold a marquisate crown above an escutcheon emblazoned with the Colbert snake. Below, to the left, is a hound above a winged creature (probably a bat) and, to the right, a unicorn whose horn impales a lizard.

Le Brun's third drawing, made for the *Portière de Mars* (fig. 1.8), has been dated to the Maincy period (1658–1661) on the basis of style.[8] But as the sketch indicates a double coat of arms and the collar for the Order of the Saint-Esprit, honors Fouquet did not possess, it must be assumed that Fouquet intended this hanging for his king.

The design for the *Portière du Char de triomphe* was also thought to belong to Le Brun's Maincy phase, but the tapestry's symbolism confirms an origin immediately afterward. The presence of the king's motto *Nec Pluribus Impar* dates the composition to 1662 at the earliest. Louis Douvrier (member of the Petite Académie founded by Colbert in 1663, died 1668) invented the motto specifically for the Grand Carrousel of 1662, when Louis XIV appeared as the Sun King dressed in the costume of the Sun God, Apollo. To distinguish Louis XIV's appropriation of this ubiquitous symbol, Douvrier created the device of the sun shining on a terrestrial globe accompanied by the text *Nec Pluribus Impar*. Translated literally as "not unequal to many," the intended interpretation was "not unequal to the most numerous tasks." Douvrier meant that the king was equal to the demands of governing in all its aspects, and additionally that his rule and influence extended to many parts of the globe just as the sun shone on many worlds.[9] Le Brun's design for the *Portière du Char de triomphe* built upon the imagery of Douvrier's powerful device, alluding not only to the extent of Louis XIV's reign but to its success—its triumph—as well. Maurice Fenaille reported that Baudrain Yvart *le père* painted the cartoon after Le Brun's design and subsequent models were prepared by François van der Meulen (1632–1690) and Joseph Yvart *le fils* (1649–1728). The *Comptes des Bâtiments du Roi* note payments to Pierre Mathieu (1657–1719) and to Yvart *le fils* for additional cartoons during 1714 and 1715.[10]

WEAVER AND DATE

Seventy-one *portières* of this design were ordered for the Garde-Meuble de la Couronne, of which the Gobelins manufactory completed sixty-six between 1662 and 1724. All but one were woven on the low-warp looms, and twelve contained gold thread. Until 1694, when the Manufacture Royale des Gobelins temporarily closed, the production of the *Char de triomphe* was always accompanied by another royal armorial, the *Portière de Mars*. The first two *tentures* woven, and the subsequent four orders commissioned by

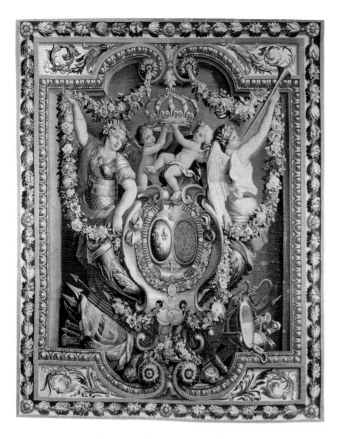

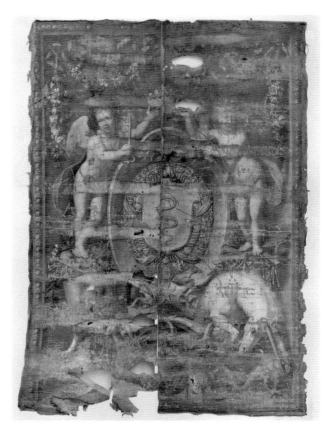

FIGURE 1.6 Gobelins manufactory (French, circa 1690). Tapestry with the Royal Arms of France and Navarre (*Portière des Renommées*). Philadelphia Museum of Art, The John D. McIlhenny Fund, inv. 1962-101-1.

FIGURE 1.7 Beaudrin Yvart *le père* (French, 1611–1680) after Charles Le Brun (French, 1619–1690). Cartoon for *Portière de la licorne* (?). Paris, Musée du Louvre, inv. 3486C. Photo R.M.N.

Louis XIV between 1690 and 1693, called for equal numbers of both these designs.

The records regarding the production of *Portières du Char de triomphe* and their delivery to the Mobilier de la Couronne are inconsistent because of the closure of the manufactory from March 1694 to January 1, 1699. During this period when the king's financial difficulties caused him to suspend his royal commissions, weaving was interrupted and tapestries were left on the looms to be completed later, in some cases by other workers.

A section of original lining still survives attached to the modern backing of the Museum's tapestry (fig. 1.9). Its inscription indicates that it was one of the hangings inventoried as number 194 of the Mobilier de la Couronne. The *Journal du Garde-Meuble de la Couronne* records on October 27, 1717, that six "portieres du Char" were delivered:

> *Livré par le Sr. Cozette concierge dela manufacture royalle des gobelins*
>
> *Six portieres de tapisserie de basse lisse de laine et soye manufacture des gobelins, dessein de Lebrun, representant au milieu les armes et la devise de Louis XIIII dans un cartouche porté sur un Char de triomphe, accompagné de trophées d'armes; La bordure est un guillochis qui enferme des fleurs delis et des roses*

> *couleur de bronze; chaque portiere contient deux aunes et demy de cours, dont cinq, sur trois aunes de haut, et la sixe. sur deux aunes cinq six.*[11]

It is assumed that the six *portières* delivered on October 17, 1717, were part of the seventh *tenture*. This was a large order of eighteen *Chars de triomphe* and production was distributed among no fewer than four low-warp ateliers. Jean de la Croix *père* began the *tenture*, weaving five *portières* between 1699 and October 1703. But work was interrupted and did not continue until 1715. The remaining twelve hangings were divided among two ateliers, six in the workshop of Souet and six in the workshop of de la Fraye. Five of de la Fraye's pieces were completed by October 1717 and the sixth in 1718, while only one of Souet's was finished in 1715, the remaining five being completed between 1718 and April 1720. One final *portière* was produced under Etienne Le Blond in 1720. On December 7, 1718, the Garde-Meuble received another three from the seventh *tenture*.[12]

The inventories of the Mobilier de la Couronne record the large numbers of armorial *portières* that were used to cover nearly every doorway in the royal *chambres de parade* year-round. Although woven for Louis XIV, these early Gobelins productions hung long after his reign ended—no fewer than sixty-three Louis XIV heraldic

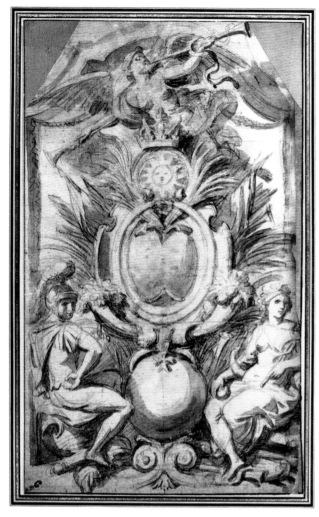

FIGURE 1.8 Charles Le Brun (French, 1619–1690). Drawing for *Portière de Mars*. Paris, Ecole des Beaux-Arts, inv. Masson 2536.

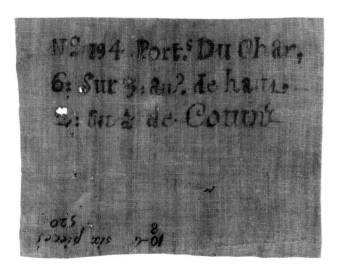

FIGURE 1.9 Detail of original lining with ink inscription.

tapestries, twenty-four of them *Chars de triomphe*, still decorated Versailles alone in 1789. Two of the six inventoried under number 194 were among this group.[13] In 1792, five *Portières du Char de triomphe* were stored in the *magasin* of the Garde-Meuble de la Couronne; three of them were described as "passée" and only one was identified by number—an example woven with gold thread from number 110 of the *Inventaire du Mobilier de la Couronne*.[14] On June 10, 1797, four *Portières du Char de triomphe* were burned at the Hôtel de la Monnaie by decree of the Revolutionary council in order to retrieve their metallic content of gold, which totaled 152 *poids*.[15]

RELATED TAPESTRIES

At least fifteen additional *Portières du Char de triomphe* are known. Six are in the Mobilier National, of which four are permanently on loan to the Château de Pau and one is displayed in the Hôtel Marigny, Paris.[16] The Monuments Historiques, Paris, possesses another stored at the Château de Chambord.[17] One in the Musée du Louvre (measuring 346 cm high by 270 cm wide) bears the woven signature *J. Le So[u]et*. Two more are in the Jagiellon University, Cracow, Poland, and in the Castle Drogo, Devonshire, England.[18] The example in the Metropolitan Museum of Art, New York, is accompanied by a *Portière des Renommées*.[19] The J. B. Speed Museum in Louisville, Kentucky, owns another.[20] Three more passed through the Paris art market in the 1920s and '30s, and one in the 1970s.[21] One other appeared in very faded condition as a television stage prop in 1990.[22]

PROVENANCE

Delivered to the Garde-Meuble de la Couronne on October 27, 1717; Madame Fulco de Bourbon, Patterson, New York; by descent to her son, Michael de Bourbon, Pikeville, Kentucky; J. Paul Getty Museum, 1983.

BIBLIOGRAPHY

Fenaille, vol. 2, pp. 16–22; Wilson 1983, no. 8, pp. 16–17, illus.; "Acquisitions / 1983," *GettyMusJ* 12 (1984), no. 5, p. 263, illus.; "Some Acquisitions (1983–84) in the Department of Decorative Arts, The J. Paul Getty Museum," *Burlington Magazine* 126 (June 1984), p. 385, illus.; Sassoon and Wilson, 1986, no. 214, p. 101, illus.; *GettyMusHbk*, 1986, p. 147, illus., enlarged detail p. 140; Bremer-David et. al., 1993, no. 290, pp. 170–171, illus.

NOTES

1. Established in 1469 by Louis XI, the order of Saint-Michel was the oldest of all honorary knighthoods in France. Originally limited to thirty-six members, it had expanded to one hundred by the end of the Ancien Régime. Louis XIV used this order to distinguish scholars, artists, and writers. It was abolished in 1830. The order of the Saint-Esprit was established in 1578 by Henri II and replaced the earlier order of Saint-Michel as the highest civil award. Limited to one hundred recipients, its original members were virtually all noble or of the Catholic Church hierarchy. The order was terminated during the Revolution, but was revived during the Restoration (1814–1830).

2. See J. Cordey, "La Manufacture de Tapisseries de Maincy," *Bulletin de la Société de l'histoire de l'art français* (1922), pp. 38–52.

3. The drawing is in the Musée de Besançon, inv. D.1786. See J. Montagu, "The Tapestries of Maincy and the Origins of the Gobelins," *Apollo Magazine* 76 (September 1962), pp. 530–535.

4. The State Hermitage, Saint Petersburg, inv. 18959.

5. Two examples sold at Galerie Charpentier, Paris, March 20, 1959, no. 142, illus. pl. XLI. Another, with the emblem removed from the escutcheon and replaced with the word "Libertas," sold Palais Galliera, Paris, March 4, 1961, no. 132. One *portière* is on loan from Les Affaires Culturelles: Ile-de-France to the Château de Vaux-le-Vicomte, near Melun. See *Colbert 1619–1683*, exh. cat. (Hôtel de la Monnaie, Paris, 1983), p. 44, illus.

6. One of Colbert's armorials with the cockerel and a dog was sold Sotheby's, Zurich, November 25, 1992, lot 74, and again Sotheby's, London, May 31, 1995, lot 32. Another two, with Colbert's serpent twisting in the opposite direction, sold Christie's, London, May 18, 1995, lots 206 and 207. Montagu (note 3) illustrated one example, p. 531, fig. 2.

7. Musée du Louvre, Paris, inv. 3486C, see Fenaille, vol. 2, p. 23. See also Compin and Roquebert, vol. 4, p. 43, illus.

8. The drawing is in the collection of the Ecole des Beaux-Arts, Paris, inv. Masson 2536. See Montagu (note 3), p. 532.

9. J.-P. Nèraudau, *L'Olympe du Roi-Soleil, Mythologie et idéologie au Grand Siècle* (Paris, 1986), p. 30 ff., and J. Vanuxem, "Emblèmes et devises vers 1660–1680," *Bulletin de la Société de l'histoire de l'art français* (1954), pp. 60–70.

10. Fenaille (note 7), pp. 16–22.

11. A.N. O¹ 3309, fol. 224, *Journal du Garde-Meuble de la Couronne, commençant 6 janvier 1716. Et suivant le 31 décembre 1723*. Fenaille (note 7), p. 20, mentions the delivery of "six portières du Char de triomphe," but states that only four were inventoried under no. 194.

12. A.N. O¹ 3338, no. 55, fol. 246.

13. A.N. O¹ 3502. See also Meyer 1989, pp. 131–138.

14. A.N. O¹ 3359.

15. J. Guiffrey, "Destruction des plus belles tentures du Mobilier de la Couronne en 1797," *Mémoirs de la Société de l'histoire de Paris et de l'Ile-de-France* 14 (1887), pp. 265–298.

16. Mobilier National, inv. GMTT 150. See "L'Hôtel Marigny," *Plaisir de France* 41 (May 1975), p. 37.

17. See *Les Gobelins (1662–1962), Trois siècles de tapisserie française*, exh. cat. (Château de Coppet, 1962), no. 31, p. 105, illus. p. 105 and on the cover. More recently exhibited in *Lisses et délices, chefs-d'oeuvre de la tapisserie de Henri IV à Louis XIV*, exh. cat. (Caisse nationale des monuments historiques et des sites, Chateau de Chambord, 1996), pp. 286–287, illus. It measures 345 cm high by 272 cm wide.

18. See *Gobeliny zachednio-europejskie w zbiorach polskich XVI–XVIII w.*, exh. cat. (Muzeum Narodowe w Poznaniu, 1971), no. 73, illus. pl. 60; and R. Feddon and R. Joekes, *National Trust Guide* (London, 1989), illus. p. 76. I thank Edith Standen, Curator Emeritus, The Metropolitan Museum of Art, New York, for this information.

19. Metropolitan Museum of Art, New York, gift of Thomas Emery, inv. 54.149 (measuring 11 ft. 2 in. high by 8 ft. 9½ in. wide). It was formerly in the collection of Madame Burat, sold Galerie Charpentier, Paris, June 17, 1937, no. 147. Both *portières* were stolen while on loan in June 1982 to the Institute of Fine Arts, New York. They were fortunately recovered in November 1994.

20. Gift of Preston Pope Satterwhite, inv. 41.102. It was previously in the collection of James A. Garland, American Art Association, New York, January 12, 1924, lot 475 (11 ft. 3 in. high by 8 ft. 8 in. wide) and was later sold by Mrs. James Van Alen, Parke-Bernet Galleries, New York, April 15, 1939, lot 161. Photographs and documentation from the French and Company photo archives (now at the GRI) suggest that the tapestry then passed twice through French and Company in New York (stock nos. 19733 and 75907). However, in unpublished research for the Speed Museum Alice Zrebiec has pointed out that while the tapestry in the photograph appears identical to the Speed tapestry, and the sizes are a near match, the dates on the French and Company stock sheets (received March 25, 1942; sent out to H. B. Harris July 14, 1943) are dates *later* than Satterwhite's 1941 donation to the museum.

21. From the collection of le comte de Reiset, Hôtel Drouot, Paris, February 3, 1922, no. 536 (340 cm high by 260 cm wide); Galerie Georges Petit, Paris, April 22, 1929, no. 113 (345 cm high by 260 cm wide), later in the collection of Jean Bloch, sold Palais Galliera, Paris, June 13, 1961, no. 145 (260 cm wide) and now in a French private collection; from the collection of François Coty, Galerie Charpentier, Paris, November 30 and December 1, 1936, no. 108 (354 cm high by 260 cm wide); from the collection of Professor R., Hôtel Drouot, Paris, November 22, 1971, no. 139 (310 cm high by 265 cm wide).

22. British Broadcasting Corporation series, "Black Adder," 1990.

2

Les Anciennes Indes: Le Cheval rayé

Gobelins manufactory, Paris; circa 1692–1730

Original cartoons designed circa 1650 or 1663 by Albert Eckhout (circa 1610–1665) and Frans Post (1612–1680) with later alterations by Jean-Baptiste Monnoyer (1636–1699), Jean-Baptiste Belin de Fontenay (1653–1715), René-Antoine Houasse (circa 1644/45–1710), and François Bonnemer (1638–1689); and with modifications by Alexandre François Desportes (1661–1743). Woven on the high-warp loom between 1692 and 1730.

WOVEN HERALDRY
In the center of the top border, and descending into the main scene below, are the arms of the Camus de Pontcarré de Viarmes de la Guibourgère family.

MATERIALS
Wool and silk

GAUGE
18 warps per inch / 60 to 86 wefts per inch

DIMENSIONS
height 10 ft. 10 in. (326 cm)
width 18 ft. 10 in. (580.2 cm)

92.DD.21

DESCRIPTION
The series *Les Anciennes Indes* (The Old Indies) consists of eight hangings portraying the flora and fauna, native people, and African slaves of the seventeenth-century Dutch-held territory of northeast Brazil. The eight scenes were titled: *Le Cheval rayé* (The Striped Horse), *Les Deux taureaux* (The Two Bulls), *L'Eléphant* or *Le Cheval isabelle* (The Elephant or The Bay Horse), *Le Chasseur Indien* (The Indian Hunter), *Le Combat d'animaux* (The Animal Combat), *Le Roi porté par deux Maures* (The King Carried by Two Moors), *Le Cheval pommelé* or *L'Indien à cheval* (The Dappled Horse or The Indian on Horseback), and *Les Pêcheurs* (The Fishermen). In composition each of these tapestries tends to divide into three zones: a foreground featuring detailed studies of fish, animals, and plants; a middle ground with larger animals and sometimes human subjects, as well as more plants, trees, and birds; and a background showing distant panoramas.

 Le Cheval rayé is a richly detailed scene that combines both scientifically recorded material and imaginative contrivances. Under a large tree (*Cassia grandis*) harboring a variety of birdlife, a spotted jaguar attacks a fancifully striped horse, presumably a zebra, biting and clawing into its back. The zebra arches its head backward and rears on its hind legs. Immediately behind them a rhinoceros stands placidly, turning its head in profile to the left. A gazelle bounds to the side of the zebra as two startled birds avoid its pawing hooves. A small alligator, two armadillos, and a long-tailed creature scurry in the foreground shrubbery (fig. 2.1). A stream, teeming with fish, cascades from the

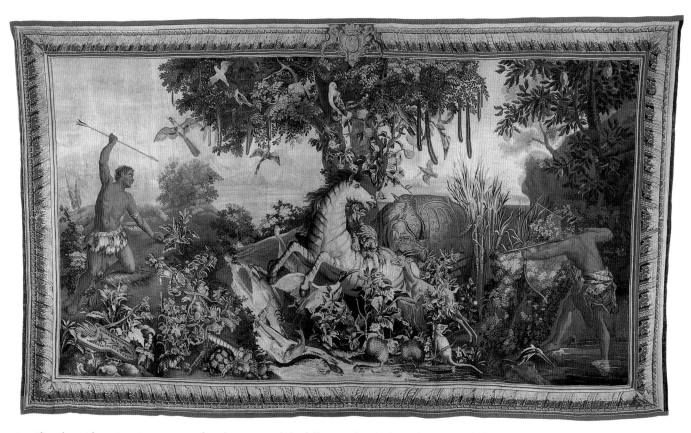

Le Cheval rayé from *Les Anciennes Indes* (this view and the following details show the tapestry before conservation) 92.DD.21

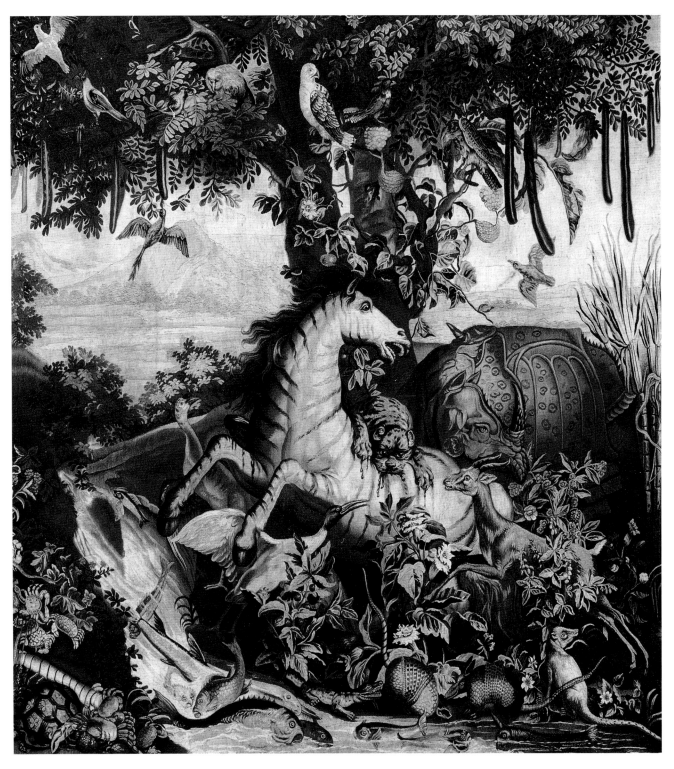

FIGURE 2.1 Detail.

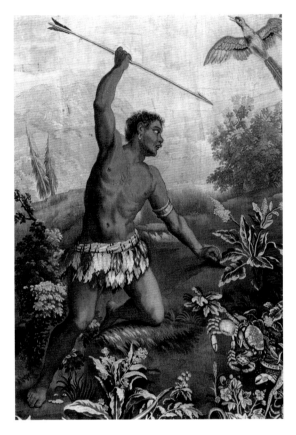

FIGURE 2.2 Detail.

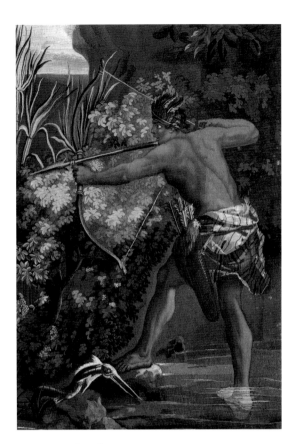

FIGURE 2.3 Detail.

FIGURE 2.4 Detail of coat of arms.

middle ground. On its bank are a tortoise, a toad, a snake, a lizard, and a variety of crustaceans. In the far distance, beyond the central tree, is a valley with waterways bordered by a range of mountains.

For the majority of commissions of this tapestry only the central subject of the animal combat by the stream was woven. This example of the scene, however, was extended on either side to include two native hunters. On the left, a spear thrower is poised (fig. 2.2), while an Indian standing in a pool of water to the right (fig. 2.3) aims at the animal combat and draws his bow. A decorated quiver filled with arrows lies on the ground at the feet of the spear thrower.

The border of *Le Cheval rayé* is of the first design applied to this series at the Gobelins.[1] It consists of a simple entwined acanthus leaf and guilloche motif against a blue ground, and has an agrafe in each corner. At the top center is the coat of arms of the family Camus de Pontcarré de Viarmes de la Guibourgère (*azure à une etoile d'or accompagné de trois croissants d'argent*), supported on either side by a lion (*deux lions d'or, rampants regardants et affrontés*) and placed under a ducal crown (fig. 2.4).

CONDITION

The warps of the tapestry are wool, Z spun S ply (3), while the wefts are wool, Z spun S ply (2), and silk, Z spun very slightly S ply (2). Comparing the reverse to the obverse, the color is generally good. There is some fading, most notably in the blue of the sky, which is almost completely gone from the front. The red, violet, and yellow hues have lost some of their intensity, but the greens and flesh tones are still present. In the lower middle of the left field of the tapestry there is a rewoven patch having an irregular contour and measuring thirty by thirty-four inches at the greatest dimensions. The patch begins at the top of the feathered skirt of the spear-throwing figure and terminates at his right foot, and it stretches from inside the left border to the hunter's inner left arm (figs. 2.5 and 2.6). Apparently an early revision, this patch resembles the rest of the tapestry in quality of weaving, fiber content, yarn count, spin, and ply. There are also numerous small repairs, particularly along the right edge, which have discolored over time. Traces of pink household paint can be detected around all the edges. The left and right blue *galons* are original, but they have been

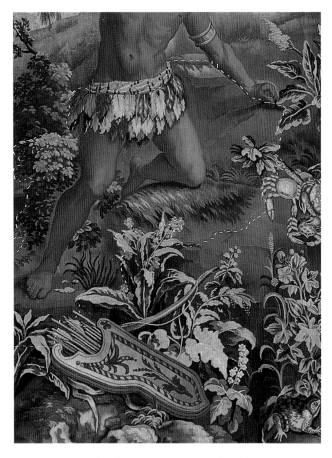

FIGURE 2.5 Detail with rewoven section outlined by white thread.

FIGURE 2.6 Reverse of 2.5.

extensively repaired. The top and bottom *galons* are covered by newly woven replacements.

COMMENTARY

The *Anciennes Indes* tapestry series ultimately derived from studies made by two Dutch artists, Albert Eckhout and Frans Post, during an expedition to northeast Brazil that took place from 1637 to 1644. Eckhout and Post recorded their observations in the form of sketches and oil paintings while accompanying the newly appointed Dutch governor and official of the Dutch West India Company, Johan Maurits de Nassau-Siegen (1604–1679). Eckhout was primarily interested in documenting plants, animals, and people, while Post executed landscapes.

Upon returning to Europe, Johan Maurits envisioned a series of tapestries representing the wonders of Brazil "en grandeur de vif," and he commissioned large-scale tapestry cartoons from the same artists. These were prepared by 1652 when Maurits presented a set of canvases to his cousin Frederick William, the Elector of Brandenburg. In 1679 he repeated the gesture and gave the same set of cartoons (or possibly another group painted by Eckhout after 1663) to Louis XIV, with the intention that the eight paintings would serve as cartoons for the French royal tapestry workshops.[2] Maurits anticipated that changes would be necessary and he suggested that Louis XIV send a

painter to The Hague "qui se coignoit Paysages, et en quelle façon on est accoustumé de peindre les models des tapisseries au quel je donneray ouverture de mes desseins, que j'ai là dessus, et formeray en sa présence une liste de la qualité de chaque animal, lesquels desseins vostre Majesté pourra faire changer selon son bon plaisir."[3]

Louis XIV accepted the eight large canvases together with thirty-four supplementary paintings, but it was not until 1687 that the designs were used by the Gobelins manufactory.[4] The king approved their weaving on the low-warp looms when the weavers lacked work.[5] At that point administrators of the tapestry workshops paid four French artists to "raccommoder" the canvases: Jean-Baptiste Monnoyer and Belin de Fontenay retouched the plants and birds, while René-Antoine Houasse and François Bonnemer retouched all eight scenes.[6] After the first two sets were woven on the low-warp looms, Alexandre François Desportes was paid in 1692–1693 to repair the cartoons for use in the high-warp workshops. In 1703, at a time when no royal orders were on the looms, treatment was again required and Claude III Audran (1658–1734) made the restorations.[7] By 1722, the cartoons had deteriorated further and Desportes was paid a second time for additional work, which included "ouvrage de peintures et desseins pour exécuter à la Manufacture des Gobelins."[8] He surely introduced slight modifications to the cartoons at this

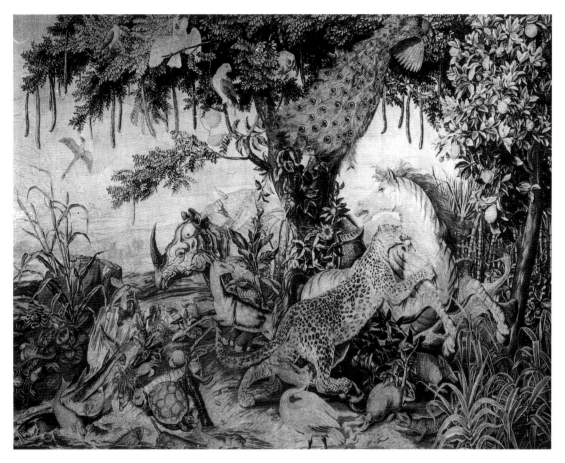

FIGURE 2.7 Gobelins manufactory (French, circa 1740). *Le Cheval rayé* from *Les Nouvelles Indes*. Paris, Mobilier National, inv. GMTT 312. Photo Mobilier National 1743/1.

point and uniformly diminished the height of all tapestries woven by one-half *aune* (approximately 59.5 cm or 22⅜ in.). These shorter tapestries of the sixth through eighth *tentures* had more elaborate borders and were distinguished by the title *Les Petites Indes*.

The Gobelins manufactory wove the complete *Anciennes Indes* series eight times—all without metallic thread—and also executed an unspecified number of private commissions between 1687 and 1730. The first (1687–1688) and second (1689–1690) sets were both produced on the low-warp looms and directly entered the Garde-Meuble de la Couronne. Four pieces of the first *tenture* survive in a private collection, and an assembled set that is assumed to consist mainly of hangings from the second *tenture* is in the Mobilier National.[9] The third woven set was begun in 1692 on the high-warp looms and completed in 1700, one year after the Gobelins reopened. Kept in the storeroom of the manufactory until June 17, 1717, the latter set of tapestries was presented as a diplomatic gift to Peter the Great of Russia (1672–1725), who transported them to Saint Petersburg, where they were destroyed by fire in 1837. The fourth set was an official commission placed in 1708 by *le grand maître des Hôpitaliers de Saint-Jean* of Malta, Raymond de Perellos (*grand maître* 1697, d. 1720), and all the hangings are still displayed in their original location in Valletta.[10] The fifth and last *tenture* woven to

the height of four *aunes* (475 cm) was produced on the high-warp looms between 1718 and 1720. It also remained in storage at the Gobelins, although none of its components are positively identified today. The last three sets were *Petites Indes*, produced on the high-warp looms to the reduced height of three and a half *aunes* (410 cm). The Académie de France in the Villa Medici in Rome still conserves eight hangings from the sixth set, which they received in 1726, and at least one of an additional four pieces that were delivered by 1731. The seventh *tenture* remained in storage at the manufactory, and a few surviving pieces are now distributed to various French ministries. The eighth weaving, completed in 1730, entered the Garde-Meuble de la Couronne; five hangings thought to be from this set (although they no longer have borders) are in Museu de Arte in São Paulo, Brazil.

By 1735 the *contrôleur général des Finances*, Philibert Orry (1689–1747, *directeur des Bâtiments du Roi* 1737–1745), commissioned Alexandre François Desportes to design a new set of cartoons based on the same New World subjects. Drawing inspiration from the original series, which he had studied and retouched in 1692–1693 and in 1722, Desportes created eight new models that were exhibited in the Salons of 1737, 1738, 1740, and 1741.[11] In these *Nouvelles Indes* the composition of *Le Cheval rayé* was altered to show the leopard attacking the zebra from

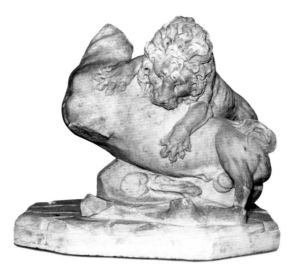

FIGURE 2.8 Unidentified sculptor (Italian, seventeenth century). *Cheval attaqué par un lion.* Musée National du Château de Versailles, inv. MV 8600.

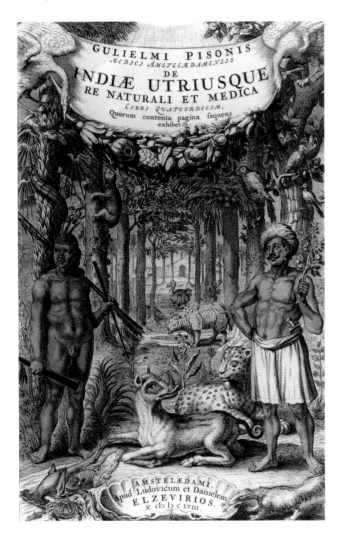

FIGURE 2.9 Willem Pies (Dutch, 1611–1678). Engraved frontispiece from *De Indiae utriusque re naturali et medica libri quatuordecim* (Amsterdam, 1658). History and Special Collections Division, Louise M. Darling Biomedical Library, University of California, Los Angeles.

the front, while the stream with all its fish was moved farther left (fig. 2.7). The *Nouvelles Indes* gained rapid success and no fewer than fourteen complete sets were woven between 1740 and 1800.[12]

The vast abundance of anthropological, botanical, and zoological detail that enriches *Les Anciennes Indes* and their subsequent variations had its source in the studies and paintings made on site in Brazil and shortly thereafter by Eckhout and Post.[13] But the artists responsible for the tapestry cartoons—whether Dutch or French—elaborated on this documentary material and produced a series of decorative schemes that are a fascinating mixture of truth and fantasy. To heighten the elements of drama, exoticism, and curiosity, an animal combat was made the central subject of *Le Cheval rayé.* As an established convention, the theme of animal combat was an expression of European notions about the primeval savagery and wildness of nature, particularly as it might be encountered in the recently discovered lands of the New World. However, in this case large animals were introduced—the strangely hybridized zebra and Indian rhinoceros—that have no known prototypes in the work of Eckhout and Post and are, of course, quite foreign to the territory of Brazil.

The animal combat theme had a long tradition in Western art, and the pose of the zebra and jaguar appears to have been based upon an antique colossal marble fragment representing a lion attacking a horse. A copy of the marble (fig. 2.8), probably made in Italy during the seventeenth century, entered the French royal collection in 1685 and must have been known to the school of artists working for the Crown.[14] The rhinoceros, with the anomalous small horn protruding from its spine, was ultimately borrowed from a widely circulated woodblock print by Albrecht Dürer (1471–1528). The intermediary in this instance was the illustrated frontispiece of the 1658 publication of *De Indiae utriusque re naturali et medica libri quatuordecim,* which included Dürer's version of the beast among its many exotic creatures (fig. 2.9). The authors of this book, the physician Willem Pies or Piso (1611–1678) and the scientist Georg Marcgraf (1610–1643), were also participants in the Mauritz expedition to Brazil.

While it is unclear how extensively the Gobelins artists modified the original cartoons, it is certain that French artists designed the extensions found to the left and right of the Museum's example. In their Baroque movement and musculature the two hunting figures are the product of contemporary French design. Indeed, the pose of the spear thrower, with bent left knee and raised right arm, is similar to a satyr painted by Charles Le Brun (1619–1690) and his assistants on the ceiling of the Galerie des Glaces at Versailles. Likewise, the scheme in which the frontal left figure is balanced by the back view of the figure on the right also recalls Le Brun's ceiling decoration. It is conceivable that René-Antoine Houasse designed the exten-

sions to the tapestry, as he was a pupil of Le Brun and a member of his master's *équipe* working on the Galerie des Glaces from 1679 to 1686. As *garde des tableaux du Roi*, Houasse officially received the original eight Dutch paintings and thirty-four accompanying works when they were deposited at the royal storeroom. As noted above, he was also one of the four artists paid by the Gobelins to retouch the cartoons in 1687. In certain respects, however, the left-hand figure does follow the Dutch site studies of Brazilian natives. Particularly in terms of deportment and facial characteristics, the spear thrower resembles the dancing Tapuyan Indians painted by Eckout, and it is possible that Houasse found such subjects among the supplemental materials.

Curiously, the figure of the spear thrower has been expertly rewoven from the hips to the feet (figs. 2.5 and 2.6). Although it is not known why this reweaving was done, it was accomplished in wefts of wool fiber that match the surrounding area in color and brilliancy. It is nearly impossible to discern the repair visually and the fading is even overall, which suggests that the reweaving followed shortly after the completion of the tapestry. It may be that the figure of the spear thrower was originally naked, as were the tribesmen depicted in the Eckout studies. If so, then the subject may have been reworked to appease the private patron. An alteration of this kind was once made for Madame de Maintenon (1635–1719), mistress and morganic wife of Louis XIV, when she was affronted by the nudity in another Gobelins series, *Les Sujets de la fable* (or *Les Amours de Psyché*), whose cartoons were prepared by Houasse and Bonnemer, among others. While the feathered skirt that was given to the spear thrower follows the usual conventions of European portrayals of American natives, it is ethnographically inaccurate.

WEAVER AND DATE

It is possible to date the hanging to after 1692 since a chronology of the surviving examples of *Le Cheval rayé* can be determined from the discrepancies between the sets that were the result of the deterioration and subsequent modification of the cartoons.[15] Comparing *Le Cheval rayé* from the second *tenture* (1689–1690) with the same subject from consecutive *tentures*—a Russian copy of the third *tenture* (1692–1700) and the Gobelins original from the fourth set (1708–1710) that is still in the Grand Master's Palace in Malta—confirms that the Museum's example must post-date the Desportes repairs to the cartoons of 1692–1693.[16] The tapestry of the second *tenture* (woven in low-warp and therefore appearing in reverse) has details not carried through in the sets that followed, such as more foliage in front of the gazelle's hind legs, the position of the zebra's foreleg behind the bird's wing, and the presence of a small llama-like mammal near the fish-filled river (fig. 2.10). Additionally, the fish in this river are woven with greater detail than in later versions.

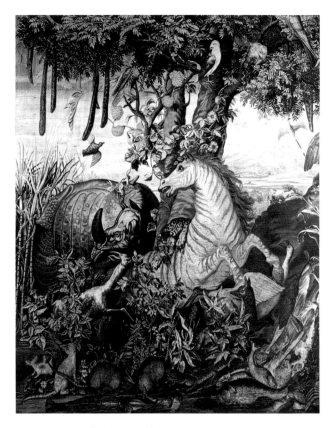

FIGURE 2.10 Gobelins manufactory (French, 1689–1690). *Le Cheval rayé* from *Les Anciennes Indes*. Paris, Mobilier National, inv. GMTT 193/1. Photo Mobilier National 1751/1.

No royal orders were placed for *Les Anciennes Indes* between 1700 and 1708, and yet the cartoons required repair in 1703. Moreover, the Gobelins factory was closed for the period between March 1694 and January 1699 when a financial crisis caused the king to suspend his royal commissions. It seems therefore likely that the weavers had engaged in the production of unofficial private commissions to support themselves during the difficult period of the factory's closure. Private weavings would account for the wear to the canvases, and they undoubtedly continued, when the cartoons were available, between 1710–1718 and 1719–1723. Although there is no woven signature on this tapestry, the weavers must have worked for one of the *entrepreneurs* operating the three high-warp Gobelins workshops during the period 1692–1730.

RELATED TAPESTRIES

Little is known regarding the private commission of this tapestry and others forming the set. Only one other hanging from the set has been traced, although its present location is unknown. It is also a wide weaving (measuring 21 ft. 8 in. in length) and combines two subjects, *Le Cheval pommelé* (or *L'Indien à cheval*) on the left and *Les Deux taureaux* on the right (fig. 2.11). Its border, including the coat of arms and ducal crown in the top center, repeats that of the Museum's *Le Cheval rayé*. Chicago collector Vincent Bendix owned

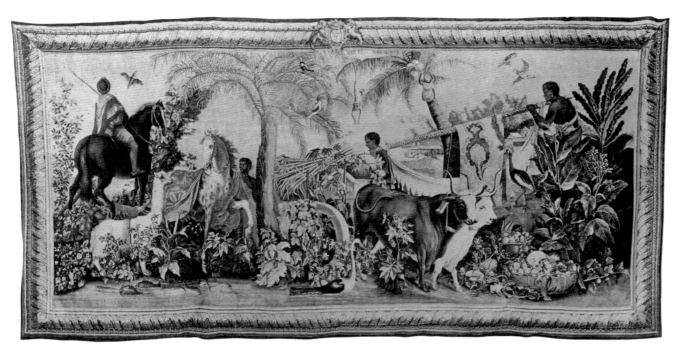

FIGURE 2.11 Gobelins manufactory (French, circa 1692–1730). *Le Cheval pommelé* together with *Les Deux taureaux* from *Les Anciennes Indes*. Sold Parke-Bernet Galleries, New York, May 29, 1942, lot 48.

the double tapestry and loaned it to Indiana University at South Bend from 1933 to 1942. It was sold at Parke-Bernet Galleries, New York, May 29, 1942, lot 48, by order of the United States Court of Bankruptcy.[17]

Whitehead and Boeseman list the locations of six examples of *Le Cheval rayé*: a private collection, Argentina; Mobilier National, Paris; the Palace of the Grand Master, Valletta, Malta; a *Petites Indes* in the French Académie, Villa Medici, Rome; one without borders that passed through the Munich dealer Bernheimer to an American collector; a *Petites Indes* without borders in the Château de Chantilly. There is also a wide, high-warp hanging in the Château de Chantilly that combines *Le Cheval pommelé* on the left with *Les Deux taureaux* on the right. Joined at the extreme right side is a section from *Le Cheval rayé* showing only the rhinoceros, the gazelle, and one armadillo. Its border of entwined acanthus leaf and guilloche pattern is patched together.[18]

Four other extended examples are known, all woven on the high-warp looms with the border of the first design: (1) In the possession of Monsieur Babin, Château de Saint-Rémy-en-l'Eau, near Saint-Julien-en-Chausée, Oise.[19] It was formerly one of four *Anciennes Indes* tapestries in the Achille Le Clercq collection, and it was attributed to the high-warp atelier of Jans (either Jean Jans *le fils, entrepreneur* of the first high-warp workshop 1668–1723, or Jean-Jacques Jans, his successor 1723–1731), because of the common height and woven signatures found on the three others of the group. The extensions of this version portray the same two hunting natives as the Museum's example, but the central scene of animals lacks the attacking jaguar and the rhinoceros.[20] (2) Musée du Louvre, Paris,

inv. OAR 24. Exhibited in *Les Gobelins (1662–1962): Trois siècles de tapisserie française* at the Château de Coppet, near Geneva, Switzerland, June–September 1962, no. 60, where it was erroneously identified as a hanging from *Les Nouvelles Indes* (measuring 330 cm high by 538 cm wide). The extensions of this version portray the same two hunting natives as the Museum's example, but the foliage and ground are treated differently in the lower left corner.[21] (3) Wattenwyl-Haus collection, Berne, Switzerland. This *Le Cheval rayé* was one of seven from *Les Anciennes Indes* purchased by Bernard Ferdinand von Wattenwyl-De Sacconay (1772–1836), and since 1886 it has hung on the staircase of the Beatrice von Wattenwyl-Haus on the Junkerngasse.[22] A running figure appears in the much extended right side and, to the left, a figure with an outstretched arm falls under the feet of the zebra. (4) Galerie Chevalier, Paris 1992. This example is extended only to the left, where the same spear thrower is repeated, while the right side terminates just beyond the rhinoceros and a few canes of sugar.[23] Like the Museum's tapestry, this example also lacks the colorful parrot in the central tree.

PROVENANCE

(?) Jean-Baptiste-Elie Camus de Pontcarré, seigneur de Viarmes (1702–1775), and his wife Françoise-Louise Raoul de la Guibourgère; by descent to Louis-Jean-Népomucene-François-Marie Camus de la Guibourgère (1747–1794); by descent to Alexandre-Prosper Camus de la Guibourgère (1793–1853), Château de la Guibourgère, Bretagne; French and Company, New York (negative no. 16817), circa 1930; Bernard Blondeel, Antwerp, Belgium, 1991; J. Paul Getty Museum, 1992.

BIBLIOGRAPHY

Bremer-David et al., 1993, no. 287, p. 169, illus.; "Acqui-sitions/1992," *GettyMusJ* 21 (1993), no. 66, p. 141, illus.; "Museum Acquisitons in the Decorative Arts," *Apollo* 137 (January 1993), pp. 36–37, illus.; C. Bremer-David, "*Le Cheval Rayé*, A French Tapestry Portraying Dutch Brazil," *GettyMusJ* 22 (1994), pp. 21–29.

NOTES

1. The same border was also applied to other Gobelins series of the period, namely *Les Triomphes des dieux*. For *Les Anciennes Indes*, this border usually had no further embellishments, such as ciphers or coats of arms.

2. One or possibly two sets of tapestries after these cartoons were woven in Delft under the direction of Maximillaan van der Gucht (d. 1689) in 1667 while they were still in the pos-session of the Elector of Brandenburg. No trace of them sur-vives. The original cartoons may have been retained by Johan Maurits after the van der Gucht weavings; if so, they may have been the models subsequently presented by Maurits to Louis XIV. See P. J. P. Whitehead and M. Boeseman, *A Por-trait of Dutch 17th-Century Brazil* (Oxford and New York, 1989), pp. 109–110.

3. Letter of February 8, 1679, as cited in Whitehead and Boese-man (note 2), p. 115.

4. Gédéon du Metz, *contrôleur général des Meubles de La Couronne*, described the gifts on January 30, 1681, in the *Inventaire Général des Meubles de la Couronne*, no. 442:
 Huit grands tableaux donnez au Roy par le Prince Mau-rice de Nassau, représentant des figures d'hommes et de femmes de grandeur naturelle, plusieurs plantes, fruits, oyseaux, animaux, poissons et paysages du Brésil, de 14 pieds 8 pouces de haut, sur [?] de large, qui peuvent servire aux peintres pour faire des desseins au naturel de tout ce qui vient dudit pais.
 and the accompanying materials as no. 443:
 Trente quatre autres tableaux aussy donnez au Roy par le prince Maurice de Nassau, représentant des villes, forteresses, ports de mer et paysages du Brésil, et quelques fruits et animaux deduit pais, dont partie sont dans des bordures d'ebeine, haults d'environ 2 à 3 pieds de large.
 The paintings were accepted by order of François Michel Le Tellier de Louvois (1639–1691, *surintendant des bâtiments, arts et manufactures* 1683–1691) and received by S[ieur] Houasse, *garde des tableaux du Roi*. Information as pub-lished in Guiffrey, *Inventaire*, vol. 2, pp. 22–23.

5. A.N., O¹ 2040. M. de la Chapelle, *contrôleur des Bâtiments du Roi* at the Gobelins records the following:
 Les ouvriers de basse lisse n'ayant plus d'ouvrage, je pro-posai de faire la première tentures des Indiens, j'en fis voir les tableaux à M. de Louvois, que je fis apporter du Garde-Meuble, il en parla ay Roy et S. M. approuva cette proposition. Les srs Houasse, Bonnemer et Baptiste eurent ordre d'en raccommoder les tableaux.
 As printed in Fenaille, vol. 2, p. 371.

6. In total Monnoyer and Belin de Fontenay received 552 *livres* and Houasse and Bonnemer received 1,550 *livres* for this work. Fenaille (note 5), pp. 371–372.

7. Fenaille interprets this repair as proof that contemporaneous private commissions were causing wear to the cartoons. See Fenaille (note 5), p. 384.

8. A.N., O¹ 2041. Some of the related Desportes sketches deposited in the Bibliothèque de la Manufacture Nationale de Porcelaine, Sèvres (but dispersed to various other institu-tions) may date from this period. See especially the Desportes oil study of the zebra, jaguar, and rhinoceros reproduced in *La Tenture des Anciennes et Nouvelles Indes*, exh.

9. cat. (Aix-en-Provence, Musée des tapisseries, June–October 1984), no. 23, p. 29, illus. p. 18. Information from Fenaille (note 5), pp. 376–398 and White-head and Boeseman (note 2), gatefold between pp. 120–121.

10. Although Fenaille (note 5), p. 384, records that the Malta set was begun in 1701, its commission was not actually placed until 1708. See Whitehead and Boeseman (note 2), p. 119.

11. For a record of payments see Engerand 1901, pp. 146–151. The eight models survive, dispersed among several museums. See R. Joppien, "Dutch Vision of Brazil: Johan Maurits and His Artists," in *Johan Maurits van Nassau-Siegen 1604–1679*, E. van den Boogaart et al., ed. (The Hague, 1979), p. 357 n. 368. The model for *Le Cheval rayé* is in the Musée de Guéret, inv. 388.

12. See *Exotisme et tapisserie au XVIIIe siècle*, exh. cat. (Musée Départemental de la Tapisserie, Aubusson, June–October 1983) nos. 1–4, pp. 5–11, and Forti Grazzini 1994, nos. 161–166, pp. 456–479.

13. More than eight hundred small oil paintings known collec-tively as *Theatrum rerum naturalium Brasiliae*, and a collec-tion of watercolor sketches known as the *Handbooks*, survive together with other materials called the *Miscellanea Cleyeri* in the Jagiellon Library, Cracow. Nearly three hun-dred watercolor and pencil studies are conserved in the archives of the Academy of Science, Saint Petersburg, and more small oil paintings from the *Theatrum* are in the Säch-sische Landesbibliothek, Dresden. See Whitehead and Boese-man (note 2).

14. The marble copy survives in the Château de Versailles, inv. MV 8600. See S. Hoog, *Musée National de Château de Ver-sailles: Les Sculptures* (Paris, 1993), vol. 1, no. 352, p. 97. Also see C. Bremer-David, "*Le Cheval Rayé*: A French Tapestry Portraying Dutch Brazil," *GettyMusJ* 22 (1994), pp. 21–29.

15. One of four cartoon panels for *Le Cheval rayé* survives in the Gobelins manufactory, inv. GOB 746. It is the left panel showing the crustaceans to the left of the stream and the Iapu campo bird near the spear thrower. Existing in three pieces that are stitched together, it is mounted on canvas and mea-sures 392 cm high by 112 cm wide.

16. *Le Cheval rayé* from the third *tenture* was destroyed by a fire in the Winter Palace, Saint Petersburg, in 1837 and is known by a copy woven in the Saint Petersburg manufactory in the 1730s or 1740s. See T. T. Korshunova, *Russian Tapestry, Petersburg Tapestry Factory* (Leningrad, 1975), figs. 32–33.

17. I thank Tom Campbell for bringing this tapestry to my attention.

18. This tapestry is hung in the gift shop on the ground floor of the Petit Château.

19. Whitehead and Boeseman (note 2), p. 122.

20. Sold from the collection of Achille Le Clerq, Hôtel Drouot, Paris, May 31–June 1, 1904, no. 315. It measured 340 cm high by 530 cm wide. See Fenaille (note 5), p. 395, and illus. in Göbel 1928, part 2, vol. 2, pl. 121.

21. See F. Joubert, A. Lefébure, and P.-F. Bertrand, *Histoire de la tapisserie en Europe du Moyen Age à nos jours* (Paris, 1995), p. 201, fig. 127, in which the tapestry is said to have been woven in the low-warp workshop of Mozin, circa 1690.

22. See Whitehead and Boeseman (note 2), p. 121.

23. It is possible that the tapestry was shortened in width, or intended to be wider, as the middle of the border does not align with the middle of the scene. It measures 292 cm high by 414 cm wide. Illus. in S. Humair, "Les Gobelins: I. De Colbert à Louvois," *Gazette de l'Hôtel Drouot* 14 (April 3, 1992), p. 89.

3

Les Maisons royales:
Le Mois de décembre, Le Château
de Monceaux

Gobelins manufactory, Paris; before 1712

Cartoon painted before 1668 collaboratively by François van der Meulen (1632–1690), Beaudrin Yvart *le père* (1611–1680), Jean-Baptiste Monnoyer (1636–1699), Pierre (Boulle) Boëls (1622–1674), Guillaume Anguier (1628–1708), Abraham Genoëls (1640–1723), Baudoin (dates unknown), Joseph Yvart *le fils* (1649–1728), Jean-Baptiste Martin (*dit* Martin des Batailles, 1659–1735), Manory (dates unknown), François Arvier (dates unknown, *premier peintre du Roi* 1687), and Garnier (possibly Jean, 1632–1705) after designs by Charles Le Brun (1619–1690). Woven on the low-warp loom under the direction of Jean de la Croix *père* (*entrepreneur* of the first low-warp atelier at the Gobelins manufactory 1662–1712).

WOVEN SIGNATURES
Woven in the lower right *galon* with the signature I.D.L. CROX for Jean de la Croix.

MATERIALS
Wool and silk; modern cotton interface and linen lining

GAUGE
20 to 26 warps per inch / 96 to 112 wefts per inch

DIMENSIONS
height 10 ft. 5 in. (317.5 cm)
width 10 ft. 10¼ in. (330.8 cm)

85.DD.309

DESCRIPTION
The *tenture* of *Les Maisons royales* (The Royal Residences) consists of twelve tapestries, one for each month of the year, each representing a royal château. For ten months, from March to December, the weavings adhere to a programmed composition: beyond a foreground portico decorated with luxurious objects and exotic creatures, Louis XIV and his court pursue outdoor activities that are appropriate to the season with the façade of one of the royal residences situated in the distance.[1] The months of January and February, however, depart from this program and show interiors; respectively, they portray the king attending an opera inside the Palais du Louvre and a ballet in the Palais-Royal opposite the Louvre. In sequence from March to December the following palaces are represented: Madrid, Versailles, Saint-Germain-en-Laye, Fontainebleau, Vincennes, Marimont en Hainaut, Chambord, Tuileries, Blois, and Monceaux.

The Museum's example of the Month of December, *Le Mois de décembre, Le Château de Monceaux*, is a narrower version than the official commissions of the Crown. In front of the balustrade are three birds, a great bustard, a crane, and a moorhen. A musical instrument (*basse de viole*) leans against a Near Eastern carpet that is being draped over the railing by two liveried pages (fig. 3.1). On the balustrade another instrument, a *treble viole*, holds some sheets of music in place. The composition is flanked on each side by a single ionic column. Garlands of winter

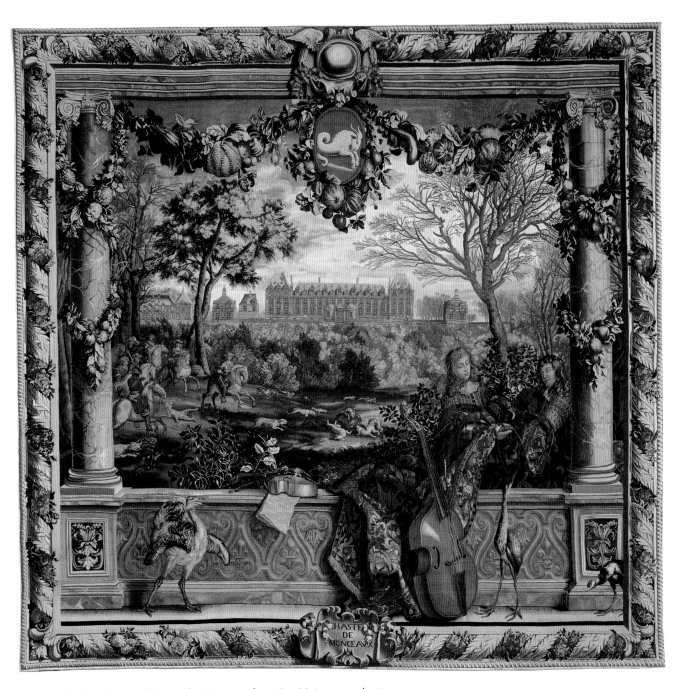

Le Mois de décembre, Le Château de Monceaux from *Les Maisons royales* 85.DD.309

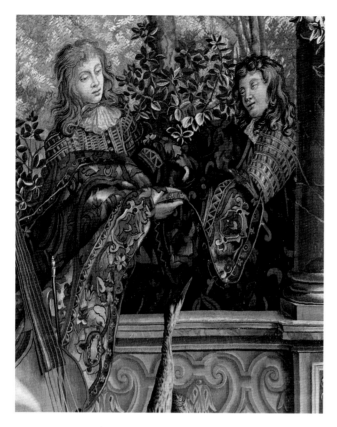

FIGURE 3.1 Detail.

FIGURE 3.2 Detail of woven signature.

fruits and gourds entwine these columns and drape in swags across the top of the portico, where they then encircle a badge that represents the zodiacal sign of Capricorn. Beyond the balustrade, the king can be seen leading a party of equestrian huntsmen after a pack of hounds that attack a wild boar. Only a few of the trees and shrubs retain their foliage. In the distance, beyond a wooded landscape thick with undergrowth, is the Château de Monceaux.

The border of the tapestry is a heavy frame of entwined flowers and acanthus leaves, with agrafes in the corners and a narrow trim of guilloche around the outside. In the center of the top border, above the sign of Capricorn, is a winged shield containing a large polished cabochon. Below, in the bottom border, a beribboned cartouche announces the name CHASTEAU DE MONCEAUX. A section of the original navy *galon* survives bearing the woven signature for Jean de la Croix. Located in the lower right corner, it has been folded under and stitched (fig. 3.2).

CONDITION

The warps of this tapestry are wool, Z spun S ply (2), while the wool wefts are Z spun S ply (2 or 4) and the silk wefts are Z spun S ply (2). Comparing the reverse to the obverse, it can be seen that the tapestry has faded, suffering losses particularly in the yellows and, to a lesser degree, in the rose and violet shades. There are small areas of reweaving throughout, especially where the silk wefts have deteriorated, as in the horses and the sheets of music. Significant losses of weft, with exposed unsupported warps, occur in the building façade and throughout the hanging. Most of these areas have been repaired, but not rewoven, by couching the exposed warps to an interface layer of plain-weave cotton fabric. This cotton interface fabric was adhered (before acquisition by the Museum) to the back of the tapestry with a synthetic adhesive. Covering the interface is a plain-weave linen outer lining that has been stitched through to the tapestry at all four corners in a series of intersecting diagonal lines. The original blue *galon* has largely been cut away from all four sides, with the remaining sections (averaging about one inch in width) turned under and stitched.

COMMENTARY

The tradition of combining imagery of the seasons and months with timely occupations derives from medieval illustrations for prayer books that were used for hourly, daily, and calendrical devotions.[2] Tapestry designs based on this theme were woven in Flemish workshops, particularly at Brussels, at least as early as the sixteenth century, and probably earlier. Louis XIV owned three sets of Flemish tapestries depicting seasonal aristocratic and rustic activities, all woven in Brussels around 1525 to 1535. These were known as *The Hunts of Emperor Maximilian*, after Bernart van Orley (1488–1541); *The Arabesque Months*, after

COUPE DU CHASTEAU.

FIGURE 3.3 Unidentified artist (French, circa 1680). Engraved elevation of the royal pavilion at the Château de Marly. Paris, Archives Nationales de France, O¹ 1472, plate 5. Archives Nationales Service Photographique.

Guilio Romano (1499–1546); and *The Months of Lucas* (named after Lucas van Leyden, but now attributed to a Flemish artist in the school of Bernart van Orley). The Gobelins manufactory copied all three sets before 1690 and continued to weave these popular series during the eighteenth century.

Another possible source of inspiration for *Les Maisons royales* are the *Vertumnus and Pomona* tapestries woven in Brussels during the 1540s. These portray Renaissance gardens with pergolas, sometimes supported by classical columns or caryatids, and the scenes are inhabited by rare animals and birds. Variations on the theme of pergolas, columns, and vases of flowers also appear in seventeenth-century productions in Antwerp. These latter tapestries had a wide circulation that reached as far as Scotland.[3]

Les Maisons royales was designed by Charles Le Brun, who inventively combined the two tapestry traditions.[4] Drawing on the sixteenth-century portrayals of both monthly occupations and garden scenes viewed through porticos, Le Brun added an additional layer of symbolism in the zodiacal theme: just as the sun resides periodically in each of the twelve houses of the zodiac, Louis XIV as the Sun King traveled among the royal residences. The allegory of the Sun King and the zodiac had many parallels in the imagery of Louis XIV's court, and it was even an element in the plans for the king's residence at Marly. In 1679, Jules Hardouin-Mansart (1646–1708) began construction of the château and pavilions at Marly according to a plan in which twelve small buildings, perhaps corresponding to the twelve houses of the zodiac, were divided into two rows that formed an alley leading to the larger royal structure on its elevated terrace. Le Brun was responsible for a design, engraved by Châtillon, of the buildings' exterior treatment in which he reinforced the heliocentric symbolism by assigning Olympian and allegorical names to each of the twelve pavilions and adorning the pediment of the royal château with a relief of Apollo as the Sun God, driving his chariot.[5] An engraved elevation of the king's pavilion at Marly in 1714 (fig. 3.3) clearly shows that at least two tapestries from *Les Maisons royales* decorated rooms on the upper floor.[6]

Nor was Le Brun's conception of *Les Maisons royales* the first instance in which he associated the king's residences with temporal themes. In the 1660s Le Brun designed a set of the Seasons (*Les Saisons*) for the Gobelins manufactory in which Spring showed the *parterres* and part of the Orangerie of the Château de Versailles, Summer included the Château de Fontainebleau as well as part of the Palais des Tuileries in a medallion supported by Minerva and Apollo, Autumn portrayed the Château de Saint-Germain-en-Laye, while the Pavillon de Flore of the Palais des Tuileries appeared in the distance of Winter. The skillful weaving accomplished in *Les Saisons* established a standard that was maintained in the execution of *Les Maisons royales*. In both series the accurate rendering of the Crown's buildings made these architectural portraits readily identifiable.[7] A comparison of an early eighteenth-century engraving of the Château de Monceaux (fig. 3.4) with the tapestry *Le Mois de décembre* attests to this.

The scope of *Les Maisons royales* called for many specialized artists to collaborate on the cartoons. This caused the records of payments to be complicated; although some of the artists worked on all twelve designs, there were

VUË DU CHATEAU ROYAL DE MONCEAUX DU COTÉ DU VILLAGE.

FIGURE 3.4 Jacques Rigaud (French, circa 1681–1754). View of the south side of Château de Monceaux first published in *Les Maisons royales de France* (1730). This engraving reproduced from the same series continued by Jean-Baptiste Rigaud (active circa 1760–1780) under the title *Recueil de cent vingt-une des plus belles vues* (1780), The Library Company of Philadelphia.

also one or two artists who participated only in a few of them.[8] The following artists received payments for work on the cartoons for the high warp-looms: Beaudrin Yvart *le père*, a history painter at the Gobelins, was paid for the large figures, carpets, and curtains; Jean-Baptiste Monnoyer received payment for flowers and fruit; Pierre (Boulle) Boëls, the Flemish animal painter at the Gobelins, was paid for the animals and birds;[9] Guillaume Anguier, painter of architecture at the Gobelins, for the small figures; François van der Meulen for the landscapes; and Abraham Genoëls and Baudoin were paid for certain other landscapes. Payments were made for work on cartoons for the low-warp looms to: Joseph Yvart *le fils* for figures, animals, and carpets;[10] Abraham Genoëls and Jean-Baptiste Martin *l'aîné* for the landscapes;[11] Manory for the architecture; and François Arvier for flowers and fruit. One other artist, a certain Garnier, is mentioned in an inventory of 1736 as painter of the musical instruments.[12] This was possibly Jean Garnier, a painter of still lifes and an active member of the Académie from 1672 until his death in 1705. Charles Le Brun also designed two *entrefenêtres* for the high-warp looms, identified as *Vue du Palais-Royal du côté du jardin* and *Le Jardin des Plantes*, while Van der Meulen painted two more for the low-warp looms, *Vincennes* and *Saint-Germain*.[13]

There are a few surviving drawings that can be specifically associated with the cartoon for *Le Mois de décembre, Le Château de Monceaux*. Among these is a drawing of a head by Le Brun, which apparently served as the model for the pages who drape the carpet over the balustrade (fig. 3.5).[14] A memoir written by van der Meulen

enumerated his contributions to the series of *Les Maisons royales*, stating ". . . Plus, Monceaux, je l'ay peint aussi entièrement, aussi Roy à la chasse. . . ."[15] Clearly van der Meulen was responsible for the middle ground of this scene, and there are two sketches by him of trees with their branches entangled and barren of leaves, which have counterparts in the tapestry.[16] Among the life studies made at the royal *menagerie* by the Flemish artist Pierre (Boulle) Boëls is the drawing for the moorhen that appears, reversed, at the far right of the tapestry.[17]

WEAVER AND DATE

An unrecorded number of tapestries of this series were woven without gold thread. Apparently not produced in complete sets, these were commissions for private individuals. Little is known about the weaving of these later tapestries, but many of them bear the woven signature of either Jean de la Croix or Mathieu Monmerqué (*entrepreneur* for the fourth low-warp *atelier* from 1730 to 1735, and for the second high-warp *atelier* from 1736 to 1749). Edith Standen suggests that the weavers began these independent orders during the period when the Gobelins manufactory was officially closed, from March 1694 to January 1699.[18] The popularity of the series extended beyond the king's death in 1715, since orders continued into the 1730s. It is interesting to note that the condition of the cartoons still permitted their use. The Museum's tapestry falls into the category of a private commission, and the presence of the woven signature for Jean de la Croix dates its weaving to before 1712.

Between 1668 and 1713 the Crown commissioned seven complete sets of *Les Maisons royales* and a number of *entre-fenêtres*, all woven with gold thread. An eighth set was begun but not finished. These official weavings were wider, and their designs were extended beyond the central scene with pairs of columns (in the low-warp versions) or with pairs of sculptured terms (in the high-warp versions) and a pilaster to the right and left (figs. 3.6 and 3.7).[19] Some of these tapestries were presented as diplomatic gifts to Danish ministers, the English court, and the Electrice of Brandenburg.[20] The remaining hangings entered the Garde-Meuble de la Couronne destined for use in the royal household.

Several privately commissioned weavings from *Les Maisons royales* share a common border design with the Museum's example of *Le Mois de décembre, Le Château de Monceaux*, and may be related. All of these have the same agrafes in the four corners, a ribboned cartouche with the name of the royal residence below, and a winged cartouche containing the blue cabochon above. The Victoria and Albert Museum, London, preserves *Le Mois de juillet, Le Château de Vincennes* with the initials L·D·L woven in the lower right *galon* (fomerly in the Paris collection of Henry Say and later in the Château de Fleury-en-Bière).[21] Two versions of *Le Mois de septembre, Le Château de Chambord* survive, one in the National Museum of Western Art, Tokyo, the other in the Château de Bizy, near Giverny (the latter is wider than the Tokyo example, however exact measurements are not available since the tapestry is fitted under *boiserie*).[22] Each of the last three tapestries has an open balustrade design; there is, however, an *entre-fenêtre* of the *Jardin des Plantes* in the Virginia Museum of Fine Arts that is embellished with the sign of Virgo and incorporates the same border and closed balustrade design as the Museum's weaving.[23]

PROVENANCE

Comte de Camondo, Paris (sold, Galerie Georges Petit, Paris, February 1–3, 1893, no. 291); Gaston Menier, Paris (sold, Galerie Charpentier, Paris, November 22, 1936, no. 111); Baron Gendebien-Salvay, Belgium; Vincent Laloux, Brussels; J. Paul Getty Museum, 1985.

PUBLICATIONS

Guiffrey 1886, reproduced in outline p. 361; *Le Journal des arts* (Paris, January 28, 1893); Fenaille, vol. 2, pp. 161–162; M. Meiss, *French Painting in the Time of Jean de Berry, the Limbourgs and their Contemporaries* (New York, 1974), vol. 2, p. 206, detail illus. fig. 713; "La Chronique des arts: Principales acquisitions des musées en 1985," *Gazette des beaux-arts* 1406 (March 1986), no. 180, p. 29, illus.; C. Bremer-David, "Tapestry 'Le Château de Monceaux' from the Series *Les Maisons Royales*," *GettyMusJ* 14 (1986), pp. 105–112; "Acquisitions/1985," *GettyMusJ* 14

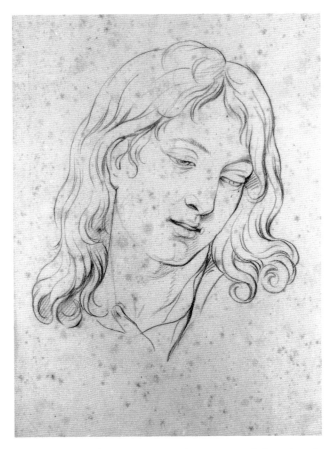

FIGURE 3.5 Charles Le Brun (French, 1619–1690). Drawing of a young man's head. Paris, Musée du Louvre, Département des Arts Graphiques, inv. 30075. Photo R.M.N.

(1986), no. 192, pp. 242–243, illus.; J. Boccara, *Ames de laine et de soie* (Saint-Just-en-Chaussée, 1988), p. 207, illus. p. 209; E. Standen, "The Jardin des Plantes; An *Entre-fenêtre* for the Maisons Royales Gobelins Tapestry Series," *Bulletin du Centre internationale d'études des textiles anciennes* 68 (1990), pp. 49, illus. p. 51; *GettyMusHbk*, 1991, p. 162, illus. p. 163; E. Standen, "The Garden of the Sun-King, A Gobelins Tapestry in the Virginia Museum of Fine Arts," *Arts in Virginia* 30 (Fall/ Winter 1992/93), p. 8, illus.; Bremer-David et al., 1993, no. 289, p. 170 illus.

NOTES

1. Many of the months display ornate silver objects on the balustrades that have been identified as actual objects inventoried in the Garde-Meuble de la Couronne. See F. Buckland, "Gobelins Tapestries and Paintings as a Source of Information about the Silver Furniture of Louis XIV," *Burlington Magazine* 75 (May 1983), pp. 271–283.

2. The well-known example, *Les Très Riches Heures du duc de Berry*, painted by the Limbourg brothers between 1415 and 1418, illustrated eight of the patron's properties, including the Louvre, the Château de Vincennes, and the Château de Saumur. Millard Meiss notes the similarity between this illuminated manuscript and the *Maisons royales* tapestry series in *French Painting in the Time of Jean de Berry, the Limbourgs and their Contemporaries* (New York, 1974), p. 206.

3. See M. Swain, "'Flowerpotts and Pilasters': Royal Tapestries at Holyroodhouse," *Burlington Magazine* 927 (June 1980), pp. 420–423.

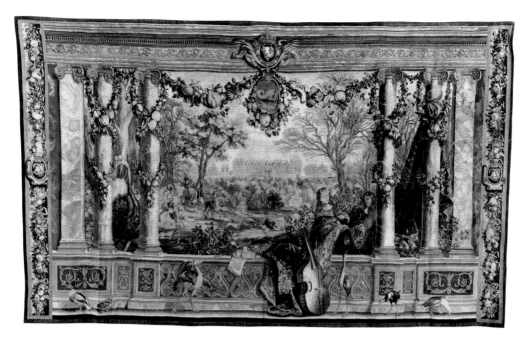

FIGURE 3.6 Gobelins manu-
factory (French, after 1680).
*Le Mois de décembre, Le
Château de Monceaux* with
pairs of columns to either
side woven in the low-warp
workshop of La Croix and
Mozin. Musée National du
Château de Pau, inv. P. 291.
Photo M-L. Perony.

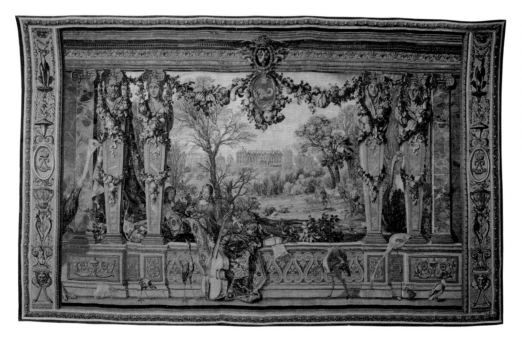

FIGURE 3.7 Gobelins manu-
factory (French, circa 1670–
1712). *Le Mois de décembre,
Le Château de Monceaux*
with pairs of terms to either
side woven in a high-warp
workshop. Paris, Mobilier
National, inv. GMTT 108/12.
Photo Mobilier National
12450.

4. "Ces douze tableaux sont de l'invention de M. Le Brun; plusiers peintres ont été employés à ces tableaux et plusieurs sur un seul. . . ." as recorded by Jean Jans *fils* in his *Etat des tapisseries faites aux Gobelins de 1662 jusqu'à 16 juillet 1691* (A.N., O¹ 2040). Printed in Fenaille, vol. 2, p. 129.

5. See J. and A. Marie, *Marly* (Paris, 1947), p. 13, and B. Shifman, *Depictions of French Royal and Imperial Châteaux: A Study of its Use in the Decorative Arts from the Reigns of Louis XIV through Napoleon* (master's thesis, University of Chicago, 1981).

6. A.N., O¹ 1472; reproduced in Marie (note 5), fig. 14 and caption p. 106.

7. See D. Denis and Y. Carlier, *Tapisseries des Gobelins au Château de Fontainebleau*, exh. cat. (Musée National du Château de Fontainebleau, 1993), p. 44, and Fenaille (note 4), pp. 68–83.

8. This information is taken from the 1691 *memoire* of Jean Jans, as published in Fenaille (note 4), p. 129.

9. One of the birds portrayed in *Le Mois de décembre*, the great bustard, is repeated exactly in landscape tapestries from the Aubusson manufactory produced during the early eighteenth century. One piece, in a private collection, is reproduced in J. Boccara, *Ames de laine et de soie* (Saint-Just-en-Chaussée, 1988), p. 260; and another passed through the art market in June 1995, illus. in *La Gazette de l'Hôtel Drouot* 23 (June 9, 1995), p. 136. The bird also appears in the foreground of a hanging titled *La Comédie italienne: La Diseuse de bonne aventure*, woven by an unidentified factory. See A. Alexandre, "La Collection Cronier," *Les Arts* 47 (November 1905), reproduced p. 18.

10. The Musée du Louvre conserves, from the Gobelins manufactory, two studies by Yvart *le fils* of Near Eastern carpets, inv. 4056 and 4057. See Compin and Roquebert 1986, vol. 4, p. 288, illus.

11. It is interesting to note that Jean-Baptiste Martin *l'aîné* (*dit* Martin des Batailles) supplied fourteen views of royal residences from 1716 to 1729 that were prepared for the Château de Versailles. Among them was "Château de Monsseaux [*sic*] . . . figures et chasse sur le devant." See Engerand 1901, pp. 291–292.

Louis-Henri, duc de Bourbon (1692–1740), also commissioned a cycle of *Maisons royales* from Jean-Baptiste Martin and his brother Pierre-Denis Martin (*dit* des Gobelins) for his Hôtel du Grand Maître in the town of Versailles. Five overdoors from the series survive in their original *boiserie* frames of 1724, installed in the Salle des Fêtes in the Hôtel de Ville on the same site. They represent the châteaux of Madrid, Chambord, Versailles, Monceaux, and the water pump for the Château de Marly. The view of Monceaux is nearly identical to the one portrayed in the Gobelins tapestry series, complete with a hunt in the foreground landscape.

12. See "L'Inventaire général des tableaux et desseins et autres choses qui ont estés faits à la Manufacture des Gobelins et qui sont à la garde particulière du Sieur Chastelain, Inspecteur et peinture de ladite Manufacture" (Bibliothèque Nationale, Manuscripts 7828) as published in Fenaille (note 4), p. 130.

13. In 1838 Louis-Philippe, King of the French, created a display of the cartoons in the Salles des Résidences Royales of the old museum in the Château de Versailles. These models for the twelve tapestries survive in the Grand Ècuries of the Musée National de Château de Versailles. That of *Le Mois de décembre, Le Château de Monceaux* is inv. MV 4691. All twelve, along with the *entrefenêtre* of *Le Jardin des Plantes*, are reproduced in C. Constans, *Musée National de Château de Versailles*, vol. 2, *Les Peintures* (Paris, 1995), nos. 3152–3164, pp. 558–560. In addition, some cut cartoon strips for both the low- and high-warp looms are inventoried in the Musée du Louvre, but conserved at the Musée des Arts Décoratifs, Paris. See Fenaille (note 4), p. 132.

14. In the Musée du Louvre, inv. 8366, red chalk on paper; mistakenly identified as "a woman's head," it is reproduced in J. Guiffrey and P. Marcel, *Inventaire général des Dessins du Musée du Louvre et du Musée de Versailles, Ecole française* (Paris, n.d.), vol. 8, p. 115.

15. "Memoire de tout ce que François Van der Meulen a peint et dessigné pour le service de Sa Majesté depuis de 1er avril 1664" (A.N., O¹ 1964) as published in Fenaille (note 4), p. 131.

16. *Etude de deux arbres sans feuilles et esquisse d'un troisième* (red chalk on paper) and *Etude d'un arbre sans feuilles* (black chalk on paper) formerly in the collection of the Gobelins manufactory, now in the Mobilier National, inv. 10 and 9 respectively. Reproduced in L. -Starcky, *Dessins de Van der Meulen et de son atelier*, exh. cat. (Mobilier National, Paris, 1988), nos. 204 and 205, illus. pp. 199–200.

17. The drawing is in the Cabinet des Dessins of the Musée du Louvre, inv. 19389, and is reproduced in Standen 1985, vol. 1, p. 396, fig. 42. Another bird on the same sheet appears in the low-warp examples of *Le Mois d'avril, Le Château de Versailles*, such as the one in the collection of the comte Patrice de Vogüé at the Château de Vaux-le-Vicomte, near Melun.

18. E. Standen, "The Garden of the Sun-King, A Gobelins Tapestry in the Virginia Museum of Fine Arts," *Arts in Virginia* 30 (Fall/Winter 1992/93), p. 8. In a letter to the author, November 1993, Miss Standen referred to the correspondence between Nicodème Tessin *le jeune* and Daniel Cronström that records the misery suffered by the Gobelins weavers from the lack of work. Several Swedish commissions for tapestries were unofficially filled at the Gobelins during the period 1694–1698. See *Les relations artistiques entre La France et La Suède, 1693–1718* (Stockholm, 1964), p. 51, letter of May 7, 1694, from Cronström to Tessin.

19. The Mobilier National, Paris, has three wide examples of *Le Mois de décembre, Le Château de Monceaux*, one with columns from the low-warp fifth or seventh *tenture* (inv. GMTT 111/12) and two with terms from the high-warp first and second *tentures* (inv. GMTT 108/12 and GMTT 110/12).

20. See Fenaille (note 4), pp. 141–160, and C. Bremer-David, "Tapestry 'Le Château de Monceaux' from the Series *Les Maisons Royales*," *GettyMusJ* 14 (1986), p. 108 n. 14.

21. Victoria and Albert Museum, London, inv. T.371-1977 (h: 10 ft. 11⅞ in. [335 cm]; w: 11 ft. 3¾ in. [345 cm]). Previously sold from the collection of Henry Say, Galerie Georges Petit, Paris, November 30, 1908, no. 32. See also P. Dubois, *Les Anciens Châteaux de France*, vol. 5, *L'Ile-de-France* (Paris, 1923), pl. 8. Wendy Hefford points out that the first initial in the *galon* signature has been transformed into an "L" by later repairs.

22. National Museum of Western Art, Tokyo, inv. OA 1977-1 (h: 10 ft. 8 in. [325 cm]; w: 14 ft. ⅛ in. [427 cm]). See Bremer-David (note 20), fig. 5, p. 110. The entry for "Bizy" in *Merveilles des châteaux de Normandie* (Paris, 1966), p. 206 shows that this version differs slightly as it does not have the winged cartouche containing a cabochon above. Both *Le Mois de septembre, Le Château de Chambord* and an altered *Le Mois de juillet, Le Château de Vincennes* in the Château de Bizy appeared in the 1995 film, *Colonel Chabert*, produced by Jean-Louis Livi.

23. Virginia Museum of Fine Arts, gift of Mrs. Dorothy K. Mondell, inv. 66.25 (h: 10 ft. 1¼ in. [312.5 cm]; w: 7 ft. 2 in. [195.5 cm]). See E. Standen, "The Jardin des Plantes: An Entrefenêtre for the Maisons Royales Gobelins Tapestry Series," *Bulletin du Centre internationale d'études des textiles anciennes* 68 (1990), pp. 47–52, and Standen (note 18), pp. 2–9. See also D. Denis and Y. Carlier, *Tapisseries des Gobelins au Château de Fontainebleau*, exh. cat. (Musée National du Château de Fontainebleau, 1993), p. 44, and Fenaille (note 4), pp. 68–83.

4

Chancellerie: Portière

Gobelins manufactory, Paris; 1728–1730

Cartoon painted 1700–1701 by Guy-Louis Vernansal (1648–1729), Pavillon (active 1690–1712), and Claude III Audran (1658–1734), with the borders painted circa 1720 by Claude III Audran. Woven on the low-warp loom under the direction of Etienne-Claude Le Blond (circa 1700–1751, *entrepreneur* of the fifth low-warp workshop 1727–1751).

WOVEN SIGNATURE
✦·G·LE·BLOИ D· is woven in the lower right *galon*.

WOVEN HERALDRY
Woven with the arms of France and Navarre and, in the borders, with those of Germain-Louis Chauvelin, marquis de Grosbois and *garde des Sceaux* (1685–1762).

MATERIALS
Wool and silk; modern linen support straps and lining

GAUGE
22 to 24 warps per inch / 60 to 76 wefts per inch

DIMENSIONS
height 11 ft. 6¼ in. (351.5 cm)
width 8 ft. 11⅜ in. (273.4 cm)

65.DD.5

DESCRIPTION
This tapestry, a *portière* designed to hang over a doorway in a formal interior, was one of a set of ten armorials presented by Louis XV to the *garde des Sceaux*, Germain-Louis Chauvelin. Displayed under a gilded and tasseled canopy that is draped with an ermine-lined mantle of blue velvet adorned with fleur-de-lys is the royal coat of arms. An elaborate gilt-bronze cartouche carries the arms of France (*d'azure à tois fleur-de-lys or*) and Navarre (*de gueules à une chaine d'or en triple orle, en croix et en sautoir*) surrounded by the collars of the orders of Saint-Michel and the Saint-Esprit. Flanked by palm and olive branches, the armorial shield is surmounted by the head of a winged putto, above which is placed the heraldic crown of the French kings. Beneath the arms is a gilt-metal box representing the casket for the royal seals. It is mounted with fleur-de-lys and monogram *L*'s, and its authority is reinforced by the two royal scepters that cross behind it. All of this rests on a stone pedestal that is carved on each side with a Vitruvian scroll and raised on a plinth. At the center of the pedestal is the all-seeing Eye of Justice, a single eye surrounded by rays of light. Backing this great trophy arrangement is a blue field adorned with yellow fleur-de-lys. The tapestry's wide borders include attributes of the *garde des Sceaux*. Both the top and bottom borders have horizontal bands of a trellis pattern that is enclosed within a frame and terminates at each end in a design of a shell,

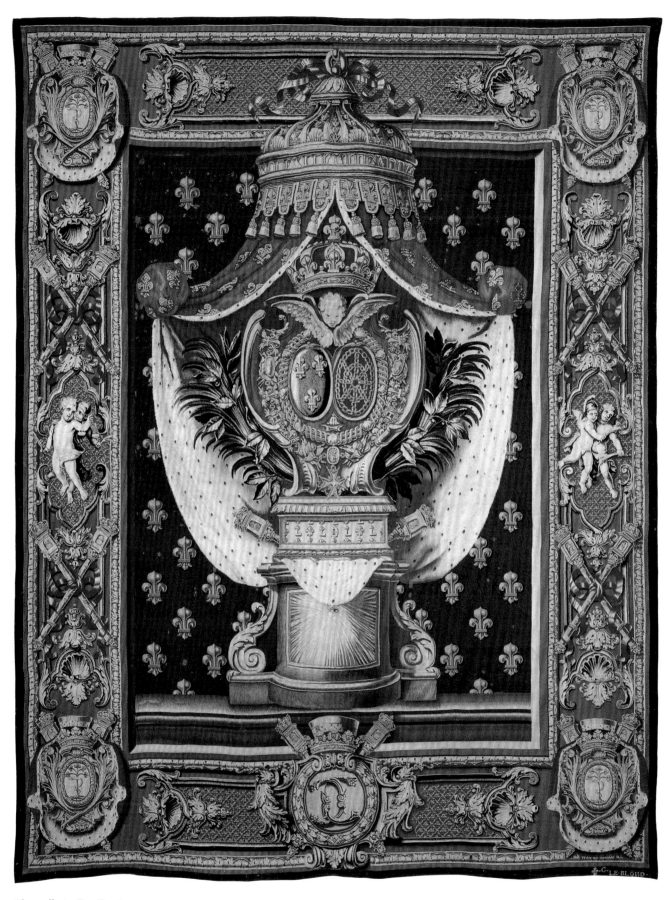

Chancellerie: Portière 65.DD.5

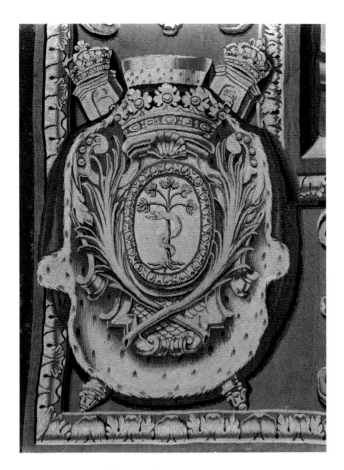

FIGURE 4.1 Detail of coat of arms.

scrolls, and leaves. Centered in the bottom border is Chau-velin's monogram of interlacing *C*'s, set within a laurel wreath on a broad cartouche adorned with stylized acan-thus leaves. Above the cipher is a ducal coronet, topped by a legal cap and trimmed with ermine. Two scepters cross behind. The upper border is centered by a ring tied with ribbon, from which hangs the canopy for the armorial. Each corner contains the arms of Chauvelin (*d'argent à un chou sauvage, pommé et arraché de sinople, la tige accolée d'un serpent ondoyant d'or, la tête vers le haut*), which are surmounted by the same coronet and legal cap, encircled by palm fronds, and draped with an ermine-lined red cape (fig. 4.1). Two scepters cross behind. Additional crossed scepters, tied with scrolling ribbons, are repeated twice on each side border above and below a trellis mandorla. Posi-tioned in the middle of the side trellises are pairs of putti, representing Justice and Mercy on the left (fig. 4.2), and perhaps Reward and Punishment on the right (fig. 4.3).[1] The entire tapestry is bordered by a narrow outer band of foliate motifs. The *galon* is woven in the lower right cor-ner with a fleur-de-lys followed by the letter G for Gobelins and the *entrepreneur's* name, LE BLOND, with the N reversed (fig. 4.4).

CONDITION

The warps of the tapestry are wool, Z spun S ply (4?), while the wefts are wool, Z spun S ply (2), and silk, Z spun

S ply (2). Comparing the reverse to the obverse, the color is good, with about a ten to twenty percent loss, particularly in the violet shades. Many small rewoven areas of the blue field have faded to gray and now stand out visually. The *galons*, undoubtedly replacements, were added as separately woven strips and have seam margins at the left and right sides and overcast joins of butted selvages at the top and bottom. The *galon* section bearing the woven signature is a separate patch that was apparently salvaged from the original bor-der. The tapestry is supported on the reverse by a series of modern linen straps, six to seven inches wide and positioned vertically, and it is backed by a modern linen lining.

COMMENTARY

Louis XIV began a tradition as early as 1679 in which he presented his chancellor (*chancelier*) or his keeper of seals (*garde des Sceaux*) with a set of tapestries from the Gobe-lins manufactory (with the exception of the set presented to Chancelier Boucherat around 1686, which came from the high-warp looms of Beauvais).[2] The tradition lasted through the next century, when the eleventh and last set left the looms in 1777.

The earliest design, dating from 1679, is known by a single example conserved in the Musée Nissim de Camondo, Paris. It portrays two winged figures supporting a shield of three fleur-de-lys, under a small canopy and ermine mantle against a blue field with golden fleur-de-lys. The crossed scepters and the box containing the royal seals are in the lower border.[3] Subsequent weavings varied from the first model by presenting the arms of Navarre as well as France and by placing the coffer for the seals on a pedestal in the central area. The Comptes des Bâtiments du Roi record payments to Vernansal in 1700 and to Pavillon, a painter of armorials, in 1701 for models for this series. A later document mentions the collaboration of Claude III Audran and his designs for new borders in 1720. By 1736 the state of the cartoons was described as "ruinez."[4] Two large sketches for this set by Claude Audran survive in the Nationalmuseum of Sweden at Stockholm. One, in red chalk and graphite, shows the two winged figures support-ing the royal arms, and the other, a watercolor, depicts the arms of France and Navarre surrounded by collars and accompanied below with the attributes of the chancel-lor.[5] While the narrower versions presented only the arms on a dais, the widest tapestries of each set included two seated figures, representing Wisdom and Justice, support-ing the arms of France and Navarre and placed within two columns. All the tapestries included the arms of the recipient, whether a *chancelier* or a *garde des Sceaux*, gar-nished with the same paired sceptors, ducal coronet, and ermine legal cap.

The chancellor of France and his close second, the keeper of the seals, were powerful figures in the seven-teenth and eighteenth centuries. The chancellor was chief

FIGURE 4.2 Detail from vertical border.

FIGURE 4.3 Detail from vertical border.

FIGURE 4.4 Detail of woven signature.

justice for life, first among the crown officers, and head of the judicial system. He represented the person of the king, interpreted the royal will, and sealed and dispatched laws, declarations, provisions of office, and letters of grace and justice. The chancellor also served as a minister to the king, sitting on almost all the royal councils. As a legal magistrate, he was entitled to preside over the sovereign courts, all the tribunals of France, and the *parlement*. The chancellor acted under the king and was advised by the *maîtres des requêtes*, a body of assessors, and the *conseillers d'Etat*. Although, historically, the power of the chancellor and the keeper of the seals had declined once Louis XIV assumed majority in 1661, by the end of the seventeenth century the position of both figures was again secure.[6]

Germain-Louis Chauvelin (fig. 4.5) was the recipient of the eighth *tenture* of *Chancelleries*, accepting the tapestry set during his tenure as keeper of seals at the height of his public life. Chauvelin started his legal career

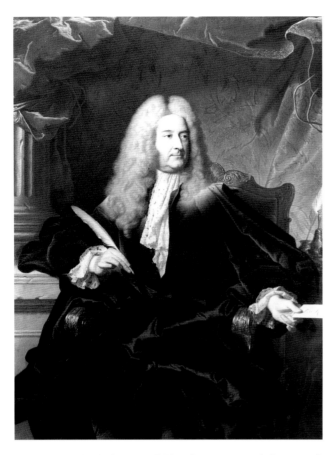

FIGURE 4.5 Hyacinthe Rigaud (French, 1659–1743). *Portrait of Germain-Louis Chauvelin, garde des Sceaux et marquis de Grosbois*. Toulouse, Musée des Augustins.

FIGURE 4.6 Gobelins manufactory (French, 1728–1730). *Chancellerie*. Sold Ader Tajan, Monaco, March 14, 1993, no. 204. Photo courtesy of Ader Tajan.

FIGURE 4.7 Gobelins manufactory (French, 1728–1730). *Chancellerie*. Formerly collection of Georges Wildenstein. Stolen during the German occupation of Paris in World War II. Present location unknown. Photo courtesy Wildenstein and Company, New York.

early, becoming an *avocat du Roi* at nineteen, legal counsel to the Paris *parlement* at twenty-three, and a *maître des requêtes* at twenty-six. After the death of the Regent in 1723, Chauvelin allied himself to Cardinal de Fleury, tutor and later minister to Louis XV, and rapidly found political advancement that culminated in his appointment as secretary of foreign affairs and keeper of the seals in 1727. By 1734 his *seigneurie* of Grosbois, Seine-et-Oise, was raised to a marquisate. But Chauvelin had taken an anti-Austrian stance against Fleury's policy in the war regarding the Polish succession. After the Treaty of Vienna in 1736 Chauvelin fell from favor and was exiled from Paris, stripped of his political positions.[7]

WEAVER AND DATE

Etienne-Claude Le Blond, whose woven signature appears in the lower right *galon*, produced three tapestries of the Chauvelin set. He began two *portières* in 1728 and a wider weaving in 1729; all three were complete in late 1730. In order to fill the commission by 1730 the three other *entrepreneurs* of the low-warp looms also worked on the order, Dominique de la Croix, Jean de la Fraye, and Mathieu Monmerqué.

RELATED TAPESTRIES

The *tenture* of *Chancelleries* delivered to Chauvelin consisted of ten weavings, four completed in 1729 and another six in 1730. A document entitled "Etat des tentures de tapisseries données aux Chanceliers et Gardes des Sceaux de France" records the dimensions of each: five large tapestries were entered as four *aunes* or more in width; one, slightly narrower, measured just less than four *aunes*; two *portières* measured two *aunes* nine *seizièmes* (one of these is the example described here); and two narrow *trumeaux*

were entered as one *aune* eight *seizièmes*.[8] The locations of only four other tapestries from this set are known. A wide *Chancellerie* from the set (fig. 4.6) recently sold from the collection of Ilhamy Hussein Pacha.[9] Another wide example is in a French private collection. The remaining two hangings are a *portière* at the Metropolitan Museum of Art, New York, and a wider *Chancellerie*, woven with seated figures of Wisdom and Justice, in the Château de Menthon, France. The latter two share a slight variation in the border design. Whereas the parallel straps in the vertical borders usually terminate in acanthus leaf scrolls above and below the Chauvelin arms, in these two examples the straps end rather sharply in truncated points.[10]

The Paris dealer Georges Wildenstein reported the theft of two *Chancelleries* with the Chauvelin arms during World War II. Photographs show one to be wider than the Pacha example and the other to be a third *portière* (unrecorded in Fenaille). Neither has been recovered (fig. 4.7).[11]

PROVENANCE

Germain-Louis Chauvelin, marquis de Grosbois and *garde des Sceaux* (1685–1762); Mortimer L. Schiff, New York (sold by his heir, John M. Schiff, Christie's, London, June 22, 1938, lot 74, and purchased at that sale by J. Paul Getty for 350 guineas);[12] J. Paul Getty Museum, 1965.

PUBLICATIONS

Fenaille, vol. 3, p. 139; Göbel 1928, part 1, pp. 172–173; Getty/LeVane 1955, pp. 170–171, illus. opp. 176; P. Verlet et al., *Chefs d'oeuvre de la collection J. Paul Getty*, (Monaco, 1963), p. 133, illus.; A. M. Jones, *A Handbook of the Decorative Arts in the J. Paul Getty Museum* (Malibu, 1965), no. A-7, p. 13; Standen 1985, vol. 1, pp. 361–364; Sassoon and Wilson 1986, no. 215, p. 101, illus.; Bremer-David et al., 1993, no. 292, p. 172, illus.

NOTES

1. See Standen 1985, vol. 1, p. 361.
2. See Fenaille, vol. 3, pp. 133–134. Woven under the direction of Philippe Béhagle (1641–1705), after the designs of François Bonnemer (1638–1689) and Jean Le Moyne (possibly *dit* de Paris 1638–1713), the Beauvais *tenture* bears the arms of France and Navarre supported by two angels. At least three examples of this design survive: two in the Mobilier National, Paris (one of which is on loan to the Musée du Louvre, inv. OA 5703); and a third, from the collection of Francis Guérault, was sold Alph. Bellier, Paris, March 21, 1935, no. 139. See also Badin 1909, pp. 9 and 12; Coural 1992, p. 21 and illus. p. 16; and also Verlet 1982, p. 405 n. 28.
3. Musée Nissim de Camondo, Paris, inv. 45. The original arms of Chancelier Le Tellier were removed from the lower border corners and replaced by those of d'Argenson. See N. Gasc and G. Mabille, *The Nissim de Camondo Museum* (Paris, reprint, 1995), pp. 92–95, illus. See also Standen (note 1), p. 361 and p. 364 n. 2; and Badin (note 2), p. 26.
4. See Fenaille (note 2), pp. 134–135. Fenaille quotes the 1736 document, "L'Inventaire des tableaux et desseins . . . qui sont

à la garde particulière du Sr. Chastelain, inspecteur et peintre de la Manufacture des Gobelins."
5. The first drawing measures 35.4 cm by 44.5 cm and the watercolor sketch measures 27.6 cm by 17.6 cm. Both are in the Cronstedt Collection of the Nationalmuseum of Sweden at Stockholm, inv. III, 21, and II, 76, respectively. See *Dessins du Nationalmuseum de Stockholm, Collections Tessin and Cronstedt, Part I: Claude III Audran (1658–1734)*, exh. cat. (Bibliothèque Nationale, Paris, 1950), nos. 146–147, pp. 36–37. Also see *Arkitekturritningar, planer och teckningar ur Carl Johan Cronstedts Fullerösamling*, exh. cat. (Nationalmuseum, Stockholm, 1942), no. 123, p. 31.
6. For a discussion of the roles of chancellor and keeper of seals, see R. Mousnier, *The Institutions of France under the Absolute Monarchy 1598–1789*, vol. 2, *The Organs of State and Society* (Chicago, 1979), p. 134 ff.
7. *Dictionnaire de biographie française* (Paris, 1959), vol. 8, p. 907, and A. Cobban, *A History of Modern France*, vol. 1, *1715–1799* (Middlesex, 1963), pp. 28–37. For the Château de Grosbois, see H. Soulange-Bodin, *Les Anciens Châteaux de France*, vol. 5, *L'Ile-de-France* (Paris, 1923).
8. Bibliothèque Nationale, Paris, manuscript Fond fr. 7825–7826. As published in Fenaille (note 2), p. 139.
9. Sold Ader Tajan, Monaco, March 14, 1993, no. 204, for 380,000 French francs. Previously it was part of the Bensimon collection and sold at Hôtel Drouot, Paris, November 18 and 19, 1981, no. 164.
10. Metropolitan Museum of Art, New York, Rogers Fund 1962 (62.91). See Standen (note 1), pp. 361–364, in which the author mentions the locations and sales of other *Chancelleries* woven for different recipients. For the wider hanging in the Château de Menthon, see *Merveilles des châteaux de Savoie et du Dauphiné* (Paris, 1972), p. 60, illus.
11. *Répertoire des biens spoliés en France durant la Guerre 1939–1945* (Berlin, 1947), vol. 2, p. 367, nos. 390–391, illus. Correspondence from E. Standen to G. Wilson, December 30, 1974.
12. J. Paul Getty was active at the Mortimer L. Schiff sale, making twenty-one purchases including this tapestry. Interestingly, the *Chancellerie* was one of seven Getty tapestries later photographed at French and Company in New York during June 1939, negative no. 21332. Each of the seven weavings was assigned a negative number but no stock number and the negative records indicate their owner as Getty. Their presence at French and Company is unexplained. Perhaps they were safeguarded there during the war or conserved or merely photographed. I thank Onica Busuioceanu of the GRI for her generous help in researching the French and Company records.

5

Nouvelle Portière aux armes de France

Gobelins manufactory, Paris; circa 1730–1740

Cartoon designed 1727 by Pierre-Josse Perrot (active 1724–1750, *peintre d'ornements* at the Administration de l'Argenterie, Menus-Plaisirs et Affaires de la Chambre du Roi, and at the manufactories of the Gobelins and the Savonnerie). Woven on the low-warp loom under the direction of Etienne-Claude Le Blond (circa 1700–1751, *entrepreneur* of the fifth low-warp workshop 1727–1751).

WOVEN SIGNATURES
✠·G·L (for the Gobelins and the *entrepreneur* Le Blond) is woven in the lower right *galon*.

WOVEN HERALDRY
Woven with the arms of France.

MATERIALS
Wool and silk; modern cotton lining

GAUGE
20 to 22 warps per inch / 72 to 128 wefts per inch

DIMENSIONS
height 11 ft. 10⅞ in. (362.7 cm)
width 9 ft. 2½ in. (280.6 cm)

85.DD.100

DESCRIPTION
This armorial *portière* was designed to hang over a door in a formal interior of a royal residence, a royal institution, or an embassy. Against a crimson ground, an ermine-lined mantle of blue adorned with yellow fleur-de-lys hangs on the brackets of a carved and gilded cornice. A simulated gilt bronze cartouche is placed in the center of the mantle and carries a shield with the arms of France (*d'azure à tois fleur-de-lys or*). The arms are surrounded by the collars of the orders of Saint-Michel and the Saint-Esprit and surmounted by the heraldic crown of the French kings. Supported in the lower scrolls of the cartouche is the royal scepter crossed with the Hand of Justice. Below the cornice, to the left and right, are military trophies consisting of French flags, a bow, quivers of arrows, swords in scabbards, spears, cannons, a trumpet, and shields; the shield on the left is adorned with a feathered thunderbolt and the one on the right with a chimera spouting flames. The supporting scrolled brackets of the cornice terminate in profile masks of bearded and winged faces. A royal ceremonial helmet with pink ostrich plumes rests on a bow with crossed quivers of arrows at the base of the tapestry, while a head of Apollo, surrounded by rays, centers the top (fig. 5.1). Thick garlands of leaves and flowers drape the upper and lower elements of the composition and entwine with the clasp and palm motifs of the four corners. The border resembles a carved and gilded picture frame, composed of an inner pattern of scrolled leaves and an outer

Nouvelle Portière aux armes de France 85.DD.100

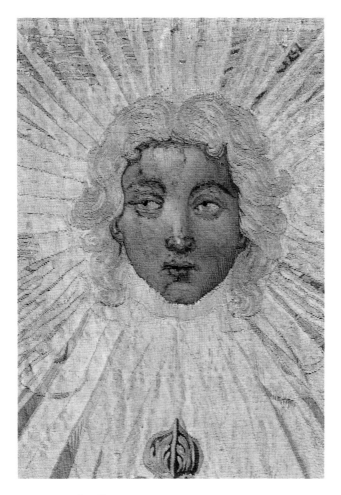

FIGURE 5.1 Detail.

FIGURE 5.2 Detail of woven signature (partial).

border of laurel leaves interspersed with berries. Part of the original *galon* is intact and at the lower right corner is a section bearing a woven fleur-de-lys for the Gobelins manufactory and the partial mark for the *entrepreneur* Le Blond (fig. 5.2).

CONDITION

The warps of this tapestry are wool, Z spun S ply (4), while the wool and silk wefts are Z spun S ply (2). There is variation in the weight of the silk weft, resulting in a range of yarns-per-inch. Moreover, the yarns were sometimes doubled for one pass of weft through the warps, thus making the yarns-per-inch count lower. The tapestry has rich color definition overall, particularly in the red and red-violet shades of the background. Comparing the reverse to obverse, the yellow and orange tones appear to have suffered the greatest color loss, the blues and greens less so (figs. 5.3 and 5.4). In the tightly woven areas where planar buckling occurs there are small areas of abrasion to the weft fibers; several small repairs, primarily reweavings, occur throughout. There are significant losses to the original blue *galons*, particularly along the bottom edge where the left and right sides have been replaced or backed by modern *galon* sections that are woven to match. The central section of the bottom *galon* is original, although it has been backed with a cotton/polyester twill fabric, and there are extensive repairs to the original top *galon*. Cotton twill tape straps, three inches wide, have been sewn vertically to the reverse of the tapestry every twenty-two inches, and one strap has been sewn horizontally along the bottom edge. The tapestry has a modern cotton lining.

COMMENTARY

Pierre-Josse (also called Pierre-Joseph) Perrot was active at three royal manufactories from around 1724 until his death in 1750. His name is rarely mentioned in the Comptes des Bâtiments and only occasionally in the registers of the Garde-Meuble. Nevertheless his designs, known primarily by a group of watercolor sketches, came to epitomize the style preferred by Louis xv, a style characterized by the repetition of royal emblems, boldly colorful acanthus scrolls, and flowers. His earliest known work, a collaboration in 1724 with Jean-Baptiste Belin de Fontenay *fils* (1668–1730), was the carpet design for the throne in the Salon d'Apollon at the Château de Versailles.[1] In the upper corners appear the *bâtons royaux*—the crossed Hand of Justice and royal scepter—which are so prominent in the *portière* created three years later.

No preliminary drawings for this tapestry are known, but a 1736 inventory of models at the Gobelins manufactory records two examples of this cartoon, both painted by "M. Perault," one registered in 1727 and the other in 1732.[2] The cartoon of 1732 varied slightly from the first one, substituting angular lightning bolts for the

FIGURE 5.3 Detail.

FIGURE 5.4 Reverse of fig. 5.3.

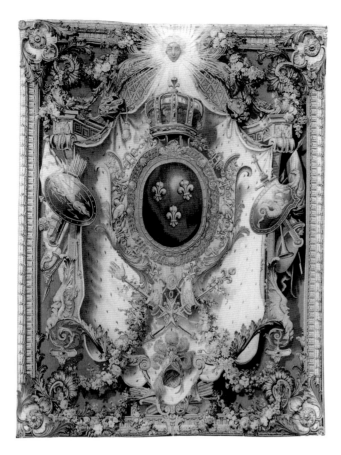

FIGURE 5.5 Gobelins manufactory (French, 1730–1740). *Nouvelle Portière aux armes de France*, second model. Paris, Mobilier National, inv. GMTT 138. Photo Mobilier National 3558.

feathered thunderbolt on the shield at the left side of the tapestry (fig. 5.5).

The early collaboration with Belin de Fontenay is significant for it typifies Perrot's link with decorative artists (*peintres d'ornements*), such as Claude III Audran (1658–1734), and with flower painters, such as the two generations of Belin de Fontenay, who worked in the French court baroque style. Perrot is considered the transitional link at the Gobelins and the Savonnerie manufactories between the personal tastes of Louis XIV and Louis XV. He frequently used the artistic vocabulary of his predecessors, but he reinterpreted the familiar forms by means of a brighter palette and a lighter composition. His connection with the elder generation of Gobelins painters may be seen in another of his designs of the same date, *La Nouvelle Portière de Diane*, which followed the taste of Claude Audran's series of *Les Portières des dieux*, particulary *Diane—La Terre*, begun twenty-eight years earlier.[3] For the *Nouvelle Portière aux armes de France* Perrot repeated a powerful image usually associated with the Sun King—the shining head of Apollo—and thereby suggested both an artistic and political continuity between the earlier king and his great-grandson, Louis XV, who was only seventeen years of age at the time of the tapestry's commission in 1727.

WEAVER AND DATE

Although designed in 1727, the actual weaving of the *Nouvelle Portière aux armes de France* did not commence until 1730 on the low-warp looms of Etienne-Claude Le Blond. Identified by the woven initials that survive in the *galon*, this tapestry must be one of twenty examples that were completed in Le Blond's workshop by 1740 (fig. 5.2). The *portières* clearly found royal approval, since a second cartoon was painted in 1732 for simultaneous weaving in the low-warp *atelier* of Mathieu Monmerqué and, later, Pierre-François Cozette. Another eight were produced there resulting in a total of twenty-eight in all.[4]

The first delivery of the *Nouvelles Portières aux armes de France* was on November 17, 1738, when "Sr. Cozette, concierge de la manufacture Royalle des Gobelins" brought four hangings to the Garde-Meuble de la Couronne "pour servir dans le Cabinet attenant la nouvelle chambre du Roy à Versailles."[5] Inventoried together as number 214, these same four were lent to le comte de Belle-Isle in his capacity as the newly appointed ambassador to Frankfurt, along with silver embroidered hangings for a dais, on January 21, 1741.[6] Identified in the eighteenth-century inventories of the royal châteaux as *portières* "à l'Ecusson," three of the four were in use in 1788 and 1789 at the Château de Choisy-le-Roi, while one decorated the Salon de l'Œil-de-Bœuf in the Château de Versailles.[7] By 1792, one had returned to the *magasin* of the Garde-Meuble.[8]

The next delivery of the armorial *portières* was a group of twelve on February 1, 1743, inventoried in the *Journal du Garde-Meuble de la Couronne* as number 216. These twelve must have been the same group that was lent to the Capuchin church backing the rue Saint-Honoré for the Te Deum mass celebrated on September 24, 1751, in thanksgiving for the birth of the duc de Bourgogne.[9] In 1789, three of the twelve were in the Salon de l'Œil-de-Bœuf at Versailles while the remaining eight were recorded in the Palais de Compiègne.[10]

Other examples of *Nouvelles Portières aux armes de France* continued to serve the needs of the Garde-Meuble through the reign of Louis XV: four armorials accompanied the French ambassador to Rome, the duc de Nivernois, in 1748; six decorated the Palais du Luxembourg from 1750 until 1789; two were lent to the Académie royale de peinture in Paris on April 17, 1765.[11]

RELATED TAPESTRIES

Of the twenty-eight tapestries woven after Pierre-Josse Perrot's two cartoons, twenty-one examples are known. Ten are in the Mobilier National, although dispersed to various public collections and ministerial offices, and a further seven belong to the Ville de Paris.[12] An additional *portière* is in the Musée du Louvre, another in the Museo del Vaticano,

and a third passed through the art market in 1993. Nine of these known examples follow the earlier cartoon and have the feathered thunderbolt in the shield: the one at the JPGM; the five from the Mobilier National, one of which is in the Musée du Louvre and another is in the Musée Carnavalet; one from the collection of the Ville de Paris, displayed in the Petit Palais; the one at the Museo del Vaticano; and the one seen in the Paris art market.[13] There are at least six examples after the later cartoon with the angular lightning bolts in the shield at the left: four in the Mobilier National, of which one is at the consulate in Buenos Aires and two are on loan to the Musée National du Château de Versailles; one in the Musée du Louvre; one with the Ville de Paris.[14] Six others remain: one from the Mobilier National on loan to the Musée National de la Legion d'Honneur et des Ordres de la Chevalerie (Hôtel de Salm) and five with the Ville de Paris, one of which has had the arms removed.[15]

Late in the nineteenth century, a variation of this tapestry was made at the Gobelins for the Première Chambre Civile du Palais du Justice, Rennes. The shield bearing the arms of France was divided to include the arms of Bretagne as well. The first weaving of 1895–1896 proved too small for its location and was replaced in 1906 with a second hanging.[16] A machine-woven imitation of this tapestry was also created by an unknown source, bearing the erroneous inscription along the lower edge LES ARMES DV ROY ✦ CH.LEBRVN. PINXIT. ANNO M.DCLXXX.[17]

PROVENANCE
Richard, 4th Marquess of Hertford, Paris, before 1865; by inheritance to Sir Richard Wallace, Paris, 1890; by inheritance to Sir John Murray Scott, Paris, 1897; by inheritance to Victoria, Lady Sackville, in the Grande Galerie of the hôtel in rue Lafitte, Paris, 1912[18]; M and Mme Jacques Seligmann, Paris (sold in the late 1940s)[19]; private collection; Franĉois-Gérard Seligmann, 23 Place Vendôme, Paris, 1953; private collection, (?) France; François-Gérard Seligmann, Paris, 1985; J. Paul Getty Museum, 1985.

EXHIBITIONS
Musée rétrospectif, Union Centrale des Beaux-Arts Appliqués à l'Industrie, Paris 1865, no. 5734, lent by the 4th Marquess of Hertford; *Exposition d'art français du XVIIIe siècle*, Paris 1916, no. 113, p. 87, illus.

PUBLICATIONS
Fenaille, vol. 3, pp. 310–314; Göbel 1928, part 1, p. 156; "Acquisitions/1985," *GettyMusJ* 14 (1986), no. 196, pp. 244–245, illus.; *GettyMusHbk*, 1991, p. 170, detail illus. p. 154; Bremer-David et al., 1993, no. 293, p. 172, illus.

NOTES
1. Illus. in Verlet 1982, p. 105, fig. 60.
2. Fenaille, vol. 3, p. 310. Presumably Fenaille is quoting "L'Inventaire des tableaux et desseins . . . qui sont à la garde particulière du Sr. Chastelain, inspecteur et peintre de la Manufacture des Gobelins."
3. Meyer 1989, p. 134.
4. Fenaille (note 2), pp. 310–314.
5. A.N., O¹ 3311, fol. 160–161.
6. A.N., O¹ 3313, fol. 37.
7. Meyer (note 3), pp. 131–138.
8. A.N., O¹ 3359.
9. A.N., O¹ 3315, fol. 94.
10. Fenaille (note 2), p. 312.
11. Ibid., pp. 311–313.
12. One of the ten from the Mobilier National was included by E. Williamson in the catalogue for *Musée du Garde-Meuble, 103 Quai d'Orsay* (Paris, 1897), no. 59, although erroneously attributed to Charles Le Brun.
13. I thank Madame Bersani of the Mobilier National for her assistance in identifying the *portières* in that collection. The Mobilier National, inv. GMTT 142, on loan to the Musée du Louvre, inv. OA 5042, see *Tapisseries françaises des XVIIᵉ et XVIIIᵉ siècles*, exh. cat. (Galeries du Théâtre Municipal, Ville de Brive, 1989), no. 8, illus. The Mobilier National, inv. GMTT 140, on loan to the Musée Carnavalet, inv. MB 651, see *Louis XV, Un Moment de perfection de l'art français*, exh. cat. (Hôtel de la Monnaie, Paris, 1974), no. 381, p. 284, illus. p. 283. Museo del Vaticano, see Göbel 1928, part 2, pl. 130. Paris art market, sold Drouot Richelieu, March 21, 1993, no. 133, with the note "fortes restaurations, usures."
14. Mobilier National, inv. GMTT 137 and 138, on loan to the Musée National du Château de Versailles et des Trianons, displayed in the king's second *antichambre* or the Salon de l'Œil-de-Bœuf. One reproduced in Meyer (note 3), p. 137. Mobilier National, inv. GMTT 139, published in *Catálogo de la Exposición de Muebles, Tapices, Objetos de Arte*, exh. cat. (Amigos del Arte, Buenos Aires, 1937), no. 7, p. 7, illus. on the cover. Musée du Louvre, inv. OA 7295, published in *Les Gobelins (1662–1962), Trois siècles de tapisserie française*, exh. cat. (Château de Coppet, near Geneva, 1962), no. 58, p. 149, illus. 151. The Ville de Paris hanging is reproduced in J. Niclausse, *Tapisseries et tapis de la ville de Paris* (Paris, 1948), no. 40, p. 39, illus.
15. Mobilier National, inv. GMTT 134, on loan to the Musée National de la Legion d'Honneur et des Ordres de la Chevalerie; see exh. cat. Hôtel de la Monnaie (note 13), no. 380, p. 284. See Niclausse (note 14), p. 39, for an enumeration and description of those in the collection of the Ville de Paris.
16. See Fenaille, vol. 5, pp. 195–197. The second weaving survived the February 1994 fire of the Palais du Justice, Rennes; see H. Grandsart, "Le Parlement de Rennes," *Connaissance des Arts* 508 (July–August 1994), pp. 78–85, illus. p. 82.
17. Sold in a wooden frame at Christie's, New York, May 25, 1993, lot 133, measuring 99 cm by 66 cm. Reproduced showing part of its reverse in N. de Pazzis-Chevalier, "Apprendre à regarder une tapisserie ancienne—faux et défauts," *Métiers d'art: La Tapisserie* 47–48 (October–December 1992), pp. 69–71.
18. Mentioned in a 1912 inventory of that residence. Information from John McKee of the Wallace Collection, London, to G. Wilson, June 11, 1985 (object file correspondence, JPGM).
19. A vellum tag inscribed in ink 17341 and measuring 2 in. by ⅞ in. was attached by string to the tapestry when it was acquired by the JPGM. It is presumed to be a Seligmann inventory number. The tag has been removed and filed.

6

Four tapestries from
L'Histoire de don Quichotte:

a. *La Poltronnerie de Sancho à la chasse*
b. *L'Entrée de Sancho dans l'Ile de Barataria*
c. *Le Repas de Sancho dans l'Ile de Barataria*
d. *Don Quichotte guéri de sa folie par la sagesse*

Gobelins manufactory, Paris; 1770–1773

Individual cartoons for the narrative scenes painted 1718–1725 by Charles-Antoine Coypel (1694–1752); *alentour* designed circa 1721–1760 by Jean-Baptiste Belin de Fontenay *fils* (1668–1730), Claude III Audran (1658–1734), Alexandre François Desportes (1661–1743), and Maurice Jacques (circa 1712–1784); *alentour* cartoon painted 1763 by Antoine Boizot (circa 1702–1782); replacement narrative cartoons after the Coypel originals painted 1766–1768 by Boizot. Woven on the high-warp loom under the direction of Michel Audran (1701–1771, *entrepreneur* of the first high-warp workshop 1732–1771) and his son, Jean Audran *fils* (succeeded his father as *entrepreneur* of the first high-warp workshop 1771–1794).

WOVEN SIGNATURES
a. bears the woven signature AUDRAN in the lower right corner of the field and AUDRAN.G.1772 (the 2 woven sideways) in the lower right corner of the *galon*;
b. has the name AUDRAN. woven in the lower right corner of the field, and in the lower right corner of the *galon* is AUDRAN.1772.;
c. bears AUDRAN above the date 1772 in the lower right corner of the field, while the *galon* is woven with AUDRAN.G ✦.1772.;
d. bears the name AUDRAN (the N incomplete) in the lower right corner of the field, and the *galon* repeats AUDRAN·G·1773·.

MATERIALS
Wool and silk; modern cotton support straps and lining

GAUGE
20 to 22 warps per inch / 84 to 100 wefts per inch

DIMENSIONS:
a. height 12 ft. 1 in. (368 cm); width 13 ft. 4 in. (406 cm)
b. height 12 ft. 1 in. (368 cm); width 13 ft. 7 in. (414 cm)
c. height 12 ft. 2 in. (371 cm); width 16 ft. 7 in. (507.5 cm)
d. height 11 ft. 10 in. (361 cm); width 12 ft. 8 in. (386 cm)

a. 82.DD.69 c. 82.DD.67
b. 82.DD.68 d. 82.DD.66

DESCRIPTION
Each tapestry in this series presents a narrative painting that depicts a scene from the popular romance, *Don Quixote de la Mancha*, by Miguel de Cervantes Saavedra (1547–1616).[1] The painting is vignetted within an elaborately carved and gilded frame, which in turn is a part of a larger decorative scheme.

a. *La Poltronnerie de Sancho à la chasse*
(Sancho's Cowardice during the Hunt)
The simulated painting in *La Poltronnerie de Sancho à la chasse* illustrates an episode from Part II, Chapter 34, of Cervantes' saga, and shows a boar hunt set in a wood (fig. 6.1). A pack of hounds attacks a wild boar as it charges the armored figure of don Quichotte. The knight skewers the animal with his sword, while his skittish companion, Sancho Pança, climbs a tree trunk to the left. Two pages also spear the beast as the duke and duchess, along with two female attendants, observe from behind.

All four tapestries feature a surrounding decoration known as the *alentour*. This elaborate augmentation represents a damask wall covering in rose and crimson, festooned with thick garlands of flowers and fruit that are tied into place by blue ribbons. On top of the picture's frame stands a peacock with its tail in full display and a lighted torch and a quiver of arrows at its feet. Each upper corner of the frame is ornamented with a scrolling grotesque profile surmounted by an oil lamp with a handle in the form of a cockerel. Two birds perch in the upper garlands beyond the frame, one to each side, while two monkeys play in the long garlands that hang down on the right and left. The

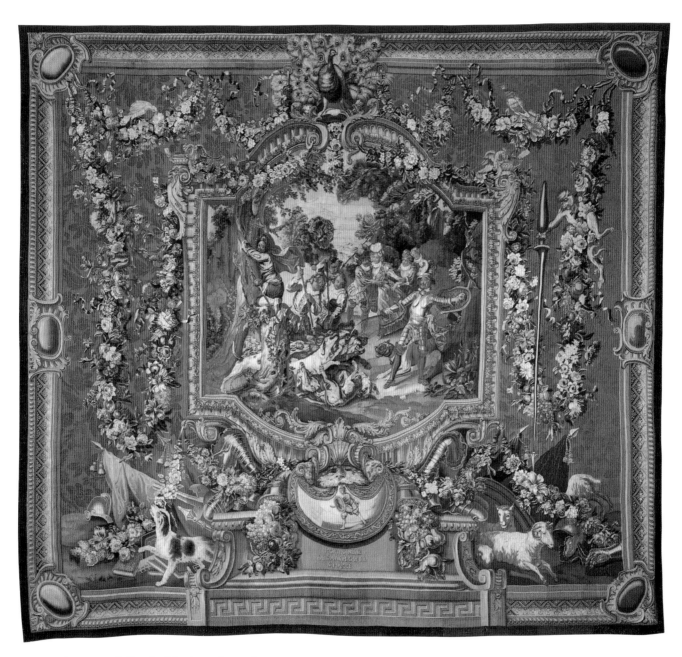

a. *La Poltronnerie de Sancho à la chasse* 82.DD.69

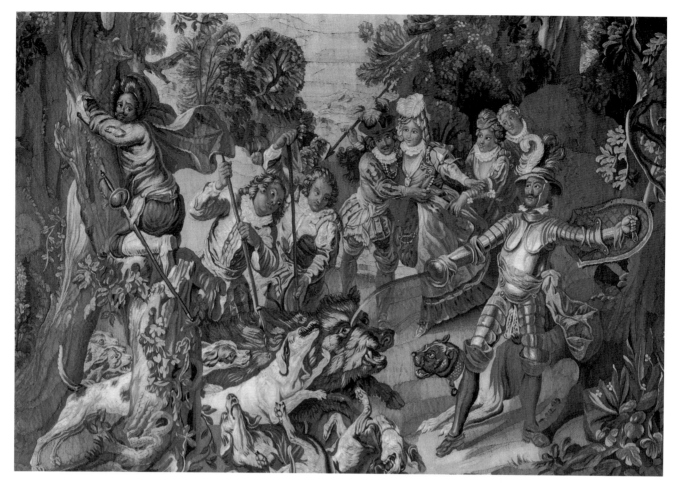

FIGURE 6.1 Detail, *La Poltronnerie de Sancho.*

FIGURE 6.2 Detail of woven signature and date, *La Poltronnerie de Sancho.*

monkey on the right dangles a long lance in the direction of three sheep below, which scatter at its sight. In the opposite corner, amid a pile of books, is a spotted spaniel that points at the other monkey above. The picture frame rests on a plinth piled with armor, an ax, a baton, flags, and two cornucopias that spill fruit to either side of a pelta held by the gripping mouth of an animal mask. The pelta is cast with ram's heads and chased with a figure of a knight. Directly below is a blue field that bears the inscription in yellow POLTRONERIE DE SANCHO A LA CHASSE. The *alentour* is enclosed by a frame of carved and gilded wood with a concave trellis pattern that is interrupted at the bottom center by the key-fret design of the plinth's base. The border is set with gilt cartouches holding blue cabochons in the four corners, and it has an unadorned gilt cartouche at the middle of each side. The tapestry is woven with the signature AUDRAN in the lower right corner of the field, while the *galon* bears AUDRAN.G.1772 (fig. 6.2).

b. *L'Entrée de Sancho dans l'Ile de Barataria*

(Sancho's Entry on the Isle of Barataria)
Based on Part II, Chapter 45, the narrative painting in this tapestry portrays the entrance of Sancho through the crenelated archway of a city that he is to govern (fig. 6.3). Astride the shoulders of two men, and flanked by two pike-bearing soldiers, Sancho is carried along the paved street

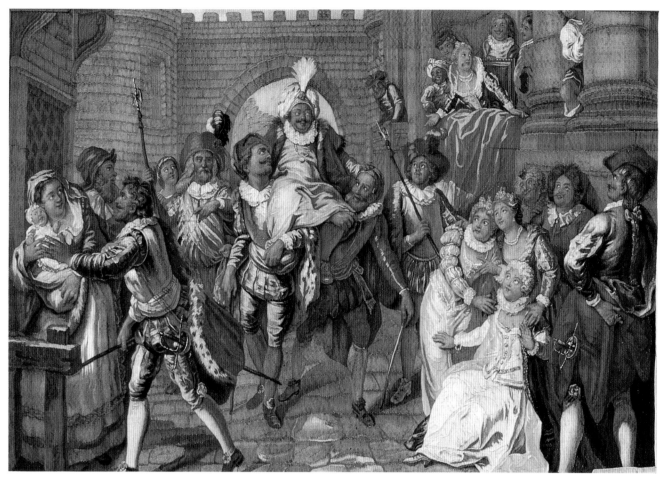

FIGURE 6.3 Detail, *L'Entrée de Sancho*.

amid a group of citizens. He wears a long yellow robe, a fur cloak, and a feathered turban. To the right, a seated woman, her two female attendants, and three men watch his procession, while, to the left, a mother and infant are bustled out of the way. A woman and several men lean from balconies in the middle ground. The blue field of the plinth below states ENTRÉE DE SANCHO DANS L'ILE DE BARATARIA. Both the lower right corner of the the *alentour* and the *galon* bear the woven name AUDRAN while the *galon* also has the date 1772 (fig. 6.4).

c. *Le Repas de Sancho dans l'Ile de Barataria*
(Sancho's Feast on the Isle of Barataria)
Le Repas de Sancho is drawn from Part II, Chapter 47. It shows Sancho, still wearing the feathered turban, seated alone at a round table with a white cloth (fig. 6.5). Surrounding him are ten courtiers and three serving pages. A gilt chandelier fitted with burning candles hangs above, and against the back wall is set a buffet with ceremonial plate. To the far right is the bearded and bespectacled figure of the doctor. Dressed in flowing robes and a wide-brimmed hat, he gesticulates toward the table with a staff. On his orders, the pages are bringing various dishes and then whisking them away as he declares their contents somehow detrimental to Sancho's health. The *alentour* of this tapestry is wider than the other three and bears the

FIGURE 6.4 Detail of woven signature and date, *L'Entrée de Sancho*.

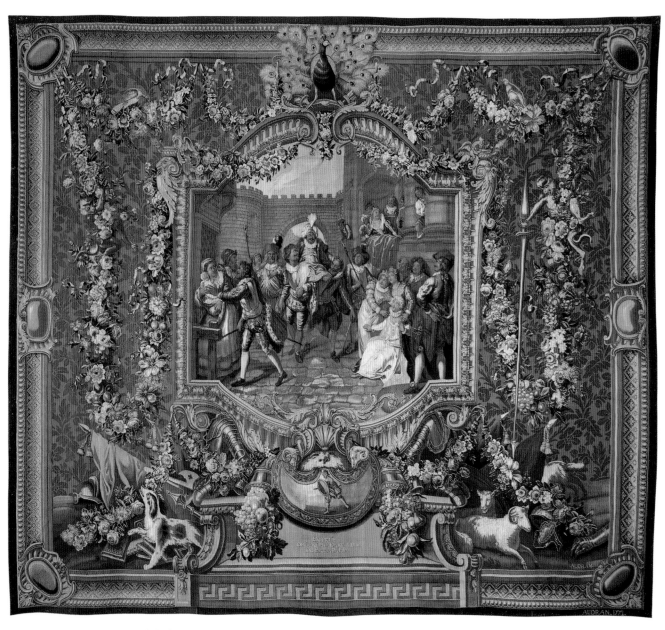

b. *L'Entrée de Sancho dans l'Ile de Barataria* 82.DD.68

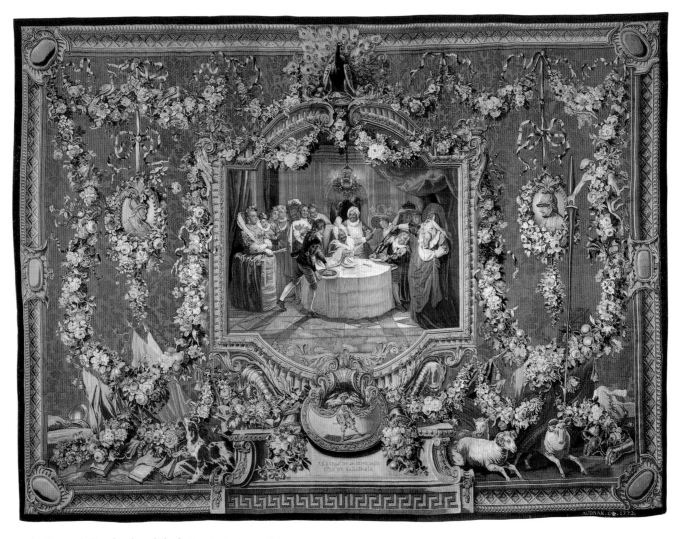

c. *Le Repas de Sancho dans l'Ile de Barataria* 82.DD.67

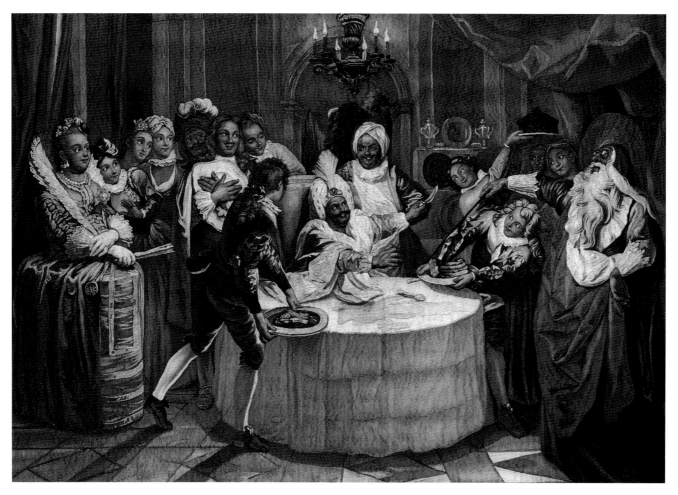

FIGURE 6.5 Detail, *Le Repas de Sancho*.

FIGURE 6.6 Detail of woven signature and date, *Le Repas de Sancho*.

additional ornament of two bronze medallions, each figured with a glowering knight in profile. Each medallion is suspended by a blue ribbon between the looping garlands that hang to either side of the central painting. The plinth below bears the title LE REPAS DE SANCHO DANS L'ÎLE DE BARATARIA. In the lower right corner of the *alentour* is the name AUDRAN and the date 1772, while woven into the lower right of the *galon* is AUDRAN.G✤.1772. (fig. 6.6).

d. *Don Quichotte guéri de sa folie par la sagesse*
(Don Quixote Cured of his Folly by Wisdom)
Don Quichotte guéri comes from Part II, Chapter 74. In the narrative scene don Quichotte and Sancho occupy a bedroom that is fitted with a fabric wall covering and a tiled floor and furnished with a bed and two chairs (fig. 6.7). Don Quichotte sleeps upright in one of the chairs, his helmet, sword, and shield cast aside on the floor. He dreams of Minerva, goddess of wisdom, who approaches in a cloud with her left arm extended to dispel his madness. Sancho, standing next to his master, gazes in a trance at the figure of Folly, who carries in her right hand a model of a castle and in her left a pole with a fool's cap. The blue field of the plinth below declares DONQUIXOTTE GUERI DE SA FOLIE PAR LE SAGES [*sic*]. The tapestry bears the name

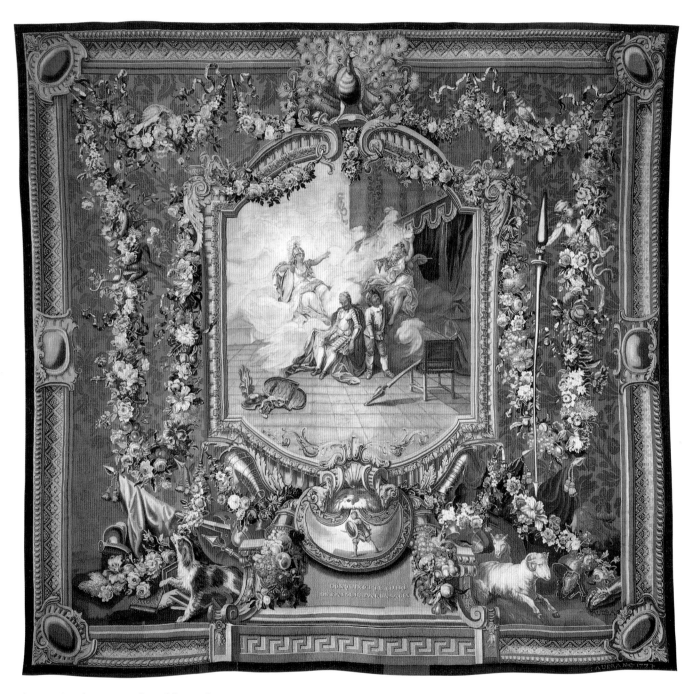

d. *Don Quichotte guéri de sa folie par la sagesse* 82.DD.66

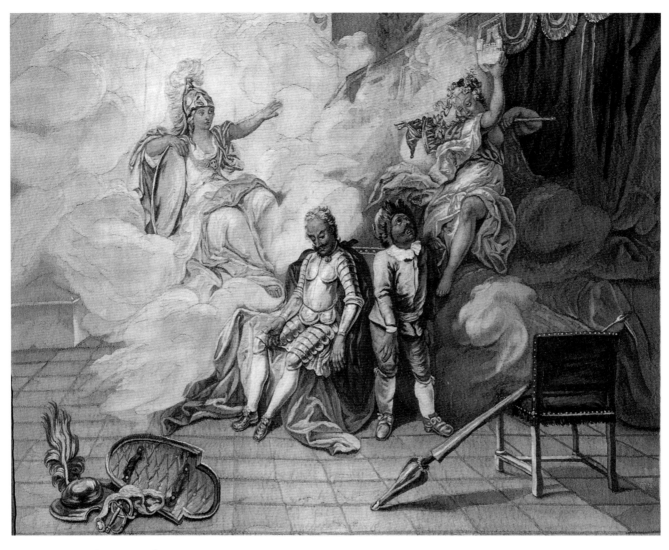

FIGURE 6.7 Detail, *Don Quichotte guéri.*

FIGURE 6.8 Detail of the woven signatures and date, *Don Quichotte guéri.*

AUDRAN (the N incomplete) in the lower right corner of the *alentour*, while the *galon* repeats AUDRAN·G·1773· (fig. 6.8).

CONDITION

The warps of these tapestries are wool, Z spun S ply (5), while the wefts are wool, Z spun S ply (2), and silk, Z spun S ply (2). The colors of all four tapestries have faded very little overall and some colors are still strong, particularly the shades of purple (which usually fade to gray upon exposure to light) in the *alentours*. There has been some color loss to the silk threads in the narrative scene of *Don Quichotte guéri de sa folie*, especially in the clouds. The surface planes of all four tapestries are covered with small ripples. Two hangings, *La Poltronnerie de Sancho* and *Le Repas de Sancho* have replacement *galon* edges along the top border. *L'Entrée de Sancho* has five small areas of loss that have been backed by fabric of compatible hue. All four bear cotton support straps sewn vertically at intervals of fifteen to twenty inches, with an additional strap along the bottom edge. Each tapestry has been lined with a plain-weave cotton fabric.

FIGURE 6.9 Charles-Antoine Coypel (French, 1694–1752). *La Poltronnerie de Sancho à la chasse*. Musée National du Château de Compiègne, inv. 66DN3876. Photo R.M.N.

FIGURE 6.10 Charles-Antoine Coypel (French, 1694–1752). *L'Entrée de Sancho dans l'Ile de Barataria*. Musée National du Château de Compiègne, inv. 80EN5588. Photo R.M.N.

FIGURE 6.11 Charles-Antoine Coypel (French, 1694–1752). *Le Repas de Sancho dans l'Ile de Barataria*. Musée National du Château de Compiègne, inv. 66DN3845. Photo R.M.N.

FIGURE 6.12 Charles-Antoine Coypel (French, 1694–1752). *Don Quichotte guéri de sa folie par la sagesse*. Musée National du Château de Compiègne, inv. 66DN3853. Photo R.M.N.

COMMENTARY

Following the reopening of the Gobelins manufactory in 1699, the artistic director Robert de Cotte (1656–1735, *surinspecteur de la Manufacture des Gobelins* 1699, *premier architecte du Roi* 1708) pursued a course of weaving innovative tapestry designs suited to the demands of the Crown and court. At the same time he kept an eye on the competition from the Beauvais manufactory, which had experienced particular success with its grotesque and chinoiserie themes. Under Robert de Cotte, Claude III Audran painted a number of cartoons for the Gobelins, such as *Les Portières des dieux* and *Les Douze mois grotesques*, in which he experimented with a change in composition. In each of these series the main subject was placed against a decorative surround that carried equal value visually.

Audran would also contribute to the decorative enhancement of *L'Histoire de don Quichotte*.

In 1714 Charles-Antoine Coypel was commissioned to provide models for a new tapestry series based on Cervantes' satirical romance. Ultimately, the *Histoire de don Quichotte* tapestries presented twenty-eight of the knight's escapades. Coypel's scenes were conceived as if they were stage settings, and the tapestries reproduce them as framed paintings displayed against a background of damask wall covering. The surrounding expanse is enriched by a profusion of thematic ornaments, such as suits of armor, thick floral garlands, and other decorative details.

Initially Coypel received payments of 400 *livres* for each painting, an amount that increased to an average of 1,200 *livres* by 1724–1727, although this was still some-

FIGURE 6.13 Gobelins manufactory (French, 1717–1718). *Don Quichotte guéri de sa folie par la sagesse* from the first woven series of *L'Histoire de don Quichotte*. Sold Christie's, London, June 10, 1993, lot XV. Photo courtesy Christie's, London.

what less than his requested sum of 2,000 *livres*.[2] In 1718 he painted *Don Quichotte guéri de sa folie par la sagesse* for 550 *livres*, in 1719 *Le Repas de Sancho dans l'Ile de Barataria* for 900 *livres*, in 1722 *L'Entrée de Sancho dans l'Ile de Barataria* for 1,000 *livres*, and in 1725 *La Poltronnerie de Sancho à la chasse* for 1,200 *livres* (figs. 6.9–6.12). By 1734 he had completed twenty-seven paintings. The last scene, *Don Quichotte chez les filles de l'hôtellerie*, was delivered seventeen years later in 1751 just before his death. Twenty-four of Coypel's subjects were engraved from 1723 to 1734 and illustrated numerous Spanish and French editions of the romance during the eighteenth century. All four of Coypel's subjects for the Museum's *tenture* were published in Pierre de Hondt's 1746 French edition printed in The Hague.[3]

The tapestry series met with such popularity that it continued to be woven until the Revolution. Although Coypel's cartoons remained unchanged, the decorative surround underwent no fewer than six alterations. The original *alentour* was the work of Jean-Baptiste Belin de Fontenay *père* (its design occupied him in the last months before his death in February 1715) and Claude III Audran, and it introduced elements that survived throughout the successive variations (fig. 6.13).[4] Against a yellow lozenge field, the central narrative scene from the story of don Quichotte was framed by carved and gilded wood, acanthus scrolls, and floral swags. A circular medallion, cast with the profile head of a chivalric hero and inscribed with his name, was placed above. At the bottom were trophies of armor, weapons, and battle flags, all heaped on a carved plinth where the title of the scene was given.[5] This compartmentalized arrangement, with its arched frames and overflowing cornucopias, echoed contemporary *boiserie*, such as that carved by François-Antoine Vassé for the *galerie dorée* of the Parisian hôtel designed by Robert de Cotte for the comte de Toulouse.[6]

A second weaving of *L'Histoire de don Quichotte*, at the order of the duc d'Antin (1665–1736, son of Madame de Montespan and *directeur* and later *surintendant des bâtiments, arts et manufactures* 1708–1736), prompted a new design of the *alentour* in 1721. This enlarged surround, executed under the supervision of Coypel, was the work primarily of Claude III Audran, Belin de Fontenay *fils*, and Alexandre François Desportes. Based on the concept of the first *alentour*, it retained such characteristics as the framed picture above the plinth with the subject's title, the textured yellow background (this time of a larger scaled mosaic pattern), and the floral garlands, profile medallions, and armor. Desportes contributed animals, some of them inspired from the story of don Quichotte and others less evidently related: sheep, dogs, monkeys, birds, and the prominent peacock. Coypel himself added two putti who perched atop the picture frame to either side of the peacock. This second, larger *alentour* effectively

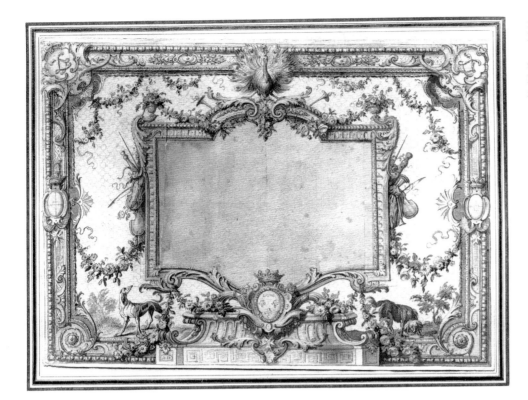

FIGURE 6.14 Pierre-Josse Perrot (French, active 1724–1750). Drawing for the third *alentour*, 1735. Paris, Musée des Art Décoratifs, inv. 18269.

altered the visual balance of the composition. Now the *alentour* exacted visual consideration equal to the narrative picture of don Quichotte.

Successive *alentours* varied the basic components of this second design. All of them used a textured background: the third (1733–1735), fourth (1749), fifth (1751), and sixth (1778) repeated the yellow backing, while an alternative version of the fifth (1760–1763) introduced a pink and crimson pattern. Pierre-Josse Perrot (active 1724–1750) contributed to the third *alentour* (fig. 6.14), basically eliminating many of the details in the lower half of the Audran composition. He reworked the plinth area, substituting an armorial shield for the animal mask, and added an inner border of a darker color called *rose violet* between the textured ground and the outer frame.[7] This concept served as the model for the fourth *alentour*. The fifth *alentour* returned to the Audran design of 1721 using, until 1763, the original yellow mosaic ground. At the suggestion of Jacques Neilson (circa 1718–1788, *entrepreneur* of the low-warp workshop 1749–1788), the same design was woven on low-warp looms with, however, a new pink and crimson damask pattern. A memoir of the Gobelins factory records that the first model of the crimson damask was painted by Maurice Jacques for Neilson's low-warp looms in 1760.[8] Later this ground was also produced on the high-warp looms. The last *alentour*, which was applied in 1788, was designed by Louis Tessier (circa 1719–1781). Retaining only the yellow damask field, he rejected the extensive ornamentation of the earlier designs and chose to reflect the prevailing taste of the Neoclassical style. He simplified the *alentour* and emphasized the painted subjects, placing the Coypel scene squarely on the tapestry.[9]

The Museum's set of tapestries has the pink and crimson damask ground of the fifth *alentour*, but it was woven in the eighth *tenture* begun in 1763. This weaving, produced on the high-warp looms of Michel and Jean Audran, required a new cartoon for the surrounds since the original was still in use on Neilson's looms. The painter Antoine Boizot provided both the *alentour* model and copies of nine of Coypel's scenes, which had suffered severe losses during nearly fifty years of use.[10] The former was complete in 1763, while the copies of the subjects in the Museum's set were prepared between 1766 and 1768. In 1766 Boizot was paid 700 *livres* for *La Poltronnerie de Sancho à la chasse* and the same amount again in 1769 for *L'Entrée de Sancho dans l'Ile de Barataria*. Both copies are stored in the Musée du Château de Compiègne along with all the known surviving Coypel originals.[11] Boizot received another 700 *livres* in 1766 for *Le Repas de Sancho dans l'Ile de Barataria* and 500 in the following year for *Don Quichotte guéri de sa folie par la sagesse*. Both of these versions remain in storage in the Musée du Louvre.[12]

WEAVER AND DATE

All four tapestries of this *tenture* bear the name of the weaver and date of completion. Audran is the family name referring to the two generations, father and son, which operated the first *atelier* of high-warp looms. Michel Audran served as *entrepreneur* from 1732 to 1771, when he was succeeded by his son, Jean, who held that position until 1794. *Le*

Repas de Sancho dans l'Ile de Barataria was begun in April 1770 and finished on May 7, 1772; *La Poltronnerie de Sancho à la chasse* was started in July 1770 and completed in 1772 (it bears this date woven into its *galon*, although Fenaille recorded its completion as a year earlier, February 8, 1771); *L'Entrée de Sancho dans l'Ile de Barataria*, commenced October 1770 and was cut from the loom on December 3, 1772; *Don Quichotte guéri de sa folie par la sagesse* was the last tapestry of this set to be woven, begun in October 1771 and completed on July 28, 1773.

RELATED TAPESTRIES

L'Histoire de don Quichotte enjoyed great popularity during the eighteenth century and was officially woven in nine *tentures* from 1717 to 1794, producing well over one hundred and seventy-five (but probably closer to two hundred) tapestries. The series was on the high-warp looms continuously; the first four *tentures*, and part of the fifth until 1758, composed individual sets of four to fifteen pieces. At least the first six pieces of the fifth *tenture*, woven with a yellow mosaic ground and the royal Bourbon arms, hung in the king's apartments in the Château de Marly during the 1750s.[13] Subsequent weavings produced large-size groups of fourteen to sixty-seven tapestries, which were created as stock and either presented as diplomatic gifts or sold from storage to visiting patrons.

Factory records indicate that the eighth *tenture*, of which the Museum's set was part, was woven between 1763–1787 in the workshops of Michel and Jean Audran and of Pierre-François Cozette (*entrepreneur* of the second high-warp *atelier* 1749–1794) and comprised no fewer than sixty-seven pieces. Only one third of these hangings served royal and administerial households: nine were delivered to the Garde-Meuble de la Couronne as number 264, five went to the comte d'Artois (one of which, *Don Quichotte guéri*, is now on loan from the Mobilier National to the Musée des Tissus, Lyon), and another eight decorated the interiors of the Château de Ménars belonging to the marquis de Marigny (1727–1781, *directeur des Bâtiments du Roi* 1751–1774).[14] The remaining tapestries entered the *magasin* at the Gobelins to be given as gifts: nineteen were presented to French recipients and more than twenty-four went to foreign dignitaries. Only two remained in the storerooms of the factory until the Revolution. The present locations for the majority of the tapestries from the eighth *tenture* are known.[15]

PROVENANCE

Given by Louis XVI on August 20, 1786, to Albert and Marie-Christine (sister of Queen Marie-Antoinette), Duke and Duchess of Saxe-Teschen and Joint Governors of the Austrian Netherlands (who received the tapestries while traveling in France incognito under the name of the comte and comtesse de Bély); by descent to Karl Ludwig Johann Joseph Lorenz, Duke of Teschen, 1822; by descent to Albrecht Friedrich Rudolf, Duke of Teschen, 1847; by descent to Friedrich Maria Albrecht Wilhelm Karl, Duke of Teschen, Schloss Haltburn, Burgenland, Austria, 1895 (removed to London, 1936); Alice Bucher, Lucerne, Switzerland (offered for sale, Sotheby's, London, December 8, 1967, lot 1); Galerie Römer, Zurich, 1981; sold, Sotheby's, Monaco, June 14, 1982, lot 571; J. Paul Getty Museum, 1982.

PUBLICATIONS

Fenaille, vol. 3, pp. 237 ff; Göbel 1928, vol. 1, p. 163; C. Bremer-David, "Set of Four Tapestries" in "Acquisitions Made by the Department of Decorative Arts in 1982," *GettyMusJ* 11 (1983), pp. 60–66, illus.; Wilson 1983, no. 6, pp. 72–73, illus.; Standen 1985, vol. 1, pp. 369–375; Sassoon and Wilson 1986, no. 223, pp. 104–105, illus.; *GettyMusHbk* 1986, p. 172, illus. (82.DD.68 only); J. Bourne and V. Brett, *Lighting in the Domestic Interior: Renaissance to Art Nouveau* (London, 1991), p. 114, illus. (82.DD.67 only); *GettyMusHbk* 1991, p. 191, illus. (82.DD.67 only); Bremer-David et al., 1993, no. 300, pp. 175–176, illus.; Forti Grazzini 1994, vol. 2, nos. 143–149, pp. 392–415.

NOTES

1. Miguel de Cervantes first published his story of Don Quixote in Spain; Part I appeared in 1604 and Part II in 1616. Its success was immediate, with six editions within the first year, and its dissemination widespread. Part I was translated into French by 1614. The translation by Filleau de Saint-Martin in 1677–1678 was the basis for the paintings by Charles-Antoine Coypel that were used in the tapestries. For contemporary French reaction to Filleau de Saint-Martin's version, see J. Seznec, "Don Quixote and His French Illustrators," *Gazette des Beaux-Arts* 34 (1948), pp. 173–192.
2. Fenaille, vol. 3, pp. 164–165. For a record of payments, see Engerand 1901, pp. 112–117.
3. P. de Hondt, *Les Principales aventures de l'admirable don Quichotte represéntées en figures par Coypel, Picart le Romain, et autres habiles maîtres: avec les explications des xxxi planches* (The Hague, 1746), pls. xx, xxiv, xxvi, and xxxi (*Poltronnerie, L'Entrée, Le Repas*, and *Don Quichotte guéri*, respectively). The "Avertissement" of this edition comments that Coypel, ". . . est sans contredit le meilleur et le plus estimable, en ce qu'il n'y a rien négligé, non seulement par rapport aux Regles de son Art, mais même par rapport aux Moeurs, Coutumes, Habillements et autres usages d'Espagne, d'où il a pris un soin tout particulier de s'en faire envoyer des desseins, pris exprès sur les lieux-mêmes et que de l'aveu même des Espagnols il y a parfaitement bien représentez."
4. See Fenaille (note 2), pp. 157–158 and 172.
5. Fifteen tapestries and four *entrefenêtre* panels of this first weaving for the duc d'Antin sold at Christie's, London, June 10, 1993. Previously they had been in the Antenor Patiño and marquis de Venevelles collections.
6. A. Gruber, "The Don Quixote Tapestries," *Christie's International Magazine* (May/June 1993), pp. 8–10. Another Gobelins series that was made under the directorship of Robert de Cotte and demonstrates the strong architectural influence of the period is *Daphnis et Chloé*, woven 1718–1720 and later. It reproduced the previously engraved scenes

of the story, but also copied the actual arrangement of original paintings as installed in the boiseries of the Regent's Château de Bagnolet. See Fenaille (note 2), pp. 283–292.

For de Cotte's relationship with the Gobelins manufactory from as early as 1699, see R. Neuman, *Robert de Cotte and the Perfection of Architecture in Eighteenth Century France* (Chicago, 1994), p. 16. For a description of Vassé's contribution to the Hôtel Toulouse, see W. von Kalnein, *Architecture in France in the Eighteenth Century* (New Haven, 1995), pp. 64–66.

7. The Perrot drawing is conserved in the Musée des Arts Décoratifs, Paris, inv. 18269. The three tapestries and two *trumeaux* of the third *tenture* woven with the *alentour* of the third design are now in the Musée du Louvre, inv. OA 10663–10667. See *Cinq années d'enrichissement du Patrimoine national 1975–1980: donations, dations, acquisitions*, exh. cat. (Galeries Nationales du Grand Palais, Paris, 1981), no. 60, pp. 80–82, in which the attribution of the *alentour* design is given to "Peyrotte."

8. "Memoire des ouvrages de peintures et desseins . . . faits dans le courant de l'année 1760 par Jacques" in Fenaille (note 2), p. 231.

9. One large hanging from the ninth *tenture* that is woven with two narrative scenes, including *Le Repas de Sancho*, is in the Château de Brissac. See G. Toscano, "Il Castello de Brissac," *Antiques* 13 (May 1991), pp. 42–49, illus. p. 46.

Nine hangings with the same *alentour*, slightly simplified by Lovinfosse, were woven for the baron de Breteuil in 1785. They are now in the Musée du Louvre. See *Nouvelles acquisitions du département des Objets d'art, 1985–1989, Musée du Louvre* (Paris, 1990), pp. 133–137, illus.

10. In 1776 a sum of 240 *livres* was spent to repair and reline *La Poltronnerie de Sancho*, in the following year 260 *livres* went toward relining *Le Repas de Sancho* and 18 *livres* for the same work on *Don Quichotte guéri*. See Fenaille (note 2), pp. 237–242.

11. Information from T. Lefrançois, *Charles Coypel Peintre du Roi (1694–1752)* (Paris, 1994), no. P.8, pp. 147–149; no. P.30, pp. 171–172; no. P.32, pp. 173–175; no. P.39, pp. 181–182; no. P.82, pp. 200–202; and no. D.8, pp. 415–416, illus. p. 181. All four of the Coypel canvases relating to the Museum's tapestries were restored in the Ateliers du Louvre during the 1840s and were then transferred to the Château de Compiègne in 1849, where they remain (Musée National du Palais de Compiègne, inv. 66DN3845 [*Le Repas*], 66DN3853 [*Don Quichotte guéri*], 66DN3876 [*La Poltronnerie*], 80EN5588 [*L'Entrée*]). Fig. D.8 of the Lefrançois publication reproduces a preparatory drawing for *L'Entrée*.

12. See Compin and Roquebert, vol. 3, inv. 3582 and 3586, p. 172, illus.

13. A.N. O¹3315, fol. 72. "3 Mai 1751 Livre par Sʳ Cozette, Concierge de la manufacture Royale des Gobelins . . . No. 225 . . . Pour servir dans la Chambre du Roy au Château de Marly une tenture de tapisserie de haute lisse laine et soye dessein de Coypel, manufacture des Gobelins, représentant dans les tableaux, sur fond petit jaune en mozaiques, quelques sujets de l'histoire de Dom quichotte [*sic*]. . . ."

A.N. O¹3315, fol. 195. Two additional pieces were delivered on April 21, 1753, for use in the "cabinet du Roy" at the same residence, and were inventoried under the same number 225 of the *Journal du Garde-Meuble de la Couronne*. One of the two tapestries, *Le Bal de Barcelone*, was exhibited in *Louis XV, un moment de perfection de l'art français* (Hôtel de la Monnaie, Paris, 1974), no. 374, illus.

A.N. O¹3316, fol. 241. Four more were delivered on December 29, 1758, "pour servir dans le Maisons Royalles" and inventoried also under number 225.

Fenaille (note 2), pp. 206–217, records a total of eighteen tapestries eventually inventoried under the number 225. Of

these, four were stored in the *magasin* of the Garde-Meuble in 1792, A.N. O¹3359.

14. During 1768 a total of nine *Don Quichotte* tapestries, inventoried as number 264, were delivered from the Garde-Meuble de la Couronne to the Château de Versailles; six arrived on March 9, 1768, for the new apartment of Madame Louise, and an additional three in October for the apartment of Madame Adélaïde. All nine had returned to the *magasin* of the Garde-Meuble de la Couronne by 1792, A.N. O¹3359. *Le Repas de Sancho* from the apartment of Madame Louise is now displayed in the Antichambre des apartements du Dauphin in the Musée National du Château de Compiègne.

For the hanging formerly in the hôtel of the comte d'Artois, see *Catalogue des tapisseries, Musée des Tissus-Musée des Arts décoratifs, Lyon* (1996), no. 27, pp. 70–71, illus.

15. See Fenaille (note 2), pp. 241–266; C. Bremer-David, "Set of Four Tapestries" in "Acquisitions Made by the Department of Decorative Arts in 1982," *GettyMusJ* 11 (1983), pp. 60–66; Standen 1985, p. 375 n. 26; Forti Grazzini 1994, vol. 2, nos. 143–149, pp. 392–415. To add to Miss Standen's note on the set of six *Don Quichotte* tapestries given to de Machault, *garde des Sceaux*, in 1783, the hanging called *La Dorotée* sold from the collection of the comte de la Panouse, Paris, Nouveau Drouot, March 15, 1983, no. 195. For the set of four given to Cardinal de La Roche-Aymon, and later acquired by King Francis of Assisi of Spain along with a fifth hanging from the seventh *tenture*, now in the Philadelphia Museum of Art, see T. Dell, "J. Pierpont Morgan, Master Collector: Lover of the 18th Century French Decorative Arts," *International Fine Art and Antique Dealers' Show*, exh. cat. (Seventh Regiment Armory, New York, 1995), pp. 25–34.

The set of eight tapestries and one *trumeau* from the eighth *tenture* that was given by Louis XVI in 1770 to the comte de Saint-Floretin, marquis de la Vrillière, was hung in the comte's Parisian hôtel (now the American embassy) only during the fall and winter. When displayed, the tapestries filled the second apartment and the antechamber. They returned each April to the Garde-Meuble to be replaced by taffeta hangings. (Information from the late Bruno Pons.) Eight of the nine pieces are now in Belvoir Castle, Leicestershire.

7

Four tapestries from
Les Tentures de François Boucher:

a. *Jupiter transformé en Diane pour
 surprendre Callisto avec Vertumne et Pomone*
b. *L'Aurore et Céphale*
c. *Vénus aux forges de Vulcain*
d. *Vénus sortant des eaux*

Gobelins manufactory, Paris; 1775–1778

Series conceived by Jacques-Germain Soufflot (1713–1780, *direc-
teur de la Manufacture des Gobelins* from 1755 until his death);
individual models and cartoons for the figurative scenes painted
1763–1769 by François Boucher (1703–1770, *surinspecteur
sur les ouvrages de la Manufacture des Gobelins* 1755, *premier
peintre du Roi* 1765); *alentour* designed circa 1758–1774 by
Maurice Jacques (circa 1712–1784) and Louis Tessier (circa
1719–1781). Woven on the low-warp loom under the direction
of Jacques Neilson (circa 1718–1788), *entrepreneur* of the low-
warp workshop 1749–1788.

WOVEN SIGNATURES
a. *Vertumne et Pomone* bears the woven signature in cursive
fBoucher in the roundel, inscribed on the rock under Vertumnus'
left foot, while the tapestry bears the signature NEILSON.ÉX. in
the lower right corner of the field.
b. bears *fBoucher.* in cursive below the sleeping Cephalus and
NEILSON.ÉX. in the lower right corner of the field.
c. has NEILSON.ÉX. woven in the lower right corner of the field.
d. *fBoucher* appears in cursive above the date *1766* in the lower
right of the roundel and NEILSON.ÉX. in the lower right corner
of the field.

MATERIALS
wool and silk; modern linen lining and support straps

GAUGE
22 to 26 warps per inch / 84 to 108 wefts per inch

DIMENSIONS
a. height 12 ft. 7⅞ in. (385.4 cm); width 20 ft. 7¾ in. (628.6 cm)
b. height 12 ft. 7⅛ in. (383.5 cm); width 10 ft. 2¾ in. (311.5 cm)
c. height 12 ft. 7½ in. (384.8 cm); width 16 ft. 3¾ in. (497.8 cm)
d. height 12 ft. 6⅞ in. (382.9 cm); width 10 ft. 4¾ in. (316.5 cm)

a. 71.DD.466 c. 71.DD.468
b. 71.DD.469 d. 71.DD.467

DESCRIPTION

**a. *Jupiter transformé en Diane pour surprendre Callisto
avec Vertumne et Pomone***
(Jupiter transformed into Diana to take advantage of
Callisto with Vertumnus and Pomona)
This tapestry contains two subjects drawn from the *Meta-
morphoses* by the Roman poet Ovid (43 B.C.–A.D. 17):
Jupiter transformé en Diane pour surprendre Callisto is
from Book II and *Vertumne et Pomone* from Book XIV.

 The background, as with each tapestry in this set,
is woven in imitation of a floral damask wall covering of
pink and crimson. Suspended from the top border by pairs
of blue bows and ribbons are two simulated paintings with
oval frames. The frames are represented as gilded wood,
carved with a laurel wreath border and set with a car-
touche at the top and three auricular brackets at the other
cardinal points. At first glance the figural scene inside the
left roundel appears to portray two female lovers in a
wooded landscape (fig. 7.1). Actually it represents Jupiter,
who has taken on the form of Diana, the goddess of the
hunt, in order to seduce one of her virginal followers. He
is kneeling at the knees of the nymph Callisto. The nearby
quiver of arrows and the hound are particular attributes
of Diana, as are the small crescent moon on the god's
brow and the leopard skin discarded along with the over-
turned quiver. Thus secure in his female disguise, the god
stares amorously into the nymph's eyes and reaches to
remove her garment.[1] Two cupids hover above: one aims
an arrow at Callisto while the other holds aloft a flaming
torch. In the clouds to the left, behind an evergreen tree, an

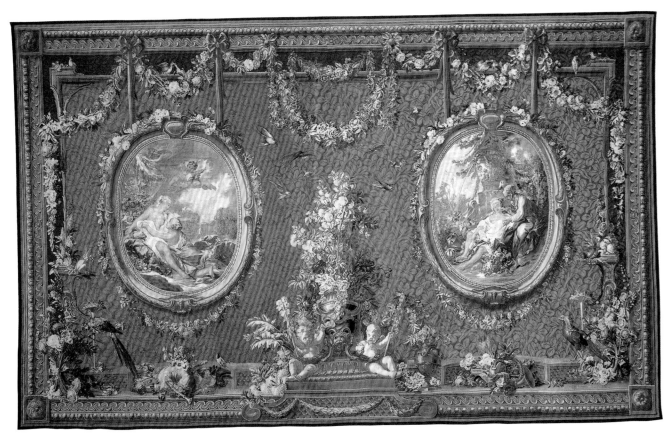

a. *Jupiter transformé en Diane pour surprendre Callisto avec Vertumne et Pomone* 71.DD.466

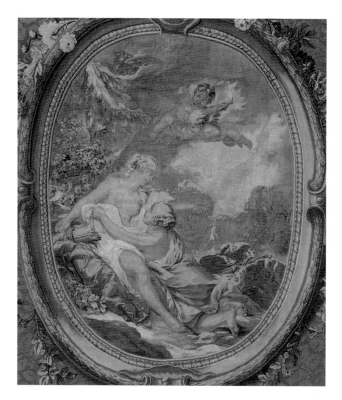

FIGURE 7.1 Detail of the left roundel, *Jupiter transformé en Diane pour surprendre Callisto.*

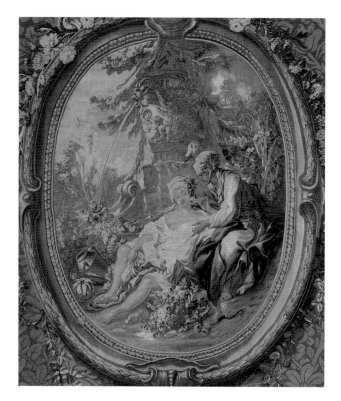

FIGURE 7.2 Detail of the right roundel, *Vertumne et Pomone.*

eagle appears with thunderbolts in its talons, an allusion to the presence of Jupiter.

The painted roundel on the right (fig. 7.2) shows a garden setting in which two figures sit before a stone fountain that is carved as a vase with putti in relief. The young goddess of gardens, Pomona, is identified by her attributes of fruit, a gourd, flowers, and a watering can. She dreamily sniffs at a rose and listens to Vertumnus, the god of orchards, who sits beside her speaking intently and gesturing with his left hand. Covered from head to ankle in heavy robes and drapery, Vertumnus has disguised himself as an old woman in order to gain entrance to Pomona's closed garden. The rock beneath his left foot bears the inscription *fBoucher.*

Surrounding the two simulated paintings is a decorative setting known as the *alentour.* Thick garlands of flowers and leaves are suspended from the top border of this background area. Another garland encircles each roundel. More flowers, tied as bouquets, stand upright in the lower left and right corners. Eight birds fly among the floral arrangements in the center while a macaw parrot grips a branch to the lower left and a pheasant struts on a low base in the right corner. This double-bowed base extends along the lower edge of the *alentour*; at its center is a pedestal supporting an elaborate gilt-bronze urn with a monstrous masque of a horned beast (fig. 7.3). Two winged putti sit to either side of the urn; the one on the left holds a staff tied with flowers, while on the right his companion holds a thyrsus hung with a bacchanalian grapevine and topped with a pinecone. The urn burgeons with a tall arrangement of flowers, including poppies, lilacs, roses, peonies, convolvulus, and hollyhocks. Along the base to the left, located under the scene of Callisto, is a musical trophy comprised of a musette, a tambourine, sheets of music, and a straw hat tied with a ribbon. To the right of the urn stands a bronze water pitcher ornamented with a triton and serpent. Below the painting of *Vertumne et Pomone* is a hunting trophy of a horn, a powder bag, a knife, and an embroidered belt. To the right is the woven signature NEILSON.ÉX. for the *entrepreneur* (fig. 7.4). Partly obscured by flowers, a narrow inner frame extends upward from each lower corner of the base. About midway up is a delicately carved shelf with a small bouquet and a white rabbit on the left and, on the right, a bird and another bouquet. The inner frame continues upward, becoming a simple architectural element that then stretches horizontally along the top edge with more birds nesting and courting along its length. Beyond the edge of this inner frame the floral damask pattern from the central ground continues, but its tonality changes to dark red and crimson, lending greater depth. A wide border frames the tapestry. Woven in imitation of carved and gilded wood, it has an inner Vitruvian-scroll pattern surrounded by an egg-and-dart outer molding. The four corners terminate in squares enclosing circular leafy rosettes.

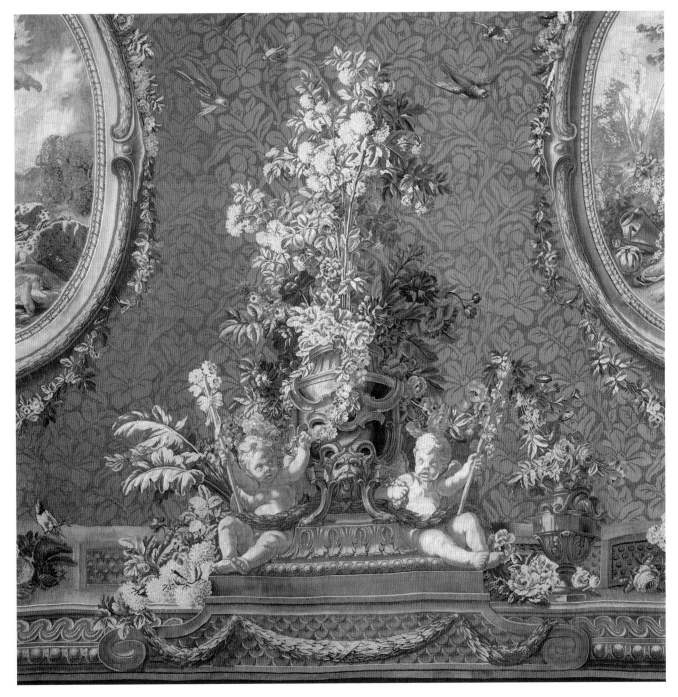

FIGURE 7.3 Detail of *alentour* of *Jupiter transformé en Diane pour surprendre Callisto avec Vertumne et Pomone.*

FIGURE 7.4 Detail of woven signature, *Jupiter transformé en Diane pour surprendre Callisto avec Vertumne et Pomone.*

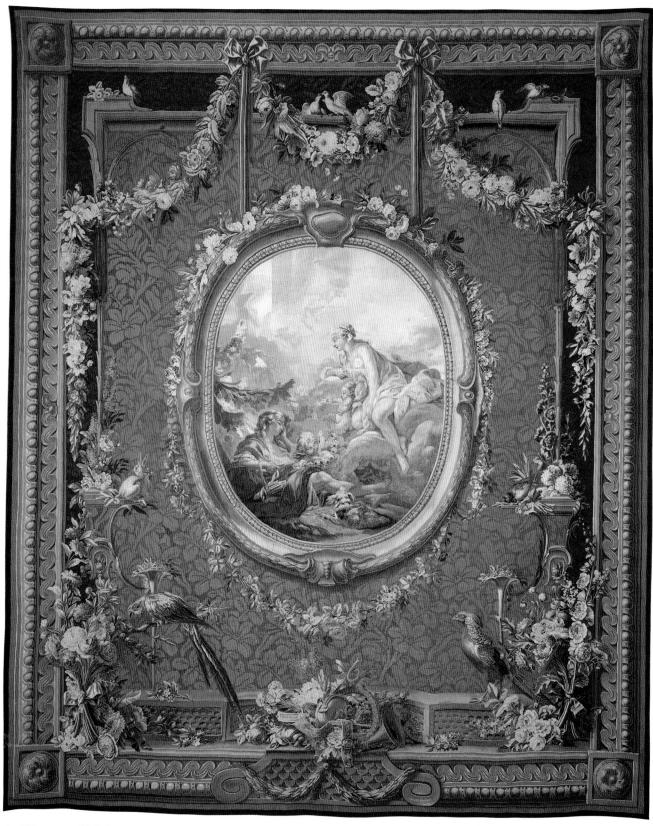

b. *L'Aurore et Céphale* 71.DD.469

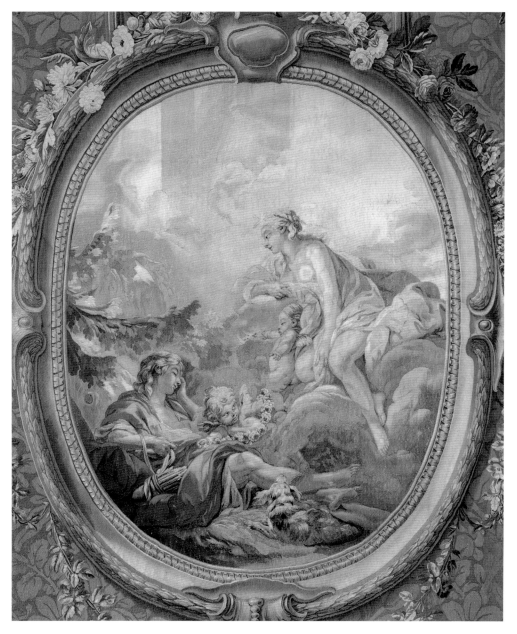

FIGURE 7.5 Detail of *L'Aurore et Céphale*.

b. *L'Aurore et Céphale* (Aurora and Cephalus)

Based on Book VII of Ovid's *Metamorphoses*, the painted roundel in this tapestry portrays Aurora, goddess of the dawn, gazing upon the sleeping form of her lover, the hunter Cephalus (fig. 7.5). She is seated among clouds with the morning star shining from her forehead. Cephalus, a mortal who is bound to the earth, reclines on the forest floor while his dog awakens at the goddess's approach. A putto stretches a garland of roses across the lap of the sleeper while another putto holds a flaming torch and parts the clouds for Aurora. The *alentour* of this narrower tapestry follows an abbreviated form of the design for the set. Only the hunting trophy, repeating that of the previous tapestry, rests below the central figural scene. The roundel bears the woven inscription *fBoucher.* under the reclining Cephalus, while the plinth in the lower right of the *alentour* is woven NEILSON.ÉX. (fig. 7.6).

FIGURE 7.6 Detail of woven signature, *L'Aurore et Céphale*.

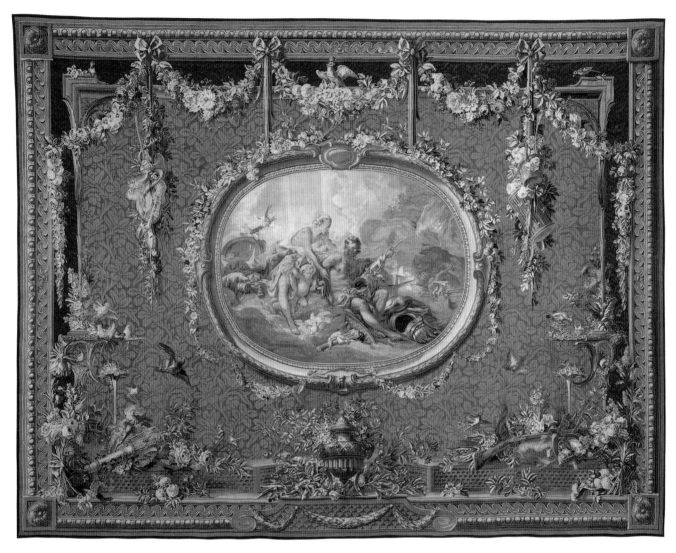

c. *Vénus aux forges de Vulcain* 71.DD.468

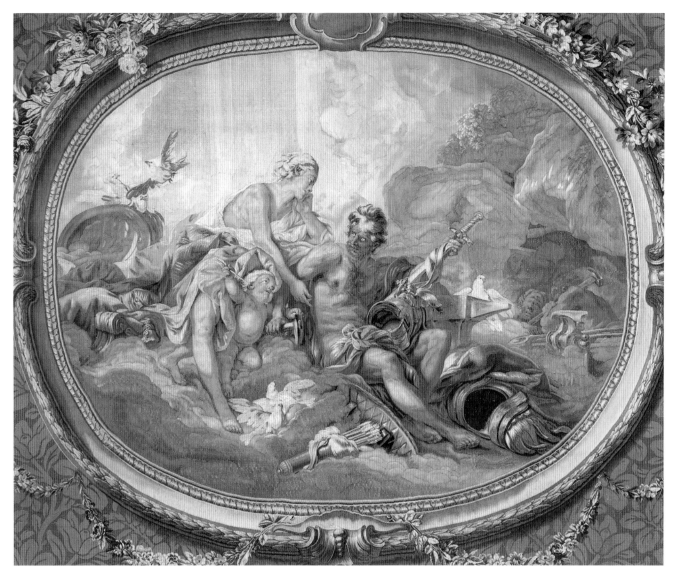

FIGURE 7.7 Detail of *Vénus aux forges de Vulcain*.

c. *Vénus aux forges de Vulcain*
(Venus at the Forge of Vulcan)

This tapestry illustrates a scene from Book VIII of the *Aeneid* by Virgil (70–19 B.C.). The oval painting for this subject has a horizontal orientation and portrays Venus as she approaches her husband, Vulcan, to coax him into forging arms for her mortal son, Aeneas (fig. 7.7). Amid clouds to the left, she has just descended from her chariot accompanied by six white doves and a cupid bearing an arrow in his right hand. Vulcan, sitting with his hammer in his right hand and a sheathed sword in his left, turns toward his wife. In his lap rests a ceremonial helmet adorned with a winged dragon and at his feet are a quiver filled with arrows, a shield, and a cuirass with leather fittings. Beyond Vulcan's anvil, two cyclopes work in his forge; one gazes at the goddess.

The width of this hanging required an expanded *alentour*. The decorative components of floral garlands, metalwork vases, and birds remained unchanged, but two new trophies depending from blue bows and ribbons have been added. To the left of the figural scene is an ornament symbolizing pastoral music, incorporating a horn, a straw hat, a staff, a musette, a book of music, and two tambourines (fig. 7.8). To the right is a trophy, also alluding to pastoral activities, which consists of a straw basket filled with roses, a shepherd's houlette, a drum, and two floral headbands (fig. 7.9). A gilt-bronze perfume burner stands on the plinth below the scene. It is in the Neoclassical style, with a fluted and trellis-work body cast with ram's heads and hoofed feet (fig. 7.10). Its pierced shoulders are topped by a lid decorated with laurel leaves and a bud finial. Honeysuckle, roses, and hollyhocks surround it. Hunting trophies lie along the base: to the left are a quiver of arrows, a target, and a flaming torch; to the right, a squirrel seated on a rifle, a horn, and a bag filled with game birds. On the trellis perches that occur midway up the vertical borders are birds; a variety of them congregate on the left while a single parent feeds its nestlings on the right. The tapestry is woven NEILSON.ÉX. in the lower right corner (fig. 7.11).

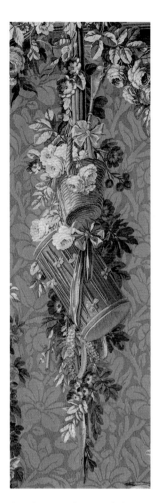

FIGURES 7.8 AND 7.9 Detail of trophy of pastoral music (left) and detail of shepherd's trophy (right), *Vénus aux forges de Vulcain*.

FIGURE 7.10 Detail of *alentour* of *Vénus aux forges de Vulcain*.

FIGURE 7.11 Detail of woven signature, *Vénus aux forges de Vulcain*.

d. *Vénus sortant des eaux*
(Venus Emerging from the Waters)

This tapestry portrays Venus arising from turbulent waters, a popular artistic subject that is based on imagery in a variety of Classical sources, including the *Homeric Hymns* and Hesiod's *Theogony* (mid-eighth century B.C.). She raises drapery from behind her head with her left hand and holds a small dart in her right (fig. 7.12). Three putti attend her: one carries a flaming torch while another, astride a dolphin, holds a quiver of arrows and the last descends from the sky with roses in his hands. The *alentour* is the same dimension and design as that of *L'Aurore et Céphale* but substitutes a musical ornament for the hunting trophy. This ornament repeats the composition from the wide weaving of the first tapestry in this set. The signature *fBoucher* and the date 1766 appear in the oval scene, while NEILSON.ÉX. is woven in the lower right (fig. 7.13).

CONDITION

The warps of all four tapestries from this set are wool, Z spun S ply (3 or 6). The wefts are wool and silk, both Z spun S ply (2 or 3). The condition of the hangings is fair, with some small degree of fading observable in the yellow and violet colors when comparing the front of the weavings to the back. There is stronger loss to the yellow and orange colors of the central medallions than to these same colors in the surrounding fields. The double tapestry (71.DD.466) has greater color loss than the other three. The two vertical ovals in the widest tapestry (71.DD.466) and the single horizontal oval in the next widest hanging (71.DD.468) were woven separately at the manufactory and inserted into their surrounds by aligning the warp threads and skillfully stitching the edges together. The warp count per square inch of the medallions remains equal to that of the surrounds, while the weft count generally equals or slightly exceeds that of the surrounds. The yarns of these medallions match the warps and wefts mentioned above in terms of fiber content and construction. All four tapestries in the set have suffered damage to their blue *galons* and possibly the inner strips of gold-colored yarns: all four *galons* have been replaced on 71.DD.466, the top *galons* were replaced and the bottom *galon* remnants covered on 71.DD.469, 71.DD.468, and 71.DD.467. All four tapestries are backed with a plain-weave linen dust cover that does not extend entirely to the top of each hanging. Each also has vertical linen support straps, six inches wide and stitched six inches apart.

COMMENTARY

The Gobelins factory first records the conception of *Les Tentures de Boucher* in 1758 when the flower painter Maurice Jacques was paid for two *alentour* designs that would surround the sketches provided by Boucher, "Une

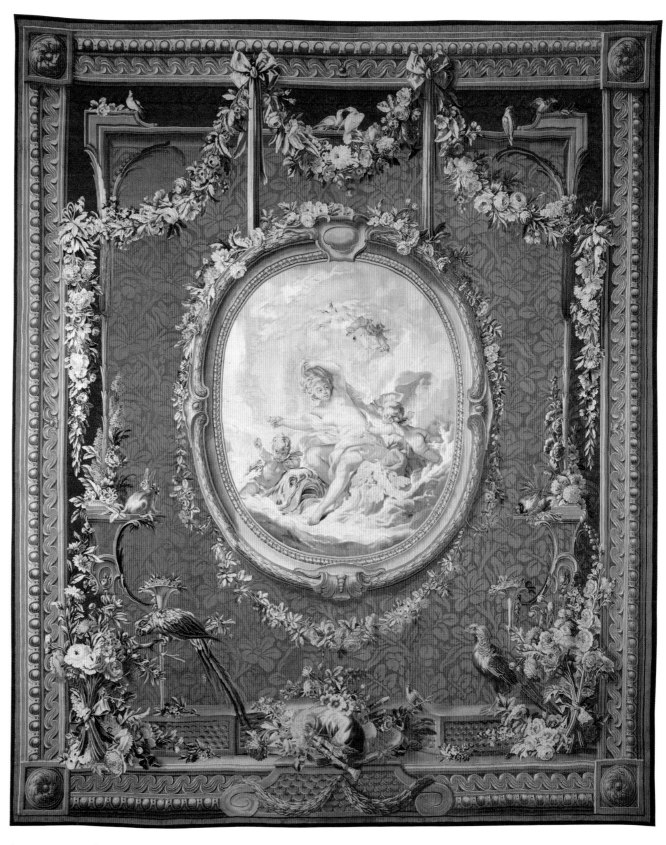

d. *Vénus sortant des eaux* 71.DD.467

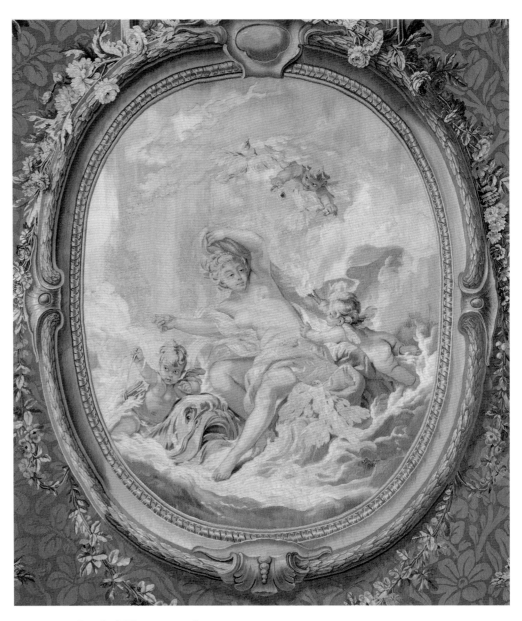

FIGURE 7.12 Detail of *Vénus sortant des eaux*.

FIGURE 7.13 Detail of woven signature, *Vénus sortant des eaux*.

autre esquisse dans le goût de celles susdites, dont les sujets des milieux sont faits par M. Boucher, lesquelles esquisses ont été faites sur l'idée de M. Soufflot."[2] But the series (at that time identified as *La Tenture des Métamorphoses* and later as *Les Elements*) did not progress until after the Treaty of Paris in February 1763 when the first customer, an English lord, requested this design. In that year the widow Flamant provided Boucher with four oval canvases, two ovals of vertical axis and two larger ones of horizontal orientation.[3] Within the year Boucher completed the upright ovals of *Vertumne et Pomone* and *L'Aurore et Céphale* for 2,000 *livres*. The two larger horizontal ovals, *Neptune et Amymone* and *Vénus aux forges de Vulcain*, followed in 1764 for 3,000 *livres*.[4] More subjects were required by the *entrepreneurs* and Boucher supplied two pastoral scenes as horizontal ovals, *La diseuse de bonne aventure* and *La pêche*, for 2,400 *livres* in 1763 and 1764.[5] In 1766 he provided an upright oval of *Vénus sortant des eaux* for 1,000

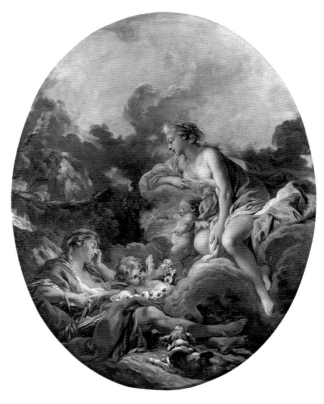

FIGURE 7.14 François Boucher (French, 1703–1770). *Vertumne et Pomone*. Paris, Musée du Louvre, inv. 2710 *bis*. Photo R.M.N.

FIGURE 7.15 François Boucher (French, 1703–1770). *Céphale et Aurore*. Paris, Musée du Louvre, inv. 2710. Photo R.M.N.

livres, perhaps as an alternate to the transverse *Neptune et Amymone*. Finally, in 1769, he produced his last model for the series, *Jupiter transformé en Diane pour surprendre Callisto*, by making a copy of his painting in the collection of the duc de Caylus, which he reduced to the same dimensions as *Vénus sortant des eaux*.[6]

Drawn from Ovid's *Metamorphoses* and other ancient sources, the mythological subjects for this series were well known to Boucher and he painted many variations on them throughout his career.[7] He had previously prepared some of the subjects for the Beauvais manufactory, such as the 1749 composition of *Vertumne et Pomone* that he adapted into a tapestry cartoon for the Beauvais series *Les Fragments d'opéra* in 1757. Both the Gobelins models for *Vertumne et Pomone* (fig. 7.14) and *L'Aurore et Céphale* (fig. 7.15) are now in the Musée du Louvre, Paris, each signed *FBoucher* and dated respectively 1763 and 1764.[8] A drawing for the marble fountain behind Vertumnus and Pomona is extant.[9] Boucher's ideas evolved over time. The mature-looking Aurora in his earliest version of the subject from the 1730s contrasts with the younger goddesses that he depicted in both the tapestry cartoon and in a slightly later canvas of 1769, which were painted when he himself was in his sixties.[10]

Venus, whether arising from the water, at her toilet, or with Vulcan or Mars, was the most frequently painted subject in all of Boucher's work. His earliest dated painting (1732) was a portrayal of the goddess requesting arms from Vulcan for her son Aeneas.[11] He repeated the subject of *Vénus aux forges de Vulcain* for no fewer than three different tapestry series. The first, in 1749, was commissioned by the rival Beauvais manufactory for a series titled *Les Amours des dieux*.[12] The second was provided in 1757 to the manufactory at the Gobelins for a series of the same title.[13] The last model (fig. 7.16) was prepared in 1764 by Boucher for the present series, *Les Tentures de Boucher*; it survives today in the Musée National du Château de Versailles, relined and enlarged into a rectangular canvas.[14] It has sometimes been suggested that the subject portrayed is actually a later moment in the narrative, an episode not described by Virgil, when Venus returned to the forge to collect the arms made by Vulcan.[15] In regard to the Gobelins commissions, however, it can only be noted that both factory records and the *Comptes des Bâtiments du Roi* used simply the title *Vénus aux forges de Vulcain*.

The earliest sketch for *Les Tentures de Boucher* was produced by Maurice Jacques, who proposed a very wide weaving with a damask ground against which three mythological paintings were represented. The central rectangular painting clearly portrayed Venus and her nymphs in water. Although this composition was never executed for the Gobelins, Boucher did provide *Vénus sortant des eaux*, in which the pose of Venus is closely related to another of his representations of the goddess, one that was engraved in 1767 by Louis-Marin Bonnet (1736–1793).[16] The tapestry cartoon was looted from the manufactory storerooms in 1870, along with that of *Jupiter transformé en Diane pour surprendre Callisto* (figs. 7.17 and 7.18).[17] Boucher

FIGURE 7.16 François Boucher (French 1703–1770). *Vénus et Vulcain*. Musée National du Château de Versailles, inv. MV 7094. Photo R.M.N.

FIGURE 7.17 François Boucher (French 1703–1770). *Venus Rising from the Waves*. Raleigh, North Carolina Museum of Art, Gift of Mr. and Mrs. Sosthenes Behn, inv. G.55.8.2.

FIGURE 7.18 François Boucher (French 1703–1770). *Jupiter and Callisto*. Raleigh, North Carolina Museum of Art, Gift of Mr. and Mrs. Sosthenes Behn, inv. G.55.8.1.

painted several versions of Callisto, one in 1759, two others that he exhibited in the 1761 and 1765 salons, and a fourth, mentioned above, which he made in 1769 for the duc de Caylus. Boucher's allusion to Jupiter by means of the eagle in the upper left was borrowed from his earlier representation of the subject in 1759.[18]

After the death of Boucher in 1770, *Les Tentures de Boucher* continued to evolve. Because of the popularity of the hangings, and the variety of their sizes, additional subjects were sought for the central oval scenes. Factory artists copied selections from Boucher's *oeuvre*, fitting them into the existing *alentour* designs. One scene from *L'Histoire de Psyché* was woven at least four times between 1775 and 1791, and four scenes from Tasso's *Sylvie et Aminte* were produced as a single commission in 1783 for the Duke of Portland after the canvases belonging to the duc de Penthièvre. Two roundels of cupids after Boucher, known as *Médaillons d'enfant*, were woven as narrower hangings in 1775–1776 and again in 1776–1778 with one more in 1788.[19]

Maurice Jacques designed at least two versions of the *alentour* from 1762 to 1764. His early model consisted of a heavy frame articulated with stylized acanthus leaves and ornate scrollwork in the corners. The later version introduced a secondary *alentour*, known as the *contrefond*, in which the floral damask background changed to a darker tonality. A modification to Jacques' *alentour* took place circa 1767 when he added a low double-bowed base

to the bottom of the decorative area. A third alteration to the surround occurred circa 1775 and reflected the contributions of Louis Tessier, a flower painter who provided new models in 1770, 1772, and 1774. A Neoclassical frame with Vitruvian scrolls and egg-and-dart molding replaced its rococo predecessor, and blue ribbons usurped the gold cords in suspending the painted roundels. This version is the *alentour* of the Museum's suite of tapestries.

After 1763 Jacques Neilson, *entrepreneur* of the low-warp looms, succeeded in winning commissions for tapestry sets and even for entire rooms of furniture with upholstery related to the series. The latter were particularly popular with the English. Thereafter, Maurice Jacques produced countless variations for smaller weavings of the *alentour* according to dimensions supplied by the foreign patrons. His annual bills record the details that he provided to the manufactory. Jacques' bill of 1762 included fees for a model of a room furnished with the tapestries and furniture—a bed, a chair, and a canapé—upholstered *en suite* with tapestry-woven covers. In 1764 he added designs for a *paravent*. In 1764 he issued a bill for creating "guirlands et festons de fleurs" and in 1765 for "un perroquet ou ara de proportion ou de grandeur naturelle." In 1767 he billed for "un troffée d'instruments pastorelle orné de fleurs et autres objets convenable au sujet" and a "socle, e[s]t peint une mozaïque, et sur le dessus du socle est jetté des fleurs par groupes, le milieu en est élevé d'une cassolette fin d'or et orné de fleurs."[20] All these details are found in the *alentours* of this set, the last item appears on the tapestry of *Vénus aux forges de Vulcain* (fig. 7.10).[21] Models by Jacques that survive in the Mobilier National include one described as "représentant une vase—orné avec des enfants en bronze doré—orné de fleurs et animaux comme perroquets, oiseaux de différents espèces," as is seen in the wide tapestry with two ovals in this set (fig. 7.3).[22]

WEAVER AND DATE

All four tapestries bear the name of the Gobelins weaver Jacques Neilson, *entrepreneur* of the low-warp looms from 1749–1788. Only one tapestry, *Vénus sortant des eaux*, includes a woven date, 1766, but this refers to the year François Boucher painted the model. Factory records indicate these four hangings were produced, against the king's account, between 1775 and 1778. *Vénus sortant des eaux* was begun in April 1775 and was finished on December 30, 1776; *Vénus aux forges de Vulcain* was started in October 1775 and was completed on July 11, 1778; *L'Aurore et Céphale* was begun in May 1776 and was cut from the looms on August 20, 1777; the tapestry with two roundels, *Vertumne et Pomone* and *Jupiter transformé en Diane pour surprendre Callisto*, commenced in November 1776 and was finished two years later. All four were woven with the *alentour* of the third design.[23] As an economy, three of the roundels from this set, *Vertumne et Pomone*, *Jupiter trans-*

formé en Diane pour surprendre Callisto, and *Vénus aux forges de Vulcain*, were woven separately by higher-paid specialist weavers and inserted into *alentours* that were made by other workers paid at a lower rate.

RELATED TAPESTRIES

Fourteen sets of *Les Tentures de Boucher* were produced in the low-warp workshop between circa 1763 and 1791; these totaled more than forty large-size hangings as well as numerous smaller panels and tapestry upholstery. English commissions accounted for six of the sets, five of them accompanied by furniture covers: the Earl of Coventry at Croome Court, William Weddell at Newby Hall, Sir Harry Bridgeman at Weston Park, the Marquis of Zetland at Aske Hall, the Earl of Jersey at Osterly Park, and the Duke of Portland at Welbeck Abbey.[24] Only two sets were kept within the extended French royal family: a set of four panels, bed hangings, and furniture covers that were made circa 1770–1776 as the *meuble d'hiver* for the Chambre Rose of the duchesse de Bourbon at the Palais Bourbon; and a set of five large panels on a yellow damask ground, woven 1783–1788, for Louis XVI.[25] Three sets were presented as diplomatic gifts by Louis XVI: one to Joseph II of Austria, Holy Roman Emperor (1740–1790), in 1777; one to Grand Duke Paul Petrovitch of Russia (1754–1801) and Grand Duchess Maria Feodorovna (1759–1828) in 1782; and one to Prince Henry of Prussia (1726–1802) in 1784.[26] After Neilson's death in 1788, Michel-Henry Cozette *fils* (*entrepreneur* of the low-warp loom 1788–1794) continued weaving the series.

Diplomatic gifts given by Louis XVI to visiting royal guests and dignitaries typically consisted of French products of the highest quality and greatest technical skill. The presents accepted by Grand Duke Paul Petrovitch, which included the Museum's four tapestries, did not fall short of this standard. In total the king approved a gift of combined Gobelins and Savonnerie products valued at 118,032 *livres*. From the Gobelins manufactory, in addition to the four weavings from *Les Tentures de Boucher*, came four tapestry pieces from *Les Loges du Vatican*, four from *L'Histoire de don Quichotte*, four from *Les Nouvelles Indes*, four from *Les Portières des dieux* with a ground of crimson damask, and two woven portraits of Henri IV and de Sully.[27] Moreover, the Grand Duke used the occasion to order a set of yellow ground "Pastorals" (i.e., *Les Tentures de Boucher*) and matching furniture covers for himself, but it is not known if the commission was ever filled.[28] The couple hung the Gobelins tapestries of *Les Tentures de Boucher* in their Palace of Pavlovsk near Saint Petersburg, in interiors designed by their architect Vincenzo Brenna (born circa 1745–died circa 1814). Three of the tapestries were placed in the Grand Duke's *Cabinet des tapisseries*, distinguished by the initial *P* (for Paul) in the carved molding (figs. 7.19 and 7.20). The tapestries were later moved

FIGURE 7.19 Vincenzo Brenna (Italian, circa 1745–1814). Design for the Grand Duke's *Cabinet des tapisseries* in the Palace of Pavlovsk. Saint Petersburg, Forchungsmuseum der Akademie der Künste. Photo courtesy E. Ducamp, Alain de Gourcuff Editeur, Paris.

FIGURE 7.20 Vincenzo Brenna (Italian, circa 1745–1814). Proposed installation for the Grand Duke's *Cabinet des tapisseries* in the Palace of Pavlovsk. Saint Petersburg, Forchungsmuseum der Akademie der Künste. Photo courtesy E. Ducamp, Alain de Gourcuff Editeur, Paris.

(probably after the death of Paul in 1801 or after the fire of 1803), as a photograph taken about 1930 shows the double hanging in Maria Feodorovna's library.[29]

PROVENANCE

Gift approved by Louis XVI on June 9, 1782, for the Grand Duke Paul Petrovitch (later Czar Paul I) and Grand Duchess Maria Feodorovna of Russia, traveling incognito as the comte and comtesse du Nord; hung in the Palace of Pavlovsk, near Saint Petersburg (sold by the Soviet government, 1931); Duveen Brothers, New York; Norton Simon (sold Parke-Bernet, New York, May 8, 1971, lot 233); J. Paul Getty Museum, 1971.

EXHIBITIONS

Great Periods of Tapestry, the Allentown Art Museum, Pennsylvania, February 3–28, 1961, illus., pl. XXIV, lent by Duveen Brothers (71.DD.466 only).

PUBLICATIONS

Grand Duchess Maria Feodorovna, "Descriptions of the Grand Palace of Pavlovsk, 1795," in *Les Trésors d'art en Russie* (Saint Petersburg, 1907), vol. 3 (1903), illus.; Fenaille, vol. 4, pp. 285–287, illus.; Hunter, 1925, p. 190; P. Ackerman, *Tapestry: The Mirror of Civilization* (New York, 1933), p. 277, illus. pl. 45; E. Standen, "The Tapestry Room from Croome Court," *Decorative Art from the Samuel H. Kress Collection at the Metropolitan Museum of Art* (London, 1964), p. 52; M. Jarry, "A Wealth of Boucher Tapestries in American Museums," *Antiques* (August 1972), pp. 222–231; Wilson 1983, no. 38, pp. 76–77, illus.; Standen 1985, vol. 1, p. 397; E. Standen, "Boucher as a Tapestry Designer," *François Boucher 1703–1770*, exh. cat. (Metropolitan Museum of Art, New York, 1986), pp. 325–333; Sassoon and Wilson, no. 224, pp. 106–107, illus.; Bremer-David et al., no. 301, pp. 177–178, illus.; E. Ducamp, ed., *Pavlovsk: The Palace and the Park* (Paris, 1993), p. 53, illus.; N. M. Verchinina, "Silks, Tapestries and Embroideries," *Pavlovsk: The Collections* (Paris, 1993), p. 120.

NOTES

1. Maurice Fenaille misidentifies the two female figures. Fenaille, vol. 4, p. 239.
2. "Mémoire des Ouvrages de Peintures, dessins faits pour le service du Roy, à la Manufacture Royalle des Gobelins, par l'ordre de M. le Marquis de Marigny, Directeur et Ordonnateur général des Bâtiments du Roy, par le Sr Jacques, Peintre, pendant l'anné 1758," in Fenaille (note 1), pp. 228–229, *alentour* sketch illus. opp. 228. See E. Standen, "Sketch for a Gobelins Tapestry," *François Boucher 1703–1770*, exh. cat. (Metropolitan Museum of Art, New York, 1986), no. 92, pp. 342–343.
3. Fenaille (note 1), p. 229.
4. Information from "Mémoire de deux tableaux faits pour le service du Roi, sous les ordres de M. le Marquis de Marigny, par le sieur Boucher pendant l'année 1765" and "Exercise 1765: aux Hérs du feu Sr Boucher, Premier Peintre du Roi, le payement de quatre mémoires de tableaux faits pour le service de Sa Majesté," as published in Fenaille (note 1), pp. 230–231. See also Engerand 1901, pp. 51–55.
5. These two subjects were actually charged to the account of the Gobelins *entrepreneur* Jacques Neilson. He recovered his investment, however, in 1769 when the marquis de Marigny authorized that the two paintings be exchanged for a tapestry of *Vénus sortant des eaux* paid for by the Crown to the sum of 3,369 *livres*. See Fenaille (note 1), pp. 236–237.
6. The duc de Caylus's painting is now in the Wallace Collection, London, inv. P.446.
7. Boucher contributed five illustrations, which were engraved by Augustin de Saint-Aubin (1736–1807) for an edition of *Les Métamorphoses d'Ovide en Latin et en Français*, published in Paris 1767–1771. See J.-R. Pierrette, *Musée du Louvre, Inventaire général des gravures, Ecole Française: L'Oeuvre gravé de François Boucher dans la Collection*

Edmond de Rothschild (Paris, 1978), nos. 1556–1567, pp. 375–376.

8. The 1749 painting of *Vertumne et Pomone* is in the Columbus Museum of Art, Ohio, inv. 80.27. The 1757 canvas is now in Fine Arts Museums of San Francisco, California (Mildred Anna Williams Collection, inv. 1967.11); see P. Rosenberg and M. C. Stewart, *French Painting 1500–1825, The Fine Arts Museums of San Francisco* (San Francisco, 1987), pp. 120–125, illus. p. 122. The Gobelins models in the Musée du Louvre, Paris, are inv. 2710 *bis* and 2710 respectively. See Compin and Roquebert 1986, vol. 3, p. 79, illus.

9. A. Ananoff, *L'Oeuvre dessiné de François Boucher (1703–1770)* (Paris, 1966), vol. 1, no. 974, fig. 158.

10. The earlier *Aurore et Céphale* is in the Musée des Beaux-Arts, Nancy, inv. 143; the 1769 painting made for Jean François Bergeret de Frouville is in the JPGM, 71.PA.55. There survived at the Gobelins manufactory yet another model of *L'Aurore et Céphale* after Boucher, closer to his early example in Nancy. See *Les Modèles et les tapisseries de la Manufacture Nationale des Gobelins* (Paris, n.d.), vol. 4, illus. pl. 410.

11. The 1732 painting is in the Musée du Louvre, Paris, inv. 2709; it is the pair to the *Aurore et Céphale* in the Musée des Beaux-Arts, Nancy. See *François Boucher 1703–1770* (note 2), no. 17, pp. 133–136.

12. See Standen 1985, vol. 2, no. 79a, pp. 536–539. Standen mentions the existence of a painting in a private collection in New York that relates to the Beauvais weaving and depicts Vulcan with a hammer in one hand and Venus behind his shoulder.

13. Boucher's painting for the Gobelins series of *Les Amours des dieux* is also in the Musée du Louvre, Paris, inv. 2707 *bis*. See *François Boucher 1703–1770* (note 2), nos. 65–67, pp. 272–276.

14. The Palais de Versailles preserves in the Salon des Nobles de la Reine two models from *Les Tentures de Boucher*: *Venus et Vulcain*, inv. MV 7094, and *Neptune et Amymone*, inv. MV 7093. For the history of the alterations to the canvases, see Engerand (note 4), pp. 51–55.

15. See A. Laing's entry 65–68 in *François Boucher 1703–1770* (note 2), pp. 272–276.

16. The engraved figure is seated upon a dolphin and pulls drapery from behind her head with her raised left arm; a putto nestles to her right. See *François Boucher, gravures et dessins provenant du Cabinet des Dessins et de la Collection Edmond de Rothschild au Musée du Louvre*, exh. cat. (Musée du Louvre, Paris, 1971), no. 39, p. 60, illus. pl. 8.

17. It has been suggested that both missing Gobelins canvases are now in the North Carolina Museum of Art, Raleigh (*Jupiter*, inv. G.55.8.1, and *Venus*, inv. G.55.8.2). See *François Boucher 1703–1770* (note 2), no. 83, pp. 314–317. The Musée du Louvre has a later cartoon executed for the Gobelins after the Boucher painting of *Vénus sur les eaux*, inv. 2731. See Compin and Roquebert (note 8), p. 83, illus.

18. The painting of 1759 is now in the Nelson-Atkins Museum of Art, Kansas City, inv. 32-29. Another larger model of *Jupiter transformé en Diane pour surprendre Callisto*, with two hounds and no eagle, has been listed as in the Palais de Fontainebleau, inv. 2707, in *Dessins et peintures décoratifs des XVI^e, XVII^e, XVIII^e et XIX^e siècles*, (Paris, n.d.), pl. 64.

19. For references to preparatory sketches and works related to the Boucher subjects in this tapestry series, see A. Ananoff and D. Wildenstein, *François Boucher* (Lausanne and Paris, 1976), vol. 2, pp. 137–142, 156–164, and 268–270.

20. For complete transcriptions of bills relating to *Les Tentures de Boucher* submitted annually by Maurice Jacques, see Fenaille (note 1), pp. 246–250.

21. The cassolette, or perfume burner, is markedly similar to one portrayed by Boucher himself in *The Toilet of Venus*, 1751,

now in the Metropolitan Museum of Art, New York, inv. 20.155.9. Instead of the acanthus leaf ornaments of Boucher's painted version, the tapestry's cassolette has a ram's head at each side and its apertures for the smoke are different. See *François Boucher 1703–1770* (note 2), no. 60, pp. 255–258, illus. p. 256.

22. Model no. XIII, according to Fenaille (note 1), p. 258. Fenaille also illustrates the Jacques models for the pastoral and musical trophies seen in *Vénus aux forges de Vulcain* opposite p. 260, as well as the model for the hunting trophy that is seen below the roundel of *Vertumne et Pomone* and *L'Aurore et Céphale*.

23. See Fenaille (note 1), p. 285.

24. See Standen 1985, vol. 1, no. 57, pp. 383–401, for a full account of all *Les Tentures de Boucher* hangings and their current locations.

25. Both sets, inventoried during the eighteenth century in the Garde-Meuble de la Couronne, remain today within the collections of the Mobilier National. The set with the crimson damask ground intended for the Palais Bourbon is presently lent to the Musée du Louvre, Paris, inv. OA 5118–5121. Formerly it was displayed in the Musée du Garde-Meuble. See E. Williamson, *Musée du Garde-Meuble 103, Quai d'Orsay* (Paris, 1897), no. 151, pp. 21–22. For the yellow ground set of Louis XVI, see Standen (note 24), no. 57, pp. 397–398.

26. The set of two tapestries and two narrower hangings given to Prince Henry were woven simultaneously with the four presented to Grand Duke Paul of Russia. All eight were made with the same *alentour* between 1775 and 1783. One of Prince Henry's hangings, *Neptune et Amymone*, was acquired by the JPGM (73.DD.90) when it sold from the collection of conte Francesco Castelbarco Albani (Sotheby's, Palazzo Capponi, Florence, May 22, 1973, lot 79). See Bremer-David et al., 1993, no. 302, p. 179, illus. It was later resold.

27. Currently visitors may see *L'Histoire de don Quichotte* tapestries and two of the four *Portières des dieux* at the Palace of Pavlovsk and the remaining two *portières* from the set, as well as the *Nouvelles Indes* hangings, at the recently opened Palace of Gatchina nearby.

28. See Fenaille (note 1), pp. 285–286, and Standen (note 24), p. 397 and p. 401 n. 29. For a discussion of the Sèvres porcelain also presented to the Grand Duke and his wife during their sojourn in Paris, see P. Ennès, "The Visit of the Comte and Comtesse du Nord to the Sèvres Manufactory," *Apollo* 325 (March 1989), pp. 150–156.

29. See E. Ducamp, ed., *Pavlovsk: The Palace and the Park* (Paris, 1993), pp. 53 and 82, illus., and N. M. Verchinina, "Silks, Tapestries and Embroideries," *Pavlovsk: The Collections* (Paris, 1993), p. 120. See also *Connaissance des Arts* 503 (February 1994), pp. 37–47, illus. p. 44. A watercolor showing the tapestries at Pavlovsk, dated 1921 and painted by Vasili Nikitich Kuchumov (1888–1959), sold Sotheby's, London, November 28, 1991, lot 518.

BEAUVAIS MANUFACTORY

8

Les Grotesques: *L'Offrande à Bacchus*

Beauvais manufactory; circa 1688–1732

Designed before 1688 by Jean-Baptiste Monnoyer (1636–1699) under the inspiration of Jean I Berain (1640–1711, *dessinateur de la Chambre et du Cabinet du Roi* within the Administration de l'Argenterie, Menus-Plaisirs et Affaires de la Chambre du Roi, 1674); border designed by Monnoyer and Guy-Louis Vernansal (1648–1729). Woven between circa 1688 and 1732.

MATERIALS
Wool (and silk?); modern cotton lining

GAUGE
20 to 22 warps per inch / 72 to 128 wefts per inch

DIMENSIONS
height 9 ft. 8½ in. (295.3 cm)
width 6 ft. 8½ in. (204.5 cm)

86.DD.645

DESCRIPTION
L'Offrande à Bacchus (The Offering to Bacchus) is one of *Les Grotesques*, a series of tapestries that usually consisted of six hangings. The vertical composition of this tapestry presents a decorated pavilion housing a statue of Bacchus. Standing on a terrace of polished stone and draped with red and orange curtains, the pavilion has a marble balustrade and twelve articulated blue and red columns that support a curved marble pediment and a latticed dome. Lattices, heavily entwined with jasmine vines, also front the terrace, while on either side two sets of steps give access to its raised platform. The white marble statue of Bacchus is placed on a colored marble pedestal in the middle of the pavilion. Holding a thyrsus in his uplifted right hand, the god is supported behind by a tree trunk entwined with a grapevine. A snarling leopard crouches at his feet. Outside the balustrade are two elaborately dressed figures attending to the deity: a boyish musician who plays a horn on the left and a young woman who bends to place a vase of flowers on the right. A set of reed pipes hangs above the statue of Bacchus while grapevines flourish in the latticed dome and trail down on either side. A red and blue floral ornament caps the center of the dome and two stylized leafy ornaments stretch upward from each side of the pediment. Two swags of jewels and two garlands of flowers drape from above. The background color is an orange-brown.

The wide border of the tapestry contains figures, birds, pink and green scrolls, baskets of flowers, and bronze perfume burners, all set against a cream-colored ground. Centered in the top and bottom borders is a Chinese warrior, who is shown reclining in a cartouche that is shaped

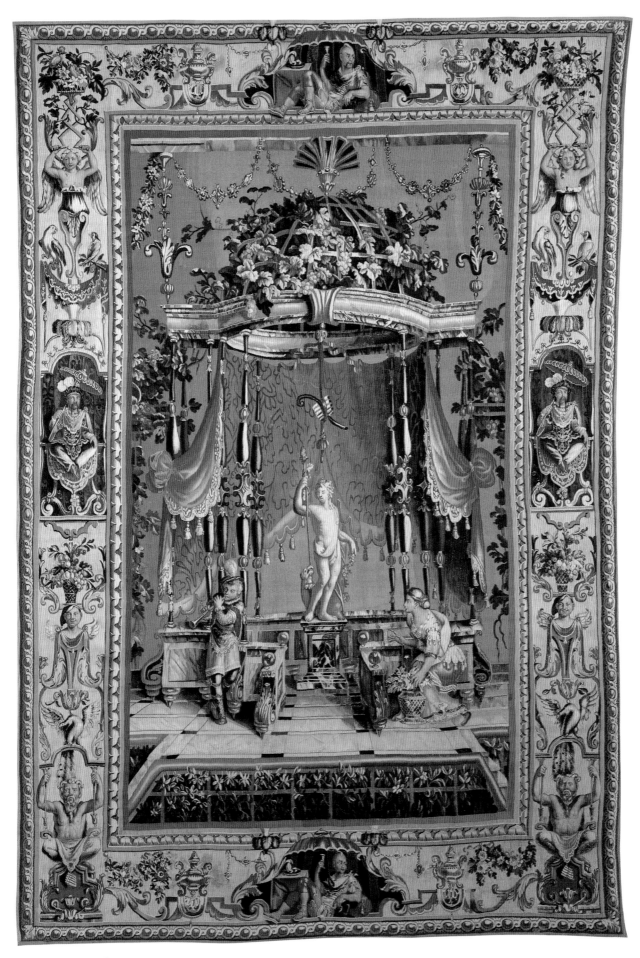

L'Offrande à Bacchus 86.DD.645

FIGURE 8.1 Detail of border.

like a tent with a red top and a back panel of brown and blue striped canvas (fig. 8.1). Although he has a shaven head and a long moustache, he wears Roman-style battle gear. He holds a goblet in his right hand, and at his side is a small table with a pink cloth and a tray with a yellow vessel and two cups. Each side border of the tapestry is also designed with cartouche, hollowed like a niche, that vignettes a seated Oriental prince (fig. 8.2). Richly dressed and wearing a plumed hat, the prince holds a red parasol in his right hand and sits on a throne ornamented with embroidered and jeweled textiles. The vertical cartouche is articulated by carved stonework and is surmounted by an arrangement of large red and blue ostrich feathers, topped with a white aigrette. In each lower corner of the border is a squatting Pan, his reed pipes hanging below. Above Pan is a peacock and then a winged herm wearing a stocking cap and balancing a basket of fruit on his head. Toward each upper corner is a winged female half-figure who extends a pair of flexible tongs to support a floral basket. A running strip of yellow and brown foliates forms an inner border, paralleled on the outside by a band of guilloche.

CONDITION

The warps of this tapestry are wool, Z spun S ply (6), and the wool wefts are Z spun S ply (2 or 3). There seems to be very little use of silk as weft yarns in this hanging. Some areas may have blended weft yarns of both wool and silk (now degraded), but this is difficult to confirm even under

microscopic examination. Despite the dryness of the weft yarns, they are stable and are in fair condition. Comparing the reverse to the obverse, the tapestry has faded over time with the greatest loss to the yellow-orange tones and with slightly less loss to the blues. The green colors have remained fairly strong. There are small occurrences of abrasion to the wefts, particularly in the tightly woven areas that have some planar buckling. Many small repairs, consisting primarily of the reweaving and couching of exposed warp threads, have been made throughout. There are a few unrepaired open slits in the top border. A stain appears on the marble terrace below the feet of the horn player. Remnants of the original blue-black *galon* survive (from three-quarters to one inch wide) under a modern replacement along all four sides. The tapestry has a lining of plain-weave, unbleached cotton sewn to its reverse by stitching in a sequence of vertical lines every thirteen to fourteen inches and horizontal lines every fifteen to eighteen inches.

COMMENTARY

A 1731 document from the Beauvais manufactory named two artists in relationship to the *Grotesques*, "Une autre tenture du dessein de *Grotesques*, avec petites figures chinoises, par Baptiste et Vernensal [*sic*]."[1] However, Roger-Armand Weigert has identified a much earlier source referring to the name of Baptiste as designer of the series. It is a letter that Baron Daniel Cronström wrote from Paris to the Swedish architect Nicodemus Tessin the Younger on

January 7, 1695, which mentions a "grotesque qui se vende en tapisserie . . . est du dessein Baptiste, excellent peintre et dessignateur d'ornemens icy."[2]

Jean-Baptiste Monnoyer, known to his contemporaries as Baptiste, was a flower painter active at Versailles and at both the Gobelins and Beauvais manufactories. He left France in 1690 for England, where he died in 1699.[3] Undoubtedly he was primarily responsible for the cartoon since it is likely that Vernansal contributed only the border design. Stylistically, however, Jean 1 Berain is clearly the source of inspiration. The composition of the *Grotesques* closely relates to Berain's engraved decorative works. At least one of his published designs portrayed Bacchus standing in a similar contrapposto pose, while two of his other designs portrayed the god seated and accompanied by leopards, including the same narrow-headed beast seen in *L'Offrande à Bacchus* (figs. 8.3 and 8.4).[4]

Berain was working for Beauvais, as it is documented that he provided a border for the series that consisted of a pattern of strapwork called "bâtons rompus."[5] There were at least three other border styles for the series and the chinoiserie design of this tapestry must be the one with "petits figures chinoises" mentioned in the 1731 factory document.[6] In 1909 Jules Badin compared this border with another Beauvais series, the *Tenture chinoise* or *L'Histoire de l'empereur de la Chine* (see catalogue entry No. 9), for which Vernansal was a collaborating artist.[7] The Oriental prince who appears in the vertical borders resembles the figures of the Chinese emperor depicted in the *Tenture chinoise*; however, there seems to have been a common engraved source since Berain published a similar Chinese figure sitting cross-legged on a plinth hung with embroidered textiles (fig. 8.5).[8] The border design with Chinese figures was also sometimes used on weavings of *L'Histoire de l'empereur de la Chine*.[9]

The series *Grotesques* usually comprised six pieces: three horizontal panels known as *Musicians and Dancers* (or *Animal Tamers*), *The Camel*, and *The Elephant*, and three vertical compositions depicting *The Offering to Bacchus*, *The Offering to Pan*, and *Musicians*.[10] But sets of fewer than six pieces were also produced, as well as single independent hangings. The advantage of this series' design lay in its adaptable composition and flexible dimensions. It could be easily adjusted—shortened, heightened, or lengthened—according to the patron's specifications. The factory was even willing to cut a completed *Grotesque* hanging into two or three pieces.[11] The wide tapestries frequently contained tripartite pavilions, each portico inhabited by a few figures. A list of "desseins et peintures servant à la Manufacture" records that eight cartoons for the *Grotesques* designs, as well as seven additional copies of them, were at the disposal of the weavers in 1710.[12] Surviving hangings demonstrate that the various components of the compositions for the wider versions were interchanged.

FIGURE 8.2 Detail of border.

Since the Beauvais *Grotesques* did not follow any of the narrative or allegorical themes from history, religion, and mythology, they were more suitable for domestic interiors than the more formal hangings that the Gobelins manufactory was producing for the court. The subjects of the *Grotesques* were intended to hang either together or independently as purely decorative weavings, a characteristic that appealed to a wider range of purchasers. Some of the depicted figures resembled characters from the Italian Commèdia dell'Arte and the compositions conveyed a sense of theater—not surprisingly, since Berain also served as *dessinateur de l'Opéra* from 1680. With the *Grotesques* Beauvais also introduced a new color in the orange-brown shade of the background, later known as "tabac d'Espagne," which proved extremely popular. To complement the wall hangings, *entrefênetres* and furniture upholstery were also woven *en suite* as early as 1696.[13]

In 1696, some eight years after their design, Louis XIV selected *Grotesques* tapestries to be hung in his more informal interiors of the Marly pavilion. Within three years this lighter, more decorative style was being used by the king to ornament the formal gardens of Versailles. In 1699 he ordered the construction of pavilions having the same slender and whimiscal qualities seen in *L'Offrande à Bacchus* to house the Girardon and Regnaudin sculptures of Apollo and the Nereids that were displaced from the Bosquet des Dômes in 1684.[14] A team of thirteen sculptors and architects was paid for the three lead pavilions (fig. 8.6), which were erected in 1704 in the Bosquet des Bains de Apollo (formerly the Bosquet du Marais).[15] This group of buildings was destroyed by 1788, but the form of the central gilt-lead structure survives in a painted and gilded, wood and wax model (fig. 8.7). The oval base and the dome of the pavilion model echo the shapes in the tapestry, as do the pairs of slender, attenuated columns; even the trailing garlands recall the grapevines in the tapestry's trellis dome. It has been suggested that René Carlier (*dessinateur aux Bâtiments du Roi*, died 1722) designed the model, and a total of 889 *livres* 20 *sols* was paid to unidentified craftsmen for its production in 1704.[16]

WEAVER AND DATE

Production of *Les Grotesques* began at the Beauvais manufactory in 1688, under the direction of Philippe Béhagle (1641–1705), who, by the next year, used four of the new hangings that were interwoven with gold as collateral for a loan.[17] Born in Audenarde and trained in the Paris workshop of Hippolyte de Comans (active 1651–1665), Béhagle worked for six years at Tournai before coming to Beauvais.[18] In 1684 he succeeded the founding director of Beauvais, Louis Hinart (1640–1697), and began a productive period of weaving new designs, while attempting to steer the manufactory through its chronic financial difficulties. At this time, the Beauvais manufactory operated high-warp

FIGURE 8.4 Jean I Berain (French, 1640–1711). Engraved plate from *100 Planches principales de l'oeuvre complet de Jean Berain 1649–1711* (Paris, n. d.). Photo courtesy the Getty Research Institute for the History of Art and the Humanities, Resource Collections.

FIGURE 8.5 Jean I Berain (French, 1640–1711). Engraving after Jean Berain by Jeremias Wolff (active Augsburg, 1703–1724). Photo courtesy the Getty Research Institute for the History of Art and the Humanities, Resource Collections.

and low-warp looms, and the *Grotesques* were woven on both. The series was one of Béhagle's most popular and enduring contributions; pieces were still on the looms as late as 1732, more than forty years—and four successive directorships—later.[19] Many hangings from the *Grotesques* bear the woven signature for Béhagle, but since the Museum's example is unmarked it may date from anywhere between 1688 and 1732.

RELATED TAPESTRIES

It is estimated that about one hundred and fifty *Grotesques* were produced.[20] Patronage ranged from the Garde-Meuble de la Couronne to foreign courts in Germany and Sweden. In 1696, "pour le service du Roy," six hangings "sur fond de laine feuille morte dans une bordure d'oves vertes" were delivered to the Château de Marly; and in 1731 another set of five was purchased by Louis xv.[21]

Warehouses in Leipzig and Ratisbon (host city to the Holy Roman Imperial Diet from 1663 to 1806, now modern Regensburg) supplied the German markets. Under the director Noël-Antoine Mérou (*directeur* of the Beauvais manufactory 1722–1734) a set of six pieces measuring about three *aunes* high averaged 6,000 to 6,734 *livres* in value; however, export duty and tariffs diminished the

FIGURE 8.6 Unidentified artist (French, circa 1700). Elevation for the project of the Bosquet des Bains de Apollo, Versailles. Musée National du Château de Versailles, MV 6776, Inv. des 84. Photo R.M.N.

FIGURE 8.7 (?) René Carlier (French, d. 1722). Wax model made 1704 after a design by (?) René Carlier for a lead pavilion erected in the Bosquet des Bains de Apollo, Versailles. Musée National du Château de Versailles, inv. v 1978. Photo R.M.N.

profit made on sets sold abroad to the extent that losses were more often incurred.[22] Copies of the *Grotesques*, including a variant *L'Offrande à Bacchus*, were produced in Berlin by Jean Barraband II around 1720.[23]

Production varied in height from two and one-third French *aunes* (277 cm or 9 ft. 1 in.) to three *aunes* (357 cm or 11 ft. 8½ in.), as did the composition. Some hangings show more of the lower steps and some show more of the decorative motifs above the latticed dome.[24] Among the known versions of *L'Offrande à Bacchus* there are eight woven with the same chinoiserie border. Seven of these are located in the following collections: Musée des Arts Décoratifs, Paris; Mobilier National, Paris[25]; the Metropolitan Museum of Art, New York, inv. 1977.437.5; Schloss Bruchsal, Karlsruhe; Château de Fillet, Normandy; the C. L. Davids Samling, Copenhagen; Námest Castle, Czechoslovakia.[26] The eighth example, woven *en suite* with an *Animal Tamers*, sold at Hôtel Drouot, Paris, December 9, 1994, lot 181. In the latter, a woman mounting the steps with a basket of flowers held above her head was substituted for the figure kneeling at the temple's balustrade.

PROVENANCE

(?) Collection of Baron Alphonse de Rothschild, Vienna; sold, London, 1929[27]; sold as one of four tapestries, Christie's, London, June 22, 1939, lot 159; Mrs. John Dewar; sold Sotheby's, London, December 16, 1966, lot 15; sold Christie's, London, July 1, 1982, lot 3, acquired at that sale by Bernheimer Fine Arts Limited, London; J. Paul Getty Museum, 1986.

PUBLICATIONS

Bremer-David et al., 1983, no. 285, p. 166, illus.; Standen 1985, vol. 2, p. 450; "Acquisitions/1986," *GettyMusJ* 15 (1987), no. 99, pp. 210–211, illus.

NOTES

1. "Etat des tapisseries dont la manufacture de Beauvais est chargée, les sujects qu'elles représentent, etc." as published by Badin 1909, p. 21.

2. R.-A. Weigert, "Les Commencements de la Manufacture Royale de Beauvais 1664–1705," *Gazette des beaux-arts* (December 1964), p. 346 n. 17. For the full text of of the correspondence, see also R.-A. Weigert and C. Hernmarck, *Les Relations artistiques entre la France et la Suède 1693–1718* (Stockholm 1964), pp. 64–68. Refer also to E. Standen, "Some Tapestries Related to Berain," *Acts of the Tapestry Symposium November 1976* (San Francisco, 1976), pp. 209–219.

3. For information regarding the career of Monnoyer, see Adelson 1994, pp. 307–321.

4. Refer to *100 Planches principales de l'oeuvre complet de Jean Berain 1649–1711*, edition published by L.-H. May (Paris, n.d.), plates unnumbered.

5. Letter from Baron Cronström of May 1695, "je fais mettre à la grotesque, une bordure d'un goût grotesque du dessein de Berain, à bastons rompus rouges sur un fond bleu," as published by Weigert (note 2), p. 346, n. 17. For an example of one of the *Grotesques* with such a border, see S. Franses, "La Musique," *European Tapestries 1450–1750, A Catalogue of Recent Acquisitions* (London, 1986), no. 5.

6. The other two borders were described by contemporaries as "feuilles de persils" (parsley leaf) and "oves vertes" (green gadroons). For descriptions of all the borders associated with the *Grotesques*, see Adelson (note 3), pp. 307–321.

7. Badin 1909, p. 19.

8. Refer to *100 Planches* (note 4) above.

9. See, for example, the three hangings in the Musée du Louvre, Paris (inv. OAR 106, 108, and 109): *Le Prince en voyage*, *L'Embarquement du prince*, and *L'Audience de l'empereur*.

10. The names of the scenes are modern identifications. Seventeenth- and eighteenth-century factory records mention only the general title *Les Grotesques* and never specify individual subjects. Edith Standen states that the name *Grotesques de Berain* was not assigned to the series until after 1850, Standen 1985, vol. 2, p. 442.

11. Correspondence from Baron Daniel Cronström to Nicodemus Tessin the Younger, January 7, 1695: " . . . je voulusse coupper une piece en deux ou trois, ce qui se peut faire dans la Grotesque sans quasy gatter le dessein, ils me feroient fabriquer des bordures en un mois de temps." Quoted from R.-A. Weigert and C. Hernmarck (note 2) p. 64.

12. A.N. F¹² 1457, as published by Coural 1992, p. 28 and p. 29 n. 47.

13. Four *entrefênetres* were sold Christie's, London, June 13, 1991, lot 37, bearing the monogram *SAL* beneath a count's coronet (measuring between 364–372 cm high and 122–131 cm wide). The back and seat panels for three chairs survive in the Metropolitan Museum of Art, New York, inv. 14.40.779–14.40.781. See Standen (note 10), no. 65, pp. 459–460.

14. "Du 25 avril 1699—Le Roy a ordonné de faire incessamment un dessin en forme de dôme porté sur les colonnes de fer ou de bronze doré pour couvir les groupes des figures des Bains d'Apollon," as published in *Les Jardins de Versailles et de Trianon d'André Le Nôtre à Richard Mique*, exh. cat. (Musée National des Châteaux de Versailles et de Trianon, Versailles, 1992), p. 90. For a history of the locations of the Apollo sculptural group in the park of Versailles, see T. Hedin, *The Sculpture of Gaspard and Balthazard Marsy* (Columbia, Missouri, 1983), no. 17, pp. 133–139.

15. Three drawings for the pavilions were published in *Versailles à Stockholm, dessins du Nationalmuseum, peintures, meubles et arts decoratifs des collections Suédoises et Danoises*, exh. cat. (Hôtel de Marle, Paris, 1985), nos. B20–B22, pp. 45–47.

16. The model survives in the Musée de Versailles, inv. V 1978 (height: 38 cm, width: 23 cm), as does a watercolor elevation of the project, inv. MV 6776 (height: 14.5 cm, width: 27.7 cm). *Les Jardins de Versailles et de Trianon* (note 14), nos. 40 and 41, pp. 43 and 90–92. See also *Dessins du Nationalmuseum de Stockholm: Versailles et les maisons royales*, exh. cat. (Musées Nationaux, Paris, 1951), no. 330, illus. p. 37.

17. Göbel 1928, p. 213, and Coural (note 12), p. 21 and p. 28 n. 18.

18. For a biographical summary of Béhagle, see J. Coural, "La Manufacture royale de Beauvais," *Monuments historiques de la France* 6 (1977), pp. 66–84.

19. Badin (note 1), p. 56, mentions an order for a single borderless *Grotesque* in 1732.

20. For the present locations and sale history of most of these hangings, see Standen (note 10), no. 64, pp. 441–458.

21. A.N. O¹ 3307 as published by Coural (note 12), p. 21 and p. 29 n. 29. Badin (note 1), p. 56, records that Louis XV's five-piece commission of 1727 was delivered in 1731.

22. Badin (note 1), pp. 20–23. The succeeding director of Beauvais, Nicolas Besnier, benefitted from the repeal of the export duty as of March 1734, see Coural (note 12), p. 47 n. 14.

23. The Berlin composition of the *L'Offrande à Bacchus* is very similar, however the deity stands with his right arm behind his back and holds a wine cup aloft with his raised left arm. The two attendants of the Beauvais scene have been replaced by three figures: to the left is a man holding a thyrsus and to the right is a woman, perhaps Minerva, followed by a dwarf. See the example (erroneously catalogued as "Beauvais") sold Sotheby Parke Bernet, London, December 16, 1966, lot 14, from the collection of Mrs. John Dewar.

24. The heights were recorded in *aunes de France* by Mérou in "Etat des tapisseries" (note 1), p. 21.

25. Mobilier National, Paris, inv. GOB 866. See *Exotisme et tapisserie au XVIIIᵉ siècle*, exh. cat. (Musée Départemental de la Tapisserie, Aubusson, 1983), no. 5, illus. p. 14.

26. See Standen (note 10), no. 64d, pp. 450–453. It is interesting to note that details from the chinoiserie border design of this series were used as upholstery covers on a pair of Neoclassical armchairs sold at Drouot Richelieu, Paris, May 10, 1989, no. 174. The figure of Pan covered the back, while the reclining Chinese man and another fawn's head formed the seat cushion. They did not, however, appear to have been cut from a tapestry but rather seemed to have been woven as seat covers.

27. This provenance, provided in the lot description of the Sotheby's London sale of December 1966, has not been confirmed.

9

Six tapestries from
L'Histoire de l'empereur de la Chine:

a. *La Collation* d. *L'Empereur en voyage*
b. *La Récolte des ananas* e. *Le Retour de la chasse*
c. *Les Astronomes* f. *Le Thé de l'impératrice*

Beauvais manufactory; circa 1697–1705

After the designs of Guy-Louis Vernansal (1648–1729), Jean-Baptiste Monnoyer (1636–1699), and Jean-Baptiste Belin de Fontenay (1653–1715). Woven under the direction of Philippe Béhagle (1641–1705).

WOVEN SIGNATURES
a. bears the woven inscription VERNANSAL.INT.ET.PU in the lower center of the scene, in the border of the depicted carpet;
b. woven with the name BEHAGLE· in the lower right field;
e. also woven with the name BEHAGLE in the lower right field.

WOVEN HERALDRY
Each corner is woven with the arms of Louis-Alexandre de Bourbon, comte de Toulouse (1678–1737), and his monogram is woven in a cartouche in the center of the border on all four sides.

MATERIALS
Wool and silk, some replacement cotton warps; modern cotton lining, support patches and support straps

GAUGE
18 to 20 warps per inch / 88 to 100 wefts per inch

DIMENSIONS
a. height 13 ft. 10½ in. (423 cm); width 10 ft. 2 in. (310 cm)
b. height 13 ft. 7½ in. (415 cm); width 8 ft. 5½ in. (258 cm)
c. height 13 ft. 11 in. (424 cm); width 10 ft. 5½ in. (319 cm)
d. height 13 ft. 10 in. (421.4 cm); width 8 ft. 4 in. (254 cm)
e. height 13 ft. 10 in. (421.4 cm); width 9 ft. 6 in. (290 cm)
f. height 13 ft. 9 in. (419.1 cm); width 6 ft. 3 in. (195 cm)

a. 83.DD.336 d. 83.DD.339
b. 83.DD.337 e. 83.DD.340
c. 83.DD.338 f. 89.DD.62

DESCRIPTION
a. *La Collation* (The Collation)
Surrounded by attendants and seated at a round table before an outdoor pavilion, the emperor and his empress partake of a light meal. A large carpet of Near Eastern design covers the platform beneath their feet. In a double entendre the edge of the carpet is woven with the inscription of the designer of the tapestry, VERNANSAL.INT.ET.PU (fig. 9.1). The table is dressed with a long undercloth trimmed with braid and fringe and a top cloth of damask. Its centerpiece is a round plate filled with fruit, and on the left is a smaller plate holding a branch of plums. Wearing an embroidered robe, a fur turban with peacock feathers, and a pearl-drop earring in his right ear, the emperor sits in an elaborate chair that is crested by a carved dragon with spread wings. He looks across the table to his wife and raises a goblet toward her. The empress, sitting cross-legged upon an upholstered tabouret, wears a flowing robe embroidered with a pattern of phoenixes and clouds. On her head is a diadem of pearls and jewels with a trailing veil. In her lowered left hand she holds a folded fan, while with her right she gestures toward her husband. Four servants and two entertainers attend the imperial couple. To the far left a male servant reaches to take a platter from a buffet of plate and porcelain arranged in the European fashion. Seated on a stool to the left, a female musician plays a stringed instrument resembling a sitar. A dwarf dances to her music in the center, and a monkey sits beside her. To the right a maid drops incense from a wooden box into a brazier. In the

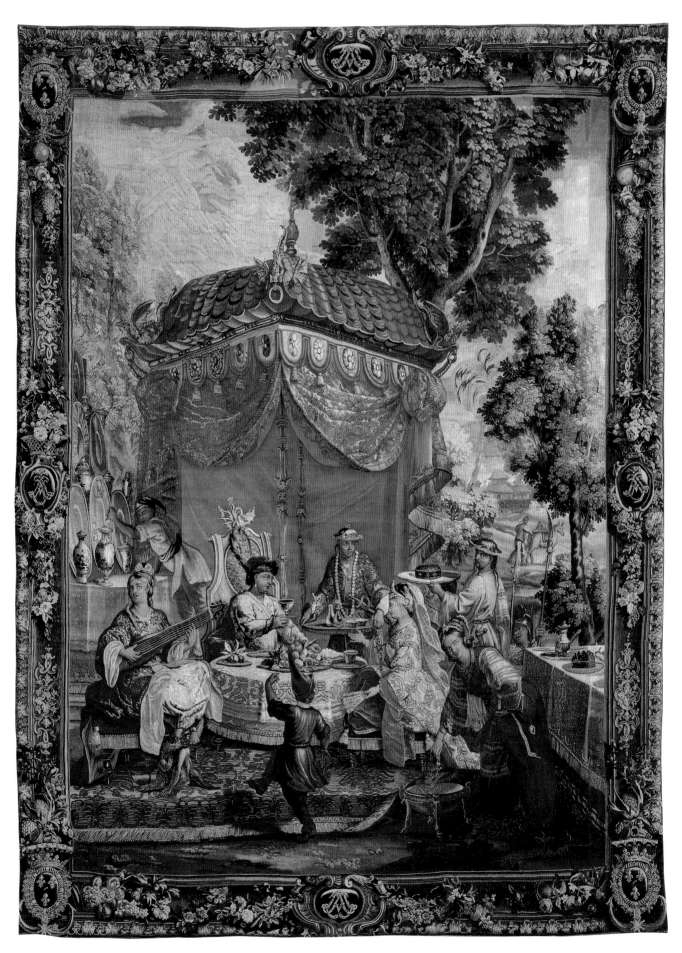

a. *La Collation* 83.DD.336

FIGURE 9.1 Detail of woven signature, *La Collation*.

FIGURE 9.2 Detail of cypher in border, *La Collation*.

FIGURE 9.3 Detail of coat of arms, *La Collation*.

back a finely dressed male attendant with a sword offers a tray of refreshments, while to the right a moustached servant carries a tray with a cake or casserole. An armored guard, grasping a pike, can be glimpsed beyond the cakebearing servant. Extending to the right is another table laden with further dishes.

The tiled roof of the square pavilion is heavy and substantial and has a gilded dragon at each of the three visible corners. Around its perimeter hangs a quilted lambrequin embellished with rosettes and tassels. The two front curtains of the tent are pulled aside and knotted above, leaving visible only two of the four slender columnar supports. Filling the background are trees, a man with a laden horse, and buildings in the distance within a crenelated fortress.

The borders of all six tapestries are of the same design and are unique to this set. Each side is centered by a gold cartouche encircling the cipher *LA* (for Louis-Alexandre de Bourbon) on a blue ground (fig. 9.2). Each corner bears a blue baton with gold fleur-de-lys from which suspend an anchor and the Bourbon coat of arms (*azure à trois fleur-de-lys d'or au bâton alésé de gueules posé en barre*). The arms are placed under the crown worn by Les Enfants de France and surrounded by the collars of the orders of Saint-Michel and the Saint-Esprit (fig. 9.3). Along

each horizontal border are garlands of exotic fruits and flowers. Down each vertical border are more exotic fruits, floral garlands, and strapwork bands, as well as a basket of fruit and flowers located above each cartouche. A narrow row of stylized acanthus leaves forms the outer border.

b. *La Récolte des ananas* (The Harvesting of Pineapples)
The foreground of this tapestry shows a field of pineapples and other plants, including a tall banana tree. The woman at the left, possibly the empress, gestures to the viewer to look beyond the fan in her left hand. Two workers, a man to the left and a woman kneeling to the right, gather pineapples in wicker baskets. A third harvester, a man wearing a turban, picks a ripe pineapple from its fanciful stalk. In the center a maid of the empress holds a broad, flat fan and turns her head to the left to gaze upwards. In the middle distance three other harvesters carry baskets into the group of buildings on the far left side. Other structures, including a six-storied pagoda, are visible in the distance. BEHAGLE· is woven in the lower right corner (fig. 9.4).

c. *Les Astronomes* (The Astronomers)
On a stone terrace five figures group around an elaborately mounted globe. Seated with dignity and pointing at the

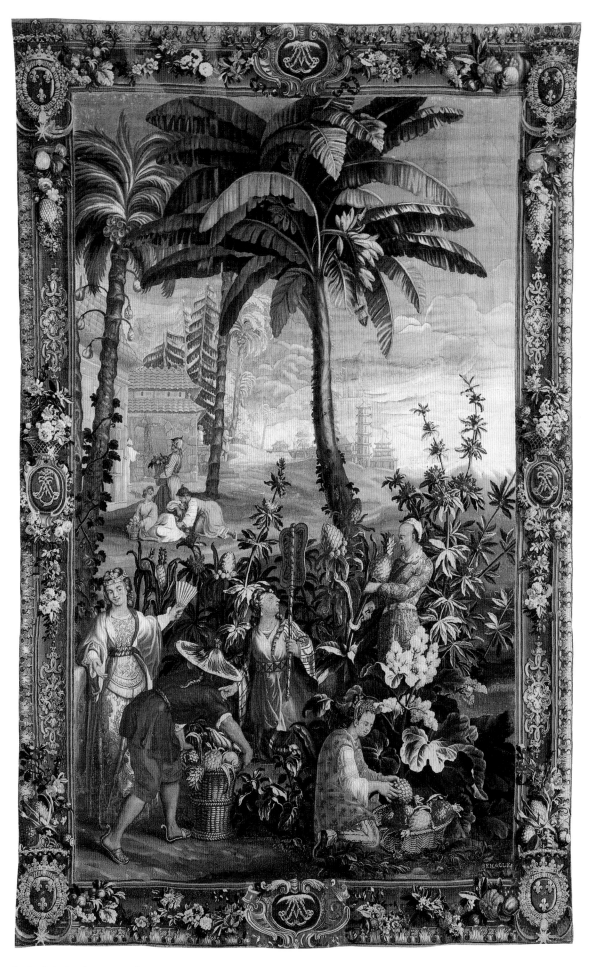

b. *La Récolte des ananas* 83.DD.337

FIGURE 9.4 Detail of woven signature, *La Récolte des ananas*.

FIGURE 9.5 Detail of woven signature, *Le Retour de la chasse*.

sphere with a pair of compasses is a bearded astronomer. The emperor stands over him. Wearing the imperial insignia of the winged dragon, the emperor is speaking and gesturing with his left hand, while his right hand rests possessively on the globe. From behind the emperor's shoulder, a figure wearing a feathered turban looks directly at us, while two other dignitaries engage in a private conversation, one bending and pointing at the globe and the other kneeling with a book under his arm.

The astronomer rests his left hand on a long narrow table (or perhaps it is a parapet) that stretches away to the right and is largely covered by a heavy, fringed drapery. The cloth is pulled back to reveal a support leg carved as a fantastic winged beast with a serpent's tail. Down the table to the right is a large ecliptic armillary sphere on a dragon-shaped base. A robed visitor passes in front of this sphere, his beard long and curled. He carries a bound folio under his right arm. On the step below a young student gazes upward toward the visitor while inscribing circles with a pair of compasses on a paper in his lap.

Behind the table rises an arcade whose arched and ribbed roof is supported by lobed columns. A small spire forms the apex of the roof, from which a pennant streams in the wind. A peacock, wings outstretched, prepares to fly from his perch on the roof. Another astronomer in a robe of vertical stripes stands between two columns and looks through a telescope. Beyond the terrace and nearby shrubbery is a distant landscape with a pagoda and a palace.

d. *L'Empereur en voyage* (The Emperor on a Journey)

A palanquin borne by four moustached and hatted attendants carries the seated emperor. Holding a scepter in his right hand and resting his left against his waist, he wears a hat, a jewelled cape and belt, and a robe embroidered with a winged dragon. The palanquin is lined and backed with textiles and its top curves into an apex fitted with a carved dragon finial. Two guards on horseback follow the procession, one wearing a sword and bearing the imperial banner, and the other carrying a quiver of arrows over his shoulder. There are plants in the foreground and the path

is littered with cut flowers, apparently strewn from baskets like the one that remains at the center by the border. Birds fill the air above and the palace is seen in the distance.

e. *Le Retour de la chasse* (The Return from the Hunt)

A terraced outdoor pavilion is the setting for the return from the hunt. The emperor, still wearing his quiver and carrying his bow, leads his empress by the hand down carpeted steps to show her a catch of game consisting of a deer, waterfowl, and other birds. Beside a smoking incense burner, a kneeling servant raises his hands to the imperial couple. Two women wait near the emperor's throne, the younger one (perhaps a princess) stands before it and the taller one watches from behind. Upholstered with an embroidered seat cushion and back, the elaborate throne is carved with winged dragons at the top of each projecting upper corner and with sphinxes at each arm rest. Peacock feathers fan out from the cresting rail of the throne and jewels line its upper edge. Heavy curtains hang from the pavilion's arches, completely enclosing and shielding the pavilion from the landscape. Two thin columns, decorated with entwined dragons, support the ribbed arches of the roof. Ornamented with carved lacework, the two arches join under an umbrella made of colored ostrich plumes. Various birds dart behind and above the pavilion. A basket of flowers, partially cropped at the base and having the same design as the one that centers the lower edge of *L'Empereur en voyage*, adorns the foreground below the steps. BEHAGLE is woven in the lower right corner (fig. 9.5).

f. *Le Thé de l'impératrice* (The Empress's Tea)

Beneath a small domed pavilion in the open air, the empress sits cross-legged on a large cushion placed on a Near Eastern carpet. She wears a light flowing garment, belted at the waist and set with pearls and gems. Her hair is wrapped under a jeweled veil and secured with a net. She raises her left hand to take a cup of tea that is being poured for her by a standing servant. The servant supports the blue and white porcelain cup on a small salver while pouring tea from a matching ewer. To the right is a square table, partially

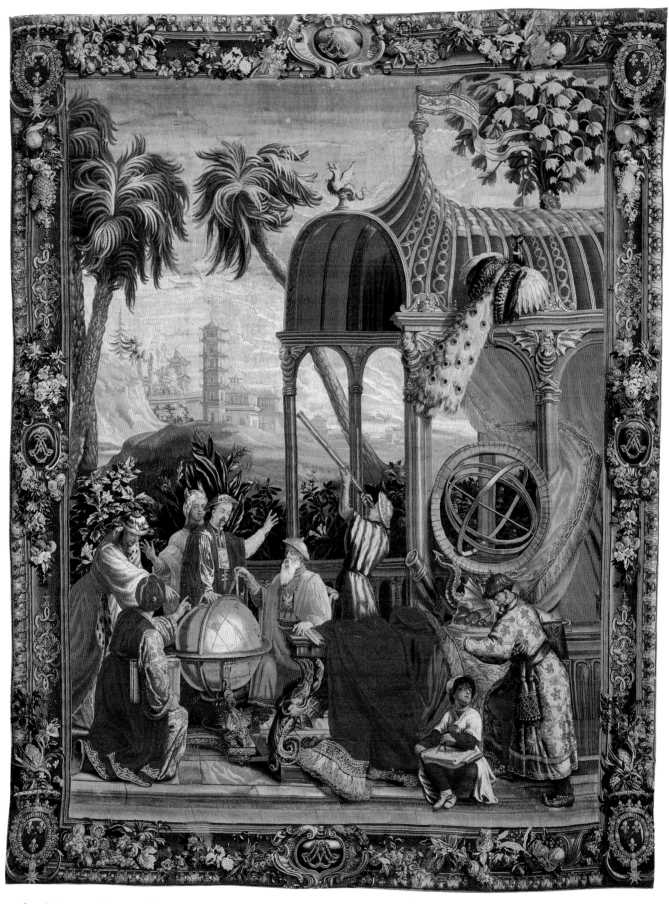

c. *Les Astronomes* 83.DD.338

d. *L'Empereur en voyage* 83.DD.339

e. *Le Retour de la chasse* 83.DD.340

f. *Le Thé de l'impératrice* 89.DD.62

draped and bearing a large metal ewer and a basket with various glass and ceramic vessels. Another servant stands over the empress, holding a parasol to shield her from the sun, while a third maid kneels before her offering a basket of fruit. A damask curtain hangs behind, knotted to two narrow poles that support the pavilion's dome. The bell-shaped dome is thatched with feathers, and a pennant flutters in the breeze at the top. Hanging from the poles of the pavilion are floral swags, and suspended in the middle is a circlet of flowers. As in the previous two tapestries, a basket of flowers centers the lower foreground.

CONDITION

The warps of all six tapestries are wool, Z spun S ply (2), although cotton warps have been used for localized repairs. The wool wefts are Z spun S ply (2), as are the silk wefts. The overall color of this set is good, but areas of silk weft in the skies have degraded. Comparing the back to the front (figs. 9.6 and 9.7), the green wools have faded to blue and the bright yellow silk to beige. The six tapestries have been narrowed in width, as evidenced in the top and bottom borders where triangular sections that were rewoven to disguise the cuts and subsequent losses of decorative elements have discolored.[1] The top and bottom borders have suffered other damage (hanging rings were removed from the top border of *Les Astronomes* in the 1980s) and were repaired numerous times with patches sewn to the reverse and with joins and darns. To support the small areas of loss and structural weakness, the top and bottom borders are now backed by cotton, dyed brown. In general, areas of weft loss have been secured by darning and backed when necessary by a neutral-colored cotton patch. All four borders of *Les Astronomes* were once cut from the main panel and then reattached to the tapestry after it had been narrowed. An old, unskillful repair to the building roof in the background of *La Collation* was removed and rewoven in the early 1990s, as were repairs to the wings of a bird located near the gilded dragon of the palanquin in *L'Empereur en voyage*. The six tapestries are supported by vertically sewn cotton straps and are backed by cotton linings.

COMMENTARY

That the series *L'Empereur de la Chine* originated at Beauvais is well established. The name "Beauvais" was woven into at least two hangings of the series, and an early undated document concerning the Beauvais manufactory's products noted the existence of "Chinoise" designs made by "four illustrious painters."[2] An inventory of 1710 listed seven "modèles" or cartoons for a "Histoire de la Chine."[3] Moreover, a later document of 1731, compiled under the directorship of Noël-Antoine Mérou (*directeur* 1722–1734), named three of the four artists: "Une Tenture du dessin des chinois, par les sieurs Batiste, Fontenay et Ver-

FIGURE 9.6 Detail of *Le Retour de la chasse.*

FIGURE 9.7 Reverse of fig. 9.6.

nensal [sic], en six pièces. . . ."⁴ "Batiste" [Baptiste] was the name used by contemporaries for the flower painter Jean-Baptiste Monnoyer, who was active at both the Gobelins and Beauvais manufactories until 1690, when he left for England; "Fontenay" was the flower painter Jean-Baptiste Belin de Fontenay. But the woven inscription VERNANSAL.INT.ET.PU (which translates roughly as "Vernansal, creator and painter") on this example and on three other examples of *La Collation*, implies that Guy-Louis Vernansal was the chief designer.⁵ The fourth artist is, as yet, unidentified.

The only other name that appears woven on any of the *Empereur de la Chine* weavings is Béhagle, seen on four tapestries from the set: two in this collection, *La Récolte des ananas* and *Le Retour de la chasse*, and two in the Musée National du Château de Compiègne, *L'Audience de l'emperor* and *L'Empereur en voyage*. Philippe Béhagle gained directorship of Beauvais in 1684 and began an active phase of commissioning and weaving new cartoons. It is difficult to date when the cartoons for this series were introduced to the Beauvais looms, but it must have been under Béhagle's directorship and before 1690 when Jean-Baptiste Monnoyer departed for England.

By the time of the early undated document mentioned above four sets of *L'Empereur de la Chine* tapestries had been woven. The overall dimensions of each set, its intermediary vendor, the price, and, in two instances, the buyer were carefully recorded. The first set of *L'Empereur de la Chine* to be woven contained gold thread and was sold by a Monsieur d'Isrode to Louis-Auguste de Bourbon, duc du Maine (1670–1736). The number of hangings comprising this set was not enumerated, however the running length of all the tapestries equalled twenty-one Flemish *aunes* (1,459.5 cm or 47 ft. 8¼ in.) at the price of 20,000 *livres*.⁶ The next two sets were also sold by Monsieur d'Isrode to unnamed buyers at the price of 14,000 and 10,000 *livres* each. The last *tenture* seems to have been commissioned directly by the patron, the comte de Toulouse, for no intermediary is mentioned; the dimensions are omitted but the price was 10,565 *livres*.⁷

A notable event in 1684, perhaps inspiring this tapestry series, was the appearance at the courts of Paris and Versailles of a Jesuit missionary from Mechlin (in modern Belgium), Père Couplet (1623–1693), who had just returned from China with his youthful Chinese convert, Michael Shen Fuzong (1658?–1691).⁸ The presence of these travelers aroused great interest among the royal mathematicians and members of the court, not the least of which was the young Louis-Auguste, duc du Maine, the legitimized son of Louis XIV and Madame de Montespan (and elder brother of Louis-Alexandre, comte de Toulouse). No more than fourteen or fifteen years of age at the time, the duc du Maine met with the Jesuits and presented them with a scientific instrument that had been made for his own

use. As a consequence of Couplet's appeal to Louis XIV, six French mathematicians, including the Jesuit Père Bouvet (1656–1730), departed in 1685 to establish a French mission in China. First Madeleine Jarry and then Edith Standen hypothesized that the appearance of these travelers, and the duc du Maine's encounter with them, may have ultimately inspired the creation of *L'Empereur de la Chine*.⁹ Given that the duc du Maine was to be the first to acquire a set, and that his younger brother, the comte de Toulouse, was also to commission a set, one wonders if the mysterious Monsieur d'Isrode acted in a greater capacity than simply that of middleman. Certainly the tapestries are a reflection of the increased interest in the East, and in this regard it might also be noted that in October of 1686 the Beauvais manufactory was visited by three Siamese ambassadors who were attending the court of Versailles.¹⁰

Memoranda of the Beauvais factory indicate that sets from this series usually comprised six subjects from a choice of nine: *L'Audience de l'empereur, La Collation, La Récolte des ananas, Les Astronomes, L'Empereur en voyage, Le Retour de la chasse, Le Thé de l'impératrice, L'Embarquement de l'empereur*, and *L'Embarquement de l'impératrice*.¹¹

Whoever conceived the series relied, in part, on engraved portrayals of the populace and architecture of China. The dominant figure in the series is based upon European engravings of Shun Chih, Emperor of China (1644–1661), and his successor, Emperor Kang Hsi (born 1654, reigned under the Oboi Regency 1661–1669, ruled independently 1669–1722). Particularly influential were images published by Johan Nieuhof in a work entitled *Legatio batavica ad magnum Tartatiae chamum sungteium, modernum sinae imperatorem* (Amsterdam, 1665). The book derived from the visit of a delegation of the Dutch East India Company to China from 1655 to 1657 and contained more than 140 engravings. It proved to be a wealth of visual information and was widely disseminated, being translated into French in 1665 and into German, Latin, and English within four years. Details of the emperor's court, his throne, the imperial use of peacock feathers, costumes with embroidered insignia of rank, equestrian figures, rural and urban settings, architecture, boats, human activities, plants, and animals were borrowed from this source.¹² Athanasius Kircher's *China Monumentis qua Sacris qua Profanis* (Amsterdam, 1667) provided botanical studies of such plants as sugar cane, tea, ginger, and coconut, as well as images of the harvesting of papaya, tea, rhubarb, and pineapples. It also portrayed the youthful Emperor Kang Hsi.

The theme of astronomy present in the series *L'Empereur de la Chine*, however, did not originate with Dutch travelogues but with the circle of the Jesuit missionaries. Certainly the French court of Louis XIV was aware that the Jesuits had infiltrated the Ching provincial and

imperial courts through the impartation of scientific and astronomical knowledge. During his visit to the French court in 1684 Père Couplet undoubtedly communicated the profitable role played by the Jesuit disciplines of mathematics and engineering in their attempt to convert China. The success of the Jesuit mission greatly depended upon a personal relationship with the emperor that was developed and nutured by a mutual interest in astronomical studies, first between the German Jesuit Johann Adam Schall von Bell (1592–1666) and Shun Chih, and later between Schall von Bell's successor, Ferdinand Verbiest (1623–1688), and Kang Hsi (fig. 9.8). Schall von Bell, who was head of the Imperial Astronomical Bureau and who was also responsible for the annual calendar, individually taught the emperor.[13]

The tapestry *Les Astronomes* clearly portrays European and Chinese figures conferring over astronomical instruments of Chinese origin that were made according to European design. Among the depicted figures, the man with the long white beard may conceivably be a portrait of Father Schall von Bell, who attained the Mandarin rank of the first class because of the knowledge he communicated (fig. 9.9). He was entitled to wear the insignia of the white crane, although the emblem woven in the tapestry appears to show the imperial winged dragon.[14] His features would have been known through an engraved intermediary (Athanasius Kircher's *China Monumentis* of 1667) or a painted likeness, such as the portrait panel that passed through the New York art market in 1991.[15] It is possible that the artists of the tapestry cartoon portrayed Schall von Bell seated before his contemporary, Emperor Shun Chih, while also representing Verbiest as the other bearded European on the right with the imperial heir, the boy Kang Hsi.[16]

The instruments shown in *Les Astronomes*—a globe, an ecliptic armillary sphere, and a telescope—were woven after descriptions of actual devices. Père Couplet was well acquainted with Schall von Bell's successor in Peking, Père Verbiest, and he brought Verbiest's latest publications with him when he returned to Europe in 1684. Verbiest's *Compendium . . . Libri Organici* of 1678 (later included as a chapter in his *Astronomia Europaea* of 1687) described and illustrated instruments that were made by 1668 in China according to his designs, including the ecliptic armillary sphere seen in *Les Astronomes*. A bird's-eye view of the Peking observatory was also engraved, indicating the positions of these instruments, which still survive.[17] It was probably due to the scientific nature of the Jesuit expedition that the duc du Maine presented Père Couplet with one of his own instruments.

The foreground architectural elements of the series are original to the artists working for the Beauvais factory. The spindly arcades, pavilions, and baldachins do not have known prototypes, but they were rapidly adopted by other practitioners of the emerging chinoiserie style. *L'Histoire*

FIGURE 9.8 Unidentified Artist. *Effigies R.P. Adami de Schall, Missionarii Soc. Iesu in China* with Emperor Shun Chih. Formerly in Gaussig, Germany. Present location unknown. Reproduced from Alfons Väth, *Johann Adam, Schall von Bell, S.J., Missionar in China, kaiserlicher Astronom und Ratgeber am Hofe von Peking 1592–1666* (Cologne, 1933) in an edition reprinted by Institut Monumenta Serica, Sankt Augustin and Steyler Verlag (Nettetal, 1991). Photo reprinted by permission of Monumenta Serica.

Le Pere Matthieu Ricci. Le Pere Adam Schaal. Le Pere Ferdinand Verbiest.

FIGURE 9.9 Engraved by Quirijn Fonbonne (active in Paris 1714–1734) after a design by Antoine Humblot (died 1758). Engraved plate from J. B. du Halde, *Description Geographique, Historique, Chronologique de l'Empire de la Chine et de la Tartarie Chinoise* (Paris, 1735). This edition was sanctioned on July 30, 1734 by Germain-Louis Chauvelin, *garde des Sceaux*. Photo courtesy the Getty Research Institute for the History of Art and the Humanities, Resource Collections.

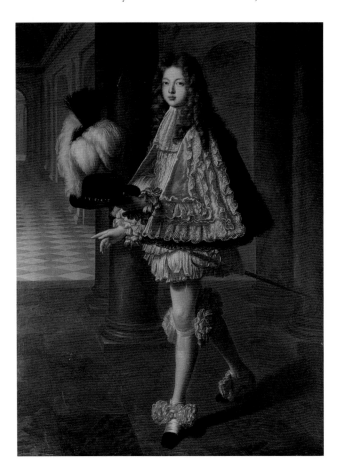

FIGURE 9.10 Attributed to Louis de Boulogne (French, 1654–1733). *Portrait of le comte de Toulouse en habit de novice du Saint-Esprit* Musée Condé, Château de Chantilly 348. Photo Giraudon.

de l'empereur de la Chine is a surprising forecast of the English taste that developed a century later and combined the chinoiserie style with gothic revival. There is also a silvered, enameled, and jeweled surtout representing the court of the Great Mogul, which was made for Augustus the Strong in 1701–1708 by Johann Melchior Dinglinger and seemingly interpreted the Beauvais tapestry series into sculptural vignettes.

By 1732 the cartoons for the *L'Empereur de Chine* series were more than forty years old and had suffered the wear of time and use. An inventory of November 3, 1732 mentions the sale of two small sketches "du dessin des *Chinois*, avec leurs bordures" by the Filleul brothers (Pierre and Etienne, *co-directeurs* of Beauvais 1711–1722) for 100 *livres*.[18] In December of that year, the Conseil de Commerce, upon inspecting the manufactory of Noël-Antoine de Mérou, discovered that the cartoons for this series were worn beyond use.[19]

WEAVER AND DATE

This set of tapestries was woven under the direction of Philippe Béhagle, whose name appears on two hangings in the Museum's collection and on another pair from the same commission conserved in the Château de Compiègne. Although the weavers who executed the set of tapestries under Béhagle are unknown, a date of production can be suggested. This *tenture* was commissioned by Louis-Alexandre de Bourbon, comte de Toulouse (1678–1737), second son of Louis XIV and Madame de Montespan (fig. 9.10). He was later legitimized and appointed admiral of the navy at age five in 1683, colonel in 1684, governor of Brittany in 1695, *maréchal de camp* in 1696, and duc de Penthièvre in 1697, hence the presence of the baton and

FIGURE 9.11 Beauvais manufactory (French, circa 1697–1705). *L'Audience de l'empereur* from the series *L'Histoire de l'empereur de la Chine*. Musée National du Château de Compiègne. Photo Hutin.

the anchor above and below his coat of arms. He earned respect and regard in military service, retiring in 1706 due to ill health.

The weaving of the Toulouse set of *L'Empereur de la Chine* may have begun in 1697 and was certainly underway in 1703. In 1697, the year Louis-Alexandre received the title duc de Penthièvre, Père Bouvet returned from the mission to the Far East that he had begun in 1685. Perhaps Bouvet's published report of the mission, *Portrait historique de l'empéreur de la Chine* (1697), and his gift of drawings (engraved that year) to Louis XIV showing figures in oriental costumes, prompted the comte to commission his own set of tapestries. It is known that the Toulouse hangings were on the looms in 1703, for on the night of February 7th the weavers revolted against years of poor wages and confiscated the tapestries recently woven for him, including one listed as "Le Roy chinois à la chasse dans un trosne."[20]

It was noted earlier that the comte de Toulouse paid 10,565 *livres* for his *tenture* of ten hangings. The set included one of each of the nine subjects and an additional wider weaving of *L'Empereur en voyage*. In 1718 they were inventoried in his residence, the Château de Rambouil-

FIGURE 9.12 Beauvais manufactory (French, circa 1697–1705). *L'Empereur en voyage* from the series *L'Histoire de l'empereur de la Chine*. Musée National du Château de Compiègne. Photo R.M.N.

FIGURE 9.13 Beauvais manufactory (French, circa 1697–1705). *L'Embarquement de l'impératrice* from the series *L'Histoire de l'empereur de la Chine*. Private collection, France. Photo courtesy of Galerie Achkar-Charrière, Paris.

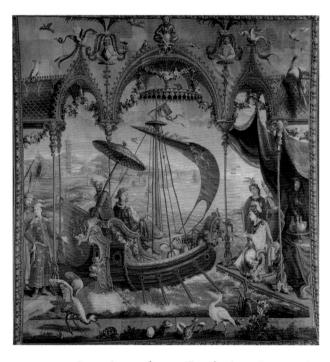

FIGURE 9.14 Beauvais manufactory (French, circa 1690–1705). *L'Embarquement du prince* from the series *L'Histoire de l'empereur de la Chine*. Paris, Boccara Collection. Photo courtesy of Jacqueline Boccara.

let, "l'histoire du roi de la Chine, sur trois aunes et demi de haut, manufacture de Beauvais, faite par Behagle." Six pieces hung in the Antichambre du Roi, three in the Chambre du Roi, and one was kept in storage above the stables.[21]

RELATED TAPESTRIES

Three other tapestries from the comte de Toulouse's original commission of ten are known to have survived. The Palais de Compiègne preserves two hangings, *L'Audience de l'empereur* and the wider version of *L'Empereur en voyage*, both of which had passed to the Empress Eugénie before 1852 (figs. 9.11 and 9.12). At her request the two hangings were sent to Compiègne, probably in 1862, to decorate the Salon de Musique. Both are uncut in width and show the full extent of the horizontal borders that are now lost from the others of the set. *L'Audience* is a wide example, showing the complete arcades to the left and right sides as well as two attendants standing behind the empress's conveyance. It is unusual to repeat the subject of *L'Empereur en voyage* twice within a single commission and why the comte de Toulouse was motivated to do so is unknown. The version in the Palais de Compiègne is extended on the left side by a panel that features three figures, one who strews flowers from a basket and two who kowtow to the imperial ruler, and it shows a temple precinct in the distance. At the base of the temple steps is a white-bearded sage who resembles the seated elder in *Les Astronomes*. This extension was also used to produce wide versions of *Les Astronomes*.[22] *L'Empereur en voyage* at Compiègne has suffered damage to the monograms in the top and bottom borders; that of the top has been replaced altogether by a shell motif. Both of the Compiègne hangings have the same wicker basket of flowers above the monogram in the lower border, a feature also found in three of the Museum's tapestries.

The two remaining tapestries from this *tenture*, *L'Embarquement de l'impératrice* and *L'Embarquement de l'empereur*, were sold by Louis Philippe in 1852 as a separate lot.[23] Their whereabouts remained unknown until 1945 when Madame Alexandrine de Rothschild, resident of France, declared a "suite" of "La Tenture des chinois" as stolen and unrecovered war loot.[24] No dimensions were given, but one of the suite, *L'Embarquement de l'impératrice*, was documented with a photograph. The photograph shows that the Toulouse coats of arms, though not the monograms, had already been cut from the corners of its borders, indicating the piece had been shortened. It is puzzling that the number of hangings for the "suite" was not specified, but it is possible that Alexandrine de Rothschild may have had the companion *L'Embarquement de l'empereur*. Her *L'Embarquement de l'impératrice* later resurfaced and passed unnoticed through a Paris auction in 1967 as "L'Embarquement du prince," only to disappear again until 1990, when the Paris dealer M. Achkar, of

Galerie Achkar-Charrière, recognized the borders with the *LA* cipher and the basket with flowers located at the bottom center (fig. 9.13). The right side of this tapestry's composition includes the scene of Chinese musicians with an acrobat standing one-legged on a pole balanced by a monkey, a vignette that was copied from an engraving in Johan Nieuhof's *Legatio batavica*.[25] The foreground of *L'Embarquement de l'impératrice* from the Toulouse commission is unlike other examples; the crane, turtle, and pelican are usually found on *L'Embarquement de l'empereur*, while other versions of *L'Embarquement de l'impératrice* show two different birds and shells (fig. 9.14).[26] The comte de Toulouse's *L'Embarquement de l'empereur*, if still intact, remains lost.

Many examples of each tapestry from this series survive. Other authors have listed some of these, to which the following may be added[27]:

L'Audience de l'emperor: (1) Formerly in the Roussel collection, sold Galerie Georges Petit, Paris, March 25–28, 1912, no. 266; Concepción Unzué de Casares, Buenos Aires; sold Christie's, London, March 19, 1964, lot 151 to "Pritchard"; Roberto Polo, Paris; Jacob Frères Gallery, 1987; Adriano Ribolzi, Monaco, 1989.[28] (2) Sold Sotheby's, Monaco, June 22, 1991, no. 535. (3) Paul Morand, sold Palais d'Orsay, November 17, 1977, no. 273 bis; sold Sotheby's, New York, November 19, 1993, lot 78. (4) Collection of the Crédit du Nord, Paris.[29]

La Collation: (1) Boccara collection, Paris; Keck collection, Los Angeles, sold Sotheby's, New York, December 5, 1991, lot 22; Galerie Chevalier, Paris.[30] (2) Ilhamy Hussein Pacha collection, sold Ader Tajan, Monaco, March 14, 1993, no. 210, with a border simulating a carved and gilded frame.

Les Astronomes: (1) Gobelins Room, Palazzo Pallavicini, Rome.[31] (2) Private collection, Buenos Aires.[32]

L'Emperor en voyage: (1) Major Geoffrey Rhodes, England; Army and Navy Club, London, 1864; sold Sotheby's, London, November 20, 1964, lot 4; sold Christie's, London, July 1, 1982, lot 1; sold Christie's, London, April 12, 1984, lot 3; sold Sotheby's, Monaco, December 9, 1984, no. 948; Jacqueline Boccara, Paris, 1986; sold Drouot Richelieu, Paris, December 17, 1993, no. 168; sold Hôtel Drouot, Paris, December 10, 1995, no. 137; private collection, England.[33] (2) Comtesse de F..., sold Galerie Charpentier, Paris, December 5, 1959, no. 131; sold Ader Picard Tajan, Monaco, November 11, 1984, no. 155B, reproduced without border; Jacob Frères Gallery, 1985, with an acanthus leaf border. (3) Baroness Lambert, New York, sold Parke-Bernet Galleries, New York, March 7, 1941, lot 61, without borders; Maurice Segoura, Paris, June 1984. (4) Gobelins Room, Palazzo Pallavicini, Rome.

Le Thé de l'impératrice: (1) offered for sale Christie's, London, May 18, 1995, lot 208; sold Christie's, London, December 14, 1995, lot 213; Galerie Chevalier, Paris, 1996.

L'Embarquement de l'impératrice: (1) Comtesse de F..., sold Galerie Charpentier, Paris, December 5, 1959, no. 129; sold Ader Picard Tajan, Monaco, November 11, 1984, no. 155A, reproduced without border; Jacob Frères Gallery, 1985, with an acanthus leaf border; from a collection formed by Roberto Polo and sold at the direction of the Internal Revenue Service, Sotheby's, New York, January 9, 1990, lot 346.

L'Embarquement de l'empereur: (1) Jacqueline Boccara, Paris, 1987.

PROVENANCE

Made for Louis-Alexandre de Bourbon, comte de Toulouse and duc de Penthièvre (1678–1737), as part of a set of ten tapestries in the Chambre du Roi and the Antichambre du Roi of the Château de Rambouillet in 1718; by descent to his son, Louis-Jean-Marie de Bourbon, duc de Penthièvre (1725–1793); by descent to his daughter, Louise-Marie-Adélaïde de Bourbon (1753–1821); by descent to her son, Louis-Philippe d'Orléans, King of the French (1773–1850) (six tapestries from the set sold Domaine de Monceaux, January 25–27, 1852, no. 8); acquired at that sale by the duc d'Uzès and placed in the Château de Bonnelles, Seine-et-Oise; by descent to Thérèse d'Albert-Luynes d'Uzès, Château de Bonnelles, Seine-et-Oise; Georges Haardt and Company, Inc., New York, 1925; French and Company, New York (stock nos. 27965-2 through 27965-6); John Thompson Dorrance, Sr., Newport, Rhode Island; by descent to John Thompson Dorrance, Jr.; [83.DD.336–83.DD.340] Rosenberg and Stiebel, Inc., New York, 1983; J. Paul Getty Museum 1983; [89.DD.62] the Preservation Society of Newport County, Château-sur-Mer, Newport, Rhode Island, 1970s; J. Paul Getty Museum, 1989.

EXHIBITIONS

Musée des Arts Décoratifs, Paris, July 17–October 1, 1925; lent by the Georges Haardt and Company, Inc.; American Art Galleries, New York, February 21–28, 1926, exhibited by Georges Haardt and Company, Inc.; [89.DD.62 only] the Preservation Society of Newport, Château-sur-Mer, Rhode Island, 1970s–1989.

PUBLICATIONS

Montié and de Dion, "Quelques documents sur le Duché-pairie de Rambouillet," *Mémoirs et documents publiés par la Société archéologique de Rambouillet* 7 (1886), pp. 208, 227; Badin 1909, p. 13; Hunter 1925, p. 162; *A Private Exhibition of Beauvais Tapestries*, exh. cat. (Georges Haardt and Company, Inc., New York 1926); Dr. Szokolny, "Vom amerikanischen Kunstmarkt," *Cicerone* 18 (1926), pp. 271–272; M. Jarry, "Chinoiseries à la mode de Beauvais," *Plaisir de France* 429 (May 1975), pp. 54–

59; E. A. Standen, "The Story of the Emperor of China: A Beauvais Tapestry Series," *The Metropolitan Museum of Art Journal* 2 (1976), pp. 103–117; M. Jarry, "La vision de la Chine dans les tapisseries de la manufacture royale de Beauvais: les premières tentures chinoises," *Les Rapports entre la Chine et l'Europe au temps des lumières: actes du IIᵉ colloque international de sinologie 1977* (Paris, 1980), pp. 173–183; C. Bremer-David, "Set of Five Tapestries, Acquisitions Made by the Department of Decorative Arts in 1983," *GettyMusJ* 12 (1984), pp. 173–181, illus.; "Acquisitions/1983," *GettyMusJ* 12 (1984), no. 3, pp. 261–262, illus.; "Some Acquisitions (1983–84) in the Department of Decorative Arts, The J. Paul Getty Museum," *Burlington Magazine* 126 (June 1984), p. 385, illus.; Standen 1985, vol. 2, pp. 461–468; Sassoon and Wilson 1986, no. 213, pp. 99–100, illus.; A. Pryce-Jones, "The Golden Age of Newport," *House and Garden* (June 1987), p. 196 [89.DD.62 only]; J. Boccara, "Voyages du grand siècle: tapisseries de Beauvais, de Bruxelles et des Gobelins," *Les Antiquaires au Grand Palais: xivᵉ biennale internationale* (Paris, 1988), pp. 112–118; Idem., *Ames de laine et de soie* (Saint-Just-en-Chaussée, 1988), p. 306, illus.; C. Clifton, *The Art of Food* (Secaucus, New Jersey, 1989), pp. 140–141 [83.DD.336] and pp. 142–143 [83.DD.337]; "Acquisitions/1989," *GettyMusJ* 18 (1990), no.54, pp. 193–194, illus. [89.DD.62 only]; Coural 1992, p. 24; Bremer-David et al., 1993, no. 286, pp. 167–168, illus.; N. Golvers, *The Astronomia Europaea of Ferdinand Verbiest, S.J. (Dillingen, 1687)*, vol. 27 of *Monumenta Serica Monograph Series* (Nettetal, 1993), p. 9, [83.DD.338 reproduced in reverse p. 453].

NOTES

1. It is known that the alterations occured before 1852 since the sale catalogue of that year lists their current dimensions. See provenance.

2. Two examples of *La Récolte des ananas* are woven with BEAUVAIS in the *galon*. The first hanging, one of a set of five with borders decorated with heads of oriental men, is in the State Hermitage, Saint Petersburg. See N. Birioukova, *Les Tapisseries françaises de la fin du xvᵉ au xxᵉ siècle dans les collections de l'Hermitage* (Leningrad, 1974), no. 59, illus. The other example, with an acanthus leaf border, was one of two hangings with the Berlin dealer, Hermann Ball, in 1928. See *Cicerone* 20 (1928), p. 45.

 L'Audience in the Metropolitan Museum of Art, New York, has an insert woven with BEAUVAIS. See Standen 1985, vol. 2, pp. 461–468.

 The early, undated document bears the title "Estat du produit de quelques marchandises fabriquées dans la manufacture royalle de tapisseryes de Beauvais" and lists an "Autre dessin de *Chinoise* faict par quatre illustre peintre." Published by Badin 1909, pp. 12–13. Badin dates the document to before 1690, but the inclusion of the Toulouse commission contradicts this.

3. Coural 1992, p. 28, and p. 29 n. 47.

4. February 3, 1731, "Etat des tapisseries dont la manufacture de Beauvais est chargée, les sujets qu'elles représentent, les prix, etc." as published by Badin (note 2), pp. 20–21.

5. One, woven with VERNANSAL·INT·ET·PIX, sold Palais Galliera, Paris, May 30, 1973, no. G, illus. without border (313 cm high by 293 cm wide). The other, woven with an acanthus leaf border and VERNANSAL INT ET PL, sold from the Keck collection, Sotheby's, New York, December 5, 1991, lot 22 (353 cm high by 335 cm wide). It was in a New York private collection in 1923, later passing through French and Company, New York, as one of three tapestries from *L'Empereur de la Chine* series in 1949–1954, stock no. 53360 (information from the GRI). The third example, also with an acanthus leaf border, is slightly narrower than the two above, lacking the buffet table to the right, and bears the inscription VERNANSAL INV. ET PIN. It was with a German dealer, Hermann Ball, in 1928; see *Cicerone* (note 2), p. 45.

6. The Beauvais manufactory used the Flemish *aune*, a measure equal to 69.5 cm or 27⅜ in. It was replaced by the metric system in 1825. H. Delesalle, "Aunes de France et aunes de Flandres," *Revue de Métrologie* (March 1964), pp. 95–98.

7. Badin (note 2), pp. 12–13.

8. T. N. Foss, "The European Sojourn of Philippe Couplet and Michael Shen Fuzong, 1683–1692," in J. Heyndrickx, ed., *Philippe Couplet, S.J. (1623–1693), The Man Who Brought China to Europe*, vol. 22 of *Monumenta Serica Monograph Series* (Nettetal, 1990), pp. 121–142.

9. M. Jarry, "Chinoiseries à la mode de Beauvais," *Plaisir de France* 429 (May 1975), pp. 54–59. E. A. Standen, "The Story of the Emperor of China: A Beauvais Tapestry Series," *The Metropolitan Museum of Art Journal* 2 (1976), pp. 103–117, and Standen 1985, vol. 2, pp. 461–468.

10. J. Coural, "La Manufacture de tapisseries de Beauvais," *Monuments historiques de la France* 6 (1977), p. 72.

11. Badin (note 2), p. 15 n. 2, mentions another subject called "La Récolte du thé" (Harvesting Tea), although no tapestry is known to represent this scene.

12. The English title of the 1669 edition was *An Embassy from the East-India Company of the United Provinces, to the Grand Tartar Cham or Emperor of China*. The original pen-and-wash sketches made on site in China are reproduced by L. Blussé and R. Falkenburg, *Johan Nieuhofs Beelden van een Chinareis, 1655–1657* (Middelburg, 1987). For further discussion of its influence on the decorative arts, see L. B. Grigsby, "Johan Nieuhof's *Embassy*: An Inspiration for Relief Decoration on English Stoneware and Earthenware," *The Magazine Antiques* (January 1993), pp. 172–184.

13. An undated painting by an unknown artist in the Gaussig Gemälde, Germany, shows Schall von Bell holding a pair of compasses and a vellum sheet and gesturing to the seated figure of Emperor Shun Chih. Reproduced in A. Väth S.J., *Johann Adam Schall von Bell S.J., Missionar in China, Kaiserlicher Astronom und Ratgebar am Hofe von Peking 1592–1666* (Cologne, 1933), p. 173.

14. For an explanation of the Ming ranks later adopted by the Ching, see R. L. Thorp, *Son of Heaven, Imperial Arts of China* (Kyoto, 1988), pp. 73–87.

15. I am grateful to Gillian Wilson, Curator of Decorative Arts at the JPGM, for pointing out the panel. Sold from the collection of Anthony Derham, Christie's East, New York, November 19, 1991, lot 59.

16. M. Jarry, "La vision de la Chine dans les tapisseries de la Manufacture Royale de Beauvais: les premières tentures chinoises," *Les Rapports entre la Chine et L'Europe au temps des lumières: actes du IIᵉ Colloque international de sinologie 1977* (Paris, 1980), pp. 173–183.

17. See N. Golvers, *The Astronomia Europaea of Ferdinand Verbiest, S.J. (Dillingen, 1687)*, vol. 27 of *Monumenta Serica Monograph Series* (Nettetal, 1993), pp. 17–47, pls. 13–19.

18. "Inventaire des ustanciles, desscins et autres effets servants tant à la fabrique des tapisseries que dans la teinturerie" in Badin (note 2), p. 25.

19. "Visite des Batiments de la Manufacture et Examen de la Comptabilité," in ibid., pp. 77–78.

20. Coural (note 3), p. 24.

21. Montié and de Dion, "Quelques documents sur le Duché-pairie de Rambouillet," *Mémoires et Documents publiés par la Société archéologique de Rambouillet* 7 (1886), pp. 208 and 227.

22. See for example fig. 5 illustrated in Standen, "The Story of the Emperor of China," (note 9), pp. 103–117.

23. Sold by Bonnefons de Lavaille, Commissaire-priseur, Domaine de Monceaux, January 28, 1852, no. 13. The height of each piece is given as 355 cm and the width as 310 cm.

24. *Repertoire des biens spoliés en France durant la guerre 1939–1945*, vol. 2, *Tableaux, tapisseries et sculptures*, p. 355, no. 132, claim no. 32.141, only *L'Embarquement de l'impératrice* illus.

25. This particular source inspired various European artistic interpretations, including one on a large Delft plaque in the Rijksmuseum, Amsterdam.

26. For an example of *L'Embarquement de l'empereur*, see J. Boccara, *Ames de laine et de soie* (Saint-Just-en-Chausée, 1988), illus. p. 312, and for *L'Embarquement de l'impératrice*, see Sotheby's, New York, January 9, 1990, lot 346. The birds in the foreground are not unlike those appearing in the Gobelins series *Les Maisons royales*.

27. See A. S. Cavallo, *Tapestries of Europe and of Colonial Peru in the Museum of Fine Arts, Boston* (1967), no. 55, pp. 170–176; Standen, "The Story of the Emperor of China" (note 9), pp. 103–117; and Standen 1985, vol. 2, pp. 464–467.

28. See *Adriano Ribolzi, Antiquaire* (Monaco, 1993), no. 15, pp. 38–39, illus.

29. *Exotisme et tapisserie au XVIII^e siècle*, exh. cat. (Musée Départemental de la Tapisserie, Aubusson, 1983), no. 10, p. 17, illus.

30. N. de Pazzis-Chevalier, "Gros Plan sur la Tapisserie Française aux XVII^e et XVIII^e siècles," *Métiers d'Art: La Tapisserie* 47–48 (October–December 1992), p. 23, illus.

31. Illus. in "Elvina Pallavicini, the art princess," *Leading* (September 1988), p. 10.

32. With an acanthus leaf border, illus. in "An Argentine Coup, Architectural Elements Shape a Turn-of-the-Century House in Buenos Aires," *Architectural Digest* (February 1992), pp. 166–173.

33. This *L'Empereur en voyage* may have formed part of a set with *L'Audience* sold by Hermann Ball, Paul Graupe, Berlin, March 15, 1933, lot 66, as both have the same border consisting of gold scrolls against a reddish ground with a shell centering each edge.

IO

Carpet

French (Lille or Beauvais?) or Flemish (Brussels); circa 1690–1720

MATERIALS
Wool and silk

GAUGE
20 warps per inch / 80 to 88 wefts per inch

DIMENSIONS
height 12 ft. 3⅛ in. (374.3 cm)
width 8 ft. 2¼ in. (249.5 cm)

86.DC.633

DESCRIPTION
On a field of mustard yellow, two broad garlands of flowers entwine, sending sprays of blossoms, leaves, and vines into the four corners: anemones, carnations, convolvulus, daffodils, daisies, irises, lilacs, lilies, peonies, pomegranate blossoms, poppies, ranunculus, roses, and tulips. In one corner are two narrow red pods (fig. 10.1). The garlands encircle a pattern of interlaced beige, brown, red, and blue rinceaux that are tied with red ribbons at the top and bottom and surround a looped wreath of green oakleaves. At the center is a red foliate motif. Around the outside edge of the carpet is a narrow border of laurel leaves bound by a red ribbon.

CONDITION
The warps of this tapestry carpet are wool, Z spun S ply (3), while both the wool and silk wefts are Z spun S ply (2). A comparison of the reverse to the obverse shows that the carpet has suffered significant fading, with almost all the deep yellow ground lost. This loss of yellow has also affected the green tones, causing them to fade to blue. Red shades have been affected variously—the intense magenta seen on the reverse has turned to crimson on the obverse— although the violets have remained relatively true. There are small areas of surface abrasion with exposed warp threads, generally less than one inch in length. The border has been turned under about one-half to three-quarters of an inch on all four edges and then stitched. The short ends of the carpet are selvage, but the long ends have been cut. The carpet is unlined.

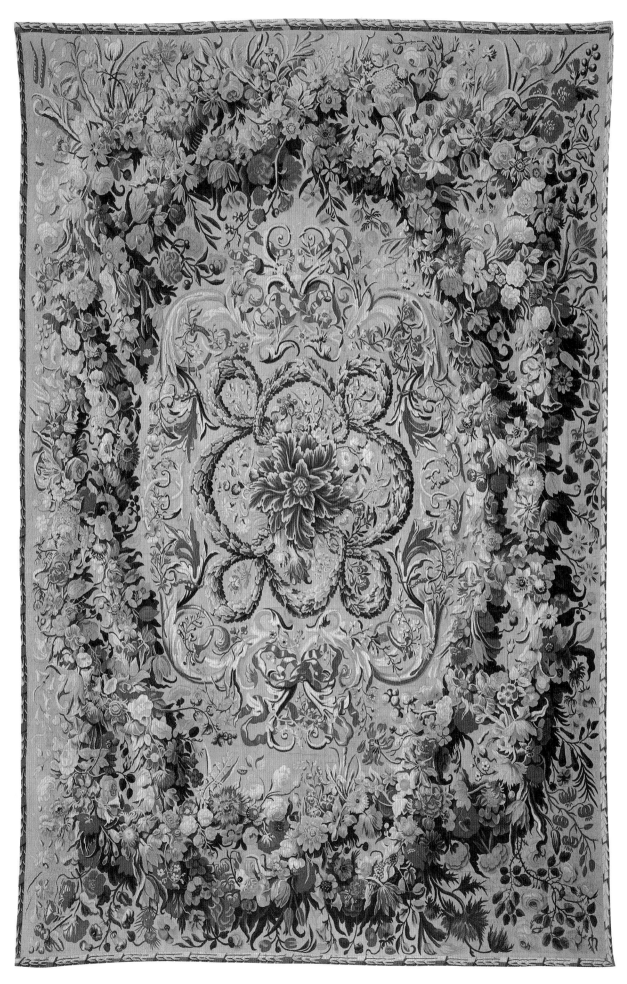

Carpet 86.DC.633

COMMENTARY

This woven carpet may have been intended to cover a table, but more likely it was meant to lie on the floor, since an imagined light source casts consistent shadows along one side of the floral garlands. The resulting dark green foliage creates an illusion of depth.

The designer of this carpet is unknown. None of the approximately one dozen works in this particular style—which includes other nearly identical carpets as well as screen panels and related upholstery covers—bears any mark. The broad flowers of generic representation, with their spiky foliage and their predominantly red and green color scheme, find ancestry in border designs used in Flemish tapestries, particularly in the 1670s and 1680s. Floral swags and sprays were commonly used to decorate the borders of tapestry verdures, allegories, and armorials, as well as historical and mythological scenes. These borders varied from thick, lush bands of blossoms to individual cut flowers interspersed with fruit, shells, rinceaux, and birds or animals. Typical of this kind of border design are those on the pastoral tapestries for the months of the year that were woven in the Brussels workshop of Jan Frans van den Hecke (active 1662–1691).[1] Eventually, these Flemish floral borders and garlands evolved into individual decorative panels that were assembled into screens, or *paravents*, such as the example that passed through the Paris art market in 1990 (fig. 10.2).[2] The deep gold ground color of this screen and the flowers portrayed in a fully opened state, particularly the red lilies and parrot tulips, are very similar to their counterparts on the carpet. The screen, however, is later in date and leans toward the rococo in its style, while the carpet is more characteristic of the late baroque.

WEAVER AND DATE

As neither this carpet nor the related panels have any identifying mark, they can only be attributed to either a Flemish or French manufactory on the basis of style.

In terms of specific composition, there is very little to compare to this carpet and the related weavings. Design elements of the carpet—the floral garlands and rinceaux—are encountered in a similiar combination on a pair of armorial tapestries that were woven in an unknown Brussels workshop after a design of 1680 by David III Teniers (1638–1685).[3] The same coloring dominates both weavings: beige, red, and blue acanthus leaves and scrolls against a background of golden yellow. Overall, however, the design and execution of the armorial are more sophisticated than the carpet.

An attribution based on stylistic details can therefore only be drawn from a comparison of the types and appearance of the flowers. In Brussels tapestry production the tradition of floral borders included a standard assortment of flowers: carnations, daffodils, irises, lilies, peonies, poppies, roses, and tulips. It has been generally assumed

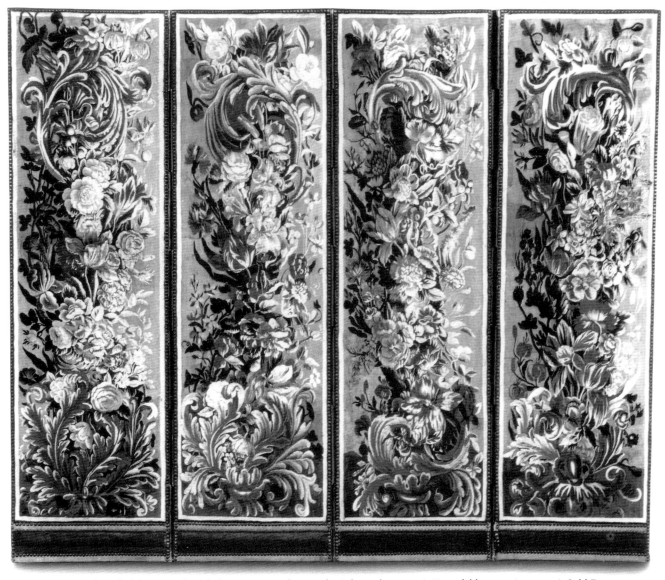

FIGURE 10.2 Unidentified factory (Flemish, late seventeenth or early eighteenth century). *Four-fold screen (paravent)*. Sold Drouot Richelieu, Paris, December 19, 1990, no. 162. Photo courtesy of Dominique Bondu, Commissaire-Priseur, Paris.

that these woven blossoms were generic representations. Research, however, has identified some varieties of flowers in these textiles as new cultivations that were introduced at known dates.[4]

Red pods of the kind seen on this carpet are rarely found in tapestry design. Among the few exceptions would be their appearance on the borders of a set of figurative Brussels verdure tapestries, and on the borders of a set of Beauvais tapestries from *L'Histoire de l'Empereur de la Chine*. In both cases the pods appear in proximity to fruit and vegetables. While the carpet itself does not contain fruit or vegetables, the related upholstery covers (which are described below) do.

Three of the hangings from the set of Brussels verdures portray hunters, and the fourth shows women in a woodland playing musical instruments. Each hanging bears a woven inscription F. DE. P or E.F.DE.PANMAKER, for François de Pannemaker (sometimes "Frans," active 1644–1720) and his brother Erasmus III, together with the

mark for the city of Brussels (fig. 10.3).[5] The borders consist of thick garlands of flowers and fruits along all four sides. The garlands on the vertical edges are suspended from the top two corners by blue ribbons. Just below the blue bow in the upper right corner are three plump red pods, thicker and shorter than their counterparts on the carpet. Other vegetables appear in the border, such as yellow and green beans, turnips, and marrow.

The floral, fruit, and vegetable borders of the verdure compare closely with the floral garlands of the carpet on several points. In both cases a sense of depth is conveyed by means of green cast shadows. The flowers in both cases are portrayed as characteristic types, identifiable by their standardized placement, petal shape, and color. Both the carpet and the verdure also feature tendrils, leaves, and sprigs that project beyond the garland and into the farthest corners of the weaving; on one verdure these elements even stretch into the brown *galon* where the signature is woven.

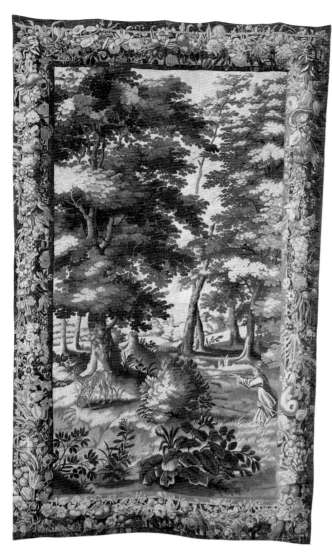

FIGURE 10.3 François de Pannemaker (Flemish, active 1744–1720). *Verdure with a deer hunter*. Sold from the collection of Henry Francis du Pont, Christie's, New York, October 14, 1994, lot 64. Photo courtesy of Christie's, New York.

FIGURE 10.4 Beauvais manufactory (French, circa 1697–1705). Detail from the border of *L'Audience de l'Empereur* from *L'Histoire de l'Empereur de la Chine*. Musée National du Château de Compiègne. Photo Jérôme Letellier.

Little is published on the Brussels production of François and Erasmus de Pannemaker beyond their activity in weaving history subjects and verdures. The brothers were active in Brussels from 1644, but François moved in 1670 to Tournai and then to Douai. In 1684 he established a workshop in Lille with his son, Andreas, that thrived in the 1690s on verdures and weavings for furniture upholstery.[6]

Given the steady stream of commerce, it is undeniable that the early products of the Beauvais manufactory were influenced by a familiarity with Flemish tapestries.[7] Few early records exist, however, regarding production at Beauvais before 1724, and there is no description among them that fits this carpet and its related pieces. Nevertheless, other documents and surviving hangings indicate that the factory was indeed weaving in the general color and style of this group. The *Inventaire du Mobilier de la Couronne* describes the French royal collection of verdure tapestries that were woven at Beauvais in the Flemish manner and had borders constructed of the same elements seen in this carpet: ". . . tapisseries de laine et soie, encadrées d'élégantes bordures courant de fleurs au naturel—anémones, roses, iris, tulipes et autres fleurs se détachant sur fond jaune ou couleur de bronze, ou encore aurore et citron, environnées de plumes et branches de lauriers—ou à rinceaux et festons de feuilles de chêne liés par des fleurs ou des rubans."[8] Such borders are seen on Beauvais verdures of this date and on other subjects as well, including the pastoral *Tenture des Jeux d'enfants*, which was begun about 1665 after designs by Florentin Damoiselet (born 1644).[9] It is possible that a designer recruited from Brussels by Louis Hinart, the founding director of Beauvais (*directeur* 1664–1684, d. 1697), or by his son Jean-Baptiste Hinart, was responsible for transporting this floral style.[10]

The background colors of the borders mentioned above—yellow, bronze, and citrus—must have been inspired from Flemish hangings. Although initially used for borders, these warm tones were adopted by the designers at Beauvais by 1688 as bold ground colors for decorative tapestries, particularly for the *Grotesques* series (see catalogue entry No. 8). Unfortunately the orange-brown color, later called "tabac d'Espagne" (Spanish tobacco), was dyed to varying shades that have now faded to dull yellow or green.

Despite the early dominance of the Flemish influence, it is still surprising to find that Beauvais also produced a border design incorporating three plump red peppers (fig. 10.4) very similar to those woven on the François and Erasmus de Pannemaker set of figured verdures. These peppers appear among other exotic flowering plants and fruits in the uncut borders of the set of ten tapestries from *L'Histoire de l'Empereur de la Chine* commissioned by the comte de Toulouse and woven between 1697 and 1705 (see catalogue entry No. 9).

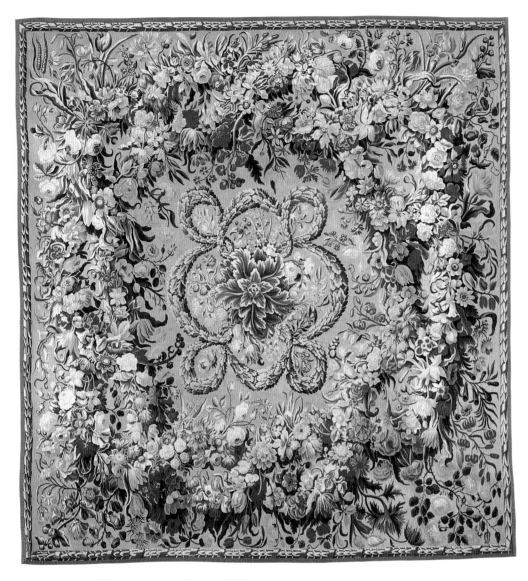

FIGURE 10.5 *Table carpet*. Amsterdam, the Rijksmuseum, inv. BK 17262.

It is known that the Beauvais manufactory wove carpets by the late seventeenth century, but the extent of this production remains to be explored. An undated document from the period of Philippe Béhagle's directorship (1684–1705) describes a commission from the Rouen *parlement* for bench covers and a table carpet for its Chambre des Enquêtes at a sum totaling 5,800 *livres*.[11] Certainly upholstery covers and *paravent* panels were made by the late seventeenth century, and this successful activity continued into the eighteenth century.[12]

RELATED EXAMPLES

Four carpets of this design, attributed to "a Paris workshop," were sold at the Hôtel Drouot, Paris, May 27, 1910, lots 131–134.[13] These were of the same approximate size as the Museum's carpet—the dimensions of each were given individually, but they varied by fewer than six inches in length (15 cm) and only two inches (5 cm) in width. Only one was reproduced. Another two carpets, described as "Beauvais" and having a "cream ground," sold from the

Viscount Wimborne's residence of Canford Manor, Wimbourne, Dorsetshire, at Christie's, London, March 6, 1923, lot 249. The auction house's annotated copy of the sale catalogue shows that the printed dimensions were manually corrected to 12 feet by 8 feet and records that the two carpets were purchased by M. [Moss] Harris. Both carpets were brought to the United States for sale by the executors of the Leverhulme estate at the Anderson Galleries, New York, February 9, 1926, lots 308 and 309. The New York firm of French and Company acquired them at that sale and used one of the carpets as upholstery fabric.[14] In 1937 Honoré Palmer presented the Art Institute of Chicago with a carpet of this design, where it is catalogued as "Aubusson."[15] Another pair of carpets was sold by the London auctioneers Knight, Frank and Rutley, Hampstead Heath, London, on October 26, 1925, lot 836 as "Beauvais," measuring 8 feet 3 inches by 7 feet 9 inches. The catalogue reproduced only one of the carpets, but the illustration clearly shows that its entire mid-section, including all of the oak leaf swags, had been cut away and the remaining

FIGURE 10.6 Lille or Beauvais (?) manufactory (French, circa 1690–1720) or Brussels (Flemish, c. 1690–1720). *Tabouret cover.* European private collection.

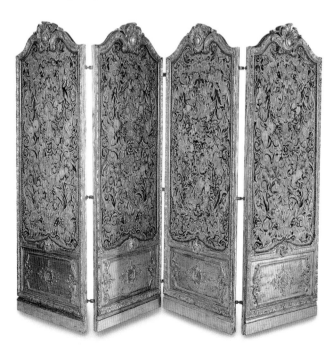

FIGURE 10.7 Lille or Beauvais (?) manufactory (French, circa 1690–1720) or Brussels (Flemish, circa 1690–1720). *Fourfold screen (paravent)*. Paris, Aveline. Photo courtesy of Jean-Marie Rossi.

ends rejoined. A nearly square carpet (9 ft. ¼ in. by 8 ft. 4⅜ in. or 275 cm by 255 cm) is conserved in the Rijksmuseum, Amsterdam (fig. 10.5). It has not been cut, but its design was somewhat condensed by omitting the acanthus scrolls tied with ribbons.[16] A carpet with three red pods, not two, sold at the Palais Galliera, Paris, on December 9, 1963, lot 94. It sold again at the Palais Galliera on December 8, 1975, lot 117,[17] and then passed through the Paris dealer Catan in 1976 catalogued as "Beauvais."[18]

A group of six related tapestry-woven tabouret covers has been identified. Four of the stools are gilt wood with four baluster legs and x-shaped stretchers, while the other two are polished wood and have curved legs with hoofed feet. The stools are rectangular and their upholstery covers measure approximately 32 inches in length. All of them have a main ground color of dull yellow or, in some cases, a yellow that has gone greenish, and have vertical borders around the four edges of the stool that repeat the laurel leaf and red ribbon borders of the carpets. Four of the covers are woven in each of the four corners with the cypher DVF or DMF, placed under a crown within a circle of cream-colored ground. The cyphers on three of the stools are surrounded by garlands of laurel leaves, while the central sections of the covers are filled with floral sprays.[19] Garlands of red berries and ivy leaves encircle the monogram of the fourth tabouret, and red rinceaux surround its central motif of a red rosette (fig. 10.6).[20] The last two stool covers differ from the others in that their centers

have a reserve with a blue ground. One reserve has a tortoise, encircled by a yellow band woven with the word CONSTANTIA; the other has a cornucopia, overflowing with fruit and flowers and surrounded by the woven word CORNUCOPIA. Eight additional cornucopias, a pair in each corner, spill flowers into the main field. Underneath the stool with the tortoise the upholstery webbing is stenciled JANSEN–PARIS (for the well-known decorator, located at number 6 rue Royale, who was active from before the Second World War until the 1970s).[21]

Also resembling the carpet are four woven tapestry panels that have been fitted into a gilt-wood *paravent* frame carved in the Régence style (fig. 10.7). Each panel repeats the same composition of red and blue rinceaux entwined with cut blossoms against a yellow field. A red foliate motif centers each panel, and two small cornucopias align with the symmetrical curves at the top; a spray of coral follows the vertical axis of the central foliates. The panels have neither the oakleaf wreaths nor the laurel leaves bound by a red ribbon that are usually featured on the related carpets and tabouret covers. Under the gilt nail heads that tack the woven panels into the *paravent* frame can be seen remnants of a dark blue or brown *galon*.[22]

PROVENANCE

(?) Sold Hôtel Drouot, Paris, May 27, 1910, one of four sold as nos. 131–134; (?) B. Fabre et Fils, Paris; Thenadey collection, Paris; Mayorcas, Limited, London, 1985; J. Paul Getty Museum, 1986.

PUBLICATIONS

"Acquisitions/1986," *GettyMusJ* 15 (1987), no. 100, p. 211, illus.; Bremer-David et al., 1993, no. 288, p. 169, illus.

NOTES

1. An example portraying November and December and bearing the initals I F V D H in the lower right corner of the *galon* is reproduced in the catalogue of the dealers Röbbig and Neumeister (Munich, Summer 1994).
2. Sold Drouot Richelieu, Paris, December 19, 1990, no. 162, measuring 165 cm high by 50 cm wide (each panel).
3. Sold Christie's, New York, January 11, 1994, lot 206. The family is, as yet, unidentified (Aragon, Poitou ?). See Göbel 1923, vol. 2, pls. 185–186, and G. Hughes-Hartman, "Armorial Tapestries," *Recent Acquisitions 1992, Partridge Fine Arts*, PLC (London, 1992), pp. 52–55, for examples of other *portières* designed by David III Teniers.
4. I am grateful to Ebeltje Hartkamp of the Rijksmuseum, Amsterdam, for providing information from the as yet unpublished work of Dr. Sam Segal, in which he has identified the flowers in a similar carpet belonging to that institution (inv. BK-17262). Dr. Segal dated the weaving to circa 1700 on the basis of the presence of flower varieties newly cultivated at that time. He considered the red pods to be blossoms of the *amaranthus caudatus* species.
5. The two tapestries with hunters and the third with women and musical instruments are reproduced in E. Duverger, "Verdures Uit Het Brusselse Atelier van Erasmus (III) en

Frans de Pannemaker," *Artes Textiles* 11 (1986), pp. 107–115. I thank Tom Campbell for bringing this article to my attention. The fourth tapestry, with a deer hunter, sold from the collection of Henry Francis du Pont, Christie's, New York, October 14, 1994, lot 64.
6. H. Göbel, *Tapestries of the Low Lands* (New York, 1934; reprint, 1974), trans. R. West, pp. 67, 77.
7. B. Jestaz, "La Manufacture de Beauvais sous la Direction de Béhagle—Documents Inedits," *Bulletin de la Société de l'histoire de l'art français* (1977), pp. 145–151.
8. Guiffrey, *Inventaire*, nos. 85–94, pp. 347–349, and Coural 1992, pp. 11–13.
9. See, for example, the verdure with birds illustrated in J. Boccara, *Ames de laine et de soie* (Saint-Just-en-Chaussée, 1988), p. 317, and *La petite reine* from the *Jeux d'enfants* series in the collection of the Musée du Louvre, Paris, illus. in J. Coural, *Les Gobelins* (Paris, 1989), p. 40.
10. Although Florentin Damoiselet was born in Paris and socialized with others among the *peintres du Roi* (such as Guy-Louis Vernansal, who witnessed his marriage), in a document dated 1731 Noël-Antoine de Mérou (*directeur* of Beauvais from 1722 to 1734) mentions an early Beauvais mythological series made by "Damoiselet de Bruxelles." See Badin 1909, p. 22. For further information regarding Florentin Damoiselet, see B. Jestaz, "The Beauvais Manufactory in 1690," *Acts of the Tapestry Symposium, San Francisco, November 1976* (San Francisco, 1979), pp. 189–190.
11. "Estat du produit de quelques marchandises fabriquée dans la manufacture royale de tapisseryes de Beauvais," as published by Badin (note 10), pp. 11–13.
12. Standen 1985, vol. 2, no. 65, pp. 459–460.
13. The frontispiece to the auction catalogue names Alexis Polovtsoff as one of the vendors.
14. Stock no. 28275, invoice date February 9, 1926. The stock sheet notes that one of the two carpets was used to upholster a sofa (later identified as "settees"). Information from the GRI Resource Center.
15. C. Mayer-Thurman, *Selected Works of Eighteenth Century French Art in the Collections of the Art Institute of Chicago*, exh. cat. (Art Institute of Chicago, 1976), no. 309, inv. 1937.1119, measuring 12 ft. 3¾ in. by 8 ft. 4 in. (375.1 cm by 253.9 cm).
16. The Rijksmuseum, Amsterdam, inv. BK-17262. I thank Ebeltje Hartkamp of the Rijksmuseum for bringing this carpet to my attention.
17. I thank Tom Campbell for bringing these two sales at the Palais Galliera to my attention.
18. The gallery was located at 129 Avenue des Champs Elysées, Paris. See the color advertisement in *Connoisseur* (September 1976), p. 11.
19. Two were sold Christie's, London, November 12, 1987, lot 56, and the third stool remains in a European private collection.
20. Private collection, France.
21. The tabouret with the woven tortoise is from the collection of Baron Thierry van Zuylen van Nyevelt van de Haar, Kasteel de Haar, near Utrecht, Netherlands. The tabouret with the cornucopia is in another European private collection.
22. With the Paris dealer Jean-Marie Rossi at Aveline, 1994–1995 (each panel measures 2 ft. 3¼ in. by an overall height of 5 ft. 9¼ in. and there are 28 warps per inch).

II

Four tapestries from
L'Histoire de Psyché:

a. *L'Arrivée de Psyché dans le palais de l'Amour*
b. *La Toilette de Psyché*
c. *L'Abandon de Psyché*
d. *Psyché et le vannier*

Beauvais manufactory; circa 1741–1770

After cartoons painted before 1741 by François Boucher (1703–1770, *premier peintre du Roi* 1765). Woven on the low-warp loom under the direction of Jean-Baptiste Oudry (1686–1755, *co-directeur de la Manufacture de Beauvais* 1734–1755) and Nicolas Besnier (d. 1754, *maître orfèvre* 1714, *co-directeur de la Manufacture de Beauvais* 1734–1753) or André Charlemagne Charron (dates unknown, *directeur de la Manufacture de Beauvais* 1754–1780).

WOVEN SIGNATURES
b. Bears the woven signature - BESNIER & OVDRY ABEAVVAIS - in the lower right corner; c. and d. each bear the woven signature *f.Boucher* on a rock at the lower left.

WOVEN HERALDRY
d. Has the arms of France and Navarre at the top center.

MATERIALS
Wool and silk; modern cotton linings

GAUGE
20 to 22 warps per inch / 60 to 136 wefts per inch

DIMENSIONS
a. height 11 ft. ½ in. (336.5 cm); width 20 ft. ½ in. (610.9 cm)
b. height 11 ft. 1¼ in. (339.7 cm); width 8 ft. 7¼ in. (263.5 cm)
c. height 11 ft. 1 in. (337.8 cm); width 9 ft. 3½ in. (282.2 cm)
d. height 11 ft. 3½ in. (344.1 cm); width 8 ft. 3¾ in. (253.3 cm)

a. 63.DD.5 c. 63.DD.3
b. 63.DD.2 d. 63.DD.4

DESCRIPTION
a. *L'Arrivée de Psyché dans le palais de l'Amour*
(Psyche's Arrival at Cupid's Palace)
The tapestries illustrate scenes from the myth of Psyche and derive from seventeenth-century adaptations of the literary work of the Roman poet Lucius Apuleius (A.D. 125–180). Psyche's youthful beauty incurs the jealousy of Venus, who is determined to see that Psyche spend her days unloved and unmarried. But the goddess's own son, Cupid, falls in love with Psyche and has her brought to his palace. Amid billowing clouds, the young Psyche is escorted into a palatial setting. Zephyr, the butterfly-winged god of the west wind, guides her steps from mid-air. Wearing a pale pink dress, a blue cloak, and sandles with blue ribbons, she treads on a Near Eastern carpet that has been partially unrolled to receive her. She appears to arrive from the direction of the palace's sun-drenched rotunda and enters into an Ionic colonnade where two groups of attendants await her. To the left, a group of eight maidens gathers around the stone base of a large perfume burner: in the foreground a reclining figure holds a red and blue parrot while her companion plays the flute; a third maiden leans on the Vitruvian scroll that decorates the stone support; and five more retainers recline, sit, or stand to catch a glimpse of Psyche through the vapors. The carved stone pedestal, draped with floral garlands, supports an enormous ewer of blued metal mounted with gilt-bronze figures of Venus and a putto. Clouds of incense stream from its aperatures. Far-

a. *L'Arrivée de Psyché dans le palais de l'Amour* 63.DD.5

b. *La Toilette de Psyché* 63.DD.2

ther to the left of the tapestry is another smoking incense burner in the form of a white ceramic vase fitted on a footed stand of gilt-bronze. Beyond the colonnade, in the sun-lit middleground, two servants carry a gilded vessel. A walled garden with a fountain and tall evergreens extends behind them. To the far right is the second group of servants who sit or lean on blue velvet cushions. One plays a tambourine and another holds a gilded lyre; two others arrange a basket of flowers, while the fifth rests on her elbows. The last attendant secures a garland of flowers to a column and stands by another stone pedestal that is topped by a third smoking incense burner, this one of gilded metal. Crimson velvet drapery hangs from the columns at the right and left. The tapestry is bordered by a blue *galon*.

b. *La Toilette de Psyché* (The Toilet of Psyche)

Beside a fountain on an outdoor stone terrace, Psyche is being groomed by her attendants. Presumably she is being prepared for her first night with her new husband, Cupid, who cannot reveal his identity and comes to her only under the cover of darkness. She sits in a gilded chair that is draped with crimson velvet, and her left foot rests on a blue velvet pillow. Two blond attendants stand behind her and dress her hair. In front of her, on a carved and gilded table that is also draped with crimson velvet, is a large mirror with a gilded frame that reflects the faces of both Psyche and one of her maids. Another maid, to the left of the mirror, gazes back at Psyche, while still another stands to the right of the mirror and holds up a length of pink silk fabric. Resting below the table is a large silver ewer and basin, with an oval silver tray to the side. Between the table and the pool of the fountain, a seated attendant is sorting flowers from a wicker basket and interacting with another maid who approaches with powder and perfume on a silver tray. To the left, behind the figure of Psyche, rises the stone wall of the fountain, topped by marble putti at play with a dolphin. Water issues from the dolphin's mouth to fill a large shell and then spills into the pool below. Immediately to the left of Psyche's gilded chair rests a pair of pink slippers with blue ribbon ties. Beyond the terrace and the fountain is a circle of tall trees, mostly pines. Woven into the stone pavement in the lower right corner is the signature - BESNiER & OVDRY ABEAVVAIS - (fig. 11.1). The tapestry is bordered only by a blue *galon*.

c. *L'Abandon de Psyché* (The Abandonment of Psyche)

Psyche is abandoned by Cupid when she disobediently lights a lamp in order to see him. She finds herself flung into a remote and stony wilderness, at the source of a spring whose cascading water becomes a stream. With arms outstretched, she gazes upward to the departing figure of Cupid, who grasps his bow in his left hand and arches his back in flight against gray clouds. The landscape is composed of jagged rock formations, including a natural stone

FIGURE 11.1 Detail of woven signature, *La Toilette de Psyché*.

FIGURE 11.2 Detail of woven signature, *L'Abandon de Psyché*.

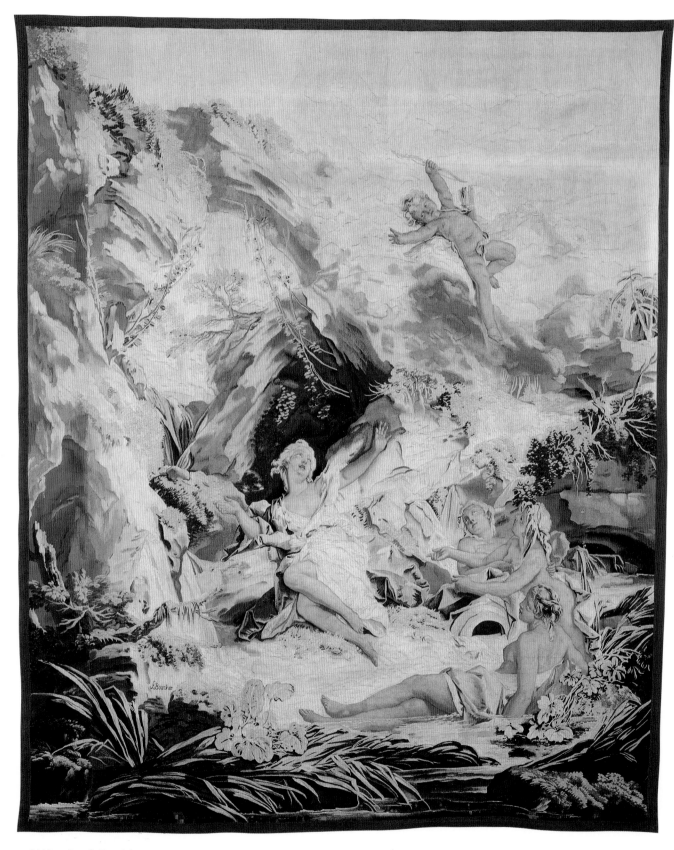

c. *L'Abandon de Psyché* 63.DD.3

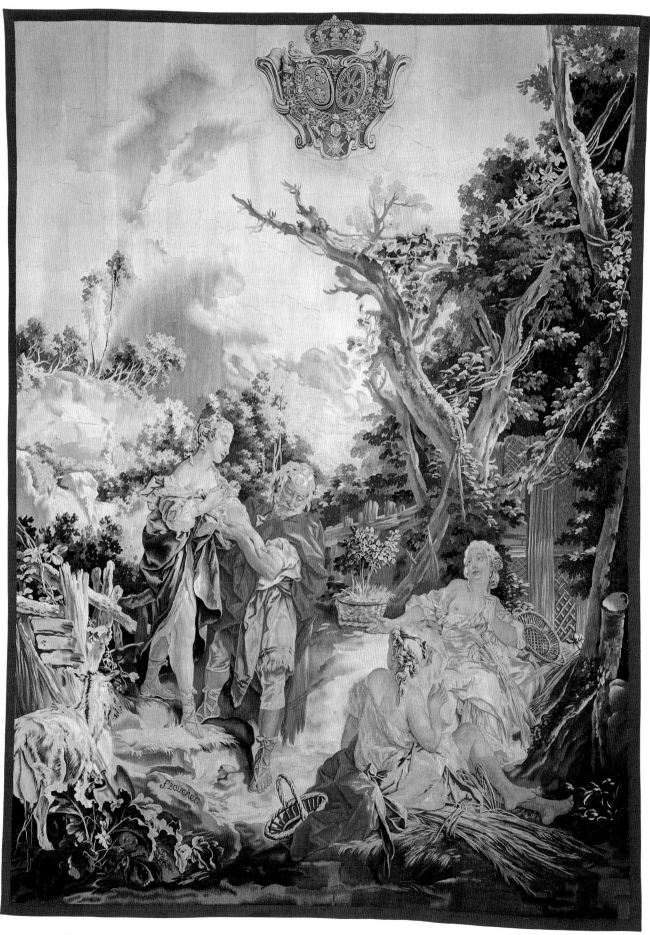

d. *Psyché et le vannier* 63.DD.4

FIGURE 11.3 Detail of woven signature, *Psyché et le vannier*.

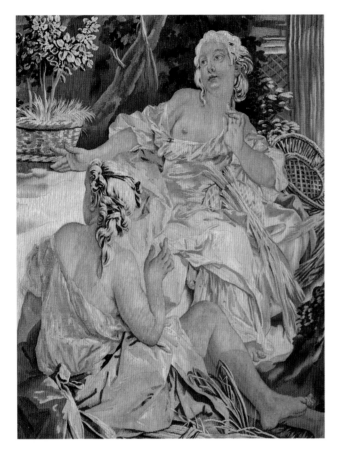

FIGURE 11.4 Detail of Proserpine and Ceres, *Psyché et le vannier*.

bridge that breaks the expanse of blue sky above Psyche. Few plants take root amid the rocks, although water reeds thrive along the bank of the stream in the foreground. Three naiads witness the event, their eyes following Cupid's aerial departure. One sheer rock, to the lower left, is woven with the signature *f.Boucher* (fig. 11.2), and the tapestry is bordered by a blue *galon*.

d. *Psyché et le vannier* (Psyche and the Basketmaker)
After her abandonment, Psyche wanders in a despair that has led her close to suicide. In a wooded vale, amid a coarsely fenced enclosure, she is seen stepping down an earthen path and supported on the arm of a bearded man, the god Pan. The disheveled Psyche wears a pink dress under a blue cloak that she clutches to her chest. Thin sandals are tied to her feet and ankles with pink ribbons. Pan wears a red cloak over his pink tunic and yellow breeches. As he comforts her, his face reflects his concern. In the foreground, to the left, is a nanny goat, an attribute of the god. On a rock near the goat is the woven signature *f.Boucher* (fig. 11.3). Across from the central figures are two seated women. The older woman is the goddess Ceres, identified by the sheaves of grain in her lap. She wears a cream dress that falls off one shoulder. Her daughter, Proserpine, faces her mother but turns her head to the left as Psyche approaches. Dressed in a cream shirt and a yellow skirt tied at the waist with a blue ribbon, Proserpine reclines upon a sheaf of wheat (fig. 11.4). On either side of the goddesses is an empty wicker basket. Beyond is a rustic shelter composed of trees and a trellis gate. Between Pan and Ceres is a small fruit tree planted in a woven basket. Blue sky with white clouds fills the upper portion of the tapestry. Set into the top center is a gilt cartouche (fig. 11.5) bearing the royal coat of arms of France (*d'azure à tois fleur-de-lys or*) and Navarre (*de gueules à une chaine d'or en triple orle, en croix et en sautoir*). The arms are surmounted by the French royal heraldic crown and surrounded by the collars of the orders of Saint-Michel and the Saint-Esprit. The tapestry has no border, only a narrow blue *galon*.

CONDITION
The warps of *L'Arrivée de Psyché*, *La Toilette*, and *L'Abandon* are wool, Z spun S ply (varying from 4 to 6). The wool wefts are Z spun S ply (2 or 3) while the silk wefts are Z spun S ply (2). Some details are woven with wefts plied of two yarns (often one silk and one wool). The blended wool and silk plys of the drapery in *L'Arrivée* are doubled (4). The presence of thicker yarns results in a lower count of wefts per inch. Comparing the back to the front, the tapestries have suffered measurable fading, most notably in the sky. There is also apparent loss in the warm yellow tones of flesh and foliage. Most green shades now have little or no yellow tones and appear blue-green. Small areas of rewo-

ven repairs occur throughout, but particularly in the silk weft of the sky. Those near the figure of Cupid in *L'Abandon* are irregular in shape, about three to five inches long. The yarns of these repairs have faded differentially. A small tear in the right corner of *La Toilette* has been repaired by couching the broken warp and weft yarns to a patch of supporting fabric behind.

All three of these tapestries have vertical and horizontal joins. *L'Arrivée* has three vertical joins: the first at fifty-two and three-quarter inches from the right edge, the second at ninety-three and one-half inches from the right edge, and the third at the left edge in an uneven line following the drapery. There is a rewoven insert in the lower left corner. Although the right edge of *La Toilette* retains part of its original border, the left edge appears cut. A woven section joined vertically to the left edge measures about three inches in width from top to bottom. Remnants of the original light-blue *galon* remain along the left vertical edge, now covered by a replacement *galon*. The intact right edge still bears part of its brown border. Similarly, *L'Abandon* has a vertical join at its left side, ten and one-half inches wide, with a remnant of its golden brown *galon* now hidden under a blue replacement. The tapestry's intact right edge still retains a portion of its original brown *galon*. All three tapestries have a horizontal addition to their lower edges, measuring between seven and one-half to eight and three-quarters inches in width. The horizontal joins were skillfully secured by slit stitching. These sections have faded to the same degree as the tapestries overall. All edges are now covered by a replacement *galon* that was applied to the perimeters in 1973. The modern *galons* were set-in about one to one and one-half inches from the vertical edges of the tapestry.

The warps of *Psyché et le vannier* are wool, Z spun S ply (4 to 6); the wool and silk wefts are Z spun S ply (2). There is extensive blending of weft yarns, including some blending of different colors to make one yarn and the use of double yarns of different color and fiber that are woven as one. The blended plys of wool and silk found in the sky are doubled (4). The overall color of this tapestry is good, showing very little fading when the front is compared to the back. Areas of yellow tone and shades of blue in the sky, ordinarily fugitive, are still visible on the obverse. The tapestry was evidently reduced in size, since the left, right, and top edges appear cut while the bottom edge seems to retain its original finishing. The coat of arms at the top center may be original, but it has been expertly moved and set-in by a reweaving technique; the top of the heraldic crown is now applied over the *galon*. The present *galon* dates from around 1931–1937 and replaces another border (fig. 11.6) that was described as "à l'imitation d'un cadre." [1]

Nail holes from a prior mounting method can be found in each tapestry along its edges and in the replace-

FIGURE 11.5 Detail of coat of arms, *Psyché et le vannier*.

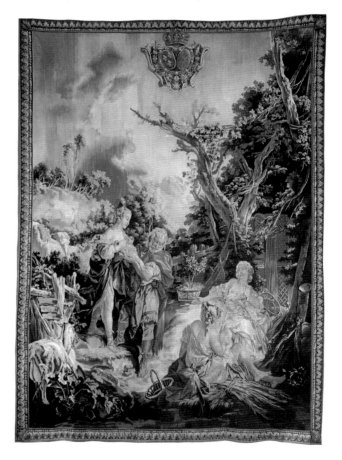

FIGURE 11.6 View of *Psyché et le vannier* from before 1931 with a different border.

ment *galon*. The tapestries were newly lined with plain-weave cotton in January 1995.

COMMENTARY

In September 1737 it was decided that at the king's expense the Beauvais manufactory would provide two sets of tapestries each year to the Département des Affaires Etrangères to be used as state diplomatic gifts.[2] Two months later Louis XV, through his *contrôleur général des Finances*, Philibert Orry (1689–1747, *directeur des Bâtiments du Roi* 1737–1745), ordered two series of tapestries, each of six scenes, for this purpose. The first series suggested was *L'Histoire de Jason et de Médée*, and the co-director of Beauvais, Jean-Baptiste Oudry (1686–1755, *co-directeur* 1734–1753) commissioned Jean-François de Troy (1679–1752) to execute five subjects. Only one model was painted as a cartoon by Dandré Bardon (1700–1778), and the tapestries were never executed (although de Troy produced another seven scenes from *L'Histoire de Jason* between 1743 and 1746 for the successful Gobelins series).[3] The second series chosen was *L'Histoire de Psyché*, whose six scenes, Orry suggested, should be "des moins répétés et de plus susceptibles de richesse et d'agrément et des plus propres à faire valoir l'art du Tapissier."[4] In this instance Oudry turned to the artist François Boucher, who had been supplying the manufactory with scenes for *Les Fêtes Italiennes* since 1734.[5] *L'Histoire de Psyché* was therefore Boucher's second major commission for the manufactory.

The king's order stipulated six scenes (measuring a total of twenty *aunes*), but Boucher prepared only five (measuring between a total of eighteen and nineteen *aunes*).[6] Completed in time to be included in the Paris salon of September 1739, the first full-scale painting of *Psyché conduite par Zéphyr dans le palais de l'Amour* (measuring fourteen *pieds* wide by ten *pieds* high) is now lost and is only known through the woven tapestry versions of *L'Arrivée de Psyché dans le palais de l'Amour*. Two preparatory drawings by Boucher have been identified for the figure of Psyché, as well as a painting for the flute player.[7] The four other subjects chosen for the Beauvais series were *La Toilette de Psyché*, *Les Richesses de Psyché* (fig. 11.7), *L'Abandon de Psyché*, and *Psyché et le vannier*.[8] Sadly, the present locations of these four Boucher paintings are unknown,[9] although two pendant preparatory grisaille sketches for *La Toilette* and *Les Richesses* exist in a private collection.[10] Alexandre Ananoff related two drawings of female heads to servants in *La Toilette*, one for the maid who holds a round silver tray and the other for her seated companion, whose coiffured hair is tied with a blue ribbon (fig. 11.8).[11] The naiad in the foreground of *L'Abandon* is a cousin to the Nereid in the artist's painting of *Le Triomphe de Vénus*, 1740, and both are associated with a pair of preliminary drawings.[12]

The myth of Cupid's love for Psyche first appeared in literary form in the second century A.D. in Lucius Apuleius's *Metamorphoses* or *The Golden Ass*. In 1669 the fable was adapted into French by Jean La Fontaine (1621–1695), in a poetic piece entitled *Les Amours de Psyché et de Cupidon*. Within two years Molière (Jean-Baptiste Poquelin, 1622–1673) produced a *tragedie-ballet* based on La Fontaine in collaboration with Pierre Corneille (1606–1684), Jean-Baptiste Lully (1632–1687), and Philippe Quinault (1635–1688). Following its initial private performance in the Palais des Tuileries in 1671, numerous productions continued throughout the first quarter of the eighteenth century, attesting to the popularity of the tale.

Kathryn B. Hiesinger and Geraldine C. Hussman have shown that Boucher was well-versed in the mythology of Cupid and Psyche.[13] Certainly Boucher was familiar with both La Fontaine's version and the Molière production. He contributed illustrations to the second edition of Molière's collected works, published in 1734 by M. A. Jolly. Identified as "Prologue de Psiché" and "L'Abandon de Psiché," Boucher's illustrations were engraved for that edition by Laurent Cars (1699–1771).[14] Hiesinger has also shown that Boucher's knowledge extended to Molière's stage instructions and Lully's orchestral arrangements.

Boucher had additional literary advice on suitable subjects for portrayal in a cycle of Psyche from the critic and connoisseur, Louis Petit de Bachaumont (1690–1771). In a well-known but undated letter to Boucher, Bachaumont recommended ten subjects. Apparently the artist shared this advice with his contemporary Charles-Joseph Natoire (1700–1777), for seven of these ten suggestions were painted by Natoire in 1738–1739 in the *salon ovale* of the princesse de Soubise's apartments in the Hôtel Soubise, Paris. Included among the group was a rustic scene that Bachaumont called "Psiché chez les Bergers." Based on La Fontaine's imagery, this scene represented an episode in which, following her disobience and subsequent abandonment, Psyche is given solace by an elderly shepherd and his female family members.

But Oudry and Boucher must have taken to heart Orry's directions in his letter to the Beauvais manufactory to select six subjects from *Psyché* "des moins répétés." It would seem that Boucher singled out Bachaumont's "Bergers" and adapted it by adding baskets to the attributes of the shepherdesses—hence the title *Psyché et le vannier*. Yet there is no mention of basketmakers in either La Fontaine or Molière, and it is likely, as Hussman has argued, that Boucher returned to Apuleius and brought together two separate episodes of the story. One is Psyche's encounter with Pan, the god of nature, who consoles her while his goats graze by a stream, and the other is her unsuccessful supplication to Ceres, the goddess of agriculture, whom Boucher portrays with her daughter, the cyclical goddess Proserpine, surrounded by the harvested grain that is their

attribute. Eighteenth-century factory records misidentified the figures, however, and the mistake has perpetuated.

Boucher also obeyed the second and third stipulations of Orry's directions to create cartoons "de plus susceptibles de richesse et d'agrément et des plus propres à faire valoir l'art du Tapissier." The five scenes of Boucher's *L'Histoire de Psyché* can be divided into two groups, the first composed of three scenes with palatial settings that unequivocally convey "richness," and the second offering two rustic outdoor vignettes filled with drama and atmospheric affect. In both cases the art of the weaver was challenged to create, through woven thread, images of polished marble, stone, bronze, silver, mirror glass, textile, flesh, trees, shrubbery, water, rock, clouds, and sky.

WEAVER AND DATE

Since the production chronology of *L'Histoire de Psyché* has not been fully published since 1909, the following summary is provided in order to determine the dates of the Museum's tapestries.[15]

FIGURE 11.7 Beauvais manufactory (French, 1744–1746). *Psyche Displaying Her Treasures* from *L'Histoire de Psyché*. The Detroit Institute of Art, Bequest of Mrs. Horace E. Dodge in memory of her husband, inv. 71.180.

Chronology of *L'Histoire de Psyché* Production

Subjects: a. *L'Arrivée de Psyché dans le palais de l'Amour*, b. *La Toilette de Psyché*, c. *Les Richesses de Psyché*, d. *L'Abandon de Psyché*, e. *Psyché et le vannier*

	DATES OF PAYMENTS TO WEAVERS	PATRON	BORDER TYPE OR PRICE PER VERTICAL LENGTH	SCENES WOVEN
1.	July 1741– September 1742	M. d'Auriac	border at the price 46.15.0 *livres* per vertical length	three pieces: a, b, d[16]
2.	November 1741– August 1744	City of Marseille	12.16.9 *livres*	complete set[17]
3.	December 1741– December 1745	City of Rouen	12.18.9 *livres*	three pieces: a, b, d[18]
4.	March 1742– December 1745	M. Miré	blue *galons* and border for 44.9.3 *livres*	two pieces: a, b[19]
5.	October 1744– July 1746	Prince Campo Florido, Ambassador of Spain	blue *galons* and border for 48.1.3 *livres*	complete set[20]
6.	October 1745– April 1747	Frederick I of Sweden	blue *galons* only 2.12.6 *livres*	complete set[21]
7.	January 1749– August 1751	"pour Naples"	49.17.6 *livres*	complete set[22]
8.	May 1756– May 1758	French Crown (1st order)	border for 43.19.3 with royal arms at added cost	complete set, with arms in the border (4.7.6 *livres*) and in the sky (12.13 *livres*)[23]
9.	March 1759– June 1760	M. Baudon	*galons* only 2.10 *livres*	two pieces: a, e[24]
10.	1761–1763	M. Cottin	(unavailable)	complete set[25]
11.	1764–1766	Madame Rondet	(unavailable)	one piece: c[26]
12.	1764–1766	Frederick the Great of Prussia	key fret design with heraldic emblem	complete set with e divided into 2 hangings for a total of six pieces[27]
13.	c. 1769–1772	French Crown (2nd order)	(unavailable)	complete set[28]

FIGURE 11.8 François Boucher (French, 1703–1770). Drawing for a female head. Sold Christie's, London, July 4, 1995, lot 133. Photo courtesy of Christie's, London.

The factory wove eight complete sets of all five subjects between 1741 and about 1770: from November 1741 to August 1744 for the city of Marseille; from October 1744 to July 1746 for the ambassador of Spain; from October 1745 to April 1747 for the king of Sweden; from August 1749 to August 1751 for Naples; from May 1756 to May 1758 for the French Crown; from 1761 to 1763 for M. Cottin; from 1764 to 1766 (in six pieces, not five) for the king of Prussia; and again around 1769 for the French Crown, delivered in 1772 and 1773 to the Département des Affaires Etrangères.

There were only four other smaller orders totaling an additional eleven tapestries: three pieces with borders for M. d' Auriac (*L'Entrée*, *L'Abandon*, and *La Toilette*, made from July 1741 to September 1742); a duplicate order with simplified borders for the city of Rouen (December 1741 to December 1745); two pieces with borders for M. Miré (*L'Entrée* and *La Toilette* from March 1742 to December 1745); two hangings with simplified borders for the *fermier-général* Baudon (*L'Entrée* and *Le Vannier* from March 1759 to June 1760); and one last hanging for Madame Rondet (*Les Richesses* from 1764 to 1766).

Three of the Museum's tapestries—*L'Arrivée de Psyché dans le palais de l'Amour*, *L'Abandon de Psyché*, and *La Toilette de Psyché*—were together earlier in the twentieth century while in the London collection of Sir Anthony de Rothschild. Although they were subsequently

divided among the collections of Henry Walters of Baltimore and E. M. Hodgkins of Paris, their earlier provenance and many of their common features strongly suggest that they were produced *en suite*. All three share a height of slightly more than eleven feet (varying from 11 ft. ½ in. to 11 ft. 1¾ in.), all three have a horizontal woven section added to the bottom edge (varying in height from 7½ in. to 8¾ in.), and two of them still retain remnants of an original brown border at the right edge.

Given these traits, it is not difficult to match these three hangings with the commission of M. d'Auriac ("M. Doriac" in the factory records), whose order was the first of this series set to the looms. The recorded height (five Flemish *aunes*) and widths of that commission correspond with the Museum's tapestries. Generally, the factory wove examples of *La Toilette* in widths from as few as four or as great as seven strips or *bandes* of the cut cartoon, often together with as many as three additions or *rallonges*. For low-warp production at Beauvais, the cartoon was cut into strips a little more than one Flemish *aune* in width (69.5 cm or 2 ft. 3⅜ in.), which were slipped successively under the horizonal warps. *La Toilette* from M. d'Auriac's order was the narrowest woven, using only three *bandes*. Moreover, all three hangings were returned to the manufactory in August–October 1743 for additions along the bottom edges, "Ralonge pour M. Doriac enbas pour la Toilette, enbas pour l'Abandon, enbas pour L'Entrée."[29] *L'Abandon* also received a vertical "ralonge sur l'envers" that included the necessary adjustments to the border.[30] All three were woven with an expensive border at the price of forty-six *livres*, fifteen *sous* per vertical length.[31] The city of Rouen ordered the same subjects, but with less expensive borders (twelve *livres*, eighteen *sous*, nine *derniers* per length). The height of these three was less (four *aunes*, five *seizièmes*), and *La Toilette* was woven significantly wider.[32] They did not have horizontal additions to the bottom edge.

The Museum's *Psyché et le vannier* is the only hanging of the known production of *L'Histoire de Psyché* that bears the French royal coat of arms. If the arms are authentic and original to the tapestry, they may identify it as the single survivor of the two sets commissioned by the French Crown. The first set bearing the royal arms (twice in each hanging, once in the border and again in the sky) was woven under André Charlemagne Charron (*directeur* of the Beauvais manufactory 1754–1780) from May 1756 to May 1758 for delivery to the Département des Affaires Etrangères.[33] Presumably the second royal order that was delivered to this department in 1772–1773 also bore the king's arms. Three hangings from the *L'Histoire de Psyché* series were sent, together with six pieces from the Beauvais series *Les Amours des dieux*, by this department in 1778 to Charles Gravier (1717–1787), marquis de Vergennes and French ambassador to Venice, to decorate his palace there.[34] However, given the frequency of alteration to tapestries of

this series, no firm conclusions can be drawn regarding the original owner of this piece. Factory records indicate that *Le Vannier* was consistently produced from three cut *bandes*, and in only one instance, for the Swedish commission, did the hanging follow two *bandes*.

RELATED TAPESTRIES
Pay sheet records for the Beauvais weavers show a total of fifty-two tapestries made from *L'Histoire de Psyché* series, eight complete sets and eleven other hangings. At least thirty-seven are now known or can be traced, with only the Museum's example of *Le Vannier* bearing the royal arms of France. Of the eight complete sets produced, the one made for Marseille is thought to be the intact set that is in the Philadelphia Museum of Art, while the set made for Frederick I of Sweden, at the cost of 8,835 *livres*, is conserved in the Swedish Royal Collections at the Husgeradskammaren in Stockholm.[35] Four of the five tapestries commissioned in 1746 "pour Naples" are displayed in the Sala degli Arazzi di Boucher in the Palazzo del Quirinale, Rome. Their borders are without coats of arms, but *Les Richesses* is woven with the signature BESNIER ET OUDRY A BEAUVAIS, thus confirming the date of the set to the years of the combined directorship of Besnier and Oudry (i.e., before 1754). The fifth tapestry, *L'Arrivée*, was separated from the set in the nineteenth century and may be the hanging now in the Corcoran Gallery of Art, Washington, D.C.[36] The set ordered by Frederick the Great of Prussia was intact in Berlin until 1945, when it was dispersed to the Kunstgewerbe Museum and the Schloss Charlottenburg.[37]

Four of the set ordered by the Spanish ambassador in 1744 may be pieced together from disparate provenances. They all bear a coat of arms identified as that of Prince de Campo Florido, Luigi Riggio Saladino Branciforti-Colonna (d. 1758, *ambassadeur extraordinaire du Roi d'Espagne* to the court of Versailles 1741–1746).[38] *La Toilette* sold from the collection of Madame P., Galerie Jean Charpentier, Paris, June 4, 1937, no. 92. Three others sold from the collection of Ernest Cronier at the Galerie Georges Petit, Paris, December 4, 1905, nos. 164–166.[39] One of the three, *Les Richesses* is conserved in the Detroit Institute of Arts (fig. 11.7).[40] The two others, *L'Abandon* and *Le Vannier*, appeared recently on the art market.[41] The 1937 sale notes that the fifth hanging (*L'Arrivée*) "fait actuellement partie d'une Galerie particulière," as yet untraced.

Individual hangings from the series are known in other public collections and from public sales. Two additional versions of *La Toilette* were formerly in the Getty Museum. One has a narrow border and bears the signature BESNIER· ET·OVDRY·A·BEAUVAIS in the lower right *galon*.[42] The other is extended on the left side and includes a tripod stand that supports a mounted bowl of smoking incense. This element is seen in only one other example of *La Toilette*, the one made about 1764 for the king of Prussia.[43] A

narrow *Toilette* with an acanthus leaf border bearing the signature for André-Charlemagne Charron was sold from the collection of Madame Dubernet-Douine at the Galerie Charpentier, Paris, April 11–12, 1946, no. 152. A hanging of *L'Arrivée* sold from the collection of Achille Le Clercq, Hôtel Drouot, Paris, May 31–June 1, 1904, no. 316; a narrow borderless example of the same subject sold Drouot Richelieu, Paris, November 27, 1992, no. 214; a left and a right section of *L'Arrivée* are in the Art Institute of Chicago[44]; and a wide tapestry combining *L'Arrivée* with *Les Richesses* is conserved in the Tuck Collection of the Musée du Petit Palais, Paris. A version of *Les Richesses* sold Palais Galliera, Paris, June 17, 1970, no. 107; and another example, borderless but woven with the signature for André-Charlemagne Charron, sold Sotheby's, Monaco, June 19–20, 1992, lot 690. It was acquired by the dealer Bernard Blondeel of Antwerp.

PROVENANCE
a. *L'Arrivée de Psyché dans le palais de l'Amour*, b. *La Toilette de Psyché*, c. *L'Abandon de Psyché*
(?) Set of three tapestries woven for M. d'Auriac, 1741–1742; Sir Anthony de Rothschild, London, early twentieth century and thereafter separated.
a. and c. only: E. M. Hodgkins, Paris; French and Company, New York; acquired by J. Paul Getty in 1937; J. Paul Getty Museum, 1963.
b. only: Henry Walters, Baltimore (sold by his widow, Parke-Bernet, New York, April 26, 1941, lot 739); purchased at that sale by French and Company, New York; J. Paul Getty, 1941; J. Paul Getty Museum, 1963.
d. *Psyché et le vannier*
(?) One of a set of five tapestries commissioned by Louis XV and delivered to the Département des Affaires Etrangères; Edward Cecil Guinness, 1st Earl of Iveagh (1847–1927), London; by descent to Walter Guinness, London; Jacques Seligmann, Paris, by 1931 (inv. 13.046); acquired by J. Paul Getty, 1938; J. Paul Getty Museum, 1963.

PUBLICATIONS
Badin 1909, p. 60; Getty/LeVane 1955, pp. 64–65, 141, 151, illus. opp. 161; M. Jarry, "A Wealth of Boucher Tapestries in American Museums," *Antiques* (August 1972), pp. 222–231; G. C. Hussman, "Boucher's *Psyche at the Basketmakers*: A Closer Look," *GettyMusJ* 4 (1977), pp. 45–50; Sassoon and Wilson 1986, nos. 217 and 220–222, pp. 102–104, illus.; Bremer-David et al., 1993, nos. 294 and 297–299, pp. 173–175, illus.; Forti Grazzini 1994, vol. 2, nos. 170–173, pp. 492–511.

NOTES
1. The tapestry was acquired in 1938 by J. Paul Getty from Jacques Seligmann, Paris. "À l'imitation d'un cadre" is quoted from stock sheet no. 13.046 of the Seligmann records and is further documented by a photograph with a duplicate inven-

tory number (JPGM Department of Decorative Arts curatorial object file 63.DD.4). The royal coat of arms was already set-in by this time.

2. Coural 1992, p. 43.

3. Fenaille, vol. 4, pp. 99–100, and Coural 1992, p. 47 n. 19.

4. Letter dated November 25, 1737, from Orry to the Beauvais manufactory (A.N. O¹ 2037) as published in Fenaille (note 3), p. 100, and Badin 1909, p. 82.

5. See E. A. Standen, "Fêtes Italiennes: Beauvais Tapestries after Boucher in the Metropolitan Museum of Art," *Metropolitan Museum Journal* 12 (1977), pp. 107–130, and "Italian Village Scenes" in Standen 1985, vol. 2, no. 78, pp. 507–533.

6. "Les desseins de l'*Histoire de Psiché* en cinq tableaux, peint par le dit sieur Boucher et fournis par ledit sieur Oudrÿ, contenant sans les bordures dix huit aunes quatre seizes non compris les rapports fait epuis par ledit sieur Oudrÿ" from "Inventaire de la Manufacture de Beauvais en 1754 (18 janvier 1754)" as published by R.-A. Weigert, "La Manufacture royale de tapisseries de Beauvais en 1754," *Bulletin de la Société de L'Histoire de l'Art Français* (1933), p. 232.

7. A. Ananoff and D. Wildenstein, *François Boucher* (Paris, 1976), vol. 1, nos. 187 and 189, pp. 306–307.

8. Factory records, however, listed the subjects differently: "L'Entrée de Spiché [sic] dans le palais de l'Amour," "Spiché abandonée par l'Amour," "La Toilette de Spiché," "Spiché et Le Vannier," and "Les Richesses de Spiché."

9. Aside from the missing canvases, cartoon strips for all five scenes remained with the Beauvais manufactory until August 1829, when they were sold along with approximately two hundred other cartoon remnants to benefit French veterans. The *directeur général des Beaux-Arts*, vicomte de La Rochefoucauld, authorized the sale, but records of buyers' names have not survived to help trace subsequent locations.

10. Ananoff and Wildenstein (note 7), vol. 1, nos. 191 and 193, pp. 309 and 311, illus.

11. Ibid., nos. 215/2 and 237/9, pp. 328 and 351, illus. The latter sold Christie's, London, July 4, 1995, lot 133.

12. *The Triumph of Venus*, Nationalmuseum, Stockholm, inv. 770. See ibid., nos. 177 and 190, pp. 296–298 and 308.

13. K. Hiesinger, "The Sources of François Boucher's *Psyche* Tapestries," *Philadelphia Museum of Art Bulletin* 72 (1976), pp. 7–23, and G. C. Hussman, "Boucher's *Psyche* at the Basketmakers: A Closer Look," *GettyMusJ* 4 (1977), pp. 45–50.

14. Boucher's drawing for the prologue is in the Musée Fabre, Montpellier. It and the Cars engraving are reproduced in Ananoff and Wildenstein (note 7), p. 7, figs. 12 and 13. Hiesinger (note 13), p. 19, fig. 9, reproduces Cars's engraving after Boucher's *L'Abandon*. See also *François Boucher*, exh. cat. (Metropolitan Museum of Art, New York, 1986), pp. 17–18, and J.-R. Pierette, *Musée du Louvre, Inventaire général des gravures Ecole française: L'Oeuvre gravé de François Boucher dans la Collection Edmond de Rothschild* (Paris, 1978), nos. 446–448, pp. 134–136.

15. Badin 1909, pp. 60 and 84–85.

16. M.N., *B-165 1740–1747*, fols. 31–37.

17. Ibid., fols. 38–48.

18. Ibid., fols. 50–57.

19. Ibid., fols. 60–64.

20. Ibid., fols. 171–184.

21. Ibid., fols. 201–210 and 218.

22. M.N., *B-166 1746–1753*, fols. 93–106.

23. M.N., *B-167 1753–1759*, fols. 175–189, and Badin 1909, p. 84. Tapestry woven upholstery covers for one "sopha" and six "fauteuils" accompanied the 1756–1758 set.

24. M.N., *B-168 1753–1763*, fols. 87–89. Badin 1909, p. 60, mentions that the commission of M. Baudon included two overdoor weavings of *L'Arrivée* and *Le Vannier*. Production records of the manufactory, however, clarify that these overdoor panels were not scenes from *L'Histoire de Psyché*. The

subjects, listed as "La Maison [sic] des Enfants" and "La Valée aux oiseaux" [sic] and woven from March to September 1759, accompanied the order for full tapestries of *L'Arrivée* and *Le Vannier*. The same overdoor scenes were also produced in 1761–1762 for M. de la Garde, who ordered three *Amours des Dieux* tapestries, and for M. Cottin, who ordered a set of *Psyché* tapestries. M.N., *B-168 1753–1763*, fols. 39, 133 and 168.

25. Manuscript of Jean Ajalbert, *Chronologue des Travaux de la Manufacture de Beauvais 1724–1801* (n.d., deposited in the Département des Objets d'Art, Musée du Louvre), p. 12, listed under "Tapisserie fabriquées de 1757–1763," nos. 4 and 20.

26. Adelson 1994, p. 353 n. 48. Manuscript of Jean Ajalbert (note 25), p. 13, "Tapisserie fabriquées de 1761–1771," no. 27.

27. Manuscript of Jean Ajalbert (note 25), p. 13, no. 28.

28. Ibid., p. 15, listed under "Tapisserie fabriquées de 1761–1771," no. 9, are *L'Entrée, La Toilette, Les Richesses*, and *Le Vannier*; and listed on p. 16 under ". . . 1769–1778," no. 4, is *L'Abandon*. Badin 1909, pp. 60, 84–85, states that only three pieces were delivered, including *Le Vannier*.

29. Between August 31 and October 26, 1743, a total of eighty-six *livres* was paid to the weavers for these additions, twelve *livres* of which covered a "tapis et planches." M.N., *B-165 1740–1747*, fol. 35.

30. This *rallonge* cost just over thirty-six *livres*, with an additional expense of twenty-one *livres* for the new lengths of border. M.N., *B-165 1740–1747*, fol. 37.

31. Consider the prices paid for vertical lengths of borders in other orders for the same series: forty-eight *livres* by the Spanish ambassador (refer to the example in the Detroit Institute of Arts, inv. 71.180 [fig. 11.7]), twelve *livres* sixteen *sous* by the city of Marseille (see the set in the Philadelphia Museum of Art, inv. 39-41-30a–d and 57-121-1), and less than three *livres* for an equal length of simple blue *galon* ("bande bleu") by the king of Sweden (see the set conserved in the Svenska Statens Samling, Stockholm).

32. *La Toilette* for the city of Rouen included six *bandes* and a *rallonge*, for a total length of eight *aunes*, seven *seizièmes*. M.N., *B-165 1740–1747*, fols. 56–57.

33. M.N., *B-167 1753–1759*, fols. 175–189.

34. Coural 1992, pp. 163–164.

35. Philadelphia Museum of Art, inv. 39-41-30a–d, bequest of Mrs. Alexander Hamilton Rice, and inv. 57-121-1, gift of Mrs. Widener Dixon and George D. Widener. See K. B. Hiesinger, "The Sources of François Boucher's *Psyche* Tapestries," *Philadelphia Museum of Art Bulletin* 72 (1976), pp. 7–23. Regarding their earlier provenance, see R. Cecil, "The Hertford Wallace Collection of Tapestries," *Burlington Magazine* (April 1956), p. 118.

Svenska Statens Samling, Stockholm, inv. HGK 161–165; each tapestry bears the woven signature BESNIER ET OUDRY A BEAUVAIS. See J. Böttiger, *Svenska Statens Samling af Väfda Tapeter, Historik och Beskrifvande Förteckning* (Stockholm, 1898), vol. 2, pp. 121–126, illus. pls. 34–37, and marks mentioned in vol. 3, pp. 52–53.

36. Inv. nos. 149, 151, 152, and 245. See C. Briganti, *Curioso itinerario delle collezioni ducali parmensi* (Milan, 1969), illus. pp. 23, 53, and 69, and mentioned in the appendix "Arazzeria de Beauvais (1664–1793)." During the nineteenth century the fifth tapestry, *L'Arrivée*, was kept separately in the art storage of Parma and was transferred first to Bologna and then to the Palazzo Pitti, Florence, in October 1865. It is possible that this tapestry is the one in the Corcoran Gallery of Art, Washington, D.C., which has a matching border and is likewise woven with BESNIER ET OUDRY A BEAUVAIS in the *galon* (William A. Clark Collection, inv. 26.259). All five tapestries share a height of 360–368 cm. See Forti Grazzini 1994, vol. 2, p. 492.

37. The suite has a border design consisting of a Greek key fret and has a Prussian eagle inside a laurel wreath located at the top center. *L'Arrivée*, *Les Richesses de Psyché*, and *La Toilette* are in the Kunstgewerbemuseum, Berlin, inv. 1985-7-9. See E. Mühlbächer's entry in *Kunstgewerbemuseum Berlin, Führer durch sie Sammlungen* (Berlin, 1988), no. 143, pp. 64–65, and illus. p. 113 (in part) and p. 191. For their modern history, see Forti Grazzini 1994, vol. 2, p. 494. According to Edith Standen, *Psyché et le vannier* is conserved in Schloss Charlottenburg, Berlin. See her "Boucher as a Tapestry Designer," in the Metropolitan Museum's *François Boucher*, exh. cat. (note 14), p. 332.

38. This identification is given in Forti Grazzini 1994, vol. 2, p. 393, which mentions that the same individual also received a set of Gobelins *Don Quichotte* tapestries in January 1745. Before Forti Grazzini's publication, varying partial identifications were provided for the coat of arms: the Galerie Jean Charpentier's Paris auction catalogue for June 4, 1937, no. 92, gave the arms as those of "Prince de Campo Florido," while the catalogue for Sotheby's, Monaco, June 19–20, 1992, no. 690, lists them as belonging to "Luigi Reggio [*sic*] Branciforte," whom it identified as "ambassador from Naples, 1757–1760"—dates that would indicate a younger family member. I thank Tracey Albainy of the Detroit Institute of Arts for her assistance in researching the coat of arms.

39. See A. Alexandre, "La Collection Cronier," *Les Arts* 47 (November 1905), pp. 1–32, illus. pp. 20–22.

40. The Detroit Institute of Arts, inv. 71.180, from the bequest of Mrs. Horace E. Dodge in memory of her husband.

41. *Le Vannier* and *L'Abandon* sold again, Sotheby's, Monaco, June 22–23, 1991, nos. 563 and 564 respectively.

42. Formerly JPGM acc. no. 68.DD.23. See Bremer-David 1993, no. 295, p. 173, which gives the provenance.

 As they share the same border design simulating a narrow carved frame, it may be possible that the *La Toilette* formerly in the JPGM, 68.DD.23, and the *L'Arrivée* from the collection of Achille Le Clerq (sold Hôtel Drouot, Paris, May 30–June 1, 1904, no. 316) were part of the same commission, probably for the city of Rouen. This conclusion is based upon the price of the border, which equaled that of the city of Marseille commission and followed the same design.

43. Thus it may be surmised that this detail was a later addition to the cartoon, and that the example formerly in the JPGM probably dates from the 1760s as well. If this hypothesis is true, then only one commission could possibly be the origin for this *Toilette*: the full set of five woven between 1761 and 1763 for M. Cottin.

 Provenance records, and a visual comparison of the stains on the Triton figure, confirm that this *Toilette* was the one sold from the collection of the duc de Gramont, Galerie Georges Petit, Paris, May 22, 1925, no. 73. Subsequent to that sale, the tapestry was reduced in size, the borders were replaced, and the woven signature *f.boucher 1749* was removed from the lower right corner. Why these alterations were carried out remains a mystery, but evidence to this effect is found on the present hanging. Very likely they occurred while in the possession of Joseph Duveen, after the Gramont sale in 1925, and before 1933, when the tapestry was published in its present appearance. If the woven signature is genuinely original to the hanging, it is the only one to appear on any known version of *La Toilette*. In any case the date 1749 cannot refer to the year of Boucher's painting, which must have been completed before 1741. Formerly JPGM acc. no. 71.DD.470. See Bremer-David 1993, no. 296, p. 173.

44. The Art Institute of Chicago, inv. 1943.1236–1237, gifts of Mrs. Chauncey McCormick and Mrs. Richard Ely Danielson. See *Selected Works of 18th Century French Arts in the Collections of the Art Institute of Chicago*, exh. cat. (The Art Institute of Chicago, 1976), no. 314a and b, pp. 198–199, illus.

I2

Les Amours des dieux: Arianne et
Bacchus et Bacchus changé en raisin

[also called Bacchus and Ariadne with Jupiter and Antiope]

Beauvais manufactory; circa 1748–1770

After cartoons painted in 1747–1748 by François Boucher
(1703–1770, premier peintre du Roi 1765). Woven on the low-
warp loom between 1748 and 1770, under the direction of Jean-
Baptiste Oudry (1686–1755, co-directeur de la Manufacture
de Beauvais 1734–1755) and Nicolas Besnier (d. 1754, maître
orfèvre 1714, co-directeur de la Manufacture de Beauvais
1734–1753) or André Charlemagne Charron (dates unknown,
directeur de la Manufacture de Beauvais 1754–1780).

MATERIALS
Wool and silk; linen interface and cotton lining

GAUGE
18 to 22 warps per inch / 88 to 120 wefts per inch

DIMENSIONS
height 11 ft. 10 in. (360.7 cm)
width 25 ft. ¾ in. (764 cm)

63.DD.6

DESCRIPTION
The series Les Amours des dieux illustrates the "loves of
the gods" from Classical mythology, particularly as these
stories were told by the Roman poet Ovid (43 B.C.–A.D.
17). This large tapestry combines two subjects that were
also woven individually. On the left is Arianne et Bacchus
(Ariadne and Bacchus), based on Ovid's Metamorphoses,
Book VIII, and a longer account in his Art of Love, Book I.
On the right is a scene that factory records referred to vari-
ously as "Bacchus changé en raisin" (Bacchus changed into
a grape) and "Jupiter en raisin," which has caused consid-
erable confusion about its subject. The scene on the left
(fig. 12.1), shows a clearing on the island of Naxos, where
the god Bacchus has arrived in his chariot to console the
weeping Ariadne. Abandoned by her lover, Theseus, she
reclines against red drapery and gazes up toward Bacchus,
her left hand holding a handkerchief to her cheek. She
wears a blue robe and a white garment that falls open at
her breast. At her side is a red casket with carved wooden
legs. Three maids attend her. One kneels at her feet and
offers a strand of pearls tied with a blue ribbon. A naked
child sleeps near the maid's lap. Two other servants peer
over the red drapery. Sitting behind Ariadne and comfort-
ing her while Theseus's ship sails into the distance, Bac-
chus wears a leopard skin and a crown of leaves and
flowers and holds a thyrsus in his left hand. There is a
commotion immediately to the right as Bacchus's chariot-
eer restrains one of the two leopards that draw the god's
gilded chariot. A child playing with grapevines cowers

between the growling wildcats (fig. 12.2). A winged putto attempts to handle the beasts' reins, while another leans over the chariot with a vine of grapes. Encircling the scene are various stone ruins: part of an Ionic colonnade, about which two putti fly with flowers; a high stone pedestal supporting a carved dolphin with two putti; and, to the left, a tumult of broken relief panels and a fallen vase. Pines and other trees and plants grow thickly to the left. In the center of the tapestry, to the right of the colonnade, is a distant view of a rocky outcrop and the sea, and in the middle ground below is a boy in a crimson tunic and yellow shirt who kneels amid brass vessels and silver plate.

The right side of the scene (fig. 12.3) shows a young woman attended by seven servants in a glade. Wearing a white dress with a pink cloak, she reclines in the foreground with two of her maids, one of them holding a flute and the other a tambourine. A male figure (sometimes interpreted as a satyr, although he displays none of the appropriate attributes) approaches from the woods. He offers the reclining woman fruit from a heavily laden basket and she reaches inside for a bunch of grapes. On the stone step to her left an overturned basket spills fruit around a theatrical mask, probably an allusion to an entertainment about to take place. Five festive attendants approach from behind, winding past a stone plinth topped with an urn; the foremost figure plays the cymbals while the second carries another basket of fruit. A taller wicker basket is placed on

the stone step to the right, and pine trees festooned with red drapery fill the background.

The border of the tapestry simulates a carved and gilded frame articulated by acanthus leaves alternating with shell motifs. Each corner is set with an asymmetrical cartouche and foliate shell. The frame's narrow inner-border consists of a string of gilded oval beads.

CONDITION

The warps of the tapestry are wool, Z spun S ply (8), while both the wool and silk wefts are Z spun S ply (2). Weaving techniques include the use of blends, which were produced by combining two yarns, each of a different color and sometimes of differing fiber, to make one-weft pairs. It is visually apparent that the tapestry has undergone a measure of uneven fading, with the right quarter, particularly in the blue silk yarns of the sky, retaining more color. A comparison of the reverse of the textile with its face cannot be made, however, due to the presence of an interface of plain-weave linen in natural color. Couched repairs have been executed through this interface layer, notably in the torso of the carved putto with the dolphin. Many small rewoven repairs occur in the blue *galon* and in the yellow-green band along the top edge, as well as along the *galon* at the right side. Some of these repairs have faded differently than the original yarns and are visibly evident.

A significant insert appears at the top center of the tapestry. Measuring twenty-two and three-quarters inches high, it incorporates both gray clouds and a section of border. The wool warps of the insert number twenty-four to twenty-six per inch; they are Z spun S ply (number of ply undetermined). The silk wefts number seventy-six per inch and are Z spun S ply (2). Under magnification, cut warps of both the tapestry and the insert are shown to be of unequal number and misaligned. All four corner motifs have also been inset, and those in the upper corners are rewoven as well. In addition to the linen interface the tapestry is also lined with a twill sateen cotton in natural color. Both the interface and the lining are attached to the tapestry with a series of stitches in a grid plan having rows of stitches every twenty-four inches.

COMMENTARY

Les Amours des dieux was the fourth tapestry series that François Boucher designed for Beauvais after his first commission from the manufactory in 1733–1735. A letter of August 12, 1747 from Jean-Baptiste Oudry (1686–1755, artistic director for Beauvais 1726–1734, and co-director of the manufactory with Nicolas Besnier 1734–1753) mentioned that Boucher had finished two unspecified models for the series.[1] The entire set consisted of nine subjects, which Boucher must have completed between 1747 and 1751 (listed here in the order given by Jules Badin): *Arianne et Bacchus, L'Enlèvement de Proserpine, Neptune et Ami-*

Arianne et Bacchus et Bacchus changé en raisin 63.DD.6

mone, Jupiter en raisin (see below), *Mars et Vénus, Borée et Orithie, L'Enlèvement d'Europe, Vulcain et Vénus* and *Apollon et Clitie*.[2] All nine cartoons were included in a factory inventory of 1754.[3]

Three canvases relating to this series now survive: *L'Enlèvement d'Europe*, which Boucher exhibited in the 1747 Paris salon; a grisaille study for *Vulcain et Vénus*; and a preparatory study for *Mars et Vénus*.[4] Several drawings by Boucher for both subjects of this tapestry have been identified. A drawing for the seated Bacchus is in the Prat collection, while sketches for the head of Ariadne and for the attendant with the child sleeping near her lap (fig. 12.4) are in the Musée du Louvre, Paris.[5] A study for the reclining figure in the right panel (fig. 12.5), and another for the woman playing cymbals, passed through Paris sales in the 1920s.[6] The figure of the boy kneeling in the middle of the tapestry is known from a drawing in the Albertina, Vienna.[7] The leopard that snarls at Bacchus's charioteer follows a painting by Oudry in the Staatliches Museum, Schwerin.[8]

There has been confusion among modern scholars regarding the subject portrayed on the right side of this double tapestry. The scene has frequently been identified as "Jupiter and Antiope," interpreting the male figure with the basket of fruit as Jupiter disguised as a satyr to seduce Antiope (*Metamorphoses*, Book VI). Although this interpretation is apparently based on the use of Jupiter's name in the Beauvais factory records, these payment sheets did not identify the scene so specifically or clearly. Indeed, the first entry for an extended tapestry with these two subjects indicates some unsureness on the part of the record keeper, who wrote: "Arianne et Bacchus dit Jupiter changé en raisin" (the word *dit* meaning "also called" or "said to be").[9] Subsequent entries for later commissions tended to abbreviate the title to "Jupiter en raisin." However, for the first royal order, which was begun shortly before September 21, 1754, the extended tapestry was registered as "Arianne et Bacchus et Bacchus changé en raisin."[10] Because this entry recorded the king's order, it is reasonable to assume that this identification is more conscientious and accurate.

While Bacchus, who appears on the left side of this double hanging, could easily be associated with the grapes being offered to the reclining female on the right side, there is no corresponding story in the ancient sources about Jupiter changing into a grape. It has been suggested that the weavers who produced the series, and in some instances joined two subjects into one hanging, may have confused Jupiter with Bacchus and merged their myths. George Leland Hunter proposed that "Jupiter en satyr" had been blended with "Bacchus en raisin."[11] Edith Standen also hypothesized that the misidentification originated in the weavers' pay sheets.[12]

In the ancient stories it was Bacchus who transformed himself into a bunch of grapes to seduce Erigone (*Metamorphoses*, Book VI). Nello Forti Grazzini persua-

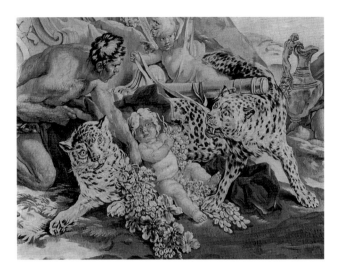

FIGURE 12.2 Detail of *Arianne et Bacchus*.

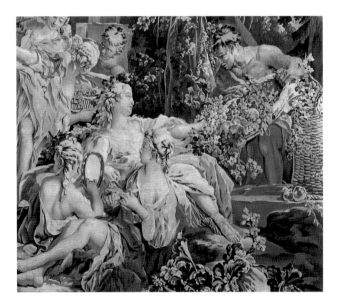

FIGURE 12.3 Detail of *Bacchus changé en raisin*.

sively argues in favor of this identification of the subject, pointing to the many details that relate to a Dionysian festival: the presence of bacchantes with cymbals and a tambourine, the herm, the theatrical mask, and the bunches of grapes. Forti Grazzini also credits the misidentification in factory records to the weavers who unwittingly substituted Jupiter for "Bacchus changé en raisin."[13]

Book VI of Ovid's *Metamorphoses*, which recounts the tale of Arachne's weaving contest with Athena, actually includes allusions to both Antiope's seduction by Jupiter in the guise of a satyr and Bacchus's appearance to Erigone in the form of grapes. These scenes, as well as the rape of Europa and other loves of the gods, were woven by Arachne into a long tapestry bordered with flowers and ivy.

It is not known exactly when the title "Jupiter and Antiope" was first applied to the scene in question. George Leland Hunter used it as early as 1925, but contemporary French auction catalogue descriptions still identified the wide double hangings by only the singular title, "Arian[n]e et Bacchus."[14] "Jupiter and Antiope" seems to have been

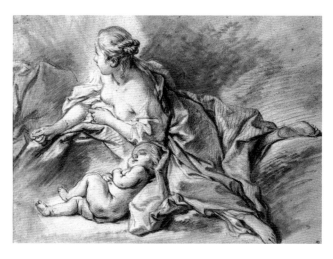

FIGURE 12.4 François Boucher (French, 1703–1770). Drawing for attendant to Ariadne. Paris, Musée du Louvre, Département des Arts Graphiques. Photo R.M.N.

FIGURE 12.5 François Boucher (French, 1703–1770). Drawing for reclining figure. Sold from the collection of E. Rodrigues, Hôtel Drouot, November 28, 1928, no. 24.

a particularly English or American identification, as demonstrated by the caption accompanying J. Paul Getty's example when it was lent to a 1942 exhibit in New York.[15] Although the Museum has traditionally followed Getty's identification and listed the title as *Bacchus and Ariadne with Jupiter and Antiope*, the male figure on the right does not appear to be a satyr, and it seems more reasonable and more iconographically consistent to use the title that was entered in the Beauvais records for the first royal commission, *Arianne et Bacchus et Bacchus changé en raisin*.

The cartoons for this series survived into the nineteenth century, still cut into strips from their use on the low-warp looms. In 1820 *Arianne et Bacchus* survived in six strips, while *Jupiter [Bacchus] changé en raisin* was in four strips. These cartoons were among the approximately two hundred sold on August 22, 1829, for the benefit of the veterans of the Napoleonic wars.[16]

WEAVER AND DATE

Records indicate that the series was produced between 1747 and about 1780, beginning with a hanging of *Arianne et Bacchus* that was started before April 29, 1747. The first example listed as "Jupiter changé en raisin" was actually half of one wide hanging, joined with "Arianne et Bacchus" and set to the looms on November 29, 1748. All of the subjects had been woven by 1751.[17]

The earliest sets were created under the joint directorship of Jean-Baptiste Oudry and Nicolas Besnier and sometimes bear their names. Four of the eight hangings made in 1750–1752 for Don Philippe de Parme, the son-in-law of Louis XV, have the woven signature, BESNIER ET OUDRY A BEAUVAIS.[18] Besnier retired in December 1753, and in 1754 Oudry continued the directorship with André Charlemagne Charron (*directeur* 1754–1780) until his own death in 1755. Both Oudry and Charron's signatures appear on examples from this series in the form OUDRY and ✤ A.C.C. BEAUVAIS, and Charron's signature is seen independently after 1755.[19]

The main elements of the border—its simulated frame with acanthus and shell motifs—appeared initially on a four-piece set of *Les Amours des dieux* ordered by the Prince d'Esterhazy in 1752.[20] This border proved to be a popular design, as no fewer than three sets ordered by Louis XV between 1761 and 1768 bore similar frames.[21] These royal commissions also carried the king's coat of arms, which consisted of a double shield surmounted by a crown and bearing the arms of France and Navarre within the collars of the orders of Saint-Michel and the Saint-Esprit (see fig. 12.6). As noted above, the Museum's tapestry has a separately woven insert at the top center. The position, shape, and size of this insert strongly suggest that it replaced a coat of arms. If this is true, then the factory production records indicate that the arms were probably

royal. Given this supposition and the style of the border, the Museum's tapestry may have been part of one of the royal commissions placed between 1754 and 1768.

RELATED TAPESTRIES

In total there were no fewer than thirty-four commissions of the *Amours des dieux*; most of these consisted of three, four, or six hangings, although the largest order, that of Don Philippe de Parme, reached nine pieces.[22] The Crown accounted for nine of the orders placed between 1754 and 1774, all of them most likely destined for the Département des Affaires Etrangères.[23] Seven of the royal orders included seat covers and some *paravent* panels *en suite*.[24]

According to the analysis of Candace Adelson, *Arianne et Bacchus* was woven nineteen times. Of these nineteen, factory records mention only two double hangings combining this subject with *Jupiter [Bacchus] en raisin*: "Tableau d'Arianne et Bacchus dit Jupiter changé en raisin," listed as on the looms from March 23, 1748, to March 3, 1749, and measuring nine Flemish *aunes* 15/16 *de cours*, for M. de Meulan; and "Arianne et Bacchus et Bacchus changé en raisin" from September 21, 1754, to February 3, 1759, measuring eleven *aunes* 14/16 *de cours*, for the

first royal order.[25] However, no fewer than seven examples of wide double hangings can be counted, each combining the same two subjects. One of these double hangings, identified by the Esterházy coat of arms, is listed in the eighteenth-century records by only one title, "Arianne."[26] One must therefore conclude that the other wide tapestries portraying two scenes were also listed by one subject only.

Comparing the count of cartoon *bandes* (strips of the cartoon canvas placed under the horizontal warps) in the descriptions of the weavers' work and payment amounts for examples of *Arianne et Bacchus* and *Jupiter [Bacchus] en raisin*, it is possible to discover wide double hangings among entries for single subjects. Ordinarily, individual hangings of *Arianne et Bacchus* were woven from four to five *bandes* (excluding additional length for borders or blue *galons*), while *Jupiter [Bacchus] en raisin* reproduced three to four *bandes* (excluding borders and *galons*). Records reveal that six of the first ten examples bearing the title "Arianne et Bacchus" (or simply "Arianne") were actually wide double tapestries that included the additional imagery of *Jupiter [Bacchus] en raisin*. For clarity, the following chart is provided to indicate double weavings:

PATRON	TITLE	NO. OF BANDES	BORDER TYPE OR PRICE	CONCLUSION
La Live	"Arianne et Bacchus"	5	blue *galons*	single hanging[27]
de Meulan	"Arianne et Bacchus dit Jupiter changé en raisin"	8	blue *galons*	double hanging[28]
Roussel	"Arianne et Bacchus"	9	blue *galons*	double hanging[29]
Don Philippe	"Arianne"	4	border at the price of 13.19.3 *livres* per vertical length	single hanging[30]
	"Jupiter en raisin"	4		single hanging
Boucher	"Arianne et Bacchus"	8	blue *galons*	double hanging[31]
Lalonde	"Arianne et Baccus"	8	blue *galons* and border for 45.13.9 *livres* per length	double hanging[32]
Esterházy	"Arianne"	9	blue *galons* and border for 42.16.3 *livres* per length (no mention of arms)	double hanging[33]
Semonville	"Jupiter changé en raisin"	3	*galons*	single hanging[34]
Thier	"Arianne"	7	*galons*	single hanging[35]
Louis XV (1st order)	"Arianne et Bacchus et Bacchus changé en raisin"	9	border for 43.19.3 *livres* per length with royal arms at the added cost of 4.7.6 *livres*	double hanging[36]
Louis XV (2nd order)	"Arianne et Baccus"	9	border as above, but royal arms at the cost of 17.0.6 *livres*	double hanging[37]
d'Ormesson	"Arianne et Baccus"	8	*galons*	single hanging[38]
Louis XV (3rd order)	"Arianne et Baccus"	9	border as per royal orders above and arms costing 17.0.6 *livres*	double hanging[39]

FIGURE 12.6 Beauvais manufactory (French, 1754–1774). *Arianne et Bacchus et Jupiter [Bacchus] changé en raisin* from the *Tenture des Amours des dieux*. Kunstindustrimuseet, Copenhagen. Photo Ole Woldbye.

The records show that there were at least three double hangings of *Arianne et Bacchus* with *Jupiter [Bacchus] en raisin* woven with the French royal coat of arms (and there may be additional double weavings entered in the records under only one title that have not yet been identified). At present only two examples of this group with the Bourbon arms have been traced. One of these sold from the collection of Madame Cibiel, Hôtel Drouot, Paris, June 30, 1919, no. 22; bearing the same border as the Museum's tapestry, its present location is unknown. The other is in the Kunstindustrimuseet, Copenhagen. It has a similar border except for cartouches in the corners rather than foliates (fig. 12.6).[40]

In addition to the Museum's tapestry and the Esterházy example (now lost), three more double weavings with both *Arianne et Bacchus* and *Jupiter [Bacchus] en raisin* are known: one at the Musée des Beaux-Arts, Chartres, bordered only with a blue *galon*[41]; one at the Württembergisches Landesmuseum, Stuttgart, woven with the same border as the Museum's and bearing the signature ♣ A.C.C. BEAUVAIS[42]; and the third (without borders) sold Sotheby's, London, June 4, 1971, lot 10.

Edith Standen and Nello Forti Grazzini have listed the locations of six tapestries representing the single scene of *Arianne et Bacchus* and five versions of *Jupiter [Bacchus] en raisin*, as well as examples from the other seven subjects in the series. To their list may be added: a *Vulcain et Vénus* with the signature *f.boucher 1749* woven backwards on a casket, which was formerly in a Los Angeles private collection in 1991 and sold Sotheby's, New York, January 13 and 15, 1992, lot 564; and a wider example of the same subject, extended with the addition of a "grand rapport" showing another two male figures and two swans and bearing the backwards signature of Boucher, sold by

1988 from the Paris dealer Jacqueline Boccara to a private collector.[43] There is also a *L'Enlèvement de Proserpine*, woven with ♣ A.C.C. BEAUVAIS, that was formerly in the collection of Antenor Patiño and sold Sotheby's, New York, November 1, 1986, lot 139, which sold again Christie's, New York, January 11, 1994, lot 205.

PROVENANCE

(?) One of a set commissioned by Louis XV and delivered to the Département des Affaires Etrangères; (?) Royal Family of Portugal[44]; Jules Paul Porgès, Portugal and later Avenue Montaigne, Paris; C. Ledyard Blair; French and Company, New York, 1937; J. Paul Getty, 1937; the J. Paul Getty Museum, 1963.

EXHIBITIONS

French and English Art Treasures of the United States, Parke-Bernet Galleries, New York, December 20–30, 1942, inv. 241, p. 39; lent by J. Paul Getty.

PUBLICATIONS

Badin 1909, pp. 61–62; G. L. Hunter, "Beauvais-Boucher's Tapestries," *Arts and Decoration* (March 1919), p. 246; Hunter 1925, p. 173; idem, "America's Beauvais-Boucher Tapestries," *International Studio* (November 1926), pp. 20–28, illus.; Göbel 1928, part 1, p. 227; Getty/Le Vane, pp. 65–67, 150, illus. opp. 209; E. Zahle, "François Boucher's dobbelte billedavaening," *Det Danske Kunstindustrimuseum: Virksomhed* 3 (1959–1964), p. 68; M. Jarry, "A Wealth of Boucher Tapestries in American Museums," *Antiques* (August 1972), pp. 222–231, illus. p. 223, fig. 2; Standen 1985, vol. 2, pp. 534–543; idem, "The *Amours des Dieux*: A Series of Beauvais Tapestries after Boucher," *Metropolitan Museum Journal* 19/20 (1986), pp. 63–84, illus. p. 69; Sassoon and Wilson 1986, no. 216, p. 102, illus.;

Bremer-David et al., 1993, no. 291, pp. 171–172, illus.; Forti Grazzini 1994, vol. 2, nos. 174–177, pp. 512–530; Adelson 1994, no. 20, pp. 343–354.

NOTES

1. "Le S^r Bouché me fais actuellement des tableaux pour une tenture qui represente les amours des dieux qui sera tres belle: illy a deja deux tableaux de fait," as published by J. Böttiger, *La Collection des tapisseries de L'Etat Suédois* (Stockholm, 1898), vol. 4, p. 96. See E. A. Standen, "Boucher as a Tapestry Designer," *François Boucher, 1703–1770*, exh. cat. (The Metropolitan Museum of Art, New York, 1986), p. 328.

2. Badin 1909, pp. 61 and 105.

3. R.-A. Weigert, "Las Manufacture royale de tapisseries de Beauvais en 1754," *Bulletin de la Société de l'histoire de l'art français* (1933), p. 233, and Standen 1985, vol. 2, no. 79, p. 534.

4. The painting of *L'Enlèvement d'Europe* is now in the Musée du Louvre, Paris, inv. 2714. The tapestry cartoon differed slightly from the canvas. See *François Boucher, 1703–1770* (note 1), no. 54, pp. 237–240. The *Vulcain et Vénus* grisaille is also conserved in the Musée du Louvre, Paris, inv. M.I. 1025. See Compin and Roquebert 1986, vol. 3, p. 81. Edith A. Standen reproduces the study for *Mars et Vénus* from the collection of the Fitzwilliam Museum, Cambridge, in "The Amours des Dieux: A Series of Beauvais Tapestries After Boucher," *Metropolitan Museum of Art Journal* 19/20 (1986), pp. 63–84, fig. 10.

5. The drawing of Bacchus is reproduced in P. Rosenberg, *Dessins français de la collection Prat: XVII^e, XVIII^e, XIX^e siècles*, exh. cat. (Musée du Louvre, Paris, 1995), no. 38, pp. 110–111. For the sketches of Ariadne and her attendant, see A. Ananoff and D. Wildenstein, *François Boucher* (Lausanne and Paris, 1976), vol. 2, no, 344, p. 43, figs. 998 and 1000.

6. A. Ananoff, *L'Oeuvre dessiné de François Boucher (1703–1770), catalogue raisonné* (Paris, 1966), vol. 1, no. 900, p. 233, and no. 747, pp. 194–195, figs. 153 and 122.

7. Ananoff and Wildenstein (note 5), vol. 2, no. 344, p. 42, fig. 996.

8. See Standen 1985, vol. 2, no. 79, p. 540 and fig. 61.

9. M.N., *B-166 1746–1753*, fol. 51.

10. M.N., *B-167 1753–1759*, fols. 92–95.

11. Hunter 1925, pp. 172–175.

12. E. A. Standen (note 4), pp. 63–84, n. 28.

13. Forti Grazzini 1994, vol. 2, pp. 519–523.

14. Hunter (note 11), pl. XIA, opp. p. 159.

15. See *French and English Art Treasures of the United States*, exh. cat. (Parke-Bernet Galleries, New York, December 20–30, 1942), no. 241, p. 39, lent by J. Paul Getty.

16. Badin 1909, pp. 47 and 105. See also Coural 1992, p. 47, n. 27.

17. Consulting the archives of the Manufacture Nationale de Beauvais at the Mobilier National, Paris, Candace J. Adelson has been able to correct and clarify the production chronology of *Les Amours des dieux* originally set forth by Jules Badin. See Adelson 1994 no. 20, pp. 343–354. One volume of records was unavailable to her, so the single weaving of *Neptune et Amimone* for M. Janel (February 9, 1760, to June 10, 1761) was omitted. M.N., *B-168 1753–1765*, fol. 132.

18. They are now in the Palazzo del Quirinale, Rome. See C. Briganti, "Arazzia de Beauvais (1664–1793)," an appendix in *Curioso itinerario delle collezioni ducali parmensi* (Milan 1969), illus. pp. 25 and 47.

19. Both Oudry and Charron's names can be seen on *Vulcain et Vénus* and *Arianne et Bacchus* in the Metropolitan Museum of Art, New York (inv. 22.16.1,2). Reproduced in Standen 1985, vol. 2, no. 79, pp. 534–543.

20. M.N., *B-166 1746–1753*, fols. 219–233.

21. See Adelson 1994, no. 20, p. 348, where she observes that the border of *Apollo and Clytie* in the collection of the Minneapolis Institute of Arts must be very similar to the borders of the third (1761–1762), fourth (1763–1767), and fifth (1764–1768) orders of the French Crown.

22. See Forti Grazzini 1994, vol. 2, nos. 174–177, pp. 512–530, where the author gives the title *Bacco ed Erigone* to no. 175.

23. One of the earliest diplomatic presentations of a set of *Amours des dieux* originated as a loan made in 1763 by Louis XV to the comte de Beauteville, future ambassador to Switzerland. The gift was officially recorded in September 6, 1775, at the value of 14,590 *livres*. See A. Maze-Sencier, *Le Livre des Collectionneurs* (Paris, 1885), p. 335. See Coural 1992, p. 164, for a summary of tapestries from *Les Amours des dieux* that became "présents du Roi" sent by the Ministère des Affaires Etrangères.

24. "Relevé des Fournitures Faites aux Affaires Etrangères et sur des Ordres Particuliers du Roy par Le Sieur Charron," as published in Badin 1909, pp. 84–85. As of September 1737, Beauvais had an agreement with the Crown to deliver to the storerooms of the Département des Affaires Etrangères two complete tapestry sets each year, at the expense of the king. See Coural 1992, p. 43.

25. M.N., *B-166 1746–1753*, fols. 50–51, and *B-167 1753–1759*, fols. 92–95.

26. See note 20 above. Weavers of the four tapestries that were commissioned by the Prince d'Esterházy and bear his arms were paid from May 20, 1752, to September 28, 1754. The piece listed simply as "Arianne" in the records actually included *Jupiter [Bacchus] en raisin* on the right hand side. See M. Vaucaire, "Les Tapisseries de Beauvais sur les cartoons de F. Boucher," *Les Arts* (August 1902), pp. 10–15, illus. pp. 16–17. This set of tapestries was lost during World War II.

27. M.N., *B-166 1746–1753*, fol. 16.

28. M.N., *B-166 1746–1753*, fols. 50–52. The manuscript index identified this as "Arianne et sa suite."

29. M.N., *B-166 1746–1753*, fols. 55–58. Like the preceeding, the manuscript index identified this as "Arianne et sa suite."

30. M.N., *B-166 1746–1753*, fols. 137–138 and 143–144.

31. M.N., *B-166 1746–1753*, fols. 157–158.

32. M.N., *B-166 1746–1753*, fols. 206–208 and 241.

33. M.N., *B-166 1746–1753*, fols. 219–222.

34. M.N., *B-167 1753–1759*, fol. 12.

35. M.N., *B-167 1753–1759*, fols. 82–84.

36. M.N., *B-167 1753–1759*, fols. 92–95.

37. M.N., *B-167 1753–1759*, fols. 190–192.

38. M.N., *B-168 1753–1763*, fols. 115–117, payments made from September 22, 1759, to April 4, 1761. Although this hanging was eight *bandes* wide, it could have represented only *Arianne et Bacchus* since the work for the seventh *bande* included Bacchus's *tigres* (leopards).

39. M.N., *B-168 1753–1763*, fols. 181–183, payments made from April 18, 1761, to November 19, 1763.

40. Sold from the collection of Alexis Polovtsoff, Galerie Georges Petit, Paris, December 2–4, 1909, no. 241; sold by the Duke of Roxburghe, Christie's, London, May 31, 1956, lot 166. E. Zahle, "François Boucher's dobbelte billedavaening," *Det Danske Kunstindustrimuseum: Virksomhed* 3 (1959–1964), p. 68.

41. Musée des Beaux-Arts de Chartres, inv. 11428, measuring 298.5 cm by 670 cm. It entered the museum collection in 1945.

42. Sold Palais des Beaux-Arts, Brussels, November 21, 1972, no. 212.

43. J. Boccara, *Ames de laine et de soie* (Saint-Just-en-Chausée, 1988), p. 101, illus. without borders.

44. Information from Getty/Le Vane 1955, pp. 65–67, 150.

Savonnerie Manufactory

13

Carpet

Savonnerie manufactory, Paris; circa 1665–1667

Designer unknown; made in the Chaillot workshop of Simon Lourdet (circa 1595?–1667?) and Philippe Lourdet (active before 1664, died 1671).

MATERIALS
Wool and linen; modern cotton lining

GAUGE
100 Turkish knots per square inch in inner field; 64 to 81 Turkish knots per square inch in replacement borders

DIMENSIONS
length 22 ft. (670.56 cm)
width 14 ft. 5¼ in. (440.06 cm)

70.DC.63

DESCRIPTION
Framed by a broad floral border, the carpet has a blue-black ground color. Its inner field is strewn with flowers and divided by thick rinceaux that scroll outward from a centralized oval cartouche. Centered in the open cartouche, and surrounded by a spray of leaves and flowers that includes convolvulus, ranunculus, hydrangea, and iris, is a prominent yellow and orange sunflower, symbol of the Sun King, Louis XIV (fig. 13.1). A blue ribbon laced into the cartouche frame forms ties with the four pairs of cream-colored acanthus scrolls that swirl toward the four corners of the inner field. The blue ribbon also loops through the rings of four vessels located inside each pair of rinceaux (fig. 13.2). These four lobed urns contain tall floral arrangements of two patterns, each appearing diagonally opposite its duplicate. Between the pairs of rinceaux are an additional four basins, filled with flowers and fruit and composed in two designs. The two basins located on the carpet's long axis are each designed with a leafy face on an elongated stem that connects to the central cartouche, while the two basins oriented on the shorter distance of the width are nested into the cartouche's sides. The carpet's rectangular inner frame has a repeating design of stylized blue and cream leaves against stripes of pink and yellow, and red and white leaves against stripes of green and white. Its main border contains floral bunches interspersed with baskets, silver basins, and Chinese porcelain bowls filled with flowers and fruit. These baskets are of open wicker-work with blue ribbons tied in bows at each handle; the basins are cast with lion's heads (three are visible on each) with rings hanging from their mouths; the Chinese bowls

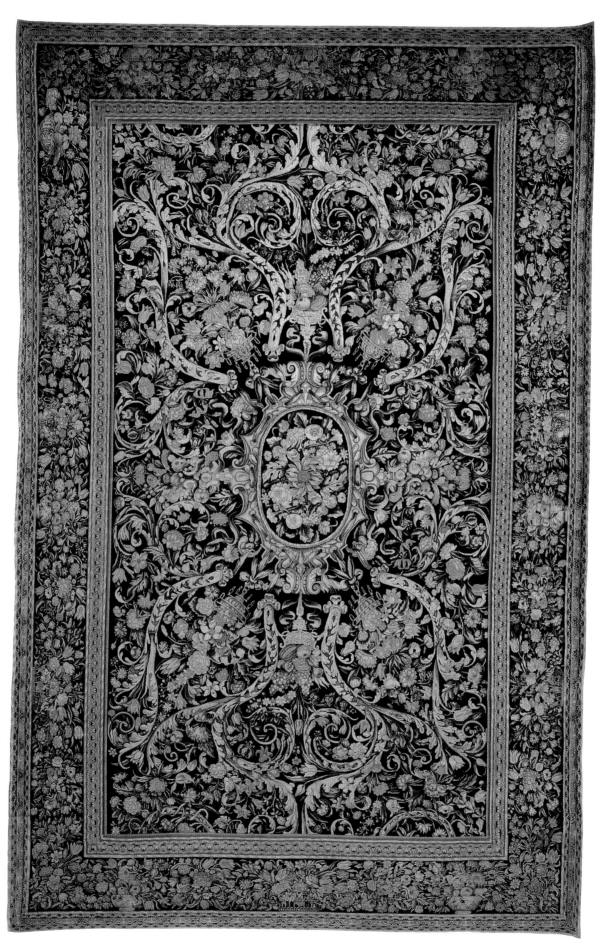

Carpet 70.DC.63

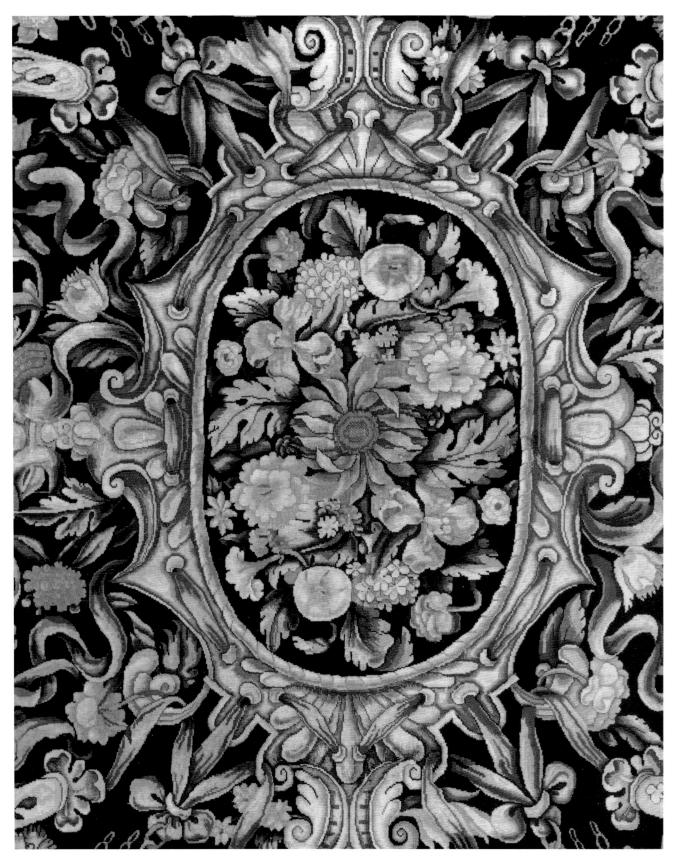

FIGURE 13.1 Detail of center with sunflower.

are white and decorated in blue with scenes of waterfowl or panels of floral ornament (figs. 13.3 and 13.4). The carpet's outside frame is composed of a series of concentric rectangular bands: two strips of cream-colored edging, striped diagonally with pink ribbons, enclose another two bands that undulate with blue and white stylized leaves, and these, in turn, surround a white and yellow band with a chain of blue flowers strung together by their green and orange leaves.

CONDITION

The warps of this knotted carpet are wool, Z spun S ply (3); there are twenty warps per inch. The knots were made in the Turkish technique,[1] and the pile fiber is wool, Z spun S ply (number of ply undetermined), with the inner field numbering 100 knots per square inch (ten knots per vertical inch and ten knots per horizontal inch). There are two to three linen wefts, Z spun S ply (2?), between each row of knots. The direction of the pile within the main field is parallel to the carpet's long axis—meaning that the carpet was knotted on the loom along its shorter dimension. Sometime around 1890, the carpet's length was reduced and an area of approximately thirty-four inches at each end was reknotted.[2] The addition of the rewoven border at each end creates both a visual and a planar delineation along the join (fig. 13.5). The warps of the addition appear to be linen, Z spun S ply, and the double rows of linen weft are also Z spun S ply. There are sixteen to twenty warps per inch in these additions. The fiber of the knotted pile of the newer sections is wool, Z spun S ply, and the knots number 64 to 81 per square inch (eight to ten knots per vertical inch and eight to ten knots per horizontal inch). The direction of the pile in the borders varies. The carpet's color is good overall, but the rewoven borders have darkened to a greater degree than the main body. This color discrepancy may be due to the different chemical compositions of the nineteenth-century dyes, but it is also possible that it results from the new wools having been matched to a dirty seventeenth-century carpet that was subsequently cleaned. Comparing the front of the carpet to the back, the orange tones have suffered some color loss, while the yellow-gold and blue-black tones remain remarkably bright. The carpet is unevenly worn, with some loss to the pile in the lighter colored scrolls and flowers of the inner field. A number of small repairs occur throughout the blue-black ground. Backing the carpet is a modern cotton lining.

COMMENTARY

Stylistically this carpet dates from the early period of Savonnerie production, circa 1650–1665, when two separate workshops were in operation under a joint patent to produce carpets "au façon du Levant." The Louvre workshop of the Dupont family had been founded in 1604 or 1608 by Pierre Dupont (circa 1577–1640), and was operated after 1640 by his son Louis (active 1639–1687). The work-

FIGURE 13.2 Detail.

shop at the Chaillot location was in operation from 1626, when Pierre Dupont's ertswhile apprentice, Simon Lourdet (circa 1595–1667?), had begun training orphans to make knotted textiles in a building that once housed a soap factory—hence its name Savonnerie. In 1664, at the prompting of Jean-Baptiste Colbert (1619–1683), the king granted an entirely new and separate contract to Simon Lourdet and his son Phillipe (d. 1671), reorganizing the Chaillot Savonnerie along the lines of the royal manufactory that Colbert was establishing at the Gobelins. (It was not until 1671, when the Duponts left the Louvre galleries for the Chaillot manufactory, that the two families combined their enterprises at one site; in 1673 the workshops were acquired by Louis XIV.)

Both floor and table carpets survive from this early phase of Savonnerie production, and they are characterized by a ground of black or dark blue, or occasionally brown, that is strewn with colorful single flowers or floral sprays, often entwined with blue ribbons.[3] The inner field of these carpets is surrounded by a broad border, also filled with flowers. In some instances open cartouches, woven baskets, and rinceaux were added. The absence of records makes it difficult to distinguish the work of the Chaillot atelier from that of the Louvre, and it is hard to determine the designer(s) of the cartoons. Pierre Verlet has suggested that design elements in these carpets were drawn from contemporary engraved designs for embroidery and passementerie work; his argument is strengthened by the knowledge that Pierre Dupont and his successors were professional embroiderers as well as weavers.[4]

FIGURE 13.3 Detail of border.

FIGURE 13.4 Detail comparing a section from the border reknotted at the end of the nineteenth century.

FIGURE 13.5 Detail showing the join of the reknotted border.

The Chinese blue and white porcelain bowls on this carpet are early portrayals in textile of the oriental wares that were imported in large quantities to France through European trading companies. Louis XIV and his court were avid collectors of oriental ceramics, although the *Inventaire du Mobilier de la Couronne* does not enlighten the reader as to the particular kinds of porcelain found in the royal collection. Only shape and quantity are mentioned but not decoration or color.[5] Nevertheless, even before the trade delegations of the Siamese ambassadors in 1684 and 1686, the French Crown was commissioning works of art influenced by these ceramics. Most notable among them was the small pavilion known as the Trianon de Porcelaine, 1670–1677. Erected in the park of Versailles, this structure had earthenware tiles imitating the decoration of blue and white Chinese ceramics. The bowls on the carpet probably represent Ching ware from the reign of Emperor Shun Chi 1644–1661, which was made in the earlier Ming style of the fifteenth century.

WEAVER AND DATE

Before this carpet was shortened in the late nineteenth century, it may have been considerably longer than other carpets dating from the early years of Savonnerie production. Its unaltered width of 440 cm seems to match that of only one other, a carpet that was documented as three and two-thirds French *aunes* wide (ie., 440 cm or 14 ft. 5 in.) and seven and one half *aunes* long (892 cm or 29 ft. 3¼ in.). By comparison, a Savonnerie carpet with similar design elements was listed in the 1653 inventory of Cardinal Mazarin (1602–1661) as measuring approximately five *aunes* in length—a full nine and one half feet (297 cm) shorter.[6] Only one carpet woven to this exceptional width and length was recorded in the *Inventaire du Mobilier de la Couronne* (see below) before the thirteen carpets commissioned by Louis XIV for the Gallerie d'Apollon in the Palais du Louvre were delivered in 1667. The length of these latter carpets, seven and three-fourths *aunes* (922 cm), was determined by the dimension of the room.

To conserve space in the crowded workshops, the looms were constructed so that the carpets were woven along their shorter dimension. Theoretically, a weaver could continue making a carpet to any length desired, as the finished section was wound around a horizontal roll at the base of the loom. However, the weight of the knotted carpet was so great that it came to restrict the potential length

FIGURE 13.6 Savonnerie manufactory (French, 1660–1665). *Carpet*. New York, the Metropolitan Museum of Art, Gift of Mr. and Mrs. Charles Wrightsman, inv. 1983.268.

FIGURE 13.7 Savonnerie manufactory (French, circa 1650–1665). *Carpet*. New York, the Metropolitan Museum of Art, Gift of Mr. and Mrs. Charles Wrightsman, inv. 1976.155.111.

of a carpet by causing stress to the wooden beams of the loom. Only the construction of a stronger loom permitted an increase in length. This was accomplished in 1665 under the direction of Jean-Baptiste Colbert in his role as *surintendant du Bâtiments, Arts et Manufactures*. The Museum's carpet may well have been among the first long examples woven on the stronger loom when it was newly installed in the Lourdets' Chaillot workshop. Verlet considers these first attempts as trials, woven according to the familiar older pattern, in preparation for executing the Galerie d'Apollon commission.[7] The *Inventaire du Mobilier de la Couronne* records the delivery of a carpet of this description in 1667:

> *18—Un grand tapis neuf de la Savonnerie, fonds brun, parsemé de grands rinseaux blanc et de fleurs au naturel, ayant au milieu un cartouche ovalle dans lequel il y a un feston de fleurs avec un tournesol au milieu dudit feston, dans une bordure aussy fonds brun avec des corbeilles et vases de fleurs, long de sept aunes ½, large de trois aunes ⅔.*[8]

It is important to note that the words "fonds brun" described a rich deep blue or black color in the seventeenth century. This ground still survives in relatively unfaded condition on carpets that can be unmistakably identified in royal inventories, such as the known examples

made for the Galerie du Bord de l'Eau of the Palais du Louvre. These all have a deep blue or black ground that the *Inventaire du Mobilier de la Couronne* recorded as "fonds brun." Later, in the eighteenth century, the term "brun" came to describe a chestnut brown color.[9]

RELATED CARPETS

This carpet may be compared to several groups of other Savonnerie weavings which have in common a dark ground of blue-black color, or occasionally brown, and similar ornaments with the customary flowers. The first group all have an inner field whose center is composed of a floral wreath entwined with a blue ribbon that encircles a spray of blossoms, the most prominent being a yellow sunflower. Extending along the length to either side of the wreath are brass urns holding floral arrangements. The borders vary, having either symmetrically placed open cartouches[10] or wicker baskets of flowers.[11] The second group of comparative examples have in common an inner field punctuated by large scrolling acanthus leaves that stretch to each corner from a central oval cartouche. There are a variety of subtle design differences among them, but they and this particular carpet probably derived from a single cartoon (fig. 13.6).[12] Having established a common cartoon for the inner field, it

is also possible to suggest a source for the surrounding wide frame. A strikingly similar border appears on a carpet conserved in the Metropolitan Museum of Art (fig. 13.7).[13] The latter has a central rectangular field dominated by a floral wreath that encircles a spray of flowers, but in both carpets the borders feature porcelain bowls along with flower-filled wicker baskets and silver basins. Carpets having only silver basins and wicker baskets in their outer fields also survive.[14]

PROVENANCE

Garde-Meuble de la Couronne, by 1667; loaned from the Garde-Meuble to the Church of Saint-André-des-Arts, Paris, 1769 (where its dimensions still matched those of the 1667 royal inventory)[15]; Parguez-Perdreau, Paris, March 1914; Arnold Seligmann, Paris, March–June 1914[16]; George A. Kessler, June 1914[17]; Mortimer L. Schiff, New York; sold by his heir John M. Schiff, Christie's, London, June 22, 1938, lot 77; acquired at that sale by J. Paul Getty; J. Paul Getty Museum, 1970.

PUBLICATIONS

Guiffrey, *Inventaire*, vol. 1, no. 18 (?), p. 378; "Die Auktion Der Kunstsammlungen Mortimer L. Schiff," *Pantheon, Monatsschrift für Freunde und Sammler der Kunst* (August 1938), p. 258; Getty/Le Vane, p. 157; P. Verlet et al., *Chefs-d'Oeuvre de la Collection J. Paul Getty* (Monaco, 1963), pp. 134–135, illus.; Verlet 1982, p. 174, and p. 421, nn. 5 and 11; Wilson 1983, no. 1, pp. 2–3, illus.; Sassoon and Wilson 1986, no. 226, p. 108, illus.; Bremer-David et al., 1993, no. 280, p. 164, illus.

NOTES

1. See the Victoria and Albert Museum publication, C. E. C. Tattersall, *Notes on Carpet Knotting and Weaving* (London, 1969), pl. 1, "The Turkish and Single-Warp Knots."
2. JPGM object file note quoting the diary of J. Paul Getty, "April 13, 1949: Mitchell Samuels said the Louis XIV carpet has two feet at each end rewoven, done superbly about sixty years ago."
3. An example of a carpet with a brown field sold Hôtel George V, Paris, June 27, 1973, no. 121.
4. Verlet 1982, pp. 163–166. Verlet also mentions the influence of acanthus leaf designs in grisaille by Jacques Androuet du Cerceau the Elder, and he traces the motif back to Annibale Caracci who used it in the Palazzo Farnese. See pp. 426–427 n. 76, as well as p. 379 n. 47. For comparative embroidery work, see the embroidered hanging sold at Drouot Richelieu, Paris, February 6, 1995, no. 115, illus. in color on the cover.
5. Guiffrey, *Inventaire*, vol. 2, pp. 85–91 (covering the period 1681–1718). For a more detailed inventory of a contemporary princely collection, see F. Watson and J. Whitehead, "An Inventory Dated 1689 of the Chinese Porcelain in the Collection of the Grand Dauphin, Son of Louis XIV, at Versailles," *Journal of the History of Collections* 3 (1991), pp. 13–52, particularly pp. 46–47, where bowls with blue and white decoration are discussed.
6. Verlet (note 4), p. 166.
7. At the time there was considerable urgency to refine loom technology, both to reduce the cost of carpet production and

to find more efficient means to meet the increased production demands made by the scale and scope of the king's new projects. The commission for thirteen carpets for the Galerie d'Apollon was followed by the extravagant program for the Galerie du Bord de l'Eau, which called for nearly one hundred carpets and would occupy the manufactory for nearly twenty years. Not only was a stronger loom required to produce these longer carpets, but a larger one as well. In the case of the Museum's carpet for the Galerie du Bord de l'Eau (see cat. entry No. 14), the carpet's orientation was changed from vertical to horizontal on a loom that stretched some thirty feet in width. Apparently this was done in order to accommodate several weavers operating together on a single carpet, thus speeding its production.

8. Guiffrey, *Inventaire* vol. 1, no. 18, p. 378. Verlet (note 4), p. 174, and p. 421 nn. 5 and 11.
9. Verlet (note 4), p. 231, and p. 426 n. 70. See cat. entry No. 14.
10. Two examples passed through the art market: (1) sold Hôtel George V, Paris, June 27, 1973, no. 121 (400 cm by 270 cm); (2) sold Palais Galliera, Paris, November 24, 1976, Supplement catalogue, no. E (380 cm by 275 cm), and sold again (?) Sotheby's, New York, October 14, 1988, lot 94 (478 cm by 295 cm).
11. Sold from the collection of Mrs. Hamilton Rice, Parke Bernet Galleries, New York, October 22–23, 1965, lot 352 (14 ft. by 10 ft. 7 in.). An example with open cartouches and baskets of flowers in the border, but without the brass urns in the main field, was with the Paris dealer Fabre in 1927; see *Tapis de la Savonnerie*, exh. cat. (Manufacture Nationale des Gobelins, Paris, 1927) no. 86, illus.
12. (1) Collection of the comte Patrice de Vogüé, Château de Vaux-le-Vicomte; (2) private collection, New York [see Verlet (note 4), p. 173, fig. 107]; (3) sold from the collection of Mrs. John E. Rovensky, Parke Bernet, New York, January 15–19, 1957, lot 833 (18 ft. 6 in. by 13 ft. 2 in.); offered for sale by Mr. and Mrs. Dean Johnson, Sotheby Parke Bernet, New York, December 9, 1972, lot 155 (18 ft. 6 in. by 12 ft. 7 in. or 563 cm by 384 cm); sold Sotheby Parke Bernet, Monaco, February 11–12, 1979, no. 300; (4) Metropolitan Museum of Art, New York, inv. 1983.268 (241 cm by 142 cm). See *The Metropolitan Museum of Art: 140th Annual Report* (New York, 1983–1984), p. 31.
13. The Metropolitan Museum of Art, New York, the Wrightsman Collection, inv. 1976.155.111. See F. J. B. Watson, *The Wrightsman Collection* (New York, 1966), vol. 2, no. 276, p. 492, illus. (370.8 cm by 254 cm). Sold from the collection of Madame la Baronne de H . . . , Galerie Georges Petit, Paris, June 17, 1904, no. 66. See also Verlet (note 4), p. 82, fig. 44, where he dates the carpet to circa 1660.
14. Musée Nissim de Camondo, Paris, inv. 177. See F. Mathey, *Union Centrale des Arts Décoratifs: Musée Nissim de Camondo* (Paris 1990), no. 177, p. 41, illus. p. 39, or N. Gasc and G. Mabille, *Musées et Monuments de France: The Nissim de Camondo Museum* (Paris, 1991), pp. 90–92, illus. A similar carpet sold from the collection of Madame de Polès, Galerie Georges Petit, Paris, June 22–24, 1927, no. 308 (263 cm by 252 cm). Another is in the Metropolitan Museum of Art, New York. See Watson (note 13), vol. 2, no. 275, p. 490, illus. (640 cm by 365.7 cm).
15. A.N., O¹3345, fol. 10, inventory compiled between 1769 and 1775. Verlet (note 4), p. 421 n. 11.
16. Information regarding the sequence of owners in 1914 is taken from correspondence between Arnold Seligmann et Fils and J. Paul Getty, dated 1938, in the object file, JPGM.
17. For a description of Mr. Kessler and his relationship with the Seligmann family, see G. Seligman, *Merchants of Art* (New York, 1961), p. 84. I am grateful to Theodore Dell for bringing this reference to my attention.

14

Carpet for the Galerie du Bord de l'Eau, Palais du Louvre

Savonnerie manufactory, Paris; by 1680

Made in the Chaillot workshop of the Lourdet family after a design of François I Francart (1622–1672) and Beaudrin Yvart *le père* (1611–1690) according to a scheme of (?) Charles Le Brun (1619–1690) and/or Louis Le Vau (1612–1670, *premier architecte du Roi* 1654), and delivered May 3, 1680, by the *veuve* Philippe Lourdet (*née* Jeanne Haffrey, widow of Lourdet).

MATERIALS
Wool and linen, modern cotton lining

GAUGE
100 Turkish knots per inch in inner field

DIMENSIONS
length 29 ft. 9¾ in. (908.6 cm)
width 15 ft. 7 in. (472.1 cm)

85.DC.515

DESCRIPTION

Surrounded by a border simulating a picture frame, this long rectangular carpet has a black ground figured with scrolling rinceaux. Its symmetrical design is dominated by a large lobed medallion in the center that encircles a smaller octagonal plaque and is flanked on either side by two more octagonal plaques. The lobed medallion contains military trophies against a brown ground (known as "tanné couleur de minime").[1] It functions as an elaborate framing device for the smaller octagonal compartment, which has a cream-colored field filled with a design based on the monogram of Louis XIV. Consisting of two pairs of interlaced L's formed from tan, blue, green, and white acanthus scrolls, the monograms support four heraldic royal crowns. A border outlines the octagon, figured with smaller tan, blue, and white scrolls within two yellow frames. In the area surrounding the octagonal plaque the military trophies include four cuirasses with square quivers of arrows emerging from their neck openings, four metal shields, eight standards, and four battering rams with wolf heads. Centered among the trophies, one to each side of the octagon, are two large, ovoid urns decorated with two ram's heads and four ram's hoof legs. A flame burns from each urn, and lances and quivers of arrows rest behind them. Draping the urns is a long floral garland that threads through the cuirasses and trophies and loops into the volutes of the outer frame of the large medallion. This lobed frame is articulated with a chain of linked C's and is set with tan, white, and blue acanthus leaves. Two ceremonial helmets, crested with blue

FIGURE 14.1 Detail.

and white ostrich feathers, rest opposite one another on the medallion's frame. In the other direction, on the carpet's long axis, the frame is garnished with four smaller urns, their yellow color highlighted against the black ground (fig. 14.1). Originating in the medallion frame are large acanthus leaves that extend as rinceaux into the black field, punctuated at their ends with rosettes. Four small bunches of flowers are suspended by blue ribbons from the short rinceaux near the lobed frame, and the long rinceaux are draped with floral garlands at either end of the carpet. Two cameo-like octagons in grisaille—or "gris de lin"—are centrally placed in the two outside panels of the carpet's tripartite design. In imitation bas-relief, these two plaques each represent a female allegorical figure. In one (fig. 14.2), the woman extends her hand to an eagle with outstretched wings; in the other (fig. 14.3), the figure holds a rectangular metallic shield or mirror. Green laurel leaf wreaths frame each plaque. The picture-frame border around the

outside of the carpet consists of a narrow yellow band of palmettes, a wide band having yellow gadroons alternating with two linked blue leaves, and another narrow band of yellow and cream guilloche. A fleur-de-lys is placed in each of the four corners.

CONDITION

The warps of this knotted pile carpet are wool, S ply (6?); the spin is unclear but probably Z. There are twenty to twenty-four warps per inch. Units of eighteen white warps are followed by two brown warps to mark each ten knots or *dizaine*.[2] Knotted in the Turkish technique, each knot consists of two wool yarns, Z spun S ply (3). In the inner field the knots number 100 per square inch (10 knots per vertical inch and 10 knots per horizontal inch), but this count drops to 80 to 88 in the border (8 knots per vertical inch and 10 to 11 knots per horizontal inch). Each horizontal row of knots is secured by two weft passes of linen

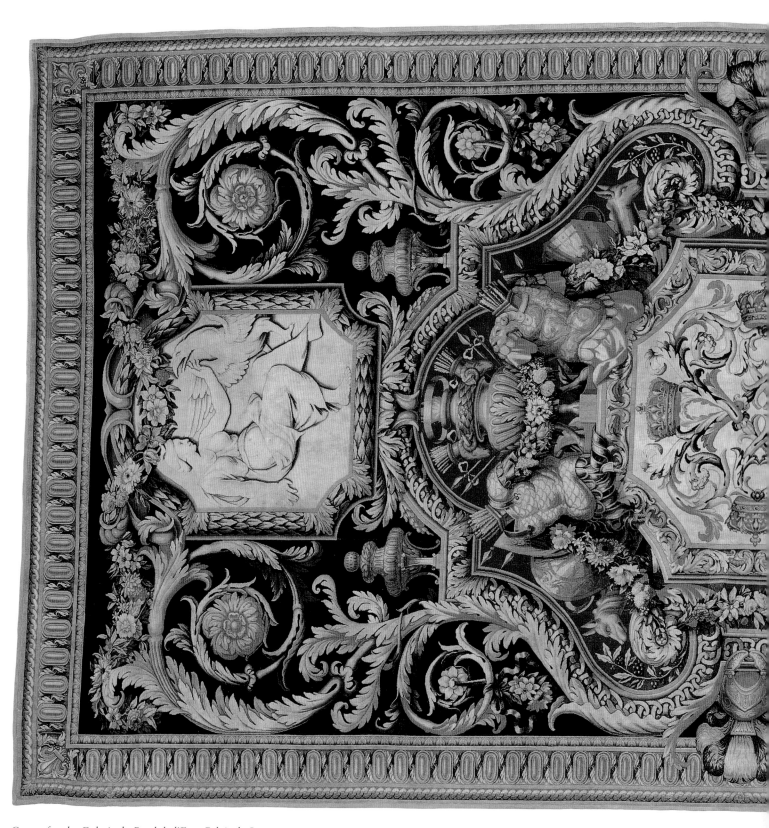

Carpet for the Galerie du Bord de l'Eau, Palais du Louvre 85.DC.515

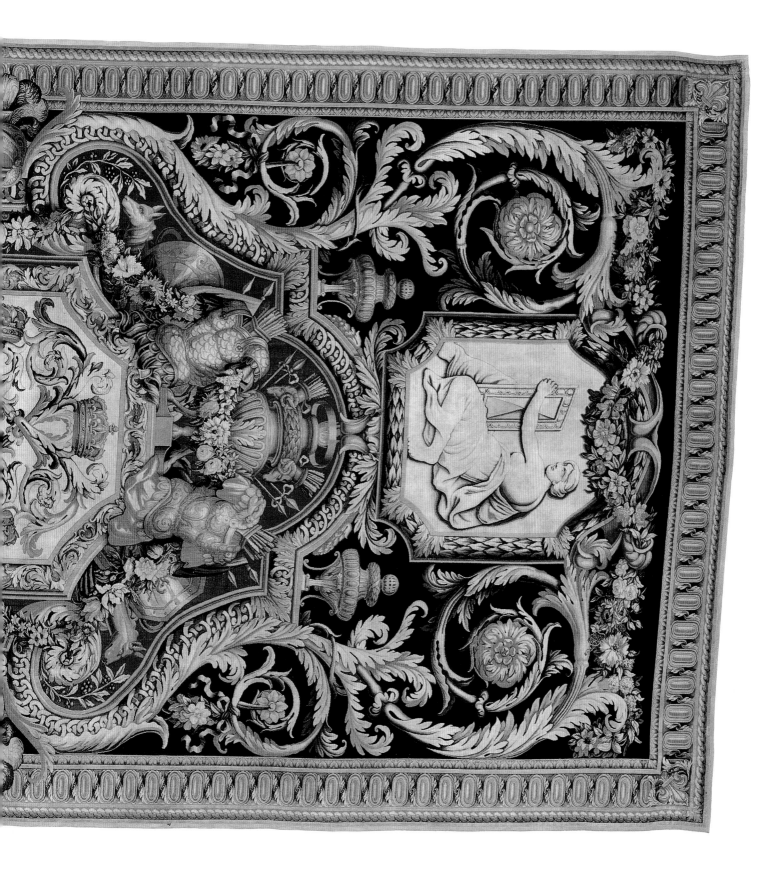

FIGURE 14.2 Detail of reserve showing "Prééminence de Rang."

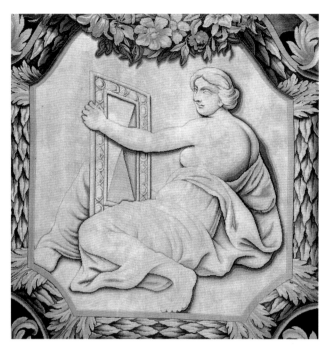

FIGURE 14.3 Detail of other reserve showing figure with shield or mirror.

yarn, Z spun S ply (2). The warps were aligned on the loom stretching vertically along the long dimension, indicating that the loom extended thirty feet or more in length. The direction of the pile is parallel to the carpet's short axis— meaning that the carpet was knotted from bottom up with the grisaille reserve containing the figure and the eagle on the left and the one showing the figure with the shield on the right. The pile averages a depth of .5 cm or less than one quarter inch. In some areas the weavers blended two different colored yarns to make one knot, thus enhancing the nuances of color. Comparing the front to the reverse, the blue-black ground of the carpet has undergone little or no fading. In general the blue tones have fared well, while the orange and rose shades have suffered moderate losses. But the delicate violet tones are nearly gone and appear gray on the obverse (particularly on the two grisaille reserves). The pile has worn unevenly over time, especially in the areas knotted with brown and gray-brown yarns. This wear is noticeable throughout the carpet. There are many reknotted repairs in the carpet. The fleur-de-lys in each corner has been altered with an inset. The warp count of these corner inserts varies from 20 to 22 per inch (all of which are natural-colored wool) and each row of knots is separated by two weft passes of linen yarns. There are 99 knots per square inch in the insets (9 knots per vertical inch and 11 knots per horizontal inch). The carpet has stains and soil discolorations, which were not removed by wet cleaning performed in 1989. In 1993 the perimeter of the carpet was rebound with cloth tape dyed to match one of two earlier bindings that are now covered by this addition. On its reverse the carpet bears two plain-weave linen tags, measuring 1¼ inches by 9¼ inches and inscribed $8^m, 90$ $4^m, 70$.

The tags are stitched to the two corners of the carpet nearest the grisaille reserve with the figure and the eagle.

COMMENTARY

This carpet was one of the ninety-three intended to extend down the length of the Galerie du Bord de l'Eau (also known as the Grande Galerie) of the Palais du Louvre. The creator of the scheme for these carpets is not named in the *Comptes des Bâtiments du Roi* nor in the records of the manufactory that have survived from this period. Such scholars as Madeleine Jarry and Pierre Verlet suggest that Charles Le Brun, as the *premier peintre du Roi* (and also artistic director of the Savonnerie manufactury from 1665), and Louis Le Vau, as the *premier architecte du Roi*, logically would have been involved.[3] These two collaborated on several projects, including the commission for the Galerie d'Apollon at the Palais du Louvre in 1661–1663. Among the furnishings for this room were thirteen Savonnerie carpets, made at the Chaillot workshop and delivered in 1667 by Philippe Lourdet. The dimensions and composition of these carpets were determined strictly by the room's interior design, and each echoed the compartment of the ceiling divisions above. Their design, therefore, must have depended upon the contributions of both the architect and the painter.[4]

Only three names are recorded in the *Comptes des Bâtiments du Roi* as painters of the carpet cartoons for the Galerie du Bord de l'Eau, although other specialized painters must have been involved. Payments were made in 1669 to François I Francart (1622–1672, *peintre ordinaire du Roi dans l'hôtel des Gobelins*), and in 1670 and 1678 to Beaudrin Yvart *le père* (1611–1690).[5] Jean Le Moyne (Jean

PLAISIR ou VOLUPTÉ. CXXVII.

FIGURE 14.4 J. Baudouin (French, active mid-seventeenth century). Engraved plate illustrating "Prééminence de Rang" from *Iconologie* (Paris, 1677). Photo courtesy of the Resource Collections, Getty Research Institute for the History of Art and the Humanities.

Lemoine *dit* le Lorraine 1638–1713) was paid for small-size work related to this project in the 1680s.[6]

A few years after the redesign of the Louvre's Galerie d'Apollon, the concept of utilizing carpets to impose regularity, order, decoration, and architectural harmony to an otherwise plain expanse of floor was also applied to the Galerie du Bord de l'Eau. The scheme, initiated circa 1665–1668 but ultimately never realized, proposed laying ninety-three carpets along the gallery's great length—one carpet per bay, stretching across the width of the gallery. Thus there would have been thirty-five carpets in the wing to the east of a pavilion known as *le lanternon* situated above a public gate, one carpet in the pavilion itself, and fifty-seven in the wing to the west. The width of the gallery set the carpets' standard length of seven and one-half French *aunes* (approximately 892 cm or 29 ft. 5 in.), with a width that varied according to the dimension of the bay from two and one-quarter *aunes* (267 cm or 8 ft. 9 in.) to five and five-eights (669 cm or 21 ft. 10 in.). Between 1668 and 1689, ninety-two carpets were delivered to the Garde-Meuble de la Couronne. An additional ten were also delivered by 1689 to replace those that had been given away as diplomatic gifts.

The interior architecture and decorative program of the Galerie du Bord de l'Eau seems to have regulated the carpets' placement, design, and possibly their iconography, although this is difficult to describe since the gallery's seventeenth-century appearance is not preserved.[7] It is believed that the carpets may have reflected the vaulting of the stuccoed and painted ceiling as well as the landscapes on the painted walls. Even the knotted rendering of either a polychrome pastoral scene or a grisaille bas-relief may have been related to whether the intended location of a carpet was in a blind bay or a windowed bay.

The surviving carpets and fragments demonstrate the creativity of their inventor(s), for they are unified and harmonious, yet varied. Certain elements, such as the black ground color, the prevalent large rinceaux, the alternating landscape or grisaille, and the gadrooned border, appear in every known example and were undoubtedly meant to provide continuity to the gallery's elongated, irregular space.[8] Continuity through symmetry seems to have been the intention, particularly in the wing to the east of *le lanternon*, where no fewer than twenty-two carpets (eleven pairs) out of the thirty-five were of repeated design.[9] Conversely, the carpets in the west wing did not repeat (except once), and

the alternating grisailles represented twenty-seven aspects of Louis XIV's *gloire*—each quality or attribute identified by title in the *Inventaire du Mobilier de la Couronne.*

The museum's carpet was a unique design, knotted only once, and since it had grisaille reserves at both ends, it was probably intended for a windowed bay in the west end of the Galerie du Bord de l'Eau. As will be discussed below, it matches the description in the royal inventory of a carpet identified by the title "Dignité." Scholars have noted that much of the allegorical imagery in these carpets derived ultimately from Cesare Ripa's *Iconologia* (first published in 1593 and widely disseminated in numerous translations and editions).[10] In most contemporary seventeenth-century French emblematic books based on Ripa, "Dignity" appears as a well-dressed woman, standing upright, who carries on her shoulders a burden of gold and jewels.[11] No such figure is portrayed in either grisaille panel, and it is unclear how the carpet's design was to be associated with the conventional imagery of dignity. It has been suggested that the female figures represent the goddesses Juno (with the eagle) and Venus (with a mirror), but this interpretation does not solve the enigma.

However, an obscure allegory, rarely included in emblemata of the period, may offer some explanation. When J. Baudouin published his *Iconologie* in Paris in 1677, he included among his moralizing devices an image called "Prééminence de Rang" (fig. 14.4). "Rank" is represented by a majestic woman who, with an outstretched hand, opposes an eagle that attempts to displace its rival, the humble *roitelet* (kinglet) bird, from its position upon the woman's head.[12] An allegorical description for the other female grisaille figure has not yet been identified, but the solution may reside in the works produced by the Petite Académie. This body was founded by Colbert in 1663 with the intent to provide the monarch with suitable mottos, inscriptions, emblems, and imagery for royal purposes, including the king's building program, public monuments, festivals, and medals. The efforts of the original four members of the Petite Académie, selected by Colbert from the preexisting Académie française, were wide-ranging. Among other projects, they contributed emblems for two tapestry series, *Les Saisons* and *Les Elements*, designed by Le Brun in the 1660s for production at the Gobelins manufactory, and they supplied inscriptions to accompany the painted vault in the Galerie des Glaces at Versailles, 1679–1686. One of the four members, Louis Douvrier, was responsible for inventing the motto *Nec Pluribus Impar* to distinguish Louis XIV's appropriation of the ubiquitous sun imagery from that of rival heads of state, notably the Spanish and Savoy houses.[13]

Color symbolism was another element of the Petite Académie's contributions, and it is possible that these concerns are reflected in the carpets for the Galerie du Bord de l'Eau. Considering the central field of the Museum's carpet,

FIGURE 14.5 Attributed to François-Hubert Drouais (French, 1727–1775). *Portrait of the marquis d'Ossun.* Washington, D.C., National Gallery of Art, Gift of Mrs. Albert J. Beveridge in memory of her grandfather, Franklin Spencer, inv. 1955.7.1 (1416).

it can be seen that the four cuirasses and their accompanying shields are a gray color representing silver, which is highlighted with yellow for the gilding on their raised ornaments. In the program of color theory utilized at the royal festivals of the 1660s, specifically the Grand Carrousel of 1662, gold was the color of the sun, but silver was associated with the moon and symbolized "royal dignity."[14] Louis XIV wore a gold cuirass for the *fête* of 1662 as a conscious allusion to the Sun God, Apollo; the armor and shields on this carpet, however, are predominantly silver. Was this choice of color for the armor that occupies such a significant portion of the composition intended in this case as an allusion to "Dignity"?

WEAVER AND DATE

The *Inventaire du Mobilier de la Couronne* lists this carpet as number 213 under *Tapis*, but situates its position in the Galerie du Bord de l'Eau of the Palais du Louvre as number 72:

> *213—Le soixante-douziesme: un tapis fonds brun, représentant la Dignité, sur lequel il y a un grand compartiment fonds tanné couleur de minime remply de trophées d'armes et de festons de fleurs, dans le milieu un plus petit compartiment octangle fonds blanc remply de quatre chiffres du Roy, entrelassez de quatre couronnes, aux bouts dudit tapis deux*

FIGURE 14.6 Savonnerie manufactory (French, by 1680). *Carpet number 73* in the project for the Galerie du Bord de l'Eau, Palais du Louvre. New York, The Metropolitan Museum of Art, Gift of Mr. and Mrs. Charles Wrightsman, inv. 1976.155.114.

bas-reliefs gris de lin dans des bordures de laurier octagones, de 7 aunes ½, sur 4 aunes.[15]

An entry in the *Journal du Garde-Meuble* records the delivery of this carpet on May 3, 1680, by the widow of Philippe Lourdet (*née* Jeanne Haffrey). It was one of six carpets she supplied during that year (the others delivered on May 3 were numbers 68, 71, and 76; on October 23 she delivered numbers 70 and 73), for which she was paid the sum of 14,475 *livres*.[16] At this rate of production, the pace had to be steady and efficiently expedient during this period. Unlike the Museum's other Savonnerie carpet (catalogue entry No. 13), this carpet was knotted along its long dimension, stretching the length of the newly developed thirty to thirty-six foot looms. This arrangement made it possible for weavers to work collaboratively side-by-side to meet the intensified production schedule. The Lourdet family produced a total of sixty carpets of the completed ninety-two, while the Dupont family, who moved their workshop from the Louvre to the Chaillot Savonnerie in 1671, delivered thirty-two.

All the carpets delivered for use in the Galerie du Bord de l'Eau were described in the *Inventaire du Mobilier de la Couronne* as having a "fond brun." The seventeenth-century usage of the term *brun* described a rich black or deep blue color that was distinct from the eighteenth-century *brun*, a markedly different color of chestnut-brown.[17] This persistent confusion should not cast doubt on the identity of this carpet.

No further mention is made of carpet 72 until an inventory, prepared between 1769 and 1775 for the *Mobilier de la Couronne*, recorded that it was one of three lent by Louis XV to his ambassador in Spain, Pierre-Paul, marquis d'Ossun (1713–1788, *ambassadeur extraordinaire du Roi à Naples* 1751, and *ambassadeur extraordinaire et plénipotentiaire de France à Madrid* 1759).[18] In 1769 the marquis (fig. 14.5) was still a resident of Madrid, and it is assumed the three carpets—which included numbers 72 and 73 (fig. 14.6) from the Galerie du Bord de l'Eau and number 10 from the Galerie d'Apollon—furnished his ambassadorial household there.[19] The last two inventories of the eighteenth century (1792 and the year V, or 1796/1797) fail to list these two carpets.[20] As the marquis died in 1788, it may be assumed that the carpets remained in Spain and were never returned to the Garde-Meuble. This would explain why the royal emblems were not altered or cut during the Revolutionary period, as was so often the case with other carpets from the series stored in the Garde-Meuble. Unconfirmed rumor still located carpets numbered 72 and 73 in the Spanish monastery of Santiago de Compostela in the early twentieth century.[21]

RELATED CARPETS

The research of Pierre Verlet has established the location of seventy-one carpets (or their fragments) of the original

ninety-two made for the Galerie du Bord de l'Eau, as well as the additional ten that became diplomatic gifts. Since the publication of his work, three more carpets have passed through the art market, all in 1993: carpet number 48 representing *L'Eau* (woven initially in 1677 and presented to a Danish minister in 1682, followed by a replacement woven in 1685) sold Drouot-Richelieu, Paris, March 31, 1993, no. 136 (630 cm by 425 cm)[22]; a carpet fitting the description of either number 61 or 89 (whose survival was unknown to Verlet) sold Christie's, New York, October 30, 1993, lot 415 (531 cm by 292 cm)[23]; carpet number 91 (woven initially in 1682 and one of the four presented to a Danish minister in that year, its replacement woven in 1685) sold Christie's, Monaco, December 5, 1993, no. 215 (560 cm by 340 cm).[24]

PROVENANCE

Delivered to the Garde-Meuble de la Couronne on May 3, 1680, by *veuve* Lourdet (Philippe Lourdet's widow) for the Galerie du Bord de l'Eau, Palais du Louvre; lent circa 1769 from the Garde-Meuble de la Couronne to Pierre-Paul, marquis d'Ossun (1713–1788); (?) Cathedral of Santiago de Compostela, Spain; (?) B. Fabre, Paris, 1938[25]; acquired through the intermediary (?) Marcel Bisset by M. Ortiz Linares, Paris, 1948; by descent to Georges Ortiz and Jaime Ortiz Patiño, Geneva; J. Paul Getty Museum, 1985.

PUBLICATIONS

Guiffrey, *Inventaire*, no. 213, pp. 405–406; Guiffrey, *Comptes des Bâtiments*, vol. 1, p. 1339; F. J. B. Watson, *The Wrightsman Collection*, vol. 2, *Furniture, Gilt Bronze and Mounted Porcelain, Carpets* (New York, 1986), pp. 495–496; P. Verlet, "Homage to the Dix-Huitième," *Apollo* (March 1967), pp. 211–212; Verlet 1982, pp. 197, 203, 211, 430 (nn. 119, 123, and 124), 432 (n. 143), 433 (n. 149), and 72nd carpet p. 491 (also included as a line drawing in a folding plan of the Galerie du Bord de l'Eau of the Palais du Louvre); "Acquisitions/1985," *GettyMusJ* 14 (1986), no. 187, p. 240, illus.; and Bremer-David et al., 1993, no. 281, pp. 164–165, illus.

NOTES

1. The ground "tanné couleur de minime" is as described in the *Inventaire du Mobilier de la Couronne* compiled in 1697 by Gédéon du Metz, *contrôleur général des Meubles de la Couronne*. Guiffrey, *Inventaire*, vol. 1, no. 213, pp. 405–406.
2. Verlet specifically noted the substitution of brown threads for the customary blue in the production of some carpets made for the Galerie du Bord de l'Eau during the period around 1670–1680. Verlet 1982, p. 370 n. 20.
3. See M. Jarry, *The Carpets of the Manufacture de la Savonnerie* (Leigh-on-Sea, 1966), p. 17, and Verlet (note 2), pp. 104, 109, and 182. For Le Brun's artistic influence on the royal manufactories, see C. Gastinel-Coural, "Les Manufactures de Tapisserie," in *Colbert 1619–1683*, exh. cat. (Hôtel de la Monnaie, Paris, 1983), pp. 155–158.
4. Verlet (note 2), p. 425 n. 54.

5. It is interesting to note that Beaudrin Yvart *le père* painted carpets and rinceaux for the *Maisons royales* tapestry series executed at the Gobelins manufactory (see cat. entry No. 3).
6. For Francart and Yvart, see Verlet (note 2), pp. 109, 181, and 427 n. 84; and for Le Moyne, see ibid., pp. 109, 182, 405 n. 30, and 424 n. 44.
7. Ibid., pp. 194–199.
8. Verlet credits Le Brun with the use of the rinceaux on the carpets for both the Galerie d'Apollon and the Galerie du Bord de l'Eau commissions. Yet rinceaux were already dominant features of Savonnerie carpets by 1660 (see cat. entry No. 13). Ibid., pp. 182 and 427 n. 85.
9. Verlet devised a layout recreating the intended placement of all nintey-two carpets, from which it is clear that carpet designs were repeated with a surprising frequency in the east wing of the Galerie du Bord de l'Eau. See ibid., pp. 184–191, and folding plan of the Galerie du Bord de l'Eau.
10. Ibid., pp. 195–196, and p. 427 n. 79 where he cites E. Mâle, *L'art religieux après le concile de Trente* (Paris, 1932).
11. "Dignité: Celle qui represente est une femme richement parée, mais qui fléchit presque sous le fardeau qu'elle porte, qui est une grosse pierre, enchasée dans une bordure d'or et de pierreries," from the French edition of Cesare Ripa published by J. Baudouin, *Iconologie ou Nouvelle explication de plusieurs images, emblemes, et autres figures hyerogliphiques des vertues, des vices, des arts, des sciences, des causes naturelles, des humeurs differentes, des passions humains / tire des recherches et des figures de Cesare Ripa* (Paris, 1677), no. XXXIX, p. 63.
12. "'Prééminence de Rang': Une femme majesteuse, qui a sur le haut de la teste l'oiseau qu'on appelle roitelet, et qui de la main droite s'oppose aux efforts d'un aigle, afin d'empêcher qu'il ne s'elance en haut, pour oster à son rival la place qu'il a prise," Ibid., no. CXXIX, p. 195.
13. See J.-P. Néraudau, *L'Olympe du Roi-Soleil, Mythologie et idéologie royale au Grand Siècle* (Paris, 1986), p. 30ff., as well as the exh. cat. *L'Académie des inscriptions et belles-lettres 1663–1693* (Archives de France, Hôtel de Rohan, Paris, 1963), p. 4. See also catalogue entry No. 1.
14. Néraudau (note 13), p. 52.
15. Guiffrey, *Inventaire*, vol. 1, no. 213, pp. 405–406.
16. Guiffrey, *Comptes des Bâtiments*, vol. 1, p. 1339, and Verlet (note 2), p. 424 n. 30, in which there is a date discrepancy of December 23 for October 23.
17. Verlet (note 2), pp. 231 and 426 n. 70.
18. Ibid., pp. 206 and 430 nn. 119 and 123.
19. Carpet number 73 is now in the Metropolitan Museum of Art, New York, inv. 1976.155.114. See F. J. B. Watson, *The Wrightsman Collection* (New York, 1966), vol. 2, no. 277, pp. 495–499.
20. Verlet (note 2), p. 430 n. 124, and pp. 433–434 n. 149.
21. Ibid., pp. 206 and 432 n. 143.
22. Ibid., pp. 486 and 498.
23. Ibid., pp. 493 and 434–435 n. 156.
24. Ibid., pp. 496 and 498. Formerly in the collection of J. Pierpont Morgan, see T. Dell, "J. Pierpont Morgan, Master Collector: Lover of the 18th century French Decorative Arts," in *International Fine Art and Antique Dealers' Show*, exh. cat. (Seventh Regiment Armory, New York, 1995), pp. 25–34, n. 22.
25. This carpet and its companion from Santiago de Campostela, which is now in the Metropolitan Museum (note 19), were viewed by J. Paul Getty in the Paris gallery of B. Fabre on October 8, 1938. Their price, dimensions, and provenance were recorded by Getty in his diary . See S. de Chair, *Getty on Getty, A Man in a Billion* (London, 1989), pp. 132–133.

15

Pair of Three-Panel Screens (*Paravents*)

Savonnerie manufactory, Paris; circa 1714–1740

Made in the Chaillot workshop of the Dupont family under the directorship of either Bertrand-François Dupont (*entrepreneur de la manufacture de la Savonnerie* 1714–1720) or Jacques de Noinville (*entrepreneur* 1721–1742) after designs by Jean-Baptiste Belin de Fontenay (1653–1715) and Alexandre François Desportes (1661–1743).

MATERIALS
Wool and linen; cotton-twill gimp; modern silk velvet; wooden frames

GAUGE
100 to 120 Turkish knots per square inch

DIMENSIONS
height 8 ft. 11¾ in. (273.6 cm); width of three panels together 6 ft. 4⅛ in. (193.2 cm); width of individual panels varies from 2 ft. 1¼ in. (64.2 cm) to 2 ft. 1½ in. (74.77 cm); depth of panels 1½ in. (3.81 cm)

83.DD.260.1–2

DESCRIPTION
Folding screens of this kind were called *paravents* and were used to protect a room's occupants against drafts. These two screens form a matched pair. Each screen is composed of three vertical panels that are hinged together and each panel has an individual knotted design that is repeated on its counterpart in the paired set. In its basic design each panel takes the form of a narrow outdoor arbor. The arbor is arched at the top; its vertical supports echo the panel's border and consist of slender red and brown poles punctuated by urn-shaped elements in dark green. Additional vertical rhythms are created by two delicate leafy vines that run down from the back of the arbor's trellis roof. The foreground at the base of each panel is occupied by a low pedestal, painted blue and ornamented with scrolling mounts and an orange diaper pattern, on which is placed a vase filled with blossoms and leaves. Behind the pedestal is a grassy lawn speckled with small yellow flowers. The background is a deep yellow. Hanging in the center of each panel is a lobed medallion, its carved frame decorated with gold scrolls and a diaper pattern. Flowers have been laced into this carved frame, and the reserve inside features an imitation painting of a pair of birds against a background of blue sky. Above, tied to the same blue ribbon that suspends the medallion, is a trophy. The ribbon is looped into a bow and connects with floral garlands strung from the arbor's inner ribs.

The left panel of each screen has flowers entwined around the near supports (fig. 15.1). The suspended trophy

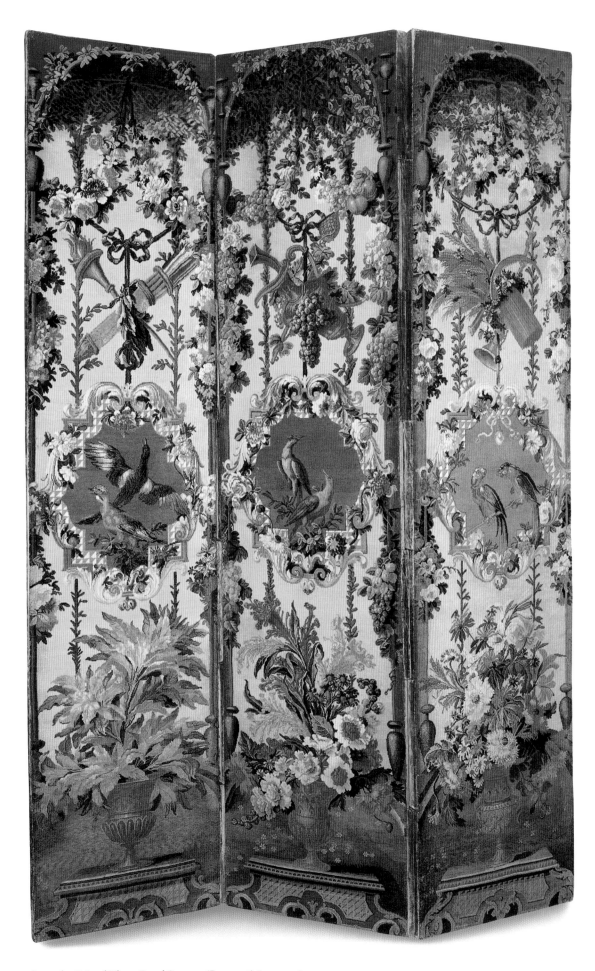

One of a Pair of Three-Panel Screens (Paravent) 82.DD.260.1–2

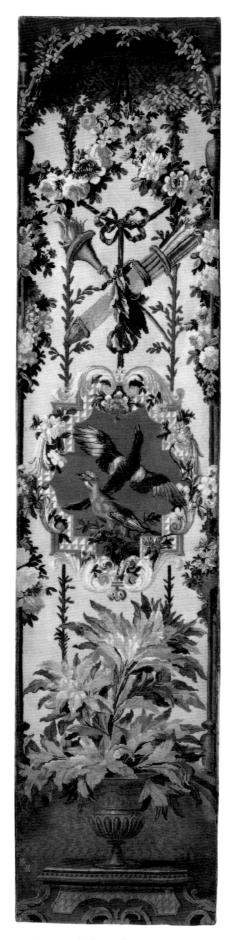

FIGURE 15.1 Left panel.

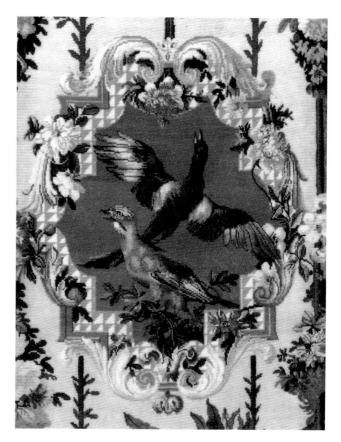

FIGURE 15.2 Detail, left panel.

is composed of a flaming torch and a quiver of arrows. In the medallion below the birds are identified as a gray and beige magpie taking wing above a brown and blue jay (fig. 15.2). The vase at the bottom contains mainly yellow and green foliage with golden blossoms.

The garlands of the central panel (fig. 15.3) have mostly bunches of grapes and grapevines, laced with only a few flowers and some peaches, twisting around the front columns of the arbor. The trophy (fig. 15.4) consists of a large golden ewer and a bunch of dark blue grapes with a thyrsus and a wind instrument crossed behind. In the lobed reserve the birds are a green woodpecker with a red cap, and an oriole with orange and brown plumage. The flowers in the vase below include peonies, cornflowers, and hollyhocks.

In the right panel of each screen floral garlands again decorate the inner supports, although the species of flowers differ from those of the left panel. The trophy is a sheaf of wheat with a sickle and a horn. In the central medallion a golden ball hangs from a yellow ribbon above two parrots, one with red and blue feathers and the other with orange and blue. The urn at the base is filled with such flowers as peonies and lilies, accented with a few stalks of wheat (figs. 15.5 and 15.6).

CONDITION

The warps of these six panels are wool. The spin and ply cannot be determined, however, because the pile is so tightly

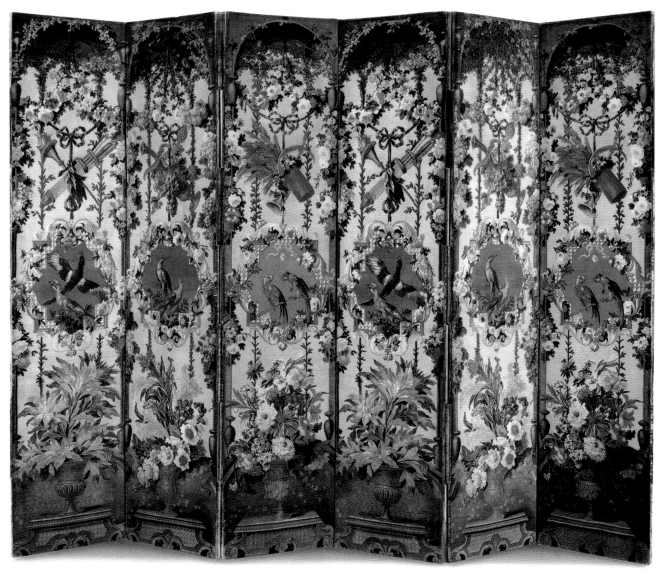

Pair of Three-Panel Screens (Paravents) 82.DD.260.1–2

knotted and a silk velvet backing impedes access to the reverse. There are twenty to twenty-four warps per inch. The knots were made in the Turkish technique and the pile fiber is wool, Z spun S ply (3), with 100 to 120 knots per square inch (ten knots per vertical inch and ten to twelve knots per horizontal inch). There appear to be two wefts of linen fiber, Z spun S ply (2), between each row of knots. The direction of the pile for all six panels is from top to bottom, laying slightly to the right, thus indicating that the weaving and knotting went from bottom up and from left to right. The length of the pile averages one quarter of an inch (.64 cm). A visual analysis to determine fading could be made from the face of the screens only; it consisted of a comparison of the surface of the pile with the lower parts of the fibers beneath the surface and showed little evident loss of color except in the shades of pink, which have aged to a yellow-brown.

A red twill gimp is sewn along the perimeter of each panel. The three panels of each screen are supported by a rigid wooden framework concealed beneath the lining of green silk velvet. This modern velvet lining also obscures the method by which the panels were secured to their frames, but it is probable that the gimp has been tacked to the wooden structure. All panels exhibit some sag near the bottom edge. The panel frames are connected to one another by means of double-fold hinges constructed from the same green velvet used in the lining. The remains of half hinges on two outer panels indicate that all six were joined at one time, and this has been corroborated by early photographs.

COMMENTARY

Pierre Verlet's exhaustive research into the Manufacture de la Savonnerie has traced the development of the source for these panels to a design by the flower painter Jean-Baptiste Belin de Fontenay for a *paravent* that was a part of the posthumous decoration of the apartments of Queen Marie-Thérèse (1638–1683). Created in 1713, the cartoon for the royal screen panels contained the crown, the monogram, and emblem of the Queen along with foliage, flowers,

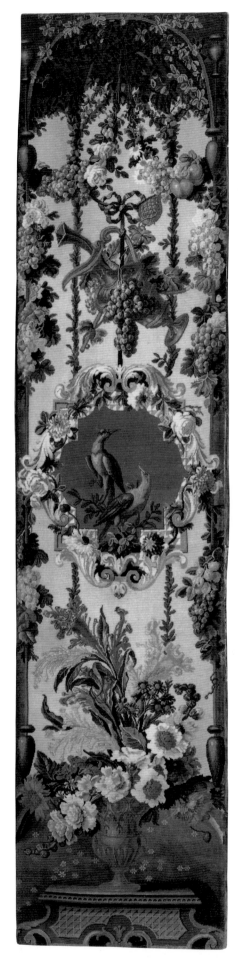

FIGURE 15.3 Middle panel.

FIGURE 15.4 Detail of trophy, middle panel.

various instruments, and at the bottom, a vase of flowers. The *Inventaire du Garde-Meuble de la Couronne* recorded the delivery of twelve of these panels in November 1716 and specified they were "dessein de M. Fontenay." Verlet believes that none of them survive, although a large screen with such panels appeared in the 1787–1788 inventory of the Palais de Fontainebleau located in the Pièce des Nobles of the comtesse d'Artois.[1]

In 1714 Belin de Fontenay altered his cartoon for the queen's *paravent* by replacing her monogram and emblems with pairs of birds attributed to the animal painter Alexandre François Desportes.[2] This cartoon of altered design became the source for the three panels of the present screens. The name of Belin de Fontenay was again identified with a delivery in 1730 of twelve pieces after the new design. The *Inventaire du Garde-Meuble* records these panels as "dessein de M. Fontenay."[3] While it is known that Belin de Fontenay painted the cartoon, Verlet suggests that Robert de Cotte (1656–1735, *premier architect du Roi* 1708) was responsible for the set's general concept.[4] In 1708 de Cotte assumed a new role at the Savonnerie as assistant to the *surintendant*, the duc d'Antin (son of Madame de Montespan, *directeur* and later *surintendant du Bâtiments, Arts et Manufactures* 1708–1736), and undoubtedly exercised a certain degree of artistic influence. But de Cotte was already familiar with both the Savonnerie and Gobelins manufactories. In 1699 he had been made director of the Paris department of the Bâtiments du Roi,

FIGURE 15.5 Detail of vase, right panel.

and in that capacity he tracked the materials used at both royal workshops.[5]

A register established by the duc d'Antin, and named after him, recorded the factory's official production history from 1708 until 1774. It provided a lengthy description of the new Belin de Fontenay panels:

Un berceau rempli de feuillages verds, au bas dudit paravent est une terasse en forme de gazon remply de petites fleurs sur lequel est pozé un vas garni de fleurs au naturel, au dessus est le milieu qui est un fond bleu clair et une petite terasse sur laquelle est posée un geay et une pie enfermée d'un cartouche orné de fleurs, audessus des festons de fleurs au naturel, à coté les soutiens du berceau autour duquel tourne une guirlande de fleurs, le tout à fond chamois enfermé d'un fond violet . . . même ordonnance excepté que dans le milieu il y a un cocq et une poulle chinoise . . . 2 colombes . . . 2 perroquets dont un rouge et l'autre jaune et bleu . . . un loriot et un pivert . . . 2 perroquets dont l'un gris et l'autre vert et rouge.[6]

The description specified six pairs of birds, of which the Museum's screens portray three. The remaining sets of birds grouped together a cock and a Chinese hen,

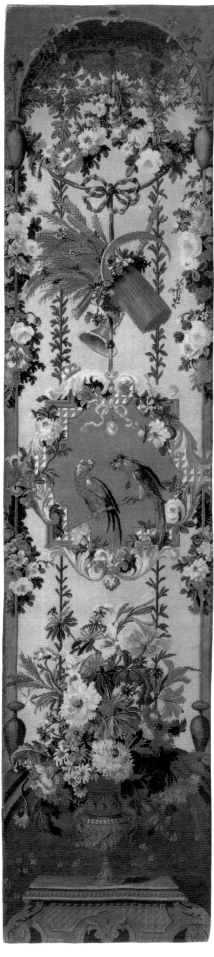

FIGURE 15.6 Right panel.

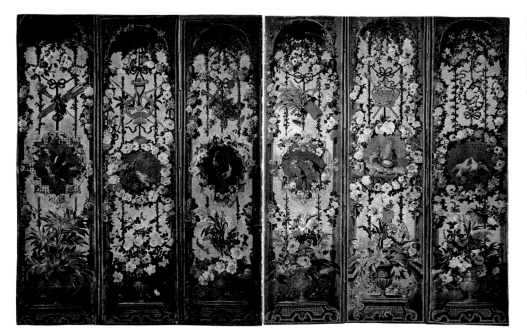

FIGURE 15.7 Savonnerie manufactory (French, circa 1714–1740). *Pair of Three-Panel Screens (Paravents)*. Sold Palais Galliera, Paris, April 1, 1965, no. 133.

two doves, and another pair of parrots with a butterfly. Surviving panels show that there were also three additional designs for trophies (fig. 15.7): one trophy consisted of a royal crown with the Hand of Justice and the royal scepter; the second was composed of two linked floral marriage wreaths that customarily hung above the billing doves; the third was a lyre, bow, and long arrow that was usually knotted above the second set of parrots. Generally the trophies were interchangeably matched with the birds, except for the floral wreaths and the lyre. Edith Standen has suggested that the trophies are attributes of the gods Cupid, Bacchus, Ceres, and Apollo.[7] Pursuing this formula, the floral rings coupled with the billing doves must then represent Venus.

The deep yellow ground used for these panels was first introduced at the Savonnerie manufactory in 1686 to replace the customary black grounds used on bench and *tabouret* covers. The brighter ground won royal favor, for three years later Louis XIV approved a change in the main color of the narrow carpets in the billiard room at the Trianon, from blue to yellow. This trend toward warm-colored grounds of yellow and orange echoes developments at the Beauvais manufactory and its successful *Grotesques* tapestry series.[8]

WEAVER AND DATE

The *Registre d'Antin* records that at least 138 panels of this group were made between 1714 and 1740: seventy-two under Bertrand-François Dupont by 1720 and sixty-six under Jacques de Noinville by 1740. Production may have continued beyond this date, but after 1744 it is difficult to distinguish these panels in the register from those of the same size (two and three-eighths *aunes*) represent-

ing Aesop's fables after designs by Jean-Baptiste Oudry (1686–1755, *co-directeur de la manufacture de Beauvais* 1734–1755) and Pierre-Josse Perrot (active 1724–1750, *peintre d'ornements* at the Administration de l'Argenterie, Menus-Plaisirs et Affaires de la Chambre du Roi, and at the manufactories of the Gobelins and the Savonnerie).[9] Fourteen leaves after the cartoons of Belin de Fontenay remained unmounted in the manufactory's storeroom in 1794–1795.[10]

Verlet publishes, in full, lists of weavers' names and ages (as well as comments on their abilities and rates of pay) gleaned from documents dated 1713, 1750, 1782, and 1790. The details of this information, especially regarding the generations of families devoted to working at the manufactory, are extensive, but unfortunately they do not reveal who was specifically paid for panels such as these.[11]

Late in the reign of Louis XIV, screens of this tall size were used to furnish the anterooms of royal apartments. This was still the case in the mid-eighteenth century when, in 1747, Madame la Dauphine received eighteen leaves for *paravents* with matching bench covers for her *antichambres* at Versailles. But Louis XV's preference for this series is reflected in the quantities he chose for his residences, including Marly, La Muette, and the king's dining room at Choisy. No fewer than eighty-two leaves were delivered to the Garde-Meuble de la Couronne in the decade 1730–1740 (panels were almost always delivered unmounted or were released to an upholsterer working for the Garde-Meuble).[12]

RELATED SCREENS

Tall screens usually consisted of six leaves, although they could comprise four, five, or eight. Early production of screens placed two knotted panels per leaf, front and back.

An intact example of a different and smaller model is conserved in the Musée Nissim de Camondo.[13] Eventually this practice was forsaken and panels were fitted on only one side of the screen, the back covered with a lining of velvet or damask.

Given an average of six leaves per screen, it is estimated that the manufactory produced twenty-three or more *paravents* of this composition between 1714 and 1740. Of these, scholars have enumerated some twelve screens, which either survive in public collections or have appeared at auction.[14] One other passed through the American art market in 1930–1931.[15]

PROVENANCE

(?) Garde-Meuble de la Couronne, first half of the eighteenth century; (?) Madame d'Yvon, Paris (sold Galerie Georges Petit, Paris, May 30–June 4, 1892, no. 673 [four of ten panels illustrated]); Jacques Seligmann, Paris (sold at the liquidation of the Société Seligmann, Galerie Georges Petit, Paris, March 9–12, 1914, no. 343); Germain Seligmann, Paris, 1927; François-Gérard Seligmann, Paris, by 1960 (sold Sotheby's, Monaco, June 14–15, 1981, no. 54); Dalva Brothers, Inc., New York, 1981; J. Paul Getty Museum, 1983.

EXHIBITIONS

Tapis de la Savonnerie, Manufacture Nationale des Gobelins, Paris, December 1926–January 1927, no. 96, illus. (lent by Germain Seligmann); *Le Siècle de Louis XIV*, Bibliothèque Nationale, Paris, February–April 1927, no. 1268 (lent by Germain Seligmann); *Louis XIV: Faste de décors*, Musée des Arts Décoratifs, Paris, May–October 1960, no. 774, p. 155, illus. pl. 52 (lent by "M. Seligmann"); *Experts' Choice: One Thousand Years of the Art Trade*, Richmond, Virginia, April 22–June 12, 1983, pp. 82–83, illus.

PUBLICATIONS

"Les Paravents," *Connaissance des arts* 177 (November 1966), pp. 122–129, illus. p. 126; Verlet 1982, pp. 301 and 457–458 n. 82; J. W. Adams, *Decorative Folding Screens in the West from 1600 to the Present Day* (London, 1982), illus. p. 131; G. Wilson et al., "Acquisitions Made by the Department of Decorative Arts in 1983," *GettyMusJ* 12 (1984) no. 2, pp. 180–183, illus.; "Acquisitions/1983" *GettyMusJ* 12 (1984), no. 4, p. 262, illus.; "Some Acquisitions (1983–84) in the Department of Decorative Arts, The J. Paul Getty Museum," *Burlington Magazine* 126 (June 1984), p. 385, illus.; Standen 1985, vol. 2, no. 112, p. 656; Sassoon and Wilson 1986, no. 227, pp. 108–109, illus.; *GettyMusHbk* 1986, p. 150, one illus.; C. Hamrick, "European Folding Screens: Mirrors of an Enduring Past," *Southern Accents* (April 1990), pp. 30–40, illus.; *GettyMusHbk* 1991, p. 164, one illus. p. 165; Bremer-David et al., 1993, no. 282, p. 165, illus.

NOTES

1. P. Verlet, "Les paravents de Savonnerie pendant la première moitié du XVIIIᵉ siècle," *L'Information d'histoire de l'art* 12 (May–June 1967), pp. 105–118. Also see Verlet 1982, pp. 301, 451–452 n. 19, and 457–458 nn. 81–82.
2. No direct studies for these birds are among the materials conserved from the Desportes atelier in the archives of the Manufacture Nationale de Sèvres except for the magpie facing left in the left-hand panels. It is related to an oil on paper study, Sèvres II.32 Fp § 2 1814 no. 50, on loan to the Musée de la Chasse et de la Nature, Paris.
3. Verlet 1982, pp. 457–458 n. 82.
4. Ibid., p. 111. De Cotte seems to have exercised a similar influence in general design at the Gobelins Manufactory. See cat. entry No. 6.
5. R. Neumann, *Robert de Cotte and the Perfection of Architecture in Eighteenth Century France* (Chicago, 1994), p. 16.
6. Verlet 1982, p. 457 n. 82.
7. Standen 1985, vol. 2, no. 112, pp. 655–657.
8. Verlet 1982, pp. 230 and p. 438 n. 31.
9. A total of twenty pieces of the large size were made from 1756 to 1769. Ibid., pp. 458–459 n. 85.
10. Ibid., pp. 459–460 n. 100.
11. Ibid., pp. 77–79 and 382–383 n. 73.
12. Ibid., p. 457 n. 85. For a description of the screen delivered to the Château de Marly in 1730 for the *chambre de la reine*, see S. Castellucio, "L'Appartement de Marie-Antoinette à Marly," *L'Objet d'Art* 274 (November 1993), pp. 48–65.
13. Paris, Musée Nissim de Camondo, inv. 141. See F. Mathey, *Union centrale des arts décoratifs: Musée Nissim de Camondo* (Paris, 1990), no 141, p. 32, illus. p. 33, and N. Gasc and G. Mabille, *Musées et monuments de France: The Nissim de Camondo Museum* (Paris, 1991), p. 92, illus. p. 93 and cover.
14. See C. Christian, J. Parker, and E. Standen, *Decorative Arts from the Samuel H. Kress Collection at the Metropolitan Museum of Art* (London, 1964) no. 61, pp. 250–253; Verlet 1982, p. 458 n. 82; Standen 1985, vol. 2, no. 112, pp. 655–657.
 A bibliography for *paravents* of this model includes the following: R. Destailleur, *Documents de décoration au XVIIIᵉ siècle* (Paris, 1906), pl. 5, from the collection of Madame Schneider; E. Dumonthier, *Le Mobilier National, etoffes et tapisseries d'ameublement de XVIIᵉ et XVIIIᵉ siècles* (Paris, 1910?), pls. 22–23; Institut de France, *Abbaye de Chaalis et Musée Jacquemart-André, notice et guide sommaire* (Paris, 1933), no. 304, p. 85, and illus. pl. XX. A more recent publication is C. Jouve, "Le Musée Privé de Nélie Jacquemart André," *L'Objet d'Art* 262 (October 1992), pp. 40–45, illus. p. 45. A pair of screens from the collection of Mlle. Luzy was illus. in *Les Vieux Hôtels de Paris: Le Quartier du Luxembourg* (Paris, 1934), vol. 21, pl. 9, and three altered panels from the Mobilier National were reproduced in E. Guichard, *Les Tapisseries décoratives du garde-meuble (Mobilier National)* (Paris, 1881), vol. 2, pl. 96.
15. A negative (no. 16231 c) from the archives of French and Company, New York, indicates a four-fold screen was in their showroom from December 1930 through the early months of 1931. Information from Onica Busuioceanu of the GRI Resource Collection.

16

Four-Panel Screen (*Paravent*)

Savonnerie manufactory, Paris; circa 1719–1784

Made in the Chaillot workshops, probably under either Jacques de Noinville (*entrepreneur de la Manufacture de la Savonnerie* 1721–1742), Pierre-Charles Duvivier (*entrepreneur* 1743–1774), or Nicolas-Cyprien Duvivier (*entrepreneur* 1775–1807) after designs by Alexandre François Desportes (1661–1743).

MATERIALS
Wool and linen; modern cotton-twill gimp; modern silk velvet; wooden frame; modern brass nails

GAUGE
80 to 120 Turkish knots per square inch

DIMENSIONS
Overall height 6 ft. 1 in. (185.4 cm); width of four panels together 8 ft. 4 in. (252.4 cm); height of individual panels 6 ft. (182.8 cm); width of individual panels varies from 2 ft. ⅜ in. (61.9 cm) to 2 ft. 1¼ in. (64.2 cm)

75.DD.1

DESCRIPTION
In the eighteenth century folding screens of this size, known as *paravents*, were used mainly in smaller salons or dining rooms to protect the occupants from drafts. This screen has four panels that are knotted after only two designs, each of which repeats once. Both patterns have a red-gold ground that frames a small grassy foreground with a trellis, above which is an arch formed by cardoon leaves, and blue sky beyond. Above the arch is a yellow ground that is framed inside a brown border articulated with scrolls in either blue or red, and the top of the frame is created by longer scrolling leaves that are colored oppositely, either red or blue.

The left panel and its duplicate (placed third from the left) have two brown and cream rabbits in front of the trellis, which in this case supports small peach trees laden with fruit. Two gray, brown, and white monkeys (fig. 16.1) sit atop the trellis; the one on the left raises a peach in his left hand to tempt a green parrot that leans down from the branches above, while his companion plucks another peach from the trellis below. A woodpecker with red, brown, and black plumage perches in the branches to the left. Two more birds sit on the red scrolls of the top-most arch—a gray and white *huppé* (crested jay), with a red-feathered cap, and a cockatiel. The arch's crest is fitted with a brown and yellow pinecone. Immediately below is a blue cartouche framed with dark green leaves and a pale yellow scroll (in the duplicate panel the scroll is red); suspended within is a five-lobed stylized shell in brown.

The other two matched panels show three waterfowl (fig. 16.2)—a *canard tadorne* to the left and two

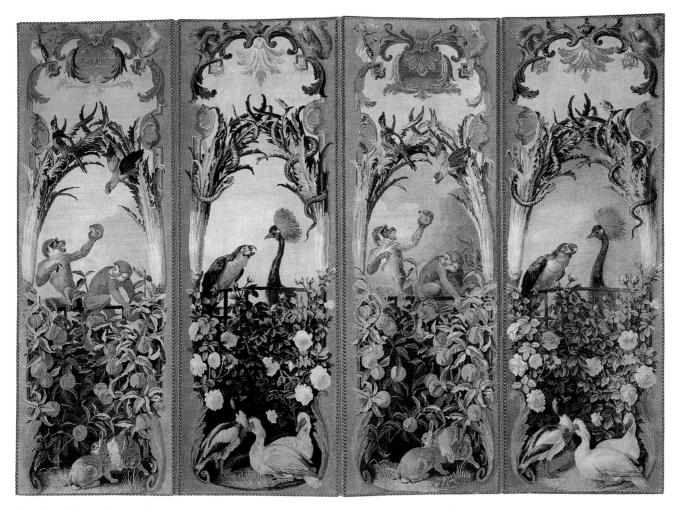

Four-Panel Screen (Paravent) 75.DD.1

FIGURE 16.1 Detail of monkeys.

FIGURE 16.2 Detail of waterfowl.

canards de Barbarie—at the base of the trellis, which is planted this time with rose bushes. A blue and yellow macaw grips the trellis rail and squawks at an African crowned crane that stands to the right behind the trellis (fig. 16.3). Twisting around the cardoon leaves above, a pair of green and gray grass snakes (fig. 16.4) look upward at two brown squirrels who stand on the blue scrolls bordering the yellow field at the top. The squirrel to the left alertly watches the snakes below as the other holds a morsel to its mouth. Suspended from the center of the upper arch is a leafy clasp in either pale yellow or orange.

CONDITION

The warps of these four knotted pile panels are wool, S ply. The spin and number of ply cannot be determined from the face of the screen, but it is assumed that the spin of the warps is Z. Blue *dizaine* warps are present. There are two passes of linen weft, S ply, between each row of knots. Numbering the panels from left to right, the first and third panels have 20 warps per inch and 100 knots per square inch (10 knots per vertical inch and 10 knots per horizontal inch), the second panel has 20 warps per inch and 80 knots per square inch (8 knots per vertical inch and 10 knots per horizontal inch), and the fourth panel has 24 warps per inch and 120 knots per square inch (10 knots per vertical inch and 12 knots per horizontal inch). The knots are made in the Turkish technique and the pile fiber is wool, S ply, and presumably Z spun. Unlike the other three panels, the direction of the pile for the first panel is from bottom to top, indicating that the knotting progressed from top to the bottom (or upside-down). The length of the pile on all four averages one quarter of an inch (.64 cm). Visual inspection of the surface and depth of the pile reveals that the panels have suffered some fading overall, most notably in the shades of red and yellow.

The perimeters of all four panels have been covered by a red cotton-twill upholstery tape, stretched over a rigid wooden frame and tacked into place with modern brass nails. Modern silk velvet conceals the frames and lines the reverse sides. The same velvet has been used to form hinges between the panels.

COMMENTARY

Pierre Verlet's study of the Manufacture de la Savonnerie reveals that folding screens were produced according to eight different compositions during the eighteenth century. Seven of these compositions were created within the twelve-year period of 1707–1719, while the last one dated from 1739. Each composition consisted of cartoons for one to six individual leaves. In total, the workshop knotted 750 individual leaves from 1707 to 1791. All but the fourth composition (from 1713 and carrying the emblems of Louis xiv's queen, Marie-Thérèse, who died in 1683) were popular enough to be made throughout the eighteenth century.[1]

The cartoons for the present screen panels were made in 1718–1719 by the animal painter Alexandre François Desportes. They formed part of the seventh composition for folding screens in the sequence of the factory's production and the third composition that involved Desportes's collaboration or creation. Payments to him were recorded in 1719 and 1720 for painting cartoon panels of at least two separate heights: three for a smaller screen of four *pieds* (one *pied* equals 12¼ in. or 32.4 cm), three for a medium-size screen of six *pieds*, and three others of unspecified height.[2] The smaller cartoons showed both game birds and birds of prey under flowered trellises. The cartoons of six *pieds* included the models for the present screen and comprised a total of six different leaves. The production record for the manufactory named "M. Desportes" in 1722 as the designer, and an entry in the *Journal du Garde-Meuble de la Couronne* for 1735 describes a set of these panels in detail, adding "dessin de Desportes."[3] The *Registre d'Antin* describes the first two panels as:

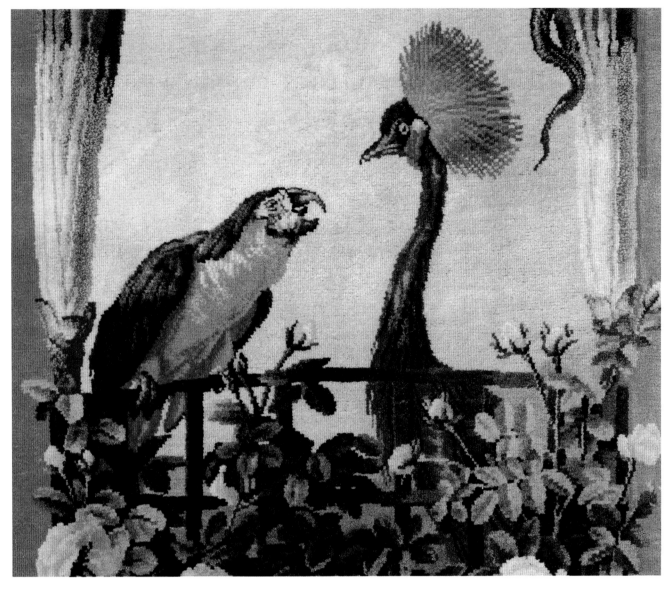

FIGURE 16.3 Detail of parrot and crane.

. . . une terasse sur lequel est possé deux lapins, un traïage de pechée au naturel, au dessus duquel il y a deux singes sur fond ciel enfermé par des cardons d'artichaux, au dessus il y a un bouquets de plumes blanches et bleux à fond couleur de paille, le tout entouré d'un fond pourpre, deux de ce desins ayant 1 aune 5 huit de hault sur 1 aune 1 huit de large.

and:

. . . une terasse sur quoy est possé trois cannes des Indes et un traïage sur quoy est attaché un rosier portant fleurs au naturelles, et au desus un gros peroquets jaune et bleu et un autre oiseau qui est le soleil royalle sur un ciel enfermé d'un cardon d'artichaux, au dessus un fond jaune sur quoy il y a un bouquet de plumes, ayant 1 aune ⅝ de hault sur 1 aune ⅛ de large.[4]

There were four additional leaves with different designs: leopards (called "tigres" in the *Registre d'Antin*) eating grapes; pheasants and a bird of prey; two hounds

FIGURE 16.4 Detail of snakes.

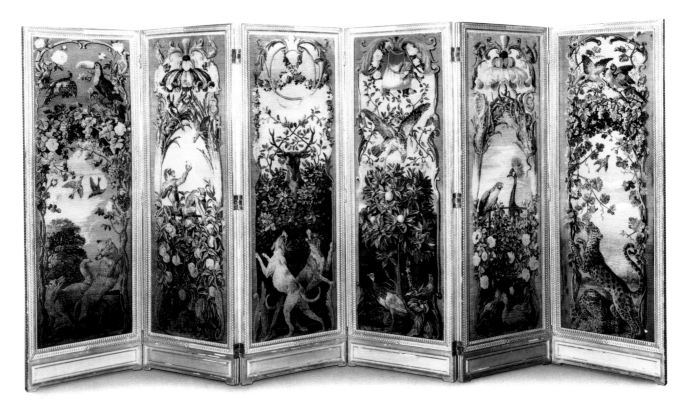

FIGURE 16.5 Savonnerie manufactory (French, mid-eighteenth century). *Sixfold Screen (Paravent)*. San Marino, California, the Henry E. Huntington Library and Art Gallery, inv. 11.41.

with a stag; and two foxes with a toucan. The descriptions of the first and second leaves each mention a canopy of feathers not seen in the Museum's example, although examples survive in other collections (fig. 16.5). At an unknown date these plumes were replaced by colorful acanthus scrolls and clasps. Verlet hypothesizes that this limited alteration was probably made only temporarily, either in order to simplify the work of the weavers by substituting a less time-consuming design, or to repair a loss in the cartoon caused by wear.[5]

The archives of the Manufacture Nationale de Sèvres preserve three paper cartoons for this screen painted in oil by Desportes; two panels have monkeys (figs. 16.6 and 16.7), while the other has hounds and a stag (third panel, fig. 16.5).[6] They are dated to about 1718. The screen panels produced at the Savonnerie, however, mixed the components of the Desportes designs. In the artist's cartoon the monkeys in the peach trellis are accompanied below by the group of three ducks, whereas in the knotted panels the monkeys are grouped with the rabbits and the ducks appear with the macaw parrot and the African crowned crane. The two squirrels in the acanthus scrolls of the Savonnerie leaves are apparently borrowed from another Desportes model that features a theatrical troupe of monkeys. A fourth model by Desportes, for the alternate panel of leopards eating grapes, is in the Metropolitan Museum of Art, New York.[7]

The archives of the Manufacture Nationale de Sèvres also contain a number of preparatory drawings and oil sketches by Desportes for nearly every creature portrayed in the Museum's *paravent*. The rabbits, the wood-

pecker, and the foliate design from the two panels with the peach trellises can be identified. Rabbits in the same position as those in the screen panels appear in two separate oil sketches of rabbits with a guinea pig. The weavers have even highlighted the same features as the artist—the left ear of the left rabbit and the fur of the right rabbit.[8] The woodpecker in the cardoon leaves to the upper left follows an example on a page of several studies of this bird, while the upper element of acanthus foliates enclosing an agrafe has its precedent on one of the few works of ornamental design contained within this body of material.[9] Preparatory studies exist for the following compositional details on the companion leaves of the Museum's screen: the group of waterfowl, the roses, the macaw parrot, the African crowned crane, and the grass snakes in the cardoon leaves, particularly the one with an open mouth. The three ducks are found as a group in one oil sketch, while the black and white *canard tadorne* also appears with other birds in a separate work.[10] The roses, the African crowned crane, and the grass snakes each have a single sheet devoted exclusively to that subject.[11] The blue and yellow macaw parrot with an open beak is after an oil study consisting of no fewer than six macaw parrots among other birds (fig. 16.8).[12]

WEAVER AND DATE

A total of 143 panels after the Desportes cartoons for the factory's seventh screen composition were made during the eighteenth century. Verlet states that production was well documented until the middle of the century; after 1739 the records are harder to interpret, but apparently the designs

FIGURE 16.7 Alexandre François Desportes (French, 1661–1743). Study for a *paravent* panel. Manufacture Nationale de Sèvres, Archives IV.51, D § 11 1873 no. 2⁶. Photo R.M.N.

FIGURE 16.6 Alexandre François Desportes (French, 1661–1743). Study for a *paravent* panel. Manufacture Nationale de Sèvres, Archives IV.50, D § 11 1873 no. 2⁵. Photo R.M.N.

FIGURE 16.8 Alexandre François Desportes (French, 1661–1743). Study of parrots. Manufacture Nationale de Sèvres, Archives S.37, F § 6 1814 no. 13. Photo Jérôme Letellier.

continued to be woven at intervals until 1784. Ninety-two leaves were made between 1719 and 1739, twenty-nine between 1766 and 1769, and an additional twenty-two from 1774 to 1784.[13] Thus production spanned the directorship of no fewer than four *entrepreneurs*: Bertrand-François Dupont (1714–1720), Jacques de Noinville (1721–1742), Pierre-Charles Duvivier (1743–1774), and Nicolas-Cyprien Duvivier (1775–1807).

As mentioned above, the two original cartoons with the feathered canopies were altered, possibly only temporarily and perhaps to substitute a simpler design for a more complicated and time-consuming one. Verlet suggested that the new frames composed of acanthus leaves and a clasp reflected the style of Pierre-Josse Perrot (active 1724–1750, *peintre d'ornements* at the Administration de l'Argenterie, Menus-Plaisirs et Affaires de la Chambre du Roi, and at the manufactories of the Gobelins and the Savonnerie). In 1739 Perrot collaborated with Jean-Baptiste Oudry on the design for the factory's eighth and last screen composition, one with leaves portraying Aesop's fables. The upper section of those panels utilized the same acanthus scrolls and clasps as framing devices (fig. 16.9).

Nevertheless, the date of the substitution of clasps for feathers is not documented, and may well have been an expediency introduced late in the century. If so, it is logical to assume that the panels with feathered canopies preceded

those with the acanthus leaf frame and it would explain why the majority of surviving panels bear the plumed ornament. If, however, the substition was limited and temporary, as Verlet hypothesized, then knotting of the feathered canopy could have resumed and continued until 1784. In the year IV (1795–1796) six screen panels with feathers ("ornemens panachés") were described in the factory's storeroom inventory.[14]

RELATED PANELS
During the mid-eighteenth century it seems that nearly half of the panels made after the Desportes cartoons remained in storage; some of these were later used as diplomatic gifts. For example, of the ninety-two leaves produced by 1739, forty-four were inventoried in the factory's storeroom in 1740.[15] Forty-eight panels were delivered by that date to the Garde-Meuble for the Grand Trianon and the Château de Marly.[16] Both Louis XV and Louis XVI presented screens of this composition as gifts to Swedish royalty: Crown Princess Louise Ulrica was given a set in 1747 and King Gustavus received a set in 1784.

In 1982 Verlet was able to account for fifty-nine panels out of the estimated production of 143.[17] A six-fold screen showing all six designs is preserved in the James A. de Rothschild Collection at Waddesdon Manor, England, and another is in the collection of the Huntington Library, Art Gallery, and Botanical Gardens in San Marino, California (fig. 16.5). The Royal Collection, Stockholm, retains the two royal gift sets, each of which has six pieces divided into three-fold screens, with two versions of the monkey panel and one of the macaw parrot. At least five additional *paravents* containing panels with monkeys and panels with the macaw parrot are known, providing a total of six examples of each.[18]

PROVENANCE
Garde-Meuble de la Couronne, eighteenth century; the Earls of Caledon, Tyttenhanger Park, St. Albans, Hertfordshire from before 1875, by descent to Denis James Alexander, sixth Earl of Caledon (b. 1920), Tyttenhanger Park; Alexander and Berendt, Limited, London, 1973; J. Paul Getty Museum, 1975.

PUBLICATIONS
R. R. Wark, *French Decorative Art in the Huntington Collection* (San Marino, California, 1979), pp. 25–27; Verlet 1982, p. 467 n. 20; Wilson 1983, no. 12, pp. 24–25, illus.; M. Komanecky and V. Fabbri Butera, *The Folding Image, Screens by Western Artists of the Nineteenth and Twentieth Centuries* (New Haven, circa 1984), p. 29, illus. fig. 18; Standen 1985, vol. 2, no. 74, p. 490 and no. 111, pp. 652–654; Sassoon and Wilson 1986, no. 228, p. 109, illus.; Bremer-David et al., 1993, no. 283, p. 166, illus.

FIGURE 16.9 Savonnerie manufactory (French, mid-eighteenth century). *Sixfold Screen (Paravent)*. Château de Vaux-le-Vicomte, near Melun. Photo courtesy of le comte Patrice de Vogüé.

NOTES

1. Verlet 1982, pp. 299–303.

2. P. Verlet, "Les Paravents de Savonnerie pendant la première moitié du XVIIIᵉ siècle," *L'Information d'histoire et d'art* 12 (May–June 1967), pp. 106–118, and pp. 112–113 n. 26, where Verlet cites "François Desportes aux Gobelins et à la Savonnerie 1717–1722," in Engerand 1901, pp. 144–146.

3. "Trois morceaux de moyens paravens faisant six feuilles des dessins de M. Desportes, ayant chacun une aune dix seize sur une aune et demy seize" were made under the *entrepreneur* Noinville in 1722. See Verlet 1982, p. 336 and pp. 337–338.

4. Verlet (note 2), pp. 115–116.

5. Verlet 1982, p. 340.

6. The monkey panel measures 37.5 by 12.5 cm (Sèvres, IV.50, D § 11 1873 no. 2⁵), its companion leaf with the squirrels is 32.5 by 14.5 cm (Sèvres, IV.51, D § 11 1873 no. 2⁶), and the hound cartoon 31.5 by 13.5 cm (Sèvres IV.48, D § 11 1873 no. 2³). See *L'Atelier de Desportes, Dessins et esquisses conservés par la Manufacture nationale de Sèvres*, exh. cat. (Musée du Louvre, Paris, 1983), nos. 122, 121, and 125, p. 114, illus. pp. 121 and 123.

7. Illustrated in Verlet 1982, p. 338, fig. 210.

8. MNS archives: Sèvres, S.9, Fp § 2 1814 no. 18 (52 by 64 cm); and Sèvres, S.254, Fp § 3 1814 no. 49 (89 by 115 cm). A note made by Mme. Brunet in the Sèvres archive relates the former to a study recorded in Engerand 1901, p. 618, as: "Un où il y a six lapins et un cochin d'Inde; ayant 2 pieds de long sur un pied 8 pouces de haut." The latter was published by H. Oursel, "Deux tableaux français des XVIIᵉ et XVIIIᵉ s aux Musée d'Aras et de Lille," *La Revue du Louvre* 5–6 (1977), pp. 316–321, illus. no. 10.

Edith Standen has observed that the rabbits appear in other works by Desportes and in drawings copying him by Jean-Baptiste Oudry (1686–1755). Some of Oudry's drawings, including that of the two rabbits, were the basis for tapestry upholstery covers woven at the Beauvais manufactory. See Standen 1985, vol. 2, no. 74, pp. 490–491.

9. The woodpecker is found on a sketch, Sèvres, S.146, F § 6 1814 no. 43 (30.5 by 52.5 cm), and the foliate ornament on Sèvres, S.276, F § 6 1814 no. 66 (32 by 52 cm) in the MNS archives. The former is presently on loan to the Musée International de la Chasse, Gien, inv. D 449.

10. MNS archives, Sèvres S.85, F § 2 1814 no. 119 (51.5 by 46 cm) and Sèvres, S.150, F § 2 1814 no. 30 (96 by 131 cm) respectively.

11. MNS archives: roses from Sèvres, III.1, F § 7 1814 no. 73 (39 by 61 cm); crane from Sèvres, S.46, Fp § 2 1814 no. 180 (103 by 54 cm) on loan to the Musée International de la Chasse, Gien (inv. D 249); snakes from Sèvres II.45, Fp § 2 1814 no. 45 (20 by 435 cm). The last was included in *L'Atelier de Desportes* (note 6), no. 41, p. 34, illus. p. 55.

12. MNS archives, Sèvres S.37, F § 6 1814 no. 13 (136 by 105 cm). As an indication of the use to which this kind of stock study (fig. 16.8) might be put, compare the pose of the left-facing green and yellow parrot that crosses in front of the model used in this screen with the parrot in the *alentour* of the Gobelins *Tentures de François Boucher*, cat. entry No. 7.

13. Verlet 1982, p. 336, and pp. 466–467 nn. 1–16.

14. Ibid., pp. 336 and 467 n. 15.

15. Ibid., p. 336.

16. See S. Castellucio, "L'Appartement de Marie-Antoinette à Marly," *L'Objet d'Art* 274 (November 1993), pp. 48–65.

17. Verlet 1982, pp. 337 and 467 n. 20.

18. An advertisement for a three-fold *paravent* with the Paris dealer Jansen, *Les Arts* 22 (October 1903), p. 33; another advertisement for a four-fold screen with the dealer Cimaise in *Les Arts* 51 (May 1906), p. 31; one panel of a five-fold screen that sold Galerie Georges Petit, Paris, May 31, 1927, no. 187; two panels of a four-fold screen in a private collection, Paris, illus. in J. Whitehead, *The French Interior in the Eighteenth Century* (London, 1992), pp. 140–141; two panels in a pair of three-fold screens in a private collection, Paris, illus. in "A Sumptuous Parisian Townhouse Preserving the Graces of the Eighteenth Century," *Architectural Digest* (December 1979), p. 52–55.

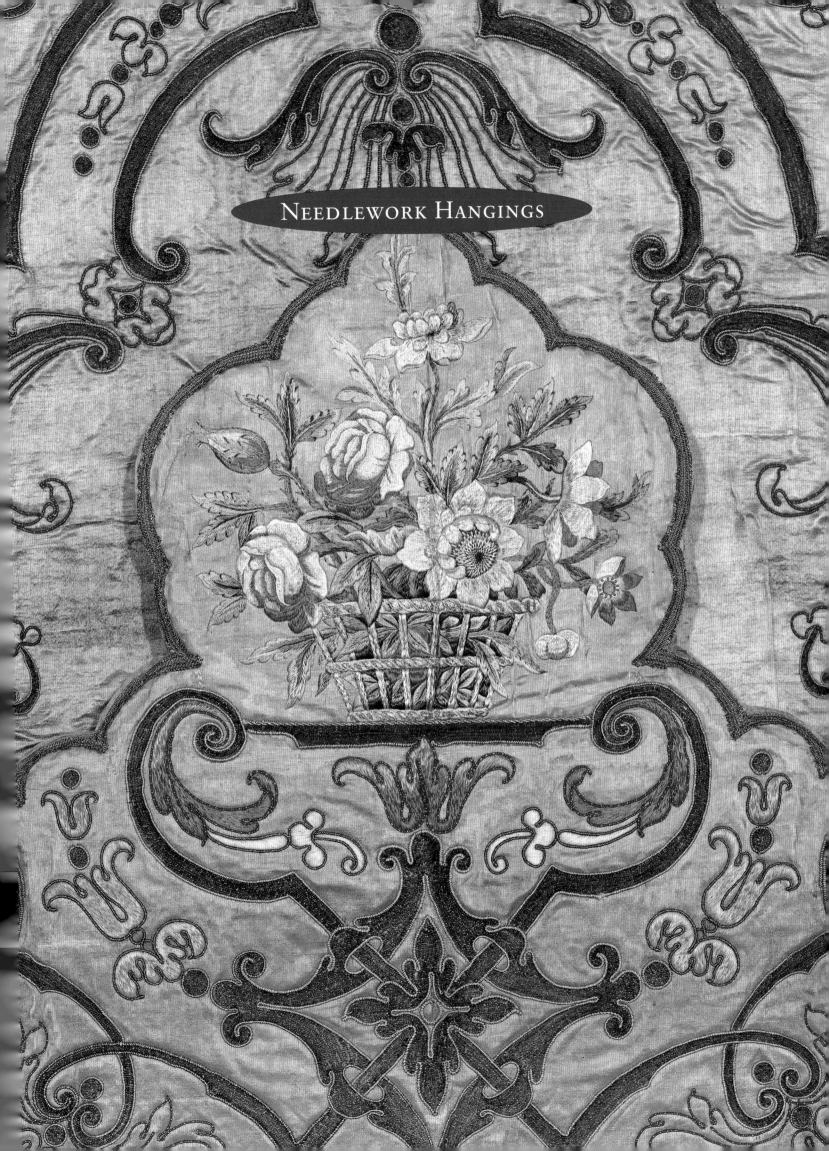

Needlework Hangings

17

Pair of Embroidered Bed Hangings (*Bonne-grâces*)

French (Paris ?); circa 1680–1690

Embroidered after a design attributed to Daniel Marot (1661–1752)

MATERIALS
Linen, silk, and wool

DIMENSIONS
panel 1:
height 11 ft. 1 in. (343 cm)
width 3 ft. 1 in. (91 cm)

panel 2:
height 11 ft. ½ in. (340 cm)
width 3 ft. ¹³⁄₁₆ in. (90 cm)

85.DD.266.1–2

DESCRIPTION
These needlework panels were originally part of a set of bed hangings for a *lit de parade*, probably intended for the *chambre de parade* in the sequence of formal rooms in a hôtel or château. The panels constitute a pair; they have nearly equal dimensions and are embroidered with the same design, although some features have been worked in yarns of differing colors.

The hangings are essentially long rectangles with a cream-colored main field, against which a variety of decorative ornaments are symetrically arranged. Anchoring the design at the base is a thick console shape, decorated with an overall diaper mosaic in blue, pink, and gray and centered by a large, scalloped shell in red (fig. 17.1). Two pairs of red, blue, and green billing birds are perched on the console, and on either side its scrolls are crested with a blue metallic urn containing an orange pomegranate amid green leaves. Gray strapwork that originates in the central shell of the base stretches upward to form two horizontal shelves for recumbent sphinxes, which are draped with red and blue caparisons and wear breastplates, collars, and blue-feathered headdresses (fig. 17.2). Above are further attenuated straps and foliage that eventually form into another shelf. Draped in the center with a diaper mosaic, this shelf supports a metallic basin filled with flowers, two cream-colored birds, and two female herms with tapering blue pedestals. Wearing grecian tunics in orange or red with blue girdles, the two female herms suspend floral and leafy garlands from one hand while using the other to support the next sequence of strapwork patterns above their heads.

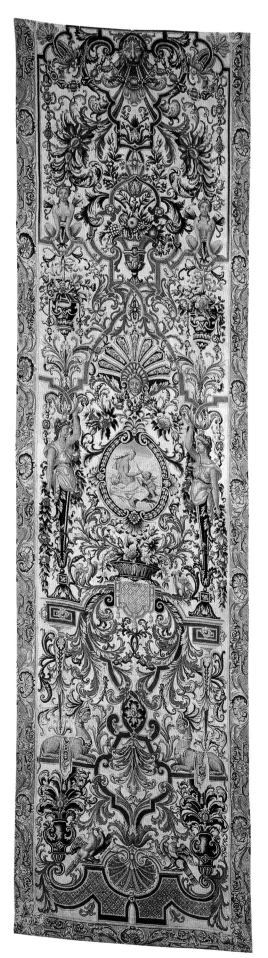

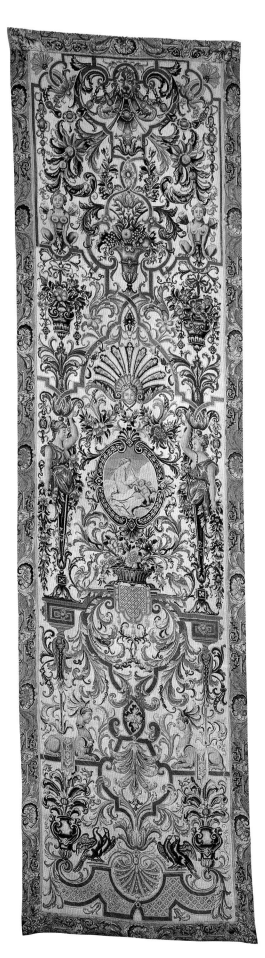

Panel 1

Panel 2

Pair of Embroidered Bed Hangings (Bonne-grâces)
85.DD.266.1–2

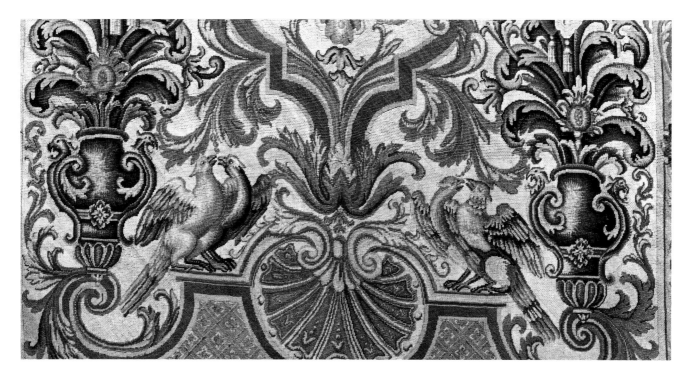

FIGURE 17.1 Detail of 85.DD.266.1.

FIGURE 17.2 Detail of 85.DD.266.2.

They face inward toward the central cartouche. This oval cartouche is the focus of the decoration and takes the form of an imitation painting, framed with laurel leaves and four shell motifs. The painting portrays Venus seated among clouds in a blue celestial setting with Cupid at her knees (fig. 17.3). Wearing a pink or peach robe draped around her legs, Venus has just disarmed Cupid by grasping his arrow in her right hand. Centered above the cartouche is a female mask within a large shell-like ornament. To either side above, paired metallic urns filled with flowers are suspended from pink or beige ribbons tied into bows. Yet another vessel, this one overflowing with fruit, is set centrally above. It is flanked by a pair of butterfly-winged harpies who crouch frontally on gray or brown strapwork (fig. 17.4). Above additional leafy tendrils and jeweled swags, the design culminates in a yellow lion's mask. Both panels are surrounded by an embroidered border consisting of a blue ground articulated by yellow-green shells and pink and green scrolls. *Panel 1* is lacking the border along its top.

CONDITION

The two panels are embroidered on plain-weave linen canvases. The canvas for *Panel 1* has 18 warps and 18 to 22 wefts per inch, while the canvas for *Panel 2* is of a finer weave with 22 to 24 warps and 24 to 28 wefts per inch; in both the warps and wefts are Z spun, single yarns. Both panels are embroidered with wool and silk yarns in a needlepoint stitch known as *petit point de panier*.[1] The silk yarns are Z spun, while the wool yarns are both Z and S spun. Pulled repeatedly by the embroiderers' hands, the interlocking stitches have skewed the panels diagonally from the upper left corners to the lower right, stretching the can-

FIGURE 17.3 Detail of 85.DD.266.2.

FIGURE 17.4 Detail of 85.DD.266.2.

FIGURE 17.5 Detail of reverse of 85.DD.266.2, with linings temporarily removed.

vases one-quarter to one-half inch at the lower right edge. This distortion is consistent with an embroiderer working left to right, from top to bottom. In some small areas on both panels a second layer of stitches has been added to achieve subtle gradations of color. Both panels have suffered fading, but the colors of *Panel 2* are brighter than those of *Panel 1*. There is some abrasion to the tops of the stitches, and where brittle upper fibers have broken off, brighter yarns are seen underneath.

While both panels are framed by a border, *Panel 1* is missing its border from the top edge. A comparison of the reverse of the two panels reveals that both the border and rectangular field of *Panel 1* were worked on one seamless piece of linen canvas. Sometime after *Panel 1* was embroidered, its top edge was trimmed away and the area finished by a fold turned to the reverse face. In the case of *Panel 2*, however, the borders were produced separately (fig. 17.5). The side and bottom strips of border canvas were joined to each other vertically and embroidered; they were then taken apart and affixed to the completed central section of *Panel 2*. At that point, apparently, the top border of *Panel 1* was also removed and joined to *Panel 2*. Presumably this was done in order to equalize the respective lengths of the two panels.

Both panels have an unevenly cut, unembroidered margin of canvas along the outermost edges. Each reverse has a layer of starch, applied in the seventeenth century to secure loose yarns, and both panels are backed by their original plain-weave linen linings. A pattern of tufts of thread along the top of each panel suggests that hanging rings were once attached at regular intervals. Velcro has been sewn along the perimeters to a new outer lining and attaches the panels to a firm support that is covered with modern plain-weave linen.

COMMENTARY

Individual elements seen on these panels come from a common vocabulary employed by two well-known *ornemanistes* who were active in the last quarter of the seventeenth century, both of whose designs were widely disseminated through engravings. The older *ornemaniste*, Jean 1 Berain (1640–1711), was *dessinateur de la Chambre et du Cabinet du Roi* within the Administration de l'Argenterie, Menus-Plaisirs et Affaires de la Chambre du Roi from 1675. He popularized an arabesque style, usually referred to as "des grotesques," that was ultimately inspired by Raphael's loggie at the Vatican; but he transformed and broadened these elements to include a seemingly endless variety of strapwork patterns, foliate scrolls, floral swags, slim arches, masks, lambrequins, animals and birds, herms and sphinxes, and cartouches populated with mythological and theatrical figures. Although employed at the court of Louis XIV, Berain also filled commissions for other princely households, among them those of Lorraine and Orléans. Surviv-

ing tapestries, armorial *portières*, and narrower weavings, woven textiles, and engravings leave a legacy of his influential design work (fig. 17.6). Specific features of the Museum's embroidered hangings that are derived from Berainesque prototypes include: opposed sphinxes draped with caparisons, pairs of billing birds with wings extended, butterfly-winged harpies sitting frontally on their haunches, female herms, and swags of jewels.[2]

Anne Ratzki-Kraatz has argued, however, that while the hangings show similarities with the style of Berain, they probably follow a design by another *ornemaniste*, Daniel Marot.[3] Son of Jean Marot (1610–1679), a Huguenot engraver and architect active at the French court, Daniel Marot was an independent engraver by the age of sixteen and had executed engravings for Berain before fleeing France in 1684, just prior to the revocation of the Edict of Nantes. Finding employment in the service of William of Orange (1650–1702), who became King William III of England in 1688, Marot worked in both the United Provinces and England. His design work is known today primarily through engravings, drawings, and surviving ceremonial beds, and it bears the life-long influence of the master *ornemaniste*, Berain.[4] Ratzki-Kraatz based her attribution to the younger Marot on an analysis of the composition of the embroidered design, its proportions, and the arrangement of elements within this structure.

Like Berain, Marot is associated with designs for textiles, embroidery, upholstery, and tapestries. Among his published engravings is a *cahier* entitled *Nouveaux livre d'Ornements propres pour faire en broderie et petit point—housse, caparaçon—montant d'ornement, dessus de table brodé, dossiers et carreaux de chaises*. Marot's drawings and engravings for ceremonial beds inspired the upholstery, embroidery, and *passementerie* (trim and lace) professionals. Armorial tapestry *portières* are also known to follow his designs.[5]

In the Victoria and Albert Museum there are three drawings by Daniel Marot that relate to the narrow vertical composition of the Museum's bed hangings and document Marot as a source for such designs. Two of these pen-and-ink studies have been linked to painted panels in the collection of the Duke of Buccleuch, but they also resemble the Museum's embroideries in their division of space and in the use of a central reserve with a mythological scene (fig. 17.7). The third drawing, with its composition of lightweight trellis motifs, banding, and connecting foliate scrolls, is even closer in design to the Museum's panels, and it has been suggested as a possible source for a set of embroidered hangings in the English royal collection (fig. 17.8).[6]

EMBROIDERER AND DATE

According to Anne Ratzki-Kraatz, wool and silk embroidery of the *petit-point* type was not executed by master embroiderers (who usually worked with gold and silver

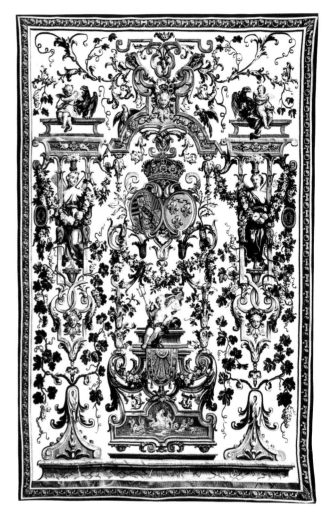

FIGURE 17.6 (?) Lunéville manufactory (French, Lorraine, before 1729). *Portière aux armes de Lorraine et d'Orléans.* Vienna, Kunsthistorisches Museum, inv. XXVIII/1.

FIGURE 17.7 Daniel Marot (French, 1661–1752). Two preparatory studies for painted paneling. London, The Victoria and Albert Museum, inv. 8480. 6 and 7. Photo courtesy the Board of Trustees of the Victoria and Albert Museum.

FIGURE 17.8 Daniel Marot (French, 1661–1752). Design for a grotesque panel. London, The Victoria and Albert Museum. Photo courtesy the Board of Trustees of the Victoria and Albert Museum.

thread), but was rather the product of professional upholsterers (*tapissièrs*) and their workshops. Members of this latter guild were required to be accomplished draftsmen, although ready-made patterns were available to them. Given the widespread circulation of such patterns, it is not possible to determine the exact origin of the Museum's hangings, but their design, techniques, and dyestuffs are consistent with the period 1680 to 1690.

Obvious and subtle discrepancies between these two panels suggest that they were embroidered *en suite* but by different artisans. Aside from variations in the colored yarns used for the same design elements, the handling of shading is distinctly different from one panel to the other, and the figural details of *Panel 2* are generally more skillfully rendered. However, given the numerous embroidered components necessary to create a *lit de parade* (see catalogue entry No. 18), it is not surprising to discover such variations within a suite of hangings.[7]

RELATED TEXTILES

A companion pair of embroidered hangings, bearing reserves that depict Jupiter with an eagle instead of Venus and Cupid, is in the Cleveland Museum or Art (fig. 17.9).[8] The two pairs of hangings must surely share a common origin; not only are their designs identical, but they have many construction details in common, including the use of canvases of two different weaves, the removal of a top border from one to the other, and a similar application of starch on the reverse. One of the Cleveland hangings bears a label stating "Collection Greffulhe," undoubtedly for the collector, active in Paris in the last quarter of the nineteenth century, comte Henri de Greffulhe.

As both pairs of panels bear traces of a system of rings, it is assumed they originally hung *en suite* as inner and outer curtains (*bonne-grâces*) for a *lit de parade*. No other textiles from this particular bed have been located, although unsubstantiated rumor alludes to valances reputedly surviving in France. There is, however, strong reason to believe that the ultimate pattern source included not only the bed but designs of various dimensions suitable for furnishing the entire suite of a *chambre de parade* or *chambre du lit*. The existence of a tapestry-woven fire screen (*écran*) of extremely similar design supports this premise.[9] Rectangular in shape, the fire screen has a cream-colored ground divided at the bottom by mosaic segments. Two portions of the mosaic base anchor pedestals at either side of the panel. Each pedestal terminates in a herm of a winged Zephyr who carries a basket of flowers on his head. A cartouche positioned in the middle portrays a seated female, Ceres or possibly Flora, attended by two putti. Filling the remaining field are swags of jewels, garlands of leafy flowers, foliate tendrils, ribbons, birds, and a baldachin. Despite the difference in medium, the screen has many close stylistic affinities to the Museum's embroidered panels.

PROVENANCE

Lt. Col. A. Heywood-Lonsdale, Shavington Hall, Salop; Partridge [Fine Arts], Ltd., London, 1985; J. Paul Getty Museum, 1985.

PUBLICATIONS

"Acquisitions/1985," *GettyMusJ* 14 (1986), no. 277, pp. 161–162, illus.; *The Bulletin of the Cleveland Museum of Art* 78/3 (June 1991), p. 26, illus.; A. Ratzki-Kraatz, "Two Embroidered Hangings in the Style of Daniel Marot," *GettyMusJ* 20 (1992), pp. 89–106, illus.; Shore, Strauss, Considine, and Wallert, "The Technical Examination of a Pair of Embroidered Panels," *GettyMusJ* 20 (1992), pp. 107–112; Bremer-David et al., 1993, no. 277, pp. 161–162, illus.

NOTES

1. See Shore, Strauss, Considine, and Wallert, "The Technical Examination of a Pair of Embroidered Panels," *GettyMusJ* 20 (1992), pp. 107–112.
2. See J. Berain, *Ornemens Inventez par J. Berain* (Paris, circa 1700?), pls. 3, 8, 15, 95.
3. A. Ratzki-Kraatz, "Two Embroidered Hangings in the Style of Daniel Marot," *GettyMusJ* 20 (1992), pp. 89–106, illus.
4. K. Ottenheym, W. Terlouw, and R. van Zoest, *Daniel Marot, Vorgever van een deftig bestaan* (Amsterdam, 1988), p. 101, and E. Evans Dee, "Printed Sources for the William and Mary Style," in P. M. Johnston, ed., *Courts and Colonies: The William and Mary Style in Holland, England, and America* (New York, 1988), pp. 80–85.
5. Standen 1985, vol. 1, no. 35, pp. 224–227.
6. London, Victoria and Albert Museum, invs. 8480.6–7. See G. Jackson Stops, "Daniel Marot and the 1st Duke of Montagu," *Nederlands Kunsthistorisch Jaarboek* 31 (1980), pp 244–262, in which the author notes the connection with textile design. See also H. Coutts, "Hangings for a Royal Closet," *Country Life* (October 13, 1988), pp. 232–233, and Evans Dee (note 4), nos. 21–24, pp. 102–106, illus.
7. A set of four early eighteenth-century *petit-point* wool embroidery panels in the collection of the Musée Nissim de Camondo, Paris, demonstrate the variations of colored yarns used for the same motifs that repeated from one piece to the next. The narrow panels measure approximately 350 cm by 83 cm and are installed within the boiserie of the dining room (inv. 263). Their original function (as bed curtains?) is not specified. See N. Gasc and G. Mabille, *The Nissim de Camondo Museum* (Paris, reprint 1995), pp. 96 and 99.
8. The Cleveland Museum of Art, inv. 90.24–25, purchased from the J. H. Wade Fund.
9. Attributed to the Beauvais manufactory after a design by Berain, the screen was in the Paris collection of M. Braquenié when published in *Principes d'analyse scientifique: Tapisserie, méthode et vocabulaire* (Paris, 1961), pls. 114–115, pp. 106–107.

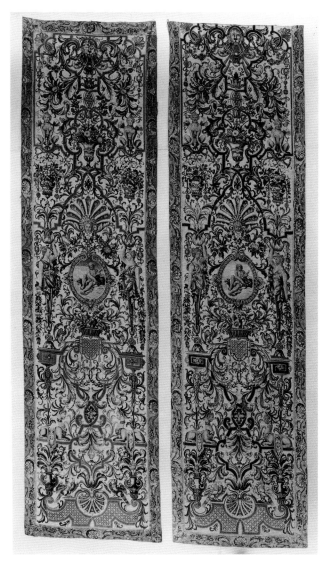

FIGURE 17.9 Unidentified embroiderer (French, circa 1680–1690). Pair of Embroidered Bed Hangings (*Bonne-grâces*). The Cleveland Museum of Art, Purchase from the J. H. Wade Fund, inv. 90.24–.25.

18

Hangings for a Bed (*Lit à la duchesse*)

French (?Paris); embroidered circa 1690–1715

MATERIALS
Silk satin with applied or inserted sections of silk lampas and partially lined with silk taffeta; embroidery and applied trim of silver and metallic-wrapped silk thread, silk cord, and silk floss; linen and bast backing; wool padding; paper

OVERALL DIMENSIONS WHEN ASSEMBLED
height 13 ft. 8½ in. (427.5 cm)
width 5 ft. 7¼ in. (170.8 cm)
depth 6 ft. 8 in. (203.2 cm)

79.DH.3.1–16

DESCRIPTION

This bed is in the form known as a *lit à la duchesse*. It is composed of silk satin hangings of a rich yellow color, embroidered with couched green, crimson, turquoise, and brown silk chenille cord (fig. 18.1 is a diagram identifying all components). The cover, headboard, back panel, inner curtains, the two original upper inside valances, and the tester are embellished with symmetrical patterns of diaper motifs, arabesques, tendrils, cartouches, rosettes, and green strapwork (fig.18.2). Two narrow rows of bluish-green and silver metallic *galon* are sewn back-to-back and stitched along each contour or straight edge. The cover is a three-dimensional shape designed to fit over the mattress and the bolster pillow at the head (fig. 18.3). The headboard is also a three-dimensional component, intended to be mounted on a shallow panel of conforming shape. The couched chenille thread of both the headborad and the back panel is complimented by satin-stitch needlework in silk floss of predominantly white, green, pink, and red color. The top of the headboard is embroidered with a cane basket filled with flowers whose leaves protrude through the open-work (fig. 18.4).

The yellow silk satin outer valances and outer side curtains (fig. 18.5) all have applied segments of a blue silk lampas with supplemental patterning in metallic-wrapped thread.[1] The latter fabric is of a "Bizarre" design, with a repeat in supplemental warp threads consisting of a large-scale, asymmetrical foliate scroll amid small pink and white flowers with yellowish-green leaves. These shaped segments of Bizarre silk are echoed by cut contour strips of other

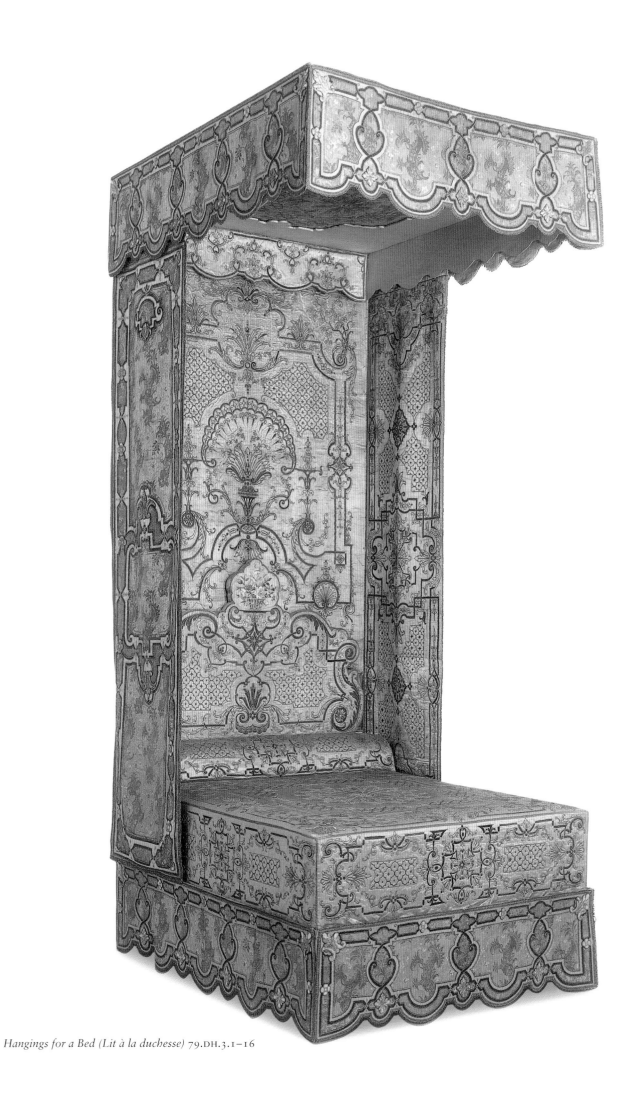

Hangings for a Bed (Lit à la duchesse) 79.DH.3.1–16

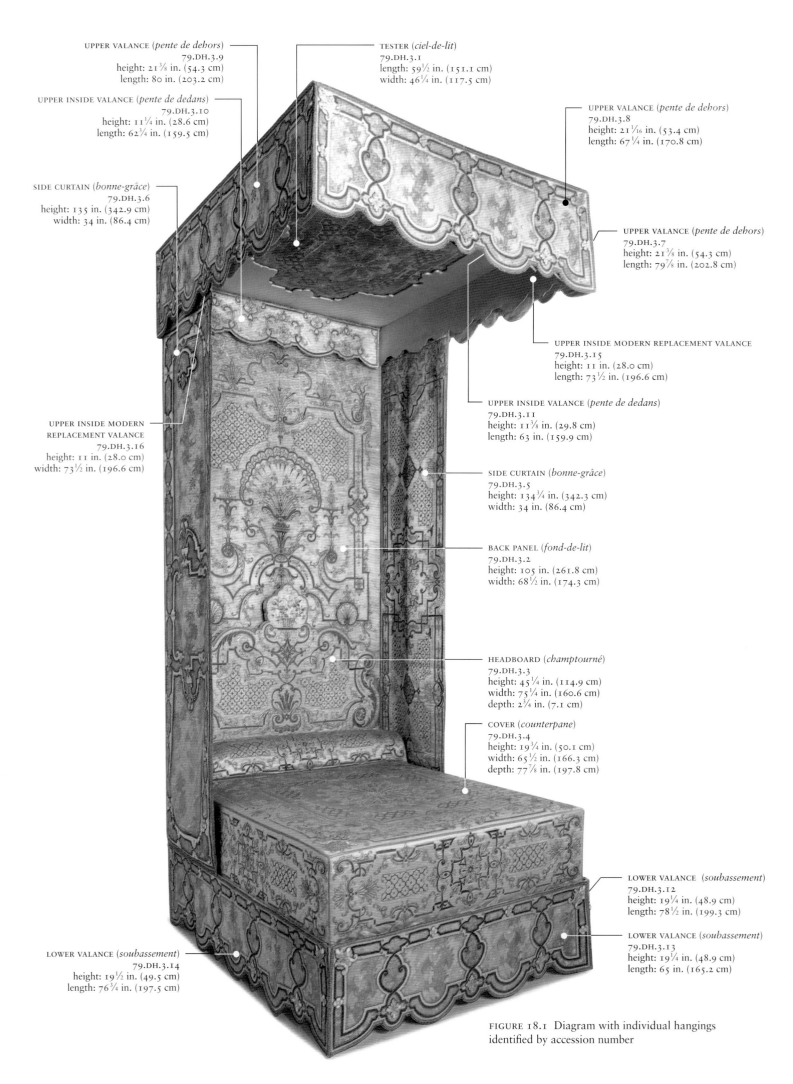

UPPER VALANCE (*pente de dehors*)
79.DH.3.9
height: 21⅜ in. (54.3 cm)
length: 80 in. (203.2 cm)

UPPER INSIDE VALANCE (*pente de dedans*)
79.DH.3.10
height: 11¼ in. (28.6 cm)
length: 62¾ in. (159.5 cm)

SIDE CURTAIN (*bonne-grâce*)
79.DH.3.6
height: 135 in. (342.9 cm)
width: 34 in. (86.4 cm)

UPPER INSIDE MODERN
REPLACEMENT VALANCE
79.DH.3.16
height: 11 in. (28.0 cm)
width: 73½ in. (196.6 cm)

TESTER (*ciel-de-lit*)
79.DH.3.1
length: 59½ in. (151.1 cm)
width: 46¼ in. (117.5 cm)

UPPER VALANCE (*pente de dehors*)
79.DH.3.8
height: 21 1/16 in. (53.4 cm)
length: 67¼ in. (170.8 cm)

UPPER VALANCE (*pente de dehors*)
79.DH.3.7
height: 21⅜ in. (54.3 cm)
length: 79⅞ in. (202.8 cm)

UPPER INSIDE MODERN REPLACEMENT VALANCE
79.DH.3.15
height: 11 in. (28.0 cm)
length: 73½ in. (196.6 cm)

UPPER INSIDE VALANCE (*pente de dedans*)
79.DH.3.11
height: 11⅜ in. (29.8 cm)
length: 63 in. (159.9 cm)

SIDE CURTAIN (*bonne-grâce*)
79.DH.3.5
height: 134¾ in. (342.3 cm)
width: 34 in. (86.4 cm)

BACK PANEL (*fond-de-lit*)
79.DH.3.2
height: 105 in. (261.8 cm)
width: 68½ in. (174.3 cm)

HEADBOARD (*champtourné*)
79.DH.3.3
height: 45¼ in. (114.9 cm)
width: 75¼ in. (160.6 cm)
depth: 2¾ in. (7.1 cm)

COVER (*counterpane*)
79.DH.3.4
height: 19¾ in. (50.1 cm)
width: 65½ in. (166.3 cm)
depth: 77⅞ in. (197.8 cm)

LOWER VALANCE (*soubassement*)
79.DH.3.12
height: 19¼ in. (48.9 cm)
length: 78½ in. (199.3 cm)

LOWER VALANCE (*soubassement*)
79.DH.3.13
height: 19¼ in. (48.9 cm)
length: 65 in. (165.2 cm)

LOWER VALANCE (*soubassement*)
79.DH.3.14
height: 19½ in. (49.5 cm)
length: 76¾ in. (197.5 cm)

FIGURE 18.1 Diagram with individual hangings
identified by accession number

lampas fabrics, brocaded with metallic wrapped threads in a variety of floral patterns. Both types of brocaded lampas are outlined by silk cords wrapped with silver metallic thread and they are framed by bands of couched, red silk chenille. Punctuating the contour bands are raised forms of fleurons, rosettes, crescents, and quatrefoils that were created from paper patterns, padded with wool, covered with silver brocaded lampas, and outlined by cording. Intersecting the contour bands are embroidered lozenge designs whose central cabochons are filled with spirals of silver thread coiled around a wire core. The extreme perimeters of these elements of the bed hangings are trimmed by an ornate *galon* of metallic-wrapped silk threads anchoring loops of red, blue, and white silk cords.

The bed is lacking the shaped, wooden inner frame that would have surrounded the embroidered tester textile. This missing element would have been covered with fabric, probably the same yellow silk satin. It would have been contoured to echo the embroidered pattern and recessed, as well, in a shallow, stepped fashion into the planar center (fig. 18.6). The exact depth of the original recess is not known. Two of the long, upper inside valances are also lacking and have been replaced by modern, unembellished approximations in yellow silk satin.

CONDITION

The general condition of the bed hangings is fair. The cover, headboard, back panel, tester, inner side curtains, and upper inside valances are made of yellow, warp-faced silk satin (irregular, possibly nine ends) with a warp count of 130 to 135 and weft count of 76 threads per inch. The loom width of this satin is 23 inches (58.4 cm) and the selvages consist of two rows of green threads separated by a narrow band of yellow threads. The headboard, back panel, tester, and upper inside valances are backed by plain, balanced-weave linen with a warp count of 26 and a weft count of 28 threads per inch. Its loom width is 39 inches (99.0 cm) and the selvages are plain. The tester is constructed of pieced silk satin in a shape approximating a cross, which has been applied to a rectangular-shaped support of linen. The cover is backed by a plain-weave linen in a plaid pattern of white, tan, light brown, and pink colors. It has a warp count of 50 and a weft count of 48 threads per inch. The headboard has been extended (or its original lower section replaced) by a five-inch strip of newer, yellow, warp-faced silk satin (regular, three to four ends). The loom width of the newer satin appears to be 19⅜ inches (49.2 cm); its selvages consist of two rows of bright pink threads that flank three threads wrapped with silver-gilt metal. The inner faces of the side curtains have also been extended (or replaced) by approximately 38 inches (96.5 cm) of this newer silk satin. The two inside upper valances retain their original partial linings of blue silk taffeta under modern outer linings of silk taffeta, dyed to match.

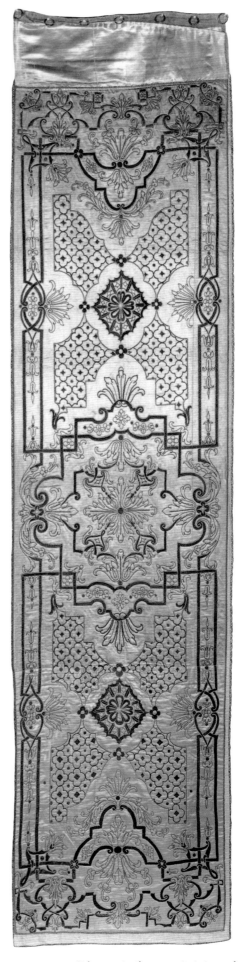

FIGURE 18.2 Side curtain (*bonne-grâce*), inner face.

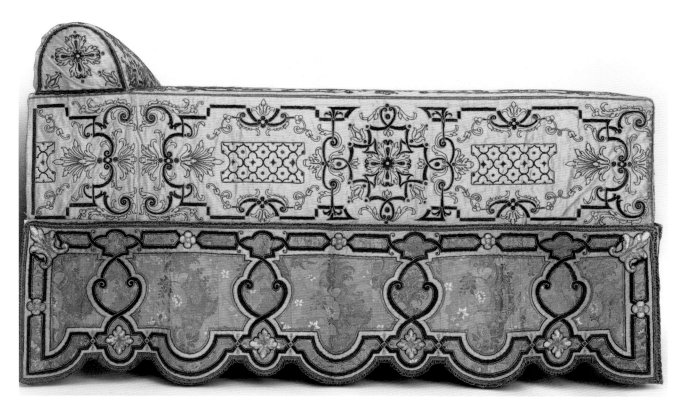

FIGURE 18.3 Profile of cover.

FIGURE 18.4 Detail of satin stitch embroidery on headboard.

The yellow satin hangings have embroidered embellishments consisting of couched silk-chenille cords, metal-wrapped cords with silk cores, and softly spun (Z) silk floss. Both the cover and the inner side curtains bear graphite marks for the embroidered pattern and on the headboard are inked markings for the satin-stitch needlework design of the basket. The embroidery is executed through the linen backing. The metal-wrapped cords actually pierce the satin and are tied off in knots on the reverse. They were not sewn with a needle but were threaded through holes made by an awl-like tool. The headboard has a layer of starch between the linen backing and the silk satin. Under the satin-stitch needlework that represents a basket of flowers on the headboard are additional backing layers of thin linen and paper. These hangings also have lengths of trim, ¼ to ⅜ inch (.7 to 1.0 cm) wide, sewn with an overcast stitch in double rows. The trim has blue silk thread that is Z spun S ply (4) and silver metallic threads that are wrapped around a silk core (Z spun).

Both the tester and the back panel have surface discolorations of overall gray soiling. The tester is pierced by 128 buttonholelike openings, applied in a curving outline beyond the blue and silver trim. These would have originally accommodated the cords or strings used to secure the textile to its frame. There are a number of old repairs and patches on the tester, probably necessitated by the stress created by this method of taut suspension. The back panel and the cover have numerous shallow creases between the couched chenille cords, caused by the shrinkage of the can-

vas lining. The former also bears a series of fine nail holes, with oxidation marks, along the lower contour of trim, which correspond in outline to the shaped headboard. There is an unfaded line along both vertical edges and the top of the back panel, indicating the former presence of blue and silver metallic trim. The silk satin ground of the tester and back panel is slightly brittle and dry, while that of the bed cover is particularly abraided and fragile at the foot corners. These areas of damage have been conserved by couching the weft threads to a support fabric of modern silk satin, inserted underneath, and by encasing them with silk crepeline.

The outer side curtains and the outside valances have grounds composed of pieced sections of the older, yellow warp-faced silk satin. Set into these grounds are sections of assorted, brocaded lampas-weave silk fabrics. The largest inset sections are of a blue ground with supplemental patterning in silver-wrapped metallic thread. The blue ground's selvage consists of a checkerboard pattern in rose, blue, and silver metallic-wrapped threads. The other fabric inserts derive from at least three or four lampas-weave silks whose ground colors are cream and/or silver with supplemental patterns in polychrome silk threads. The side curtains are doubled faced, with the smaller yellow satin ground panels stitched to the inside, although it is apparent that the four pieces were originally separate. The inner faces of the curtains have a lining of blue silk taffeta visible along only two perimeters where the yellow silk satin ground does not extend to the full dimensions of the outer faces.

The valances are backed by a coarse plain-weave bast fabric and there is a heavy coating of a starchlike substance between the bast backing and silk face. The three upper outside valances retain their original partial linings of blue silk taffeta under modern outer linings of silk taffeta, dyed to match. The three lower valances are lined with plain-weave linen woven in a plaid pattern of tan, cream, natural, and brick red colors (a different plaid from that lining the cover). The loom width of this plaid linen is 20½ inches (52.0 cm) and the selvages are plain.

The outer side curtains and outside valances have embroidered embellishments in addition to the silk lampas inserts: couched silk chenille cords, silk cords wrapped with metallic thread, silver metal wire coiled around another metal wire core, and trim of silk and silver metallic-wrapped silk threads. Like the yellow silk satin hangings, these components are also embroidered through the linen backing. Additionally, these panels have applied padded shapes, made of brocaded fabrics on paper linings. The upper outside foot valance (79.DH.3.8) lost the padded fleuron from its left corner; it has been replaced by a modern approximation. The lower valances each have a linen casing or sleeve along the top edge, and they must have hung from rods. Each sleeve is covered by long narrow sections of the

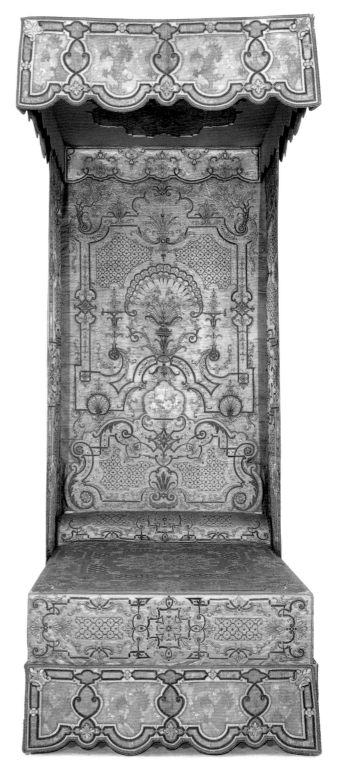

Hangings for a Bed (Lit à la duchesse), frontal view 79.DH.3.1–16

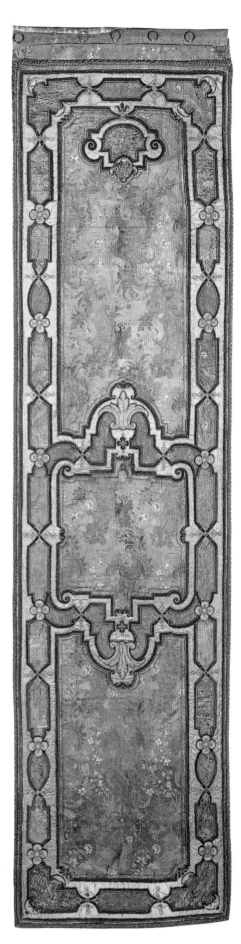

FIGURE 18.5 Side curtain (*bonne-grâce*), outer face.

older yellow silk satin in order to disguise the linen casing, which would otherwise have been visible. Remnants of a system of metal hooks and eyelets survive on the vertical edges of the lower valances at the foot end.

Overall, the bed has suffered little fading. The yellow silk satin is a rich color; comparing the obverse of the older satin to its reverse, there is about a twenty percent loss of color. The newer satin is brighter.

COMMENTARY

At the end of the seventeenth century, beds used in French households generally had a tester and curtains that could be drawn to enclose the bed entirely and thus provide both warmth and privacy, since the room containing the bed frequently fulfilled many purposes other than exclusively sleeping.[2] Among the most commonly named types of beds at the end of the seventeenth century were *lits à l'impériale* (or *en pentes*), which had four posts and curtains at each corner, and *lits à la duchesse*, which were without columns and had curtains only at the head. Given the elaborate and expensive embellishments on this *lit à la duchesse*, it probably furnished a formal chamber (*chambre de parade*) in a wealthy home.

While no specific designer can be named for this set of bed hangings, its decorative elements were probably inspired by one of the many ornament books that were available for embroiderers and upholsterers. Anne Ratzki-Kraatz has discussed a group of *ornemanistes* active at the end of the seventeenth century whose engravings are stylistically close to the embroidered design of this set of bed hangings.[3] Although little-known today, their collective work indicates the type of patterns circulating in those decades. Among the group she names are Gabriel-Androuet DuCerceau (active 1690–1705), Nicolas Guérard (active 1670–1696), and Baptiste Antheaume (active end of seventeenth century). Since her article, Ratzki-Kraatz has added another name to the circle: P. P. Bacqueville (active 1709–1720, *peintre d'ornemens* at both the Gobelins and the Savonnerie manufactories), whose *Livre d'ornemens propres pour les meubles et pour les peintres* (Paris, circa 1710) included engravings for beds with polylobed central patterns like that found on the bed cover and eight-pointed foliate rosettes like the one embroidered on the tester (fig. 18.7).[4]

Period engravings are also useful for the clues they provide in the contemporary assembly of seventeenth-century bed hangings. While sets of hangings have survived, their original frames and support systems have not. One can only approximate the frame's dimensions, the placement of the textile components in relation to one another, and the depth of the tester. Engravings, such as the three by Gabriel-Androuet DuCerceau reproduced by Ratzki-Kraatz, provide essential details of the *lit à la duchesse*. Its textile components were fixed in number: the

cover, three lower valances, the headboard, the back panel, the tester, three outside upper valances, and four inside upper valances. At the head of the bed, suspended from the tester and hung between the inner and outer valances, were side curtains that extended down to about the level of the lower valances. (In DuCerceau's examples these side curtains were rather simply embellished and they hung loosely in folds rather than as straight panels. They could, in turn, be supplemented by drapes, which were hung between the inner and outer side curtains and could be drawn on a metal rod to entirely enclose the bed.) The mattress cover incorporated the bolster and the cover's lower perimeter was tucked behind the three lower valances. When the upper valances had scalloped or shaped edges, the inner valances aligned with the outer. The embroidered design of the headboard also aligned precisely with that of the back panel, as if the two fields were a unified surface. And finally, the rigidly symmetrical pattern of the cover was echoed by that of the tester.

EMBROIDERER AND DATE

Undoubtedly a professional workshop was responsible for the assembly of the yellow silk satin hangings as well as their embroidery. The yardage of the satin is expertly utilized and the seams joining the selvages exactly align from the back panel to the headboard to the cover. The embroidery of the couched chenille threads is extremely fine, as is the satin stitch detailing. Further evidence of a workshop origin is found in the presence of the paper interface between the embroidered basket and its linen backing. This paper was a recycled needlework pattern, with punchings of a different design clearly visible, whose deteriorated condition rendered it a ready material for reinforcing the silk.[5]

Although the bed has two padded fleur-de-lys applied to each lower and upper outside valance, there is nothing to substantiate this as a royal bed. Accounts of the Garde-Meuble de la Couronne, however, indicate that beds of this type were supplied to the royal household and assembled by professional upholsterers. From the 1660s, the bed hangings were only a part of a large suite of *emmeublements* that furnished a room with matching curtains, table covers, screen panels, and covers for a variety of seat furniture. The same records describe how the furnishing fabrics—whether velour, taffeta, or *satin de la Chine*—were heavily embroidered, often with gold and silver thread.

Lits à la duchesse came into vogue in the 1690s and remained in fashion with little change for about one hundred years. For example, the *tapissier* (upholsterer) Lallié delivered a *lit à la duchesse* to the *commandant de l'equipage du sanglier* at Versailles in August 1733 comprising:

> *Un lit a la duchesse et pentes de serge d'aumalle verte, rubané de soïe de meme couleur, composé de trois pentes de dehors, deux grands rideaux, deux bonngraces, fond ou sont attachées quatre pentes de*

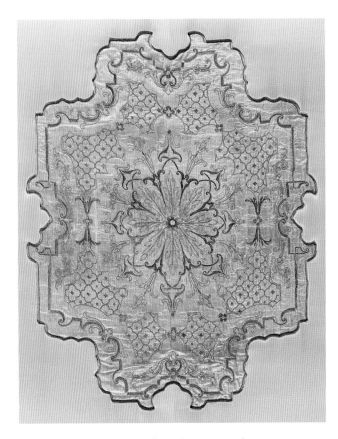

FIGURE 18.6 Inner tester with modern surround.

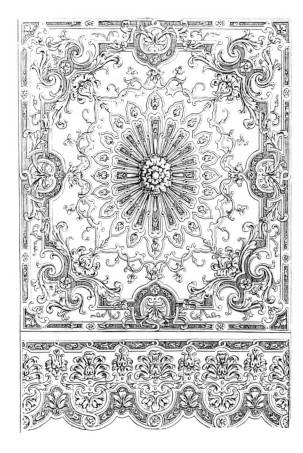

FIGURE 18.7 P. P. Bacqueville, (French, active 1709–1720). Plate from *Livre d'Ornemens propres pour les meubles et pour les peintures* (Paris, 1710). London, the Victoria and Albert Museum, inv. 26463.1. Photo courtesy the Board of Trustees of the Victoria and Albert Museum.

dedans, dossier, counterpointe - trois soubassmens,
avec leur antibois et 4 pommes.[6]

The frame of this bed, with its winter hangings, measured six *pieds*, four *pouces* long (about 6 ft. 4 in.) by four *pieds* wide (about 4 ft. 3 in.). It was fitted with three mattresses: the first was a mattress of straw, covered by a blue and white striped canvas and stitched with horse hair; the second was a mattress of wool with a cotton cover (*futaine*); and the last mattress, also of wool, was covered with striped canvas. Additionally, there was a down quilt, a feather bolster, and two blankets of fine white wool.[7] No sheets were mentioned since they were usually inventoried with the linen.[8]

The color of the yellow satin and its symmetrical embroidery patterns of red and green couched chenille date the Museum's example to the late seventeenth century. While red and green were the dominant color choices for bed hangings in this period, yellow was not unusual. Contemporary accounts feature numerous instances of *brocatelle fond jaune, taffetas jaune, satin jaune, damas jaune,* and *damas aurore* (a pale yellow).[9]

A few decades following the original professional assembly of the Museum's *lit à la duchesse*, it was deemed necessary to refurbish it. One can only speculate whether damage or fashion required these subsequent alterations. This later work appears to have been the effort of non-professional needleworkers, as the work is relatively less skilled, even though it is executed in such costly materials as coiled silver thread, metallic-wrapped threads, and silver brocaded damasks. It was not uncommon for cloistered nuns and women of the court to pursue needlework, even for such large projects as bed hangings. It may have been private needleworkers of this sort who embarked on these alterations, particulary given that various brocaded dress fabrics were recycled and applied to the lower valances, the outer side curtains, and the upper outside valances. These same pieces were trimmed with an ornate *galon* of silver metallic thread and loops in red, white, and blue silk cord. At this time, new matching yellow silk satin was also obtained and used to lengthen (or replace the lower portion of) the original yellow satin of the inner side curtains and the lower portion of the headboard behind the bolster roll. The inner curtains were then sewn to the reverse of the refurbished outer hangings.

The largest fabric appliqués are of blue lampas with a Bizarre pattern in metallic thread. Given the short-lived popularity of these Bizarre textiles, it is possible to date the fabrics from about 1705 to 1715. The alterations to the bed probably occurred once the woman's costume was no longer fashionable, some time shortly after 1715. It must have coincided with the taste for complimenting light blue furnishing fabrics with silver metallic trim, a taste introduced about 1715–1720 when the French court under the Regent, the duc d'Orléans (1674–1723), left the sobriety of Versailles for private households in Paris.[10]

RELATED HANGINGS FOR BEDS

By 1788, it appears that *lits à la duchesse* were no longer popular and the few examples cited in the records of the Garde-Meuble located them in storage.[11] By 1792, these richly embellished beds were valued only for their metallic content by an impoverished government, as a Garde-Meuble inventory entry for that year states "Argent et dorure à brûler—un lit damas jaune broderie et galon en argent."[12] In their place fashion dictated a preference for *lits à la Polonaise*, beds with four posts and an oval dome.

Consequently, very few French *lits à la duchesse* from either the seventeenth or eighteenth centuries survive, and no others are known to be intact with embroidered decoration similar to this bed.[13] A complete set of bed hangings embroidered with grotesques and exotic motifs and dating from about 1720 is conserved in the Abegg-Stiftung, Riggisberg, near Bern, Switzerland.[14] The Musée Historique des Tissus, Lyons, preserves a back panel whose crimson taffeta fabric is embroidered with strapwork of a similar, though bolder, form and garnished with applied ribbons.[15] The Château de Cheverny has a rare *lit à la duchesse* that was assembled in the seventeenth century from cloth embroidered earlier in Persia.[16] *Lits* of this date and form, also garnished with applied ribbons, exist in the Château de Bussy-Rabutin, Côte-d'Or; the Château Azay-Le-Rideau, Loire (lent from the Chateau d'Effiat); and the Musée des Arts Décoratifs, Paris.[17] An example with red velour and black satin appliqués is in the Château de Bazoches, Nièvre.[18] There are two beds that were embroidered in *petit-point* around 1740 and show Endymion in an allegory of Sleep on their head boards; one is displayed in the Chambre du Dauphin, Musée National de Château de Versailles, and the other in the Chambre du Roi of the Château de Vaux-le-Vicomte near Melun.[19] Valances and side curtains for a *lit à la duchesse*, embroidered in *petit-point* with scenes from Ovid's *Metamorphoses*, have been assembled with modern hangings for display in the Metropolitan Museum of Art.[20] A cover for a *lit à la duchesse*, embroidered with figures of the four seasons, sold from the collection of Anténor Patiño, Palais Galliera, Paris, June 9–10, 1976, no. 226; its present location is unknown.

PROVENANCE
(?) Château de Monbrian, near Messimy, Aix-en-Provence[21]; P. Bertrans et Cie, 10, rue d'Argenson, Paris, 1933; Gerald C. Paget, London and New York, 1970s; J. Paul Getty Museum, 1979.

EXHIBITIONS
L'Exposition rétrospective de la chambre à coucher, Grand Palais, Salon des Arts Ménagers, Paris, January–February 1933, no. 192, illus.; Château de Versailles (actually placed in Salon de la Guerre), as stage furnishing for the Comédie

Française performance of Racine's *Esther* in the Galerie des Glaces, June 20, 1936.

PUBLICATIONS

M. Loyer, "L'Exposition rétrospective de la chambre à coucher," *Revue Officielle du Salon des Arts Ménagers* (February 1933), pp. 45–47; G. Wilson, "Acquisitions Made by the Department of Decorative Arts, 1977 to mid 1979," *GettyMusJ* 6–7 (1978–1979), pp. 48–49; Sassoon and Wilson 1986, no. 209, pp. 96–97, illus.; A. Ratzki-Kraatz, "A French Lit de Parade 'A la Duchesse' 1690–1715," *GettyMusJ* 14 (1986), pp. 81–104, illus.; Bremer-David et al., 1993, no. 278, p. 162, illus.

NOTES

1. Textile terms used here are in accordance with D. K. Burnham, *Warp and Weft: A Textile Terminology* (Toronto, 1980).

2. Approximately seventy percent of the beds mentioned in after-death inventories compiled by notaries working in the Parisian area from 1640 to 1790 had curtains. See the study published by A. Pardailhé-Galabrun, *The Birth of Intimacy: Privacy and Domestic Life in Early Modern Paris* (Cambridge, 1991) pp. 74 ff.

3. A. Ratzki-Kraatz, "A French Lit de Parade 'A la Duchesse' 1690–1715," *GettyMusJ* 14 (1986), pp. 81–104, illus.

4. *Livre d'ornemens propres pour les meubles et pour les peintres. Inventé par Bacqueville. Se vend à Paris chez l'autheur au milieu de la rüe des petits champs. F.J. Spoëtt sculp.*, in Verlet 1982, pp. 232–233, fig. 144, and p. 427 n. 84.

5. Ratzki-Kraatz also concluded that the presence of the punched paper interface alluded to the bed's ultimate origins in a professional embroidery workshop. The Museum's bed is therefore unlikely to be the example she laters mentions as the subject of several payments made in 1691 to an Ursuline nun, Melle de la Feuillade, by the proprietor of the Château de Montbrian. See Ratzki-Kraatz (note 3), pp. 81–104, illus.

6. A.N., O¹ 3311, no. 2765g. The "4 pommes" are the four ornamental vases positioned at each corner of the tester, probably intended to partially obscure the chains necessary to suspend it from the ceiling.

7. "La couchette de six pieds: 4 pouces de long, sur quatre pieds de large et 8 pieds ½ de haut, garnie d'une paillasse de toile barée bleu et blanc piquée de crin, deux matelas de laine dont un de futaine, l'autre de toile barée, un lit et traversin de plume et coutil; et deux convertures de laine blanche fine." A.N., O¹ 3311, no. 2765g et 285 des meubles.

8. Pardailhé-Galabrun (note 2), p. 78.

9. Guiffrey, *Inventaire* vol. 2, pp. 209–244. For a general discussion on colors preferred in seventeenth- and eighteenth-century Parisian households, see Pardailhé-Galabrun (note 2), pp. 170–173.

10. I thank Alexandre Pradère who noted this transition.

11. A.N., O¹ 3357, Magasin du Garde-Meuble, Inventaire des petits meubles 1788.

12. A.N., O¹ 3359, Inventaire des petits meubles, Année 1792.

13. French-style parade beds were used in courts throughout Europe during the eighteenth century. For example, Salomon Kleiner engraved renderings of *lits à la duchesse* in his *Suite des residences memorables d'Eugene François, duc de Savoye et de Piedmont* (Augsburg, 1731), reprinted as *Das Belvedere in Wien* (Graz, Austria, 1969). A *lit à la duchesse* with red silk velvet and silver brocaded damask survives, together with wall coverings *en suite*, in the state bedroom of the Schloss Schleissheim, Munich. See H. Kreisel, "Régence

14. Abegg-Stiftung, Riggisberg, near Bern, Switzerland, inv. 2398. See A. Gruber, *Grotesques: Un style ornemental dans les arts textiles du XVI–XIXᵉ siècle*, exh. cat. (Abegg-Stiftung, Bern, 1985), no. 11, pp. 71, illus.

15. R. Cox, *Le Musée historique des tissus: soieries et broderies, Renaissance, Louis XIV, Louis XV, Louis XVI, Directoire, Premier Empire* (Paris, 1914), vol. 1, pl. 21.

16. See "Cheverny" in *Merveilles des châteaux du Val de Loire* (Paris, 1964), p. 80.

17. See "Bussy-Rabutin," in ibid., p. 30, and "Azay-le-Rideau," p. 132. See also Ratzki-Kraatz (note 3), p. 97, tester only illus. fig. 20.

18. J. Feray, *Architecture intérieure et décoration en France des origines à 1875* (Paris, 1988), illus. p. 165.

19. Musée National de Château de Versailles, inv. v.4131. See Le Comte Patrice de Vogüé, *Vaux-le-Vicomte*, in collaboration with *Connaissance des Arts* (Paris, n.d.), illus. p. 22.

20. See A. M. Zrebiec's contribution to "French Decorative Arts during the Reign of Louis XIV 1654–1715," *The Metropolitan Museum of Art Bulletin* (Spring 1989), illus. p. 10 and in details p. 34.

21. Information from the London dealer Gerald C. Paget.

Furniture in Munich," *Apollo* (November 1969), pp. 390–403, illus. pl. III.

Index

Museums are listed under the city in which they are located. Palaces and buildings that appear in a historical context are listed by name. **Boldface** indicates extended discussion.